BRITISH ART AND VISUAL CULTURE SINCE 1750
New Readings
General Editor: David Peters Corbett, University of York

This series examines the social and cultural history of British visual culture, including the interpretation of individual works of art, and perspectives on reception, consumption and display.

In the same series:

Memory and Desire
Painting in Britain and Ireland at the Turn of the Twentieth Century
Kenneth McConkey

The Cultural Devolution
Art in Britain in the Late Twentieth Century
Neil Mulholland

British Artists and the Modernist Landscape
Ysanne Holt

Modern Architecture and the End of Empire
Mark Crinson

Representations of G. F. Watts
Art Making in Victorian Culture
Edited by Colin Trodd and Stephanie Brown

Reassessing Nikolaus Pevsner
Edited by Peter Draper

Purchasing Power
Representing Prostitution in Eighteenth-Century English Popular Print Culture
Sophie Carter

English Accents
Interactions with British Art c. 1776–1855
Edited by Christiana Payne and William Vaughan

Sculpture and the Pursuit of a Modern Ideal in Britain c. 1880–1930
Edited by David J. Getsy

A Shared Legacy
Essays on Irish and Scottish Art and Visual Culture
Edited by Fintan Cullen and John Morrison

Time Present and Time Past
The Art of John Everett Millais
Paul Barlow

Alfred Gilbert's Aestheticism
Gilbert Amongst Whistler, Wilde, Leighton, Pater and Burne-Jones
Jason Edwards

History's Beauties
Women and the National Portrait Gallery, 1856–1900
Lara Perry

Painting the Bible

Representation and Belief in Mid-Victorian Britain

Michaela Giebelhausen

ASHGATE

Published by
Ashgate Publishing Limited
Gower House
Croft Road
Aldershot
Hants GU11 3HR
England

Ashgate Publishing Company
Suite 420
101 Cherry Street
Burlington, VT 05401-4405
USA

Ashgate website: http://www.ashgate.com

British Library Cataloguing in Publication Data
Giebelhausen, Michaela
 Painting the Bible : representation and belief in
 mid-Victorian Britain. - (British art and visual culture
 since 1750 : new readings)
 1. Christian art and symbolism - Great Britain - History -
 19th century 2. Pre-Raphaelitism - England
 3. Pre-Raphaelitism - Religious aspects 4. Painting, English
 - 19th century
 I. Title
 755.4'0942'09034

Library of Congress Cataloging-in-Publication Data
Giebelhausen, Michaela.
 Painting the Bible : representation and belief in mid-Victorian Britain /
 Michaela Giebelhausen.
 p. cm. - (British art and visual culture since 1750, new readings)
 Includes bibliographical references and index.
 ISBN 0-7546-3074-9 (alk. paper)
 1. Painting, British--19th century. 2. Painting, Victorian--Great Britain.
 3. Art and religion--Great Britain--History--19th century. 4. Bible--
 Illustrations. 5. Pre-Raphaelites--Great Britain. I. Title. II. Series.

ND467.G53 2006
755'.4094109034--dc22

755. 4094 GIE 2005058876

ISBN 0 7546 3074 9

Typeset by Bournemouth Colour Press, Parkstone, Poole.
Printed by and bound in Great Britain by MPG Book Ltd, Bodmin, Cornwall.

Contents

List of Illustrations VII

Acknowledgements XIII

1 **Introduction: translating the Bible for the age** 1
 Themes at once sacred and stale: the problem of religious
 painting 5
 Painting the Bible: issues and methodologies 12

2 **Religious painting and the high-art ideal: tradition, modification
 and innovation** 21
 Under the sanction of a Royal Academy: the lectures of Henry
 Howard and Charles Robert Leslie 22
 The practice of religious painting and the periodical press 30
 The case of Benjamin Robert Haydon: the reform of tradition and
 the quest for public space 40
 Charles Lock Eastlake and the undefinable arch-quality of
 sentiment 48
 Modification and innovation: continental influence and matters
 of genre 55

3 **The fascination of paradox: the Pre-Raphaelite challenge** 67
 A kindred simplicity: the search for an expressive language of art 68
 Early Pre-Raphaelite work: Giottesque or grotesque? 87
 A step too far: the signal for a perfect crusade against the PRB 100
 Reading *Christ in the House of His Parents*: a gesture of defiance 111

4 **The making of William Holman Hunt as the painter of the Christ** 127
 Reconfiguring Christ: history, biography, myth 128
 Illustrating the Bible: a context for Hunt's pictorial concerns 134
 Private motivations: suppressing the religious experience 147
 Public narratives: work, art and the figure of Christ as hero 155
 Experiencing the East 159
 Finding the Saviour, at last 164

The success of the Saviour: a contemporary reaffirmation of faith 172
The spheres of art and religion 177

5 **Epilogue: ideal subjects glowing with poetry** 189

Notes 201
Bibliography 229
Index 241

List of Illustrations

Plates

1 Benjamin Robert Haydon, *Christ's Entry into Jerusalem*, 396 x 457 cm, oil on canvas, 1814–20. Photograph: Matt Lee, used with the permission of The Athenaeum of Ohio, Cincinnati, Ohio

2 Charles Lock Eastlake, *Christ lamenting over Jerusalem*, 104.8 x 156.2 cm, oil on canvas, 1846 (replica of picture exhibited RA 1841). © Tate, London 2005

3 William Dyce, *Joash shooting the Arrow of Deliverance*, 76.3 x 109.5 cm, oil on canvas, 1844. Photograph: Elke Walford, Hamburg, Hamburger Kunsthalle / bpk Berlin

4 John Rogers Herbert, *The Youth of Our Lord* (replica of picture exhibited RA 1847 as *Our Saviour subject to His Parents at Nazareth*), 81.3 x 129.5 cm, oil on canvas, 1847–56. © Guildhall Art Gallery, Corporation of London, UK / Bridgeman Art Library

5 Ford Madox Brown, *Jesus washing Peter's Feet*, 116.8 x 133.3 cm, oil on canvas, 1852–56. © Tate, London 2005

6 Dante Gabriel Rossetti, *The Girlhood of Mary Virgin*, 83.2 x 65.4 cm, oil on canvas, 1848–49. © Tate, London 2005

7 John Everett Millais, *Christ in the House of His Parents* (*The Carpenter's Shop*), 86.4 x 139.7 cm, oil on canvas, 1849–50. © Tate, London 2005

8 Sano di Pietro, *Virgin and Child with Six Saints*, 43 x 52.8 cm, oil on linen laid down on canvas, mid-fifteenth century. Christ Church Picture Gallery, Oxford

9 Annibale Carracci, *The Butcher's Shop*, 190 x 271 cm, oil on canvas, 1580s. Christ Church Picture Gallery, Oxford

10 William Holman Hunt, *The Finding of the Saviour in the Temple*, 86 x 141 cm, oil on canvas, 1854–60. Birmingham Museums and Art Gallery

11 William Dyce, *The Man of Sorrows*, 34.9 x 48.4 cm, oil on board, 1860. © The National Gallery of Scotland, Edinburgh

12 William Holman Hunt, *The Shadow of Death*, 214.2 x 168.2 cm, oil on canvas, 1870–73. © Manchester Art Gallery

13 Arthur Hughes, *The Nativity*, 61.2 x 35.8 cm, oil on canvas, 1858. Birmingham Museums and Art Gallery

Figures

1 Introduction

1.1 Ford Madox Brown, *John Wycliffe reading his Translation of the New Testament to John of Gaunt*, 119.5 x 153.5 cm, oil on canvas, 1847–48 and 1859–61. © Bradford Art Galleries and Museums, West Yorkshire, UK/ Bridgeman Art Library

1.2 Raphael, *Christ's Charge to Peter*, 340 x 530 cm, bodycolour on paper mounted onto canvas, 1515–16. Victoria and Albert Museum, London

1.3 Dante Gabriel Rossetti, *Fra Angelico Painting*, 18 × 11.3 cm, pen, brown ink and wash on paper, *c.* 1853. Birmingham Museums and Art Gallery

1.4 William Holman Hunt, *Painting in England. Hastings, 1852*, 12.3 × 17.9 cm, pen and sepia ink and wash on paper, 1852. Collection of Christopher Wood

1.5 William Holman Hunt, *Self-portrait in Egyptian Landscape*, pen and ink on paper, 1854. Courtesy William Holman Hunt Letters, Special Collections, Arizona State University Libraries

2 Religious painting and the high-art ideal

2.1 Benjamin Robert Haydon, *The Raising of Lazarus*, 426.7 × 632.5 cm, oil on canvas, 1821–23. © Tate, London 2005

2.2 Charles Lock Eastlake, *Hagar and Ishmael*, 58.4 × 50.8 cm, oil on panel, 1830. Photograph: John Hammond, © Royal Academy of Arts, London

2.3 Charles Lock Eastlake, *Christ blessing Little Children*, 79 × 103.2 cm, oil on canvas, 1839. © Manchester Art Gallery

2.4 Charles Lock Eastlake, *Hagar and Ishmael*, 76 × 96.5 cm, oil on canvas, 1843. Sold at Phillips, Early British and Victorian Paintings, 16 December 1997, lot 74

2.5 Charles Lock Eastlake, *The Good Samaritan*, 111.7 × 157.8 cm, oil on canvas, 1850. Royal Collection, Osborne House

2.6 William Dyce, *Jacob and Rachel*, 70.4 × 91.1 cm, oil on canvas, 1850–53 (a later version of the painting exhibited at the RA, 1850, untraced). © New Walk Museum, Leicester City Museum Service / Bridgeman Art Library

2.7 A. Strähuber, *The Meeting of Jacob and Rachel*, wood-engraving, *Art Journal*, 1851, p. 90. By permission of the British Library (shelfmark: PP 1931 pc)

2.8 Henry Nelson O'Neil, *Esther*, 102.5 × 76 cm, oil on canvas, 1850. Sold at Sotheby's Belgravia Sale, 29 June 1976, lot 68, as *Esther's Emotions*. Photograph: courtesy of Sotheby's, London

2.9 F. R. Pickersgill, *Samson Betrayed*, 243.8 × 306 cm, oil on canvas, 1850. © Manchester Art Gallery

2.10 Daniel Maclise, *Noah's Sacrifice*, 205 × 254 cm, oil on canvas, 1847–53. © Leeds Museums and Galleries (City Art Gallery)/ Bridgeman Art Library

2.11 Nicolas Poussin, *Noah's Sacrifice*, 99 × 135 cm, oil on canvas, n.d. Tatton Park, Cheshire. Photograph: John Hammond © NTPL / John Hammond

2.12 Gustav Jäger, *Noah's Sacrifice*, wood-engraving from *Bibel mit Bildern*, 1844. Stuttgart: Cotta

2.13 Daniel Maclise, sketch of *Noah's Sacrifice*, 17.8 × 21.6 cm, pen and ink on paper, *c.* 1847. Victoria and Albert Museum, London

3 The fascination of paradox

3.1 Benozzo Gozzoli, *The Departure of Hagar from the House of Abraham* (1472), detail of engraving from Lasinio's *Pitture a Fresco del Campo Santo di Pisa*, Florence: Presso Molini, Landé e Compagno, 1812. By permission of the British Library (shelfmark: 559*h8 74)

3.2 Dante Gabriel Rossetti, *William Holman Hunt (caricature)*, 18 × 11.3 cm, pen and ink on paper, 1851–53. Birmingham Museums and Art Gallery

3.3 Dante Gabriel Rossetti, *Sir John Everett Millais (caricature)*, 18 × 11.3 cm, pen and ink on paper, 1851–53. Birmingham Museums and Art Gallery

3.4 Ford Madox Brown, *Our Lady of Good Children*, 78.1 × 59.1 cm, pastel, watercolour and gold paint on paper, 1847–61. © Tate, London 2005

3.5 Biago di Antonio da Firenze, *Virgin and Child with the Young Saint John and an Angel holding the Three Holy Nails*, 64.8 × 50.2 cm, oil on panel, second half of the fifteenth century. Christ Church College Picture Gallery, Oxford

3.6 William Dyce, *Madonna and Child*,

80.2 × 58.7 cm, oil on canvas, 1845. Royal Collection

3.7 *Design for Justice*, wood-engraving, *Punch*, 9 (1845), p. 150. By permission of the British Library (shelfmark: PP 5270)

3.8 *High Art and the Royal Academy*, wood-engraving, *Punch*, 14 (1848), p. 197. By permission of the British Library (shelfmark: PP 5270)

3.9 Richard Doyle, *Punch presenting Ye Tenth Volume to Ye Queene*, wood-engraving, *Punch*, 10 (1846), p. iii. By permission of the British Library (shelfmark: PP 5270)

3.10 *A Young Man about Town (Gothic)*, wood-engraving, *Punch*, 9 (1845), p. 103. By permission of the British Library (shelfmark: PP 5270)

3.11 *A Scene from Gothic Life*, wood-engraving, *Punch*, 9 (1845), p. 103. By permission of the British Library (shelfmark: PP 5270)

3.12 Dante Gabriel Rossetti, *Ecce Ancilla Domini*, 72.4 × 41.9 cm, oil on canvas, 1849–50. © Tate, London 2005

3.13 *The Ensuing Exhibition of the Royal Academy* and *Smithfield Market Prize Show*, wood-engraving, *Punch*, 12 (1847), p. 177. By permission of the British Library (shelfmark: PP 5270)

3.14 *The Deformito-Mania*, wood-engraving, *Punch*, 13 (1847), p. 90. By permission of the British Library (shelfmark: PP 5270)

3.15 Caricature of John Everett Millais's *Mariana*, wood-engraving, *Punch*, 20 (1851), p. 219. By permission of the British Library (shelfmark: PP 5270)

3.16 Caricature of Charles Allston Collins's *Convent Thoughts*, wood-engraving, *Punch*, 20 (1851), p. 219. By permission of the British Library (shelfmark: PP 5270)

3.17 John Everett Millais, *Christ in the House of His Parents*, wood-engraving, *The Illustrated London News*, 11 May 1850, p. 336. By permission of the British Library (shelfmark: LD 47)

3.18 Ford Madox Brown, *An Abstract Representation of Justice*, wood-engraving, reproduced in Frederick Knight Hunt, *The Book of Art: Cartoons, Frescoes, Sculpture and Decorative Art*, London: Jeremiah How, 1846, p. 182. By permission of the British Library (shelfmark: 1266 g 13)

3.19 Annibale Carracci, *The Holy Family in the Carpenter's Shop*, wood-engraving of the painting in the Suffolk Collection, on loan to Kenwood House, London, from *The Illustrated London News*, 8 November 1856, p. 475. By permission of the British Library (shelfmark: LD 47)

3.20 James Collinson, illustration to his poem, *The Child Jesus*, wood-engraving, 1850, 2nd issue of *The Germ*. By permission of the British Library (shelfmark: C59 c 20)

3.21 John Everett Millais, sketch for *Christ in the House of His Parents*, 11.6 × 19.2 cm, pencil on paper, 1849–50. Victoria and Albert Museum, London

3.22 John Everett Millais, sketch for *Christ in the House of His Parents*, 19.5 × 33.6 cm, pencil on paper, 1849–50. Fitzwilliam Museum, Cambridge

3.23 John Everett Millais, sketch for *Christ in the House of His Parents*, 19 × 33.7 cm, pen on paper, *c*. 1849. © Tate, London 2005

3.24 John Everett Millais, sketch for *Christ in the House of His Parents*, 19 × 28.9 cm, pen and ink and wash on paper, *c*. 1849. © Tate, London 2005

3.25 John Everett Millais, *James Wyatt and his Granddaughter Mary Wyatt*, 35.5 × 45 cm, oil on panel, 1849. Lord Lloyd-Webber Collection

3.26 John Everett Millais, *Mrs James Wyatt Jnr and her Daughter Sarah*, 35.3 × 45.7 cm, oil on panel, *c*. 1850. © Tate, London 2005

3.27 John Everett Millais, *Sketch of Madonna and Child*, 18.8 × 18.6 cm, pen and ink, *c*. 1853. Birmingham Museums and Art Gallery

4 The making of William Holman Hunt as the painter of the Christ

4.1 *Flax (Linum usitatissimum)*, wood-engraving from *The Pictorial Bible*, London: Charles Knight, 1836–38, vol. 1, p. 154. By permission of the British Library (shelfmark: 689 e 3)

4.2 *Locusts*, wood-engraving from *The Pictorial Bible*, London: Charles Knight 1836–38, vol. 1, p. 155. By permission of the British Library (shelfmark: 689 e 3)

4.3 *Sicilian Women grinding in a Mill*, wood-engraving from *The Pictorial Bible*, London: Charles Knight, 1836–38, vol. 3, p. 60. By permission of the British Library (shelfmark: 689 e 3)

4.4 *Jerusalem, with the Mount of Olives*, wood-engraving from *The Pictorial Bible*, London: Charles Knight, 1836–38, vol. 3, p. 61. By permission of the British Library (shelfmark: 689 e 3)

4.5 Horace Vernet, *Rebekah and Abraham's Servant*, steel-engraving from *The Imperial Family Bible*, Glasgow: Blackie & Son, 1844, p. 24. By permission of the British Library (shelfmark: 1219 m 2)

4.6 *The Embalming of Joseph*, wood-engraving from *Cassell's Illustrated Family Bible*, London and New York: Cassell, Petter & Galpin, 1859–63, vol. 1, p. 96. By permission of the British Library (shelfmark: L 15 a 2)

4.7 *Judas Iscariot bargaining with the Chief Priests*, wood-engraving from *Cassell's Illustrated Family Bible*, London and New York: Cassell, Petter & Galpin, 1859–63, vol. 3, p. 163. By permission of the British Library (shelfmark: L 15 a 2)

4.8 *The Sick laid in the Streets to be healed*, wood-engraving from *Cassell's Illustrated Family Bible*, London and New York: Cassell, Petter & Galpin, 1859–63, vol. 3, p. 69. By permission of the British Library (shelfmark: L 15 a 2)

4.9 William Holman Hunt, *Christ and the two Marys*, 117.5 x 94 cm, oil on canvas over wood panel, 1847 (completed in 1897), d'Auvergne Boxall Bequest Fund 1964, Art Gallery of South Australia, Adelaide

4.10 William Holman Hunt, *The Light of the World*, 125.5 x 59.8 cm, oil on canvas over panel, 1851–53. Warden and Fellows of Keble College, Oxford

4.11 William Holman Hunt, sheet of sketches for *The Light of the World*, 24.5 x 34.6 cm, pen and brown ink over graphite on paper, 1851. Ashmolean Museum, Oxford

4.12 William Holman Hunt, *Painting in the East, Grand Cairo 185—*, 12.3 x 18.3 cm, pen and sepia wash on paper, 1852. Maas Gallery, London

4.13 William Holman Hunt, *The Scapegoat*, 87 x 139.8 cm, oil on canvas, 1854–55. National Museums Liverpool (Lady Lever Art Gallery)

4.14 *Mr. Holman Hunt in his Costume when painting 'The Scapegoat'*, photograph reproduced in Farrar and Meynell, *William Holman Hunt: His Life and Work*, London: Art Journal Office, 1893, p. 3. By permission of the British Library (shelfmark: PP 1931 pc/2)

4.15 William Dyce, *The Good Shepherd*, 78.9 x 63.5 cm, oil on paper mounted on canvas, 1859. Photograph © Manchester Art Gallery

4.16 William J. Webb, *The Lost Sheep*, 33.1 x 25.1 cm, oil on panel, 1864. © Manchester Art Gallery

4.17 William Holman Hunt, *Interior of a Carpenter's Shop*, wood-engraving from F. W. Farrar, *The Life of Christ*, 2nd edn, London: Cassell, Petter & Galpin, 1874, frontispiece. By permission of the British Library (shelfmark: 4808 g 4)

5 Epilogue

5.1 Gustave Doré, *Christ blessing Little Children*, wood-engraving from *The Holy Bible*, London: Cassell & Co, 1866–70, vol. 2, p. 60. By permission of the British Library (shelfmark: L 10 d 1)

5.2 John Everett Millais, *The Foolish Virgins*, wood-engraving from *The Parables of Our Lord and Saviour Jesus Christ*, London: Routledge, Warne and

Routledge, 1864. By permission of the British Library (shelfmark: C194 b 15)

5.3 Dante Gabriel Rossetti, *Mary in the House of St John*, 45.8 × 35.6 cm, watercolour, 1858. Wilmington Society of Fine Arts, Delaware

5.4 William Bell Scott, *The Nativity*, engraving after William Blake from William Bell Scott, *William Blake: Etchings from his Works*, London: Chatto and Windus, 1878. By permission of the British Library (shelfmark: 1763 d 7)

5.5 Edward Burne-Jones, *The Parable of the Boiling Pot*, wood-engraving from *Dalziels' Bible Gallery: Illustrations from the Old Testament*, London: Dalziel Brothers, 1880. By permission of the British Library (shelfmark: 1261 d 25)

5.6 William Bell Scott, *Moses bringing down the Tables of the Law*, wood-engraving from *The Illustrated Family Bible*, London: A. Fullarton and Co., n.d. [1876], opposite p. 105. By permission of the British Library (shelfmark: L 14 f 9)

5.7 William Bell Scott, *The Resurrection*, wood-engraving from *The Illustrated Family Bible*, London: A. Fullarton & Co., n.d. [1876], opposite p. 1159. By permission of the British Library (shelfmark: L 14 f 9)

Graphs

2.1 Religious paintings shown at the Royal Academy, 1825–70

2.2 Old Testament subjects shown at the Royal Academy, 1825–70

2.3 New Testament subjects shown at the Royal Academy, 1825–70

Acknowledgements

During the years I have worked on this book, which began life as a DPhil thesis, I have received help and support from many different quarters. First of all I would like to thank my DPhil supervisors Jon Whiteley and particularly Will Vaughan, whose generous support I could count on at every stage.

I wish to thank the following institutions for financial support I have received both as a DPhil student and during the time of writing the book. My post-graduate studies at Oxford University were made possible by grants from the Michael Wills Scholarship Fund, Oxford University, and from the Deutscher Akademischer Austauschdienst (German Academic Exchange Service). The much-needed time to actually write the book came in the form of a Paul Mellon Centre Postdoctoral Research Fellowship and additional study leave financed by the Research Promotion Fund, University of Essex. During this time, I also received funding from the Getty Research Library Grant Scheme and the British Academy to undertake archival research in the UK and the US. I received generous financial support for the illustrations of the book from the British Academy and the Research Promotion Fund, University of Essex, without whose repeated help the project would have taken far longer to see the light of day. Worcester College, Oxford, provided a small bursary to acquire reproductions during the early stages of my research.

I also wish to thank the Bodleian Library, Oxford; the John Rylands University Library of Manchester; and the Getty Research Institute, Los Angeles for granting permission to quote from manuscript sources in their collections.

While one tends to remember the financial and institutional support a project has received over the years, it seems far more difficult to keep track of the emotional and intellectual support one has been given along the way. I wish to thank Tim Barringer, Carrie Hintz and Sarah Symmons for their astute and insightful comments on the manuscript, and Mark Turner and Peter Vergo for reading and commenting on parts of the DPhil thesis all those years ago. My special thanks go to David Smith for playing the part of the common reader with such exacting rigour and for ridding the text of an

embarrassing amount of jumbled paragraphs and opaque Germanisms. For those that remain I take full responsibility.

And finally, my biggest thanks go to my family and friends for taking my mind off Jesus and making me laugh when it mattered most.

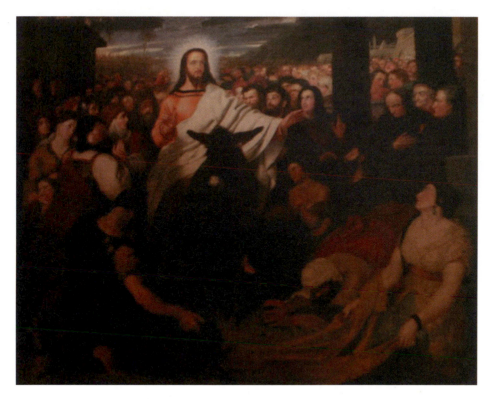

Plate 1 Benjamin Robert Haydon, *Christ's Entry into Jerusalem*, 396 × 457 cm, oil on
canvas, 1814–20

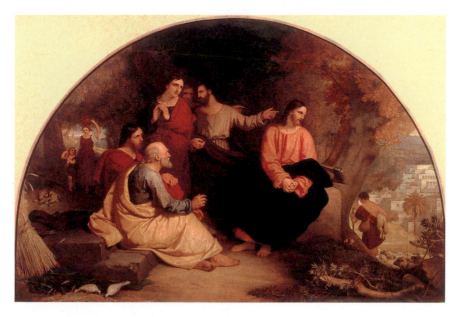

Plate 2 Charles Lock Eastlake, *Christ lamenting over Jerusalem*, 104.8 × 156.2 cm, oil
on canvas, 1846 (replica of picture exhibited RA 1841)

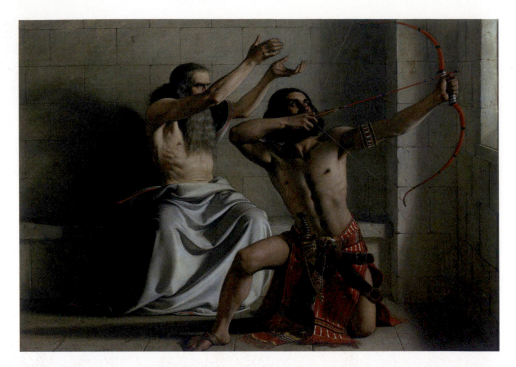

Plate 3 William Dyce, *Joash shooting the Arrow of Deliverance*, 76.3 x 109.5 cm, oil on canvas, 1844

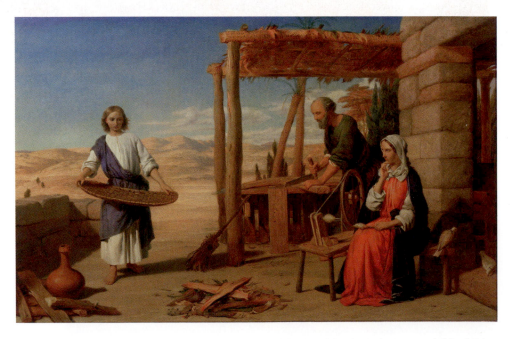

Plate 4 John Rogers Herbert, *The Youth of Our Lord* (replica of picture exhibited RA 1847 as *Our Saviour subject to His Parents at Nazareth*), 81.3 x 129.5 cm, oil on canvas, 1847–56

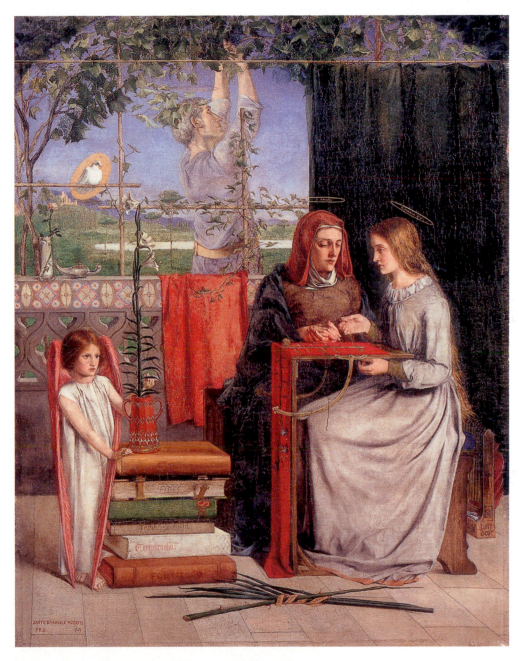

Plate 6 Dante Gabriel Rossetti, *The Girlhood of Mary Virgin*, 83.2 x 65.4 cm, oil on canvas, 1848–49

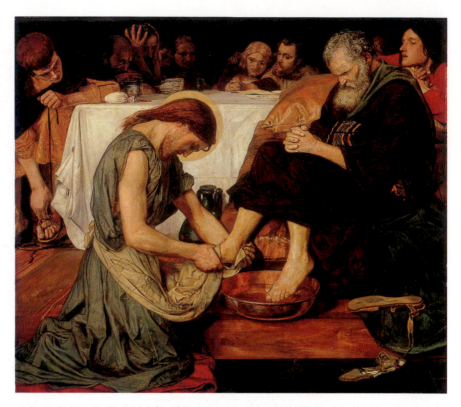

Plate 5 Ford Madox Brown, *Jesus washing Peter's Feet*, 116.8 × 133.3 cm, oil on canvas, 1852–56

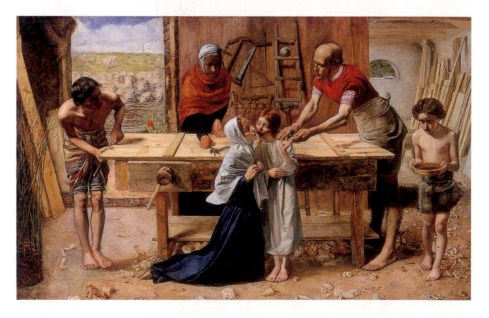

Plate 7 John Everett Millais, *Christ in the House of His Parents* (*The Carpenter's Shop*), 86.4 × 139.7 cm, oil on canvas, 1849–50

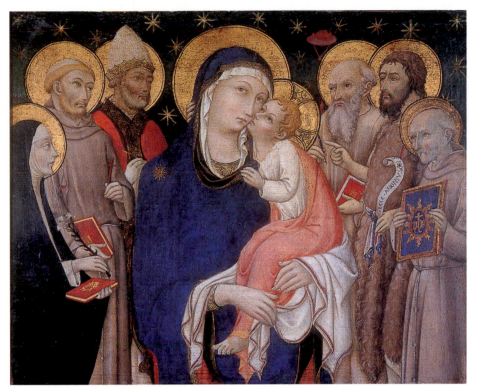

Plate 8 Sano di Pietro, *Virgin and Child with Six Saints*, 43 × 52.8 cm, oil on linen laid down on canvas, mid-fifteenth century

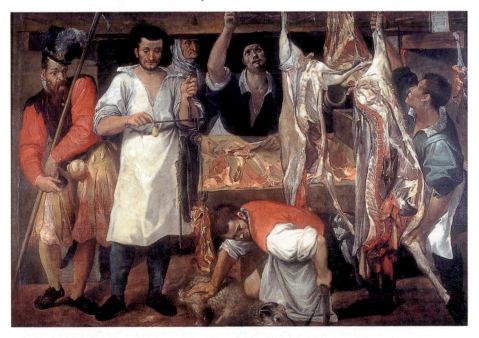

Plate 9 Annibale Carracci, *The Butcher's Shop*, 190 × 271 cm, oil on canvas, 1580s

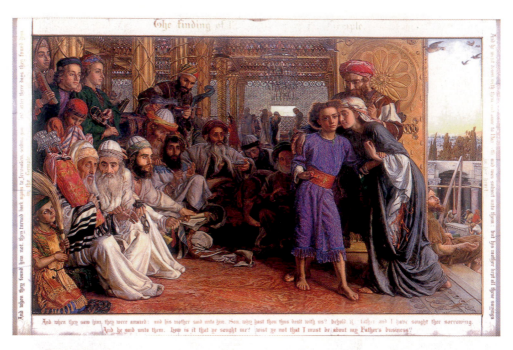

Plate 10 William Holman Hunt, *The Finding of the Saviour in the Temple*, 86 × 141 cm, oil on canvas, 1854–60

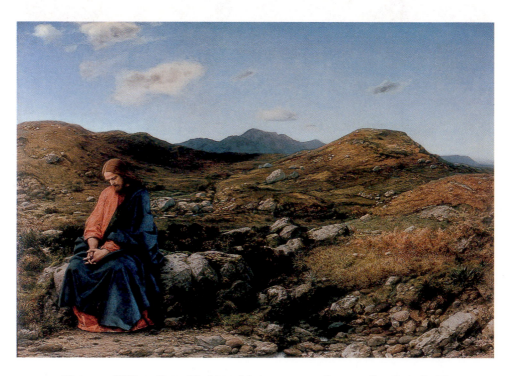

Plate 11 William Dyce, *The Man of Sorrows*, 34.9 × 48.4 cm, oil on board, 1860

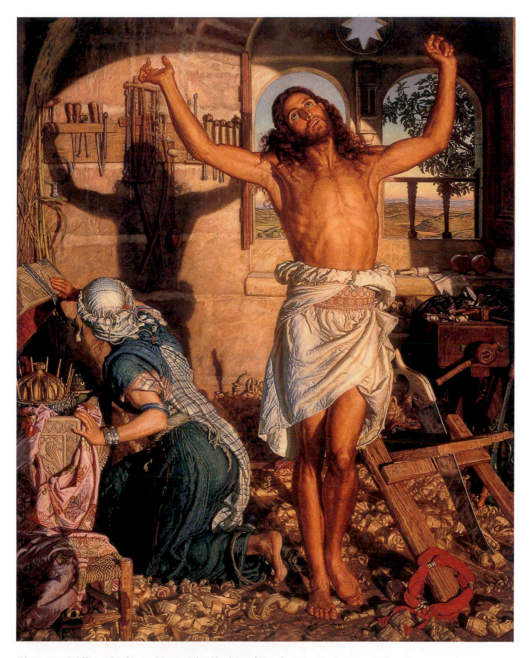

Plate 12 William Holman Hunt, *The Shadow of Death*, 214.2 x 168.2 cm, oil on canvas, 1870–73

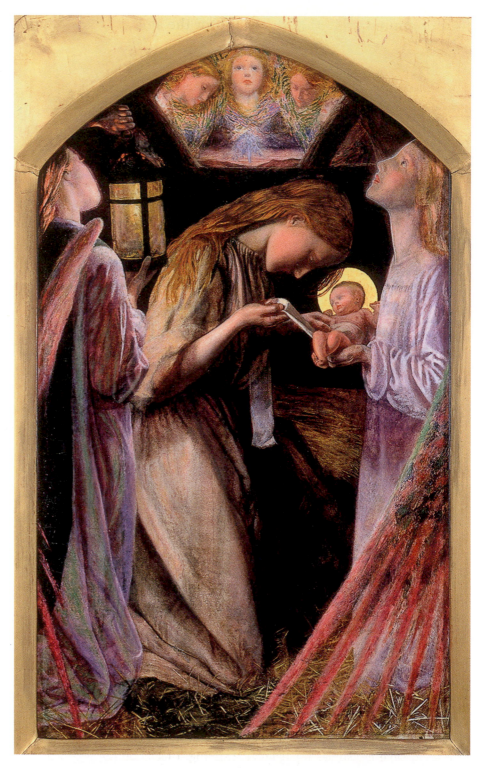

Plate 13 Arthur Hughes, *The Nativity*, 61.2 x 35.8 cm, oil on canvas, 1858

Introduction: translating the Bible for the age

The learning of the age may be a benefit to its art, or a misfortune; but it is a fact, and cannot be ignored.[1]

Nowhere did William Michael Rossetti's observation hold more true than in the Victorians' attempts to redefine religious painting. It was, as one contemporary put it, 'like a ship without a rudder', and both its form and function were being called into question.[2] During the mid-Victorian period, in an increasingly secular age plagued by repeated crises of faith, painting the Bible represented a conflicted practice. The Scriptures came under scrutiny from contemporary science and biblical scholarship. Research in disciplines such as geology, palaeontology, history and ethnography repeatedly challenged established biblical truths. As the traditional understanding of the Bible underwent contested reinterpretations, the burden of learning weighed heavily and artists too felt the need to respond. However, in a Protestant culture in which established pictorial traditions held no sway and belief centred exclusively on the biblical text, painters faced the complex task of translating the Bible for the age.

This book charts the transformations that religious painting underwent in mid-Victorian Britain and chronicles the troubled emergence of a unique form of naturalistic religious painting. Despite the centrality of religion to Victorian culture, this is the first study to engage with the theory and practice of religious painting in nineteenth-century Britain. The book focuses on the role the Pre-Raphaelite Brotherhood (PRB) played in challenging and invigorating the practice of religious painting. Most scholars would agree with Herbert Sussman that 'biblical painting was a major occupation of the circle and forms an important portion of its production during the Brotherhood years'.[3] However, rarely has this preoccupation with religious subject matter been further investigated. In this book, I offer an original account of the problems and practice of religious painting during the mid-Victorian age. I chart the artistic climate of the 1840s during which the PRB was founded, and discuss the Brotherhood's irreverent and innovative intervention in the field of religious painting. From this provocation emerged several possible modalities for religious painting. I focus on the naturalist mode best exemplified in the work of William Holman Hunt and investigate

his determined engagement with the figure of Christ which made him – according to contemporary opinion – the century's painter of the Christ.

The early-Victorian art world was dominated by heated debates over the future and function of high art. During the 1840s, religious painting was regarded as the one branch of history painting still relevant for contemporary audiences, carrying the moral charge traditionally associated with high art. This was also the decade during which the artistic project of the PRB was formulated. The fact that religious painting was seen to hold contemporary relevance made it attractive to the members of the group. For a group of young artists keen to establish themselves as successful agents in the field of cultural production, religious painting – regarded as the one living branch of high art – presented the perfect arena in which to stage their intervention.

The Pre-Raphaelite engagement with biblical subject matter was at once original and provocative, sparking some of the most vitriolic art-critical writing the Victorian age witnessed. The Pre-Raphaelites' intervention was instrumental in rethinking and revitalizing religious painting at mid-century and beyond. Their work combined detailed observation of nature with stylistic archaism derived from early art. This practice is best represented in John Everett Millais's *Christ in the House of His Parents* (1849–50). One critic considered this picture 'the *reductio ad absurdum* of the central theory in the practice … of the brotherhood'.[4] This important early Pre-Raphaelite work was widely regarded as egregiously grotesque, irreverent and subversive of the academic order of things. While Millais's picture represented a fundamental challenge to the established academic paradigm it also enabled the redefinition of religious painting. William Holman Hunt's work emerged as a strong response. Rigorously Protestant in outlook, his work combined an understanding of contemporary biblical scholarship with naturalist and orientalist modes of representation. It presented a successful reinterpretation of Scripture that spoke to the age.

As early as 1848, Ford Madox Brown had exhibited *John Wycliffe reading his Translation of the New Testament to John of Gaunt* (Figure 1.1). The picture's pronounced archaism, light palette (substantially modified at a later retouching) and nationalist subject matter were seen to chime with the high-minded times. During the 1840s, the artistic agenda was set by the Westminster Cartoon Competitions, held to determine the decoration scheme for the recently rebuilt Houses of Parliament. Entries were invited in subject areas such as national history and literature and religious subject matter.

Brown's painting directly addressed some of the current artistic preoccupations. The picture not only celebrated the national contribution to literature but also commemorated a seminal moment in the early history of English Protestantism. John Wycliffe was the first to translate the New Testament into English, when the gospels were thrown open to individual scrutiny, becoming the defining characteristic of Protestant belief.

Brown highlighted the literary value of the project by presenting Wycliffe,

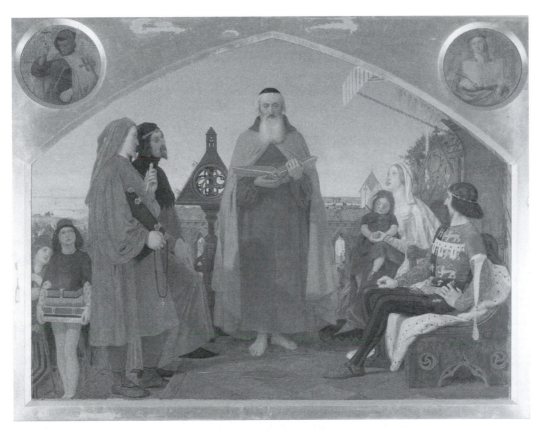

1.1 Ford Madox Brown, *John Wycliffe reading his Translation of the New Testament to John of Gaunt*, 119.5 × 153.5 cm, oil on canvas, 1847–48 and 1859–61

devout man of religion, bearded and barefoot, in the company of Chaucer and Gower, who listen attentively to the gospel-reading. The literary context was further emphasized by the little page-boy on the left who is struggling under the weight of four heavy tomes, two of which are identified as the works of Gower. None of the men attending the event expresses the deeply emotional reaction of the seated female figure. Her enraptured gaze attests to the emotive power of the Scriptures. The gospel account has visibly touched her, a response, the viewer is led to believe, that will be passed on to the next generation, here represented by the dozing child seated on the woman's lap. Only in her has the gospel-reading produced that 'sacred impression' which W. M. Rossetti deemed essential for a successful religious art.[5]

Brown framed the central scene with two small tondos in which Catholicism and Protestantism were personified as the stereotypical figures of the ascetic monk and the fresh-faced maiden. The hooded monk, his gaze downcast, is depicted clutching a crucifix in his right hand and holding a closed book, chained and padlocked, under his left arm. In contrast, the serene young woman meets the viewer's gaze as she presents an open book, whose pages reveal the beginning of the gospel according to St Matthew. Their respective attitudes to the written word are highly significant: for the Catholic monk the Bible constitutes just one of the paraphernalia of ritual,

whereas the maiden's gesture reveals the centrality of the gospels to Protestant belief and suggests the dissemination of the text.

Many nineteenth-century artists shared Wycliffe's desire to enable a broader understanding of the Bible. Their pictorial translations also aimed to make the gospel narratives comprehensible and relevant to a wide audience. John Ruskin spoke for many of his contemporaries when he claimed, 'All the histories of the Bible are ... yet waiting to be painted.'[6] William Holman Hunt enthusiastically proclaimed that 'with the New Testament in our hands we have new suggestions to make'.[7] There was disagreement, however, on how this could be achieved.

Brown framed the heroic moment of proto-Protestantism with representations that indicated Christianity's conflicting sectarian forces, a dichotomy that also structured Ralph N. Wornum's essay 'Romanism and Protestantism in their relation to painting' (1850). In the span of half a paragraph, Wornum summed up the malaise of English painting at mid-century. He invoked two national stereotypes – Italian and German – to indicate international opinion, concluding categorically that English painting had no glorious past or future prospects:

We were once told by an Italian gentleman in Florence, – 'You English will never be painters, you believe nothing.' It would certainly be very difficult to produce a picture of anything, where there is no faith in anything. Again by a learned German in Munich and an Art-critic too, it was asked: – 'How is it that the English have never produced a single great painter; West was an American!' – of course implying a limitation of the designation *great painter*, to History and Religion, as understood; and it is a limitation which courtesy may perhaps grant, on an occasion.[8]

In an off-hand and emphatic comment, the Italian (and presumably Catholic) gentleman identified lack of belief as the main reason for the continued failure of English art, referencing a clear connection between representation and belief. The equally type-cast 'learned' German, who applied the lofty categories of history and religion as criteria for artistic greatness, dismissed the entire history of English painting in one curt sentence. This high-minded focus on history painting reflected recent transformations in German art, which had resulted in large-scale work for public buildings and had attracted international interest.[9]

Wornum used these stereotypical observations – 'two hard positions, anything but flattering to the Englishman' – as opening remarks to anchor his investigation into the relationship between Protestantism and high art. '[I]t is evident', he wrote, 'that both impressions have proceeded from the same idea, that Protestantism is essentially antagonistic to the development of high religious Art'.[10]

Wornum set out to refute this view, arguing that Protestantism and religious art were *not* mutually exclusive. But in its close connection of representation and belief the Italian gentleman's remark harboured an unholy alliance. Wornum described the extremes of Romanist art in ways that recalled the charged and stereotypical rhetoric of Brown's representation. In a pell-mell mixture that conflated themes and rituals, he

listed Romanism's 'ecclesiastical legends, its martyrdoms, its mortifications, its votive offerings, its conciliations, atonements, commemorations, and sacrifices; its ceremonies, its pomp, its seclusion, its monastic severity, and asceticism': a catalogue designed to send shivers down the spine of any self-respecting Protestant.[11] In the face of such a charged history, Wornum affirmed the need for a 'Protestant development, which is yet in embryo' and argued for 'pictures of a universal character of sentiment'.[12] He regarded the scriptural narratives as central to Christianity. From these, so he hoped, a contemporary Protestant culture would develop a 'high religious art'.

The universality Wornum repeatedly invoked was that of academic art, and he cited Raphael's pictures as 'so essentially human, so universal, that they are appropriate to the good of all times and countries'. The emphasis Wornum placed on the universal helped to play down the troublesome fact that Raphael's most important works had been commissioned by the Pope and resided in the Vatican. In the rhetoric of the academic discourse the impeccable Catholic heritage of Raphael's work was neutralized and hence the artist could serve as an exemplar for contemporary practice. Wornum's aspirations for a national Protestant art were symptomatic of a wider debate.

Brown's *Wycliffe* is an icon of Protestant endeavour that typifies the artistic climate of the 1840s. However, close scrutiny reveals a strange detail. On the lectern rests a Bible, clearly indicated by the black lettering on the white leather spine. But it is sitting there upside-down. The picture's noble rhetoric seems subverted by this incongruous detail. In the mid-Victorian viewer, this might have created a sense of bafflement not unlike 'the fascination of paradox', which contemporary critics associated with the work of the PRB.[13] For the modern scholar, it may serve as a reminder that any attempt to fully comprehend the mid-Victorian spheres of art and religion proves complex and elusive. In order to gain some understanding of the complexities inherent in the debates over a contemporary practice of religious painting, I have selected three paradigmatic voices: those of Nicholas Wiseman, John Ruskin and William Michael Rossetti. Their work offers a diverse range of opinions which help to sketch some of the central arguments.

Themes at once sacred and stale: the problem of religious painting

In 1847, Nicholas Wiseman, editor of *The Dublin Review* and soon to become the designated leader of the English Catholics as Archbishop of Westminster, pronounced his views on the foundation of a 'Catholic school of art' which 'must not be an antiquarian establishment'.[14] He criticized the recent efforts at creating a Catholic art for their 'almost canonized defects, and sanctified monstrosities' – displayed in stained glass and religious prints – and that were called "mystical," or "symbolical," or "conventional" forms and representations'.[15] Wiseman recognized that a revivalism exclusively based on medieval art was not the way to achieve an immediate and relevant Catholic art and consequently rejected attempts 'to return to given models,

and to reproduce, as nearly as possible, the works of other times'.[16] '[W]e do not think', he wrote, 'that artists should be bound in a country like ours, where the very existence of such traditions has been lost, and where the reproduction could only cause misunderstanding, and would be equivalent to a new creation.'[17]

In his view, 'religious art does not look at time, but at nature, which changes not'.[18] He argued for a Catholic art that would not align itself with recent revivalism but would seek a new eclectic creativity:

It must start on the principle that it is essentially a creative art, that it must invent as well as the old masters did, that it must study them and cull out their excellencies, but must not servilely copy them: it may imitate, but not transcribe.[19]

Wiseman here advocated a fundamentally academic ideal, complete with references to invention and imitation. He also demanded a pictorial language capable of conveying emotional impact and clearly communicating the biblical story. In his view, sentiment and legibility were crucial in an art that aimed to address contemporary audiences: 'we now desire and expect to see, in the representation of sacred histories, the simplicity of action, naturalness of arrangement, and power of expression, which enables the eye to read them, and the feelings to apprehend them – the truest test of real religious art'.[20]

Although he shared such aspirations with mid-nineteenth century commentators of all religious persuasions, Wiseman – writing from a staunchly Catholic perspective – had a marked advantage. He not only held firm views on the meaning and function of religious art but also proposed a relatively straightforward way to implement his vision. This depended on devout artists – 'men who will do their work with faith and for love, whose outward performances will be only counterparts of an inward devotion'.[21] He, therefore, argued for a clear connection between representation and belief: the viewer should be 'satisfied, that the work which he admires is the fruit of sincere faith and religious meditation'.[22] In his view, religious art had always been 'essentially *for the people*'; works were 'to be hung over some altar, or to adorn the walls of a cloister, or perhaps a public hall'.[23] Wiseman proposed a predictable route for the establishment of a new school of religious painters: 'let us throw open one good church', he demanded, to be decorated 'with a series of large and simple histories, comprising the chief Gospel mysteries and the life of the Blessed Virgin or any other great Saint'.[24]

In order to give some idea of what a new religious painting might achieve, he had to point to the decoration scheme of 'the splendid church … at Apollinarisberg, near Bonn'.[25] Four Nazarene artists – Ernst Deger, Franz Ittenbach, Karl and Andreas Müller – executed the monumental frescoes there during the 1840s. Whilst Apollinarisberg was an out of the way site for most of his readers, closer at hand Wiseman could point to John Rogers Herbert's recent exhibit at the Royal Academy, *Our Saviour subject to His Parents at Nazareth* (Plate 4). For Wiseman, Herbert's work combined legibility and sentiment – 'how completely it addressed itself at once to the

minds and hearts of the people', he marvelled – and could thus be seen as a landmark: 'we have secured to us the basis ... upon which Christian art can work'.[26] The characteristics Wiseman admired in Herbert's work were ones that Wornum not only proposed as universal to a Christian art but also regarded as the departure point for a contemporary Protestant painting.

Although 'a branch of art, which does not as yet exist on a scale to permit' a 'strong demonstration', Wiseman was adamant that a new Christian art would have to be Catholic because '[n]o Protestant country has yet produced a religious artist of any sort; every Catholic one has produced a school.'[27] Wiseman here shared the opinion of Wornum's Italian gentleman. To him, Catholicism seemed better equipped to meet the challenge of establishing a contemporary religious art than Protestantism, as the latter appeared to be 'void of that reverence, which is as necessary an ingredient in religious art as oil or some other vehicle is in the composition of its colours'.[28]

In England, where the connections between pictorial and religious traditions had been severed during the Reformation, the establishment of a new religious art was a daunting task. Unsurprisingly, Wiseman proposed a solution which exclusively framed the production and function of religious art through clearly defined forms of belief. For him, a school of contemporary religious art would be grounded in the academic ideal, and, most importantly, it would rely on a believing practitioner and would produce works intended for places of worship. While his fundamental Catholicism made it easy for him to construct such a close connection between representation and belief, it also made him oblivious to the complexities of the Victorian art world.

In his analysis 'Of the false ideal' (1856), John Ruskin problematized the academic approach, which – irrespective of denominational differences – had served both Wiseman and Wornum as the basis for a contemporary religious art. He traced the demise of religious art to the 'fatal change of aim' which 'took place throughout the whole world of art in the early sixteenth century'. 'In early times', he wrote, *'art was employed for the display of religious facts*; now, *religious facts were employed for the display of art.'*[29] Through this reversal of values, Ruskin claimed, the artist was no longer a devout practitioner but a slave to academic conventions and the art market. This is his trenchant description of the artist's changed outlook:

He could think of her [the Madonna] as an available subject for the display of transparent shadows, skilful tints, and scientific foreshortenings, – as a fair woman, forming, if well painted, a pleasant piece of furniture for the corner of a boudoir, and best imagined by combination of the beauties of the prettiest contadinas. He could think of her, in her last maternal agony, with academical discrimination; sketch first her skeleton, invest her, in serene science, with the muscles of misery and the fibres of sorrow; then cast the grace of antique drapery over the nakedness of her desolation, and fulfil, with studious lustre of tears and delicately painted pallor, the perfect type of the 'Mater Dolorosa.'[30]

In Ruskin's view, sacred subjects had become just another type of art, executed with attention to academic conventions and destined for private

consumption. The rules of taste and the market governing the value of art in modern society, he argued, jeopardized the true sentiment of sacred art. The cold, almost scientific perception of the academically trained artist, which Ruskin described in astute detail, was further marred by the suspicion that a painter's choice of subject matter – especially in the field of high art – was not always sincere:

The greater number of men who have lately painted religious or heroic subjects have done so in mere ambition, because they had been taught that it was a good thing to be a 'high art' painter; and the fact is that in nine cases out of ten, the so-called historical or 'high art' painter is a person infinitely inferior to the painter of flowers or still life.[31]

A damning assessment indeed. Ruskin sketched an unstable art world: it was governed by supply and demand, populated with over-ambitious artists, and patrons no longer functioned as guarantors for meaningful artistic production. Here sacred subject matter played no special role. With the Reformation, Ruskin claimed, 'pure Christianity and "high art" took separate roads, and fared on, as best they might, independently of each other'.[32] As the spheres of art and religion parted company, a clear connection between representation and belief no longer existed. Hence Ruskin found it difficult to provide a framework for religious art. He had his exasperated reader ask: 'Has there, then … been *no* true religious ideal? Has religious art never been of any service to mankind?' And Ruskin tersely replied: 'I fear, on the whole, not.'[33]

Predictably, he used the Raphael Cartoons – the epitome of the academic ideal in England – to illustrate his point. These compositions, Ruskin argued, were 'cold arrangements of propriety and agreeableness, according to academical formulas' which bore no resemblance to 'the thing as it really must have happened'.[34] He pitched a highly emotive reading of the gospel account against the artist's representation and found the latter not only factually inaccurate but lacking in psychological depth, emotion and sentiment. Ruskin chose *Christ's Charge to Peter* for a detailed analysis (Figure 1.2). First, he gave an imaginary and sensitive account of the event – based on the Gospel of St John (chapter 21) – and then he asked his reader to consider Raphael's representation, which he termed 'a faded concoction of fringes, muscular arms, and curly heads of Greek philosophers'.[35] In his opinion, such inaccurate and formulaic representation threatened belief: 'The simple truth is, that the moment we look at the picture we feel our belief of the whole thing taken away. There is, visibly, no possibility of that group ever having existed, in any place, or on any occasion. It is all a mere mythic absurdity'. In his assessment, the spheres of art and religion collided uneasily. Bland academism was regarded as truly pernicious when applied to religious subject matter:

… this fatal sense of fair fabulousness, and well-composed impossibility, steals gradually from the picture into the history, until we find ourselves reading St. Mark or St. Luke with the same admiring, but uninterested, incredulity, with which we contemplate Raphael.[36]

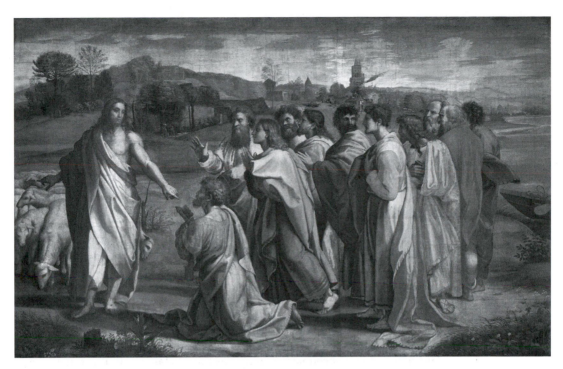

The 'clear and tasteless poison of the art of Raphael' – as Ruskin so memorably put it – continued to impede the formulation of a contemporary religious art.

Ruskin claimed that the myriad of biblical pictures on view in galleries such as the Louvre and the Uffizi failed to elicit a deep emotional response – a rapture so completely captured in Brown's portrayal of the woman listening to Wycliffe's reading of the New Testament. The pictures functioned as just another form of high art, and Ruskin invited the viewer to 'meditate over the matter, and he will find ultimately that what I say is true, and that religious art, at once complete and sincere, never yet has existed'.[37] While he here shared Wiseman's opinion that England had yet to establish a proper school of religious art, Ruskin's vision was very different from Wiseman's.

In Ruskin's view, biblical subject matter was charged with difficulties not usually associated with high art. He saw pictorial representation as having the power to either enhance or undermine belief. The dilemma of the modern artist stemmed, then, from the fact that his work was judged according to both aesthetic criteria and a less clearly defined sense of sincerity. For a staunch (though at times lapsed) Protestant such as Ruskin, historical naturalism was the only way to retain and enhance belief in the Scriptures. He defined the 'true religious ideal' as a sincere and unaffected attempt to represent historically recorded events.[38] In conclusion, Ruskin remarked 'that sacred art, so far from being exhausted, has yet to attain the development of its highest branches'.[39] The task was 'to produce an art which shall be at once

entirely skilful and entirely *sincere*'.[40] He stated that 'True historical ideal, founded on sense, correctness of knowledge, and purpose of usefulness, does not yet exist; the production of it is a task which the closing nineteenth century may propose to itself.'[41]

William Michael Rossetti further explored the 'vast question which Ruskin has mooted – How far Fine Art has … been conducive to the religious life'.[42] He addressed the dilemma of 'writing artistically' about the subject more directly than Ruskin had done, declaring that 'we do not profess to speak of the religious but simply of the "artistic feelings and sympathies" engaged in this question'.[43] But he also admitted that these could not 'be trenchantly and absolutely severed' from each other. Rossetti identified naturalism as the prevailing artistic mode of the age. Naturalism paired with diligence, devotion and an attention to the spirit of sacred art was the formula Rossetti promoted: 'when attained with labour and longing' it constituted 'the highest ideal of sacred art for the day wherein we live'.[44] In regard to sacred subject matter, Rossetti observed, it 'implies and prescribes a prevalence of direct or narrative over typical representations'.[45] He continued to ask how the question of religious art 'presents itself to a Protestant people of the nineteenth century', and defined 'the two most distinctive characteristics of protestantism': 'the assertion of the right to private judgement … and reverence for the Bible'. Consequently, a preference for 'any conscientious and heartfelt representation of scriptural history' was the dominant Protestant approach which tallied with the general disposition towards naturalism in art. Rossetti advocated narrative over typological representation, and so he advised artists who wanted to reach a wide audience 'to understand narrative, and translate it into form, rather than to symbolize a conception for translation by others'.[46]

Rossetti dared to ask more precise and uncomfortable questions: 'Is our Madonna to be a Jewess, our biblical costume oriental, our scenery that of the Holy Land?' Such questions, he argued, affected the traditionalist and the naturalist in different ways. In his opinion, it was not simply a matter of literal truth versus falsification – 'this fatal sense of fair fabulousness, and well-composed impossibility' which Ruskin had whole-heartedly rejected.[47] Instead, Rossetti's discussion was premised on the assumption that 'sacred art has utterly failed unless it produces a sacred impression'.[48] With this in mind, he proceeded to question the usefulness of both literal truth – 'in ethnology, chronology, costume, or what not' – and 'most absolute falsification' as means to attaining the elusive goal. Rossetti also focused on the Cartoons and enlisted Raphael as the 'most accepted model of the traditionalist'. His stylistic eclecticism and lack of attention to detail – 'dress[ing] his figures in blankets which were never worn' – made traditional composition 'a subject such as never could have been in being, and which does not even ask to be genuinely credited'. While Rossetti granted that such a composition might command respect, it deserved no sympathy because it failed to 'awaken … associations save of the artistic (not to say artificial)

kind'.[49] He agreed with Ruskin's assessment that eclectic and cold academism was devoid of sentiment. Consequently, naturalism was seen as the appropriate mode for religious painting. But it harboured its own complexities:

The naturalist has no model except nature; but he has a choice, and in each of its alternatives a prototype … he has to decide whether he will abide unreservedly by the nature of his own time and clime, or whether he will aim at realizing his subject according to the authentic details properly belonging to that.

The two options available to the naturalist – historical reconstruction and contemporary updating – had to be approached with care. Rossetti acknowledged that 'the mediaeval artist murdered chronology'.[50] While medieval audiences seemed not to have minded or even noticed, Rossetti feared 'the modern spectator would be so offended at the anachronism as to be seriously impeded … from estimating aright the essentials of the subject across the inaccuracy of its details'. The charming 'innocence' of the medieval artist could not simply be recaptured. If *faux naïveté* was to be avoided, the other extreme – 'veritable reality of detail' – also had its drawbacks. Rossetti cited the work of the French artist Horace Vernet, who painted 'a number of biblical subjects as true studies of Arabian, Egyptian, or Hebrew life' (see Figure 4.5). While he pointed out the importance of this work as 'a sufficient prototype', he thought it lacked 'religious feeling and conception'. His hope was 'soon to see works of similar form and nobler spirit':

We believe … that a great imaginative naturalist will, in the present day, seek for the very reality of his sacred theme with genuine devotion to truth, and love of its power; and that, diligently husbanding his faculties, he will, with this devotion and his love, enter into the reality in spirit as well as form, and show at once the facts to our eyes, and the substance and meaning to our souls.[51]

Writing in 1857, it seems Rossetti was paving the way for the future naturalist of religious painting, William Holman Hunt, who was at that time busy working on *The Finding of the Saviour in the Temple* (1854–60), his first orientalist rendering of a New Testament subject (Plate 10).

When the picture went on display at the German Gallery in Bond Street in the spring of 1860, William Michael Rossetti looked back on the transformations religious painting had witnessed over the past decade and a half:

If fifteen years ago it had been suggested that on a journey to Jerusalem, and resultant correct grasp of oriental externals there hung a chance of attaining a wholly fresh and original realization of themes at once sacred and stale, it would have struck us as an unpromising speculation.[52]

The time-span mentioned here by Rossetti is roughly that covered by the authorities I have referred to in this introduction, Rossetti, himself, Wiseman and Ruskin. The period from the mid-1840s to 1860 was indeed the crucial time during which religious painting was rethought and in which a naturalist Protestant practice – best exemplified in the orientalist works of William Holman Hunt – emerged, as we shall see.

Painting the Bible: issues and methodologies

From the discordant, conflicting and overlapping voices which cut across the diverse forms of Victorian Christian belief emerges a complex and contradictory discussion of the problems besetting a contemporary practice of religious painting. Though situated at the opposite ends of the denominational spectrum, both Wiseman and Wornum promoted the academic tradition as the basis for a contemporary school of religious art. In contrast, Ruskin and W. M. Rossetti rejected conventional academism in favour of an imaginative and factual translation of Bible stories which, in their view, had hitherto not been adequately depicted. As Rossetti suggested, the rejection of the academic paradigm could take two forms: deliberate archaism or naturalism. The PRB's willingness to experiment with both anti-academic modalities made its members' highly original practice central to the problems of mid-Victorian religious painting. While Rossetti regarded deliberate archaism as unworkable and naïve, he presented naturalism as the up-to-date response to the dilemma of the age: its immense learning was a fact that could not be ignored.

Pierre Bourdieu's analysis of the 'restricted field' of cultural production provides a theoretical framework which helps to reconcile the internal and external determinants that lay at the heart of the practice of religious painting at mid-century.[53] The unique position of religious painting was due to two sets of simultaneous challenges: conceptual changes within the field of art and the new historical methods and scientific discoveries which were undermining established biblical truths. These conflicting forces had to be brought together in ways that were not mutually reductive and that recognized the relative autonomy of the artistic field. Bourdieu's editor, Randal Johnson, suggests that the impact external determinants have on the structure of the field is not simply one of cause and effect but a subtler transformation, effected by 'refraction'. In Johnson's words, 'the field's structure *refracts*, much like a prism, external determinants in terms of its own logic, and it is only through such refraction that external factors can have an effect on the field'.[54]

These refractions are central to this book, in which I explore the delicate balance between internal and external factors impacting on the production of religious art. Unlike nineteenth-century France where religious painting was mostly commissioned for display in churches or public buildings, or bought directly from the Salon exhibitions for such purposes, there existed no comparable structure for the consumption of religious painting in England.[55] The mid-Victorian art world was characterized mostly by the absence of public patronage in the form of crown, state or church and was dominated by the idiosyncrasies of private patronage.[56] This rendered the relationship between representation and belief complex, unstable and unpredictable. Just like any other form of art, religious painting had to function in the marketplace and was judged according to aesthetic criteria. At the same time, it was also seen to have the power to consolidate or threaten belief, as Ruskin's analysis of the Raphael Cartoons demonstrates.

However, the complexities which writers such as Ruskin and W. M. Rossetti had identified in their discussion of a modern naturalist approach to religious painting barely registered at the Royal Academy (RA), whose annual exhibition constituted the most important arena for the display, critical reception and commercial exchange of contemporary art. The academic discourse – promoted by the RA in lectures and presidential addresses – continued to present religious art, or more specifically biblical painting, as a sub-genre of history painting, whose idealism and moral values it shared. Religious painting was conceived as being free from denominational concerns. Hence more general questions regarding the connection between representation and belief remained unarticulated. Most of the writing on religious painting, in particular the widely available RA reviews in the periodical press, followed prescribed and ritualized patterns, frequently referencing academic values.

Wiseman, Ruskin and Rossetti also took the academic ideal as their point of departure. Whilst Wiseman claimed it as the basis for a contemporary school of religious art; the other two refuted such a claim. Regardless of such differences in opinion, the academic paradigm coloured their views on archaism. Most critics agreed that deliberate archaism did not constitute a sensible way forward. The notion of progress, clearly inscribed in the academic discourse and informing contemporary artistic production, made any overt reversal of tradition suspect.

However, most writers on religious art appreciated the spiritual sincerity of the medieval artist-monk that was captured in Vasari's account of Fra Angelico, which had recently been retold and expanded by Lord Lindsay in his *Sketches of the History of Christian Art* (1847): 'Ecstasy and enthusiasm were his native element, and the emotions of his heart animated his pencil with a tenderness and repose, a love and a peace in which no one has yet excelled or even equalled him.'[57] Medieval painting was conceived as a labour of love and devotion: a practice driven by the emotions of the heart. This fascination with the figure of the devout practitioner provided a strong antidote to Ruskin's cynical view of contemporary artists: 'men who have lately painted religious or heroic subjects … in mere ambition'.[58] Consequently, Fra Angelico's practice took on renewed relevance. According to Vasari, the artist was known for 'employing a keen eye and heartfelt sincerity' and his depiction of the archangel Gabriel in the annunciation was 'so devout, delicate, and well executed that it truly seems to have been created in Paradise rather than by a human hand'.[59] Across the denominational divide, both Lord Lindsay and Nicholas Wiseman upheld the example of Fra Angelico as worthy of emulation. Wiseman, arguing from an emphatically Catholic position, concluded that a contemporary practice of religious painting depended on devout artists, straightforwardly equating representation and belief. However, for critics who understood religious painting primarily as an *artistic* practice and were familiar with the intricacies of the Victorian art world, this equation simply did not hold. In Ruskin's view, the struggle to configure 'an art … at once entirely skilful and entirely *sincere*' was to be resolved in the devotion to *art*.[60]

This desire for artistic sincerity was the subject of Dante Gabriel Rossetti's small pen-and-ink drawing, *Fra Angelico Painting* (*c.* 1853) which showed the devout artist-monk painting the Madonna and Child (Figure 1.3). The cluttered interior and the dramatic lighting invest this moment with an intensity that turns the production of art into total devotion. Kneeling in front of the easel, Fra Angelico fixes his concentrated gaze on the work. He is drawing the outline of the Madonna with a short brush while holding a palette in his left hand. It was the pose of the artist-monk that made this inherently modern mode of artistic production – easel painting – resonate with Ruskin's demand for simultaneous skill and sincerity in art. Rossetti's sympathetic representation also extends to a second monk who is leaning on the easel and intently perusing a book. The proximity of the acts of reading and painting represented here seems to suggest a close relationship between the textual and the visual. Brown handled a similar subject very differently in his overtly Protestant *Wycliffe* (Figure 1.1). Here the monk in the roundel, clutching a padlocked book, functions as a charged personification of Catholicism. In contrast, Rossetti's monks engage with, articulate and translate the sacred text.

The total devotion to art epitomized in the figure of Fra Angelico provided a desirable alternative to the jaded contemporary practitioner of Ruskin's relentless description; it also constituted the *modus operandi* of the PRB. Rossetti modelled his representation of artistic sincerity on the widely available mythology of the artist-monk, which was in itself highly ambiguous. A paradigm of artistic sincerity, the figure of the artist-monk also proved problematic as a role model for contemporary practice because it generated suspicions of stylistic archaism and of a devotion that oscillated between religion and art. Furthermore, the figure also bore an uneasy relationship to the polemical configurations of anti-Catholic sentiment such as Brown's or Wornum's.

The PRB's self-consciously ascetic stance, apparent in the monastic overtones of their name and in the stylistic characteristics of their work, expressed a devotion to art in ways that seemed to imply religious resonances. In their 'return to the sources' – a strategy Pierre Bourdieu regarded as 'the basis of all heretical subversions and all aesthetic revolutions' – the Pre-Raphaelites combined close observation of nature and stylistic archaism.[61] Though contradictory, both modalities were motivated by the Brotherhood's anti-academic stance. The mixed and at times hostile response to their early religious works led the Pre-Raphaelites to reconsider the way they framed their desire to express artistic sincerity.

William Holman Hunt was instrumental in this process of redefinition. While Rossetti celebrated the spiritual intensity and emotion of the artist-monk, Hunt promoted an image of a militant art-worker, replacing the claustrophobic atmosphere of the monastery with the great outdoors, both English and Middle Eastern. Two images may stand as emblems of the roles of Hunt's artistic identity. The humorous sketch *Painting in England. Hastings 1852* (1852) shows the artist sketching on top of a windswept and bleak cliff

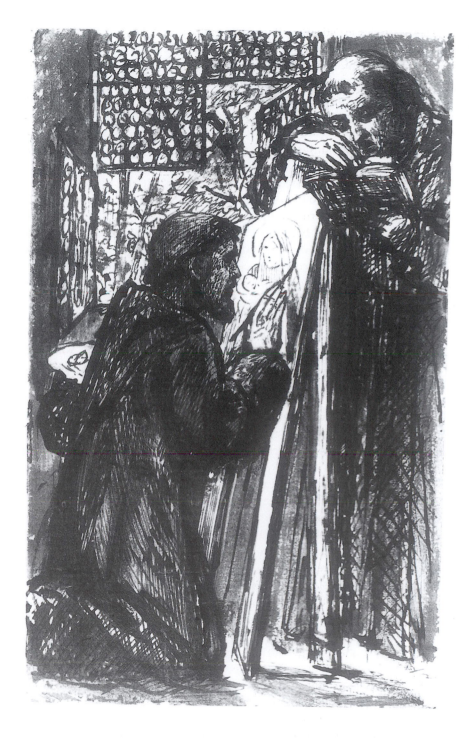

1.3 Dante Gabriel Rossetti, *Fra Angelico Painting*, 18 x 11.3 cm, pen, brown ink and wash on paper, *c.* 1853

(Figure 1.4). He is uncomfortably hunched over his sketch pad; the relentless wind has wrecked his umbrella and blown away his hat, wisely secured with a string. This is devotion of a different kind: Hunt is braving the elements in the pursuit of Ruskinian truth to nature.

A sketch he included in a letter to his patron, Thomas Combe, written during his first Eastern sojourn again shows the artist at work (Figure 1.5). This time he is sitting at his easel in a landscape easily recognized as Egyptian, with pyramids in the background. The most striking features, however, concern the artist's attire. Dressed in Western-style clothes with a hint of the military, he is armed to the teeth. On his belt he carries a pistol in a holster. He steadies his painting hand, a dagger dangling from the wrist, with a double-barrelled shotgun functioning as a makeshift maulstick. The restyling of the Pre-Raphaelite artist is complete: as imperial explorer he braves all attendant trials and tribulations, remaining faithful to the Carlylean gospel of work even in the most adverse conditions.

Hunt succeeded in formulating a truly Protestant image of the artist whose work – as William Michael Rossetti remarked – 'when attained with labour and longing' constituted 'the highest ideal of sacred art for the day wherein we live'.[62] But he did so outside of established patterns of patronage. In her eulogy of him, Mrs Meynell summed up the dilemma of the celebrated painter of the Christ: 'He never received a commission from any ecclesiastic. "The Light of the World" was bought by a printer, "The Finding of the Saviour in the Temple" by a brewer.'[63] Meynell failed to mention that their true commercial value was located in the prints based on the works, which circulated widely. In fact, F. G. Stephens announced with missionary zeal that where the pictures could not go the prints would.[64] Hunt's artistic enterprise was sustained through the print market, which provided an important form of bourgeois patronage for religious art. Despite the commercial success of his one-man shows and print sales, Hunt himself was adamant that the available structures of patronage had adversely affected his output. In 1886 he wrote to John Graham, the owner of the small version of *The Finding of the Saviour in the Temple*, 'Had there been purchasers of pictures with the independence of taste which you acted upon I should probably have done more of such subjects, but in England it seems as tho' the idea of a picture is generally that it should treat two men playing chefs, or smoking, or of a horse, or a cow, or deer eating, drinking, or lying down, or some such very obvious matter of fact.'[65]

For Wiseman, the spheres of art and religion were inseparable; the sincere artist produced work for a public space where the community of believers was invited to share his vision. For most contemporary commentators, however, the relationship between representation and belief was by no means as straightforward as this. Hunt's ironically evoked 'idea of a picture' summed up the workings of the art market, from which even a noble and sincere religious painting could not break free. Furthermore, even the sincerest religious painting was subjected to aesthetic scrutiny. William Hazlitt had offered a crucial distinction between high art and true art, based

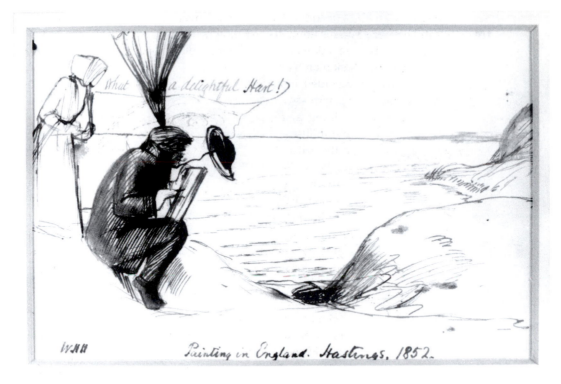

What a delightful Hart!)

Painting in England. Hastings. 1852.

on 'the knowledge of what is contained in nature' as 'the only foundation of legitimate art'.[66] He argued that there was no distinction between 'painting an archangel's or a butterfly's wing; and the very finest picture in the finest collection may be one of a very common subject'. W. M. Rossetti took this a step further. Distinguishing between a good picture of a cat and a bad picture of Christ, he left his readers in no doubt that aesthetic criteria superseded religious ones when dealing with the appreciation and criticism of art. While aesthetic criteria did indeed outweigh religious considerations, the sphere of art was dominated by the demands of the market and the taste of private patrons, as William Holman Hunt had expressed so clearly in his letter to John Graham and elsewhere in his autobiography. Hunt found a way to authenticate his work in the conflicting spheres of art and religion by soliciting the help of Frederic George Stephens, one-time Pre-Raphaelite Brother and influential art critic, and Archdeacon Frederick Farrar, prominent member of the Broad Church faction of the Church of England and author of a highly successful biography of Christ. The art critic and the archdeacon were able to speak with authority about the separate aspects of Hunt's work, thus certifying its aesthetic value as well as its Protestant, in particular Broad Church, validity.

The issues I have mapped here, both through a reading of contemporary sources and through a conceptual analysis, inform the rest of this book.

In Chapter 2 I investigate the different approaches to religious painting

1.4 William Holman Hunt, *Painting in England. Hastings, 1852,* 12.3 × 17.9 cm, pen and sepia ink and wash on paper, 1852

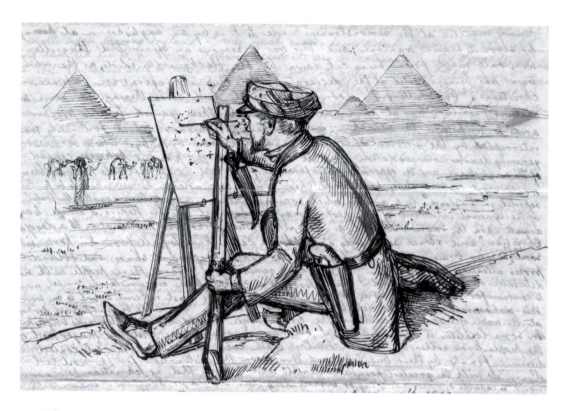

1.5 William Holman Hunt, *Self-portrait in Egyptian Landscape*, pen and ink on paper, 1854

that emerge from a close reading of RA lectures and press coverage of the annual RA exhibitions. Religious painting needed to function in a climate of diluted academism and brash commercialism – a dichotomy the RA itself epitomized. As a sub-genre of history painting, it was hailed as the one living branch of high art, or artists were urged to adapt it to the exacting demands made of historical genre painting. In a series of case studies that focus on individual artists or particular stylistic developments, I investigate the difficulties inherent in pursuing religious painting both within the framework of the RA and outside of it. This approach sheds light on changes in the critical reception of religious painting submitted to the RA and other exhibition venues around the capital. It also helps to map the ways in which artists positioned their work in the early-Victorian art world. With the exception of Benjamin Robert Haydon, the artists discussed here mostly followed the pattern Pierre Bourdieu identified as typical for practitioners in academies and consecrated art institutions which 'combine tradition and tempered innovation'.[67]

The focus in Chapter 3 is on the PRB's original intervention in this highly charged field of cultural production. The fascination of the paradox which the Pre-Raphaelite project engendered in contemporary critics lay in the overlapping of contradictory strategies that are fundamental to Bourdieu's concept of 'experimental art' which 'originates in the field's own internal dialectic': 'Its most specific effects, for example, derive from games of

suspense and surprise, from the consecrated betrayal of expectations, and from the gratifying frustration provoked by archaism ... syntactic dissonances, the destruction of ... ready-made formulae, *idées reçues* and commonplaces.'[68]

The Brotherhood's position combined two classic characteristics of the artistic newcomer: an ascetic return to the sources and youthful irreverence, which resulted in a complex play of signification and meaning. This is epitomized in John Everett Millais's *Christ in the House of His Parents* of 1849–50, which was both a challenge to the dominant discourse of religious painting and an articulation of the Pre-Raphaelite aesthetic (Plate 7). The work met with a paranoid and vicious reception, which can be read – in Bourdieu's terminology – as a typical defence of the established orthodoxy. For most critics, the picture constituted a betrayal of expectations: a 'pictorial blasphemy'.[69] It seemed to negate and deride the moderate attempts at a redefinition of high art which had been formulated in the context of the RA and supported by the periodical press. The picture's idiosyncratic visual language, which combined stylistic archaism and aggressive realism, was perceived as grotesque: both exaggerated and inappropriate. While it posed a challenge to 'ready-made formulae, *idées reçues* and commonplaces', critics found its multiple and eclectic sources difficult to place and decipher. Such complexities made the work ideologically suspect. In particular, its pronounced archaism engendered fears of cultural retrogression.

In Chapter 4 I explore the self-conscious formulation and promotion of William Holman Hunt's robustly modern and Protestant painting. It followed in the footsteps of David Wilkie, who was among the first British painters to venture to the East in order to paint scriptural subjects. This Scottish artist claimed that the precise locations at which the moments of Jesus's life had been played out – 'every movement and resting-place' – 'may be traced, with scarcely a doubt of any of the leading points of that eventful period'.[70] Wilkie pondered the fact that, despite the extant material evidence, 'the art of Italy [that is, of Raphael and Michelangelo, for example] ha[d] arisen and ha[d] triumphed in her devotion to such scenes, with scarcely a reference or resemblance to these palpable localities, where these events were transacted'. He cautioned that these were 'hazardous questions ... but steam-boat navigation must bring them into view'. The modern artist had to face up to them in his endeavour to circumnavigate the dominant Italian and, by implication, Catholic tradition. Wilkie concluded on the optimistic note that 'there still remains ... a demand for the reader of Scripture, which the divine art of painting can alone supply'.

In his engagement with the East, Hunt pursued yet another form of Bourdieu's paradigmatic 'return to the sources', at once pragmatic and literal. The naturalism advocated by Ruskin and W. M. Rossetti not only helped to invigorate 'themes at once sacred and stale' but also to resolve the conceptual impasse inherent in early Pre-Raphaelite work, which was conceived in strict opposition to the academic paradigm. From the Brotherhood's complex and

idiosyncratic attempts at redefining the practice of high art, which left contemporary critics baffled and incensed, Hunt emerged as the century's painter of the Christ.

Out of the multivalent sources of early Pre-Raphaelite work, he created a form of biblical naturalism that was saturated with typological symbolism. He replaced the ambiguous pose of the artist-monk which the PRB had promoted with the figure of the militant explorer-artist and imperial art worker. Hunt's artistic enterprise was geared towards a wide, populist market. Its success depended on the promotion of the work and the explication of its production process, establishing his practice as truly Protestant. Through texts such as reviews, catalogues and autobiographical accounts, the artist emerged as the heroic worker who successfully grappled with the burden of knowledge the current age presented.

Brown's *Wycliffe* captured a general interest in the Reformation which was also applied to the visual arts. For example, Wilkie claimed that 'a Martin Luther, in painting, is as much called for as in theology, to sweep away the abuses by which our divine pursuit is encumbered'.[71] He further asked: 'may not a system of Scripture painting be required corresponding, not to our ignorance, but to our improving knowledge of Syria?'[72] This was a more positive version of W. M. Rossetti's measured statement quoted at the very beginning of this introduction: 'The learning of the age may be a benefit to its art, or a misfortune; but it is a fact, and cannot be ignored.'[73] Ruskin, on the other hand, was emphatically positive about the possibilities for a contemporary religious art. 'It will exist', he proclaimed; 'I believe the era of its birth has come … those calm Pre-Raphaelite studies … form the first foundation that has been ever laid for true sacred art.'[74]

Religious painting and the high-art ideal: tradition, modification and innovation

In this chapter I explore the ways in which religious painting was conceptualized and practised during the 1840s. My investigation centres on the Royal Academy (RA) as the major site for the theory and practice of art and the arena in which the Pre-Raphaelite controversy was staged. I trace the legacy of Sir Joshua Reynolds's *Discourses on Art* (originally given as presidential addresses) and focus on the lectures of Henry Howard and Charles Robert Leslie, the RA's two Professors of Painting during the 1840s. Their lectures formed part of an established academic discourse that consisted mainly of presidential addresses and lectures given by the RA's professors. This discourse continued to promote history painting as the highest form of art, claiming that it embodied universal moral truths. As a sub-genre of history painting, religious painting shared these lofty claims. It was defined as universal, non-sectarian and free from considerations of devotional functions and contexts. However, there is a marked shift in tone between Howard's conservative lectures and those of Leslie, in which he engaged with contemporary debates about the revaluation of early art and incorporated the anti-academic thought of writers such as William Hazlitt.

Extensive press coverage of the RA exhibitions provided a central forum for the discussion of the state of British art. Here its stylistic developments were noted and critiqued, and its progress was closely monitored. The art journalism of the periodical press also conceived of a new role for religious painting, as the one branch of traditional history painting still relevant to contemporary audiences.

My investigation focuses on the type of picture that was produced for the expanding mid-Victorian art market, governed by supply and demand. In a series of case studies I investigate how artists met the demands of the market and responded to general changes in taste. The career of Benjamin Robert Haydon exemplifies the single-minded pursuit of high art on a grand scale conducted without public support and mainly outside the RA. By contrast, Charles Lock Eastlake's work successfully negotiated the conflicting demands made of religious painting during the 1840s. It combined religious subject matter with two essential prerequisites – drawing-room size and

appealing sentiment. Artists such as William Dyce, Daniel Maclise and John Rogers Herbert explored the varying degrees to which the innovative traits of contemporary European art could be incorporated into the established pictorial conventions dominating the production of religious painting in Britain.

Under the sanction of a Royal Academy: the lectures of Henry Howard and Charles Robert Leslie

In his fifteen *Discourses on Art* (1769–90), Sir Joshua Reynolds, the RA's first President, supplied the newly founded institution with a humanist framework to support the intellectual claims of the fine arts and to enhance contemporary practice. He discussed the aims and limitations of academic teaching, laid down the maxims of the grand style and reflected on the intricate relationship of art and nature. The *Discourses* 'were tantamount to a statement of policy for the young institution'.[1] They lived on in the minds of subsequent presidents and professors and bound copies were given out to students at the RA's prize ceremonies.[2] Even William Hazlitt, one of the most rigorous critics of the *Discourses*, admitted that they were 'by common consent, considered as a text-book on the subject of art, in our English school of painting'.[3]

Although the professors continued to share Reynolds's assumption that they delivered their teaching 'under the sanction of a Royal Academy', their views underwent subtle modifications. These were highlighted in 1848, when Ralph Wornum republished the RA lectures of three past Professors of Painting: James Barry, John Opie and Henry Fuseli.[4] The compilation made available lectures which had been out of print for decades, and it showed that the institutional voice of the RA had never been strictly monolithic but allowed space for individual opinion, modification and change. During the 1840s, two very different artists occupied the post of Professor of Painting. Henry Howard, who held the position from 1833 until his death in 1847, was succeeded by Charles Robert Leslie. Howard was known mainly for his history paintings of traditional classical subject matter, while Leslie was a leading practitioner of historical genre painting. The two men belonged to different generations, which was reflected in their artistic practice and in the tone of their lectures. They dealt with the Reynoldsian legacy in very different ways. One would maintain a highly conservative reading; the other aimed to open up the academic discourse to consideration of an eclectic range of contemporary positions on art.

For Reynolds, religious painting constituted a branch of history painting whose aspirations to the synthetic ideal, to universality and timelessness it shared. He frequently drew on the Raphael Cartoons – the noblest example of high art to be found in Britain – when explaining the characteristics of the academic ideal, as in this passage on pictorial invention:

How much the great stile [*sic*] exacts from its professors to conceive and represent their subjects in a poetical manner, not confined to mere matter of fact, may be seen in the Cartoons of RAFFAELLE. In all the pictures in which the painter has represented the apostles, he has drawn them with great nobleness; he has given them as much dignity as the human figure is capable of receiving; yet we are expressly told in scripture they had no such respectable appearance; and of St. Paul in particular, we are told by himself, that his *bodily* presence was *mean* ...

ALL this is not falsifying any fact; it is taking an allowed poetical licence ... The Painter has no other means of giving an idea of the dignity of the mind, but by that external appearance which grandeur of thought does generally, though not always, impress on the countenance; and by that correspondence of figure to sentiment and situation, which all men wish, but cannot command ... He cannot make his hero talk like a great man; he must make him look like one.[5]

In this well-known passage, Reynolds argued for poetic licence in the representation of history. He conceived of art as a complex convention whose rules artist and viewer comprehended. Furthermore, he refuted the idea that representation equalled imitation 'so far as it belongs to any thing like deception'.[6] Drawing on the experience of the theatre, he argued that it was ridiculous 'to expect that the spectators should think that the events there represented are really passing before them, [or that] Raffaelle in his Cartoons, or Poussin in his Sacraments, expected it to be believed, even for a moment, that what they exhibited were real figures'. Reynolds's notion of representation depended on a clearly defined set of conventions that eschewed simple naturalism and aimed to elevate painting to the level of the liberal arts.

This legacy was evident in Henry Howard's endeavour 'to advocate, as my office requires, the higher styles of art'.[7] His lectures were a highly conventional reiteration of the Reynoldsian dogma. Throughout he claimed that high art was truly universal: 'Every country may have its native or popular style; but high art, like truth, is limited to no country, is independent of local associations, and belongs to all periods and climes.'[8] Such complete universality also suggested that some subjects had already been rendered in their perfect form. Consequently, Howard asked, 'Who, for instance, would now undertake the "Last Judgment," the "Death of Ananias," or the "Last Supper?"'[9] He thereby implied a seamless continuity of artistic production in which no artist could ever hope to surpass the work of Michelangelo, Raphael or Leonardo da Vinci. In his view, there was neither room nor need for reinterpretation. Perfectly rendered subjects retained their validity over time and continued to be meaningful even to contemporary audiences.

However, Howard saw the universal qualities of history painting being eroded by an increasing emphasis on the accuracy of period details. He reluctantly conceded that 'the historical painter should make himself acquainted with the civil, military, and religious costumes of different nations, at different periods, as it must occasionally be requisite to introduce various objects, dresses, and implements, for the sake of historical truth'.[10] The debate over the correct representation of historic events was, of course, not new; it dated back to Reynolds's own time, as the case of Benjamin West's

The Death of General Wolfe (1770) testified.[11] In this controversial picture, the artist abandoned the universal timelessness of classical draperies and dressed his protagonists in period costume. Although West contributed to the redefinition of history painting, in some ways historical genre painting, which was beginning to make its mark during the first decades of the nineteenth century, proved more influential. With its keyhole perspective and strong emphasis on authentically reconstructed period detail, it provided a visual equivalent to Sir Walter Scott's extremely popular novels.[12]

In order to distinguish religious painting from the newly established category of historical genre, Howard drew on Henry Fuseli, who had situated religious painting in a dramatic or epic realm free from concerns for correct period detail.[13] Like Reynolds, Howard regarded the Raphael Cartoons as the pinnacle of history painting.[14] However, his insistence on compositional clarity was so strong that he criticized some of the Cartoons for their distracting profusion of background detail.[15] This view of history painting was deeply conservative, making few concessions to the changes the genre had witnessed. By using examples from scriptural painting to substantiate his view of the academic ideal, Howard avoided the debates surrounding the degree of historical authenticity that dominated the depiction of historical subjects. Although Howard was acutely aware of the impossibility of reversing the transformations that history painting had undergone, his criticism of Raphael's Cartoons reads like a zealous attempt to uphold the purest form of academic orthodoxy.

His approach to the other mainstay of academic dogma, the traditional hierarchy of genres, was also deeply conservative. This was evident in his evaluation of William Hogarth, whom he called 'one of the most original inventors that the art has ever produced'.[16] Despite acknowledging the artist's innovative 'conceptions of character and truth of expression', Howard firmly placed his works in 'the class of art' which he called 'low comedy'. However, he acknowledged that Hogarth possessed 'an inexhaustible fund of wit and humour, a dramatic invention not surpassed by Raffaelle himself'. But rather than jeopardize the hierarchy of genres, Howard had to conclude that Hogarth 'has shown such a fertile imagination in his combinations of details, such a knowledge of nature and of art in the scheme and treatment of his subjects, as place him alone in his particular department'. Although Howard recognized the individual merit of a work of art, he tended to judge it with a rigid adherence to the established hierarchy of genres. His lectures so obviously lacked the idiosyncratic generosity and sympathetic value-judgements of the *Discourses* that they represented a dogmatization of the academic position.

Howard's understanding of the RA's role was also deeply conservative: 'The legitimate object of all academies, and their chief utility … is to foster and promote its highest aims, and to secure its true principles … against the fluctuations or temporary invasions of fashion, caprice, or neglect, and preserve them as in an ark for a more propitious era.'[17] In his retrograde rescue mission Howard aimed to preserve a universal and timeless notion of

high art – unaffected by historical circumstance and change – which could be reactivated in more favourable conditions. In the closing passages of his lectures, Howard commented on the consistent lack of patronage for high art, which had 'prevent[ed] the naturalization among us of what is generally included under the name of historical painting'.[18] Describing the patchy history of attempts to promote the practice of high art in Britain, he concluded simply that 'Great works are not produced, because great works are not wanted.'[19] He blamed the predominance of private patronage for 'the present unfriendly feeling towards historical art'[20] and argued that painters could not be bothered to engage with the higher spheres of art since 'patronage and reputation are to be obtained more easily in humbler walks'. He therefore strongly believed in the necessity of public patronage for the promotion of high art which 'would lead to the general dissemination of taste'.[21] Consequently he invested hopes in the Fine Arts Commission that was set up in 1841 to manage the decoration scheme for the newly rebuilt Houses of Parliament.[22] In Howard's view, this opportunity would also alleviate the growing national concern that Britain 'still remain[ed] the only civilized country in Europe that affords no public demand for the great works of Painting'.[23] Howard charged his extremely conservative notion of history painting with the task of improving the standard of taste and serving as a marker for the nation's degree of civilization.

In late 1847 Charles Robert Leslie succeeded Henry Howard as Professor of Painting. His lectures marked a decisive change in the institutional voice of the RA. They took account of contemporary art-historical scholarship, which was reconsidering the qualities of pre-Renaissance art, and expressed a need to define the academic position in relation to the artistic debates that had gained momentum during the 1840s. Furthermore, Leslie discussed some of the anti-academic tenets originally put forward by William Hazlitt, and softened the strict hierarchy of genres so rigorously upheld by his predecessor.[24] As a result, Leslie's lectures reflected and refracted several conflicting influences through which he sought to modernize the academic discourse. However, he was fully aware of his strategy when he claimed that 'There are fashions in criticism as in everything else; and as the torrent of fashion can never be stopped or turned till it has run its course, it should be our endeavour to profit by it as far as we can without being wholly carried away.'[25] Leslie's view was diametrically opposed to that of Howard, who had wanted to protect a pure form of high art by placing it in an ark where it could be safely stored until the dangerous currents of fashion had subsided.

On the whole, Leslie had little to say about religious painting, but his subtle attempt at reworking the traditional academic discourse to make it receptive to a broader naturalist perspective was also to influence the practice of religious painting. This important shift registered with the young Pre-Raphaelites, who echoed some of his essentially Hazlittian views in their own early writings, and indeed in their controversial practice. Since the days of Reynolds, the academic discourse had maintained a delicate balance

between the appreciation of relative artistic merit and the overriding principle of hierarchy. In stark contrast to this established assumption, Leslie confessed that to insist on placing all works of art into categories with a strict hierarchy was problematic since 'no classification of its branches according to difference of style or subject has ever appeared to me entirely satisfactory'.[26] He further admitted that 'when I stand before that which impresses me as the work of a truly great painter, it belongs for the time being, in my mind, to the highest class of Art, let the subject be what it will'. Such a response recalled Hazlitt's consciously maintained dichotomy of *high* art and *true* art, which provided a core concept of the Pre-Raphaelite project, so memorably expressed in this description: 'The principle is the same in painting an archangel's or a butterfly's wing; and the very finest picture in the finest collection may be one of a very common subject.'[27] Although Leslie was careful not to challenge the canon – 'for I ever recur to Michael Angelo and Raphael as the greatest of all painters' – his appreciation of art depended on individual taste and the recognition of relative artistic merit.

Leslie's lectures reveal a general move towards naturalism. He warned his students that 'theories deduced from Art *merely* are always to be mistrusted', suggesting that the basis of sound theory depended on 'principles derived from Nature and from an enlarged comparison of Art with Nature'.[28] He insisted on the combination of the ideal with character and expression since, in his opinion, the 'indiscriminate aim at beauty ... only produces insipidity'.[29] Regarding achievements in invention and expression, Leslie considered Hogarth 'a master ... wholly unequalled excepting by Raphael alone'.[30] Unlike his predecessor, who had also applauded Hogarth, he did not feel the need to qualify his praise by assigning the artist's work to an exclusive category. Leslie's approach indicated a less rigidly maintained hierarchy of genres: 'Hogarth was a painter of nature, in the highest sense, as distinguished from a painter of matter-of-fact; and that he did not aim at mere *literal* truth is shown by many little circumstances in his pictures'.[31] Combining historical circumstance with moral purpose, Leslie continued the revaluation of history painting started by Hazlitt, who had asked why Hogarth was not considered a historical painter. Unlike the critic's polemical and well-crafted essays, Leslie's lectures were marked by a covert subversion of traditional academic tenets. This subtler strategy may have been necessitated by his role as the RA's Professor of Painting, a position of tradition and authority that made the outright rejection of academic theory impossible.

The art critic and playwright Tom Taylor called Leslie's prose 'modest and tolerant' and recognized that even in the expanded version of his RA lectures, *Hand-book for Young Painters* (1855), the author 'nowhere devote[d] himself to detailed refutation of Sir Joshua's theory'.[32] This task Taylor took on himself when completing Leslie's two-volume *Life and Times of Sir Joshua Reynolds* (1865). Here criticism of the *Discourses* hinged on the concept of a 'central type of form' and the constant promotion of 'general ideas' which, in Taylor's view, 'was to make "High Art" empty, academic and lifeless'.[33] Taylor's

vehement critique, for which he summoned Ruskin's elegant rebuttal of the academic discourse in *Modern Painters*, indicated the critical trajectory on which Leslie's lectures were located. He argued that Ruskin's outspoken naturalist view was to 'be found underlying Leslie's reasoning throughout'.[34] This assertion does indeed lend weight to the moderate claims of Leslie's lectures, where he repeatedly insisted that historical genre painting should be recognized as a form of high art. In his discussion of the importance of period detail, Leslie openly contradicted the views of his predecessor. Once more referring to Hogarth, he argued that the use of period costume greatly enhanced the legibility of an image.[35] He also sought to partly redeem the artist's well-known 'failure … in subjects from Sacred History', and argued that even in these Hogarth had shown an uncommon degree of observation and expression.[36] Leslie's positive revaluation was part of a larger campaign that claimed the artist as one of the father figures of 'a distinctively British tradition of genre painting'.[37]

The second important issue concerns Leslie's views on contemporary art-historical scholarship's reappraisal of pre-Renaissance painting. He was sympathetic and generous in his appreciation of the relative merits of early art. But he was also mindful of his position as Professor of Painting and protective of the established canon:

Nay, I will say that the simplicity and the purity of feeling of Giotto, Angelico, and others of the early Italian masters, will be best felt by him who is most sensibly alive to every variety of excellence that has been displayed in the painters of all ages to the world.[38]

Leslie also invoked the relativity of excellence as a means to achieve a balanced artistic education, encouraging his 'younger auditors … to look to the old masters in order to discover the faults of the living painters, and to every style to discover the faults of every other style'.[39] This notion of relativity was modelled on Reynolds; it strove for an amalgamation that would take account of the qualities of various styles. But Leslie added the forceful exhortation 'and above all, to look to Nature for the instruction that Art cannot give', thus tempering the traditional position of the synthesized ideal with a plea for naturalism.

Over a number of decades, the art-historical research of William Young Ottley, Carl Friedrich von Rumohr, Franz Kugler, Alexis François Rio and others had initiated a fundamental reappraisal of early art.[40] The work of Ottley, Rumohr and Kugler displayed the methodologies of the nascent discipline of art history, which analysed the iconography and evaluated the relative artistic merits of early art. By contrast, Alexis François Rio's *De la Poésie chrétienne* (1836) established a close link between the production of art and Christian belief. Although no English edition was available before 1854, Rio's work played an important role in establishing the notion of 'early art' in England, where his ideas became known mainly through assimilation by writers such as Lord Lindsay, Anna Jameson and John Ruskin. Jameson's *Memoirs of Early Italian Painters* (1845) – based on her articles previously

published in the *Penny Magazine* – popularized research into early art, turning Giotto, Cimabue and Gozzoli into household names.[41] Her systematic iconographical explorations – *Sacred and Legendary Art* (1848), *Legends of the Monastic Orders* (1850) and *Legends of the Madonna* (1852) – made an important contribution to the understanding and appreciation of early art and were to supply the Pre-Raphaelites with a much needed impetus to enrich the tired conventions of early-Victorian religious painting. Jameson, who has been termed 'the first professional English art historian', was a meticulous scholar whose impartial investigations even won the praise of the militant Protestant Charles Kingsley.[42] On the whole, such a reappraisal of early art broadened the aesthetic horizons of the age without threatening the academic hierarchy, because the key values of early art – earnestness and simplicity – could be incorporated into academic discourse. For example, Thomas Phillips, RA Professor of Painting from 1825 to 1832, admired 'the perfection of feeling and understanding that mingled with the imperfections to be found in the works of early painters'.[43] In his third lecture, Leslie was full of praise for Gozzoli's Campo Santo frescoes at Pisa. His evaluation was based on the academic notion of technical progress, claiming that 'the vast superiority in the compositions of Gozzoli over those of the earlier painters' was 'the result almost entirely of his knowledge of perspective'.[44] Acknowledging the merits of early art posed no problem: medieval artists occupied a useful position as precursors to the achievements of the High Renaissance.

During the 1840s, however, value judgements that placed the achievements of early art above those of the academic heroes Raphael and Michelangelo increasingly challenged the delicate balance between relative artistic merit and the traditional canon. Franz Kugler's *A Hand-Book of the History of Painting* was the first book-length study to become available in English that gave a favourable account of pre-Renaissance art. In his preface to the first edition (1842), the painter and arts administrator Charles Lock Eastlake argued for an historical relativism that aimed to 'comprehend why various schools have attained great celebrity in spite of certain defects'.[45] In his editorial comments he further modified Kugler's radical revaluation of early art and sought to understand the development of Italian painting in terms of increasing mimetic skills. Eastlake's editorial interventions aimed to make Kugler's radical opinions more widely acceptable.

Nevertheless, in his RA lectures Leslie took issue with Kugler's opinion that 'in the conception of the two principal figures in the "Last Judgment" Michel Angelo "stands far below the dignified grandeur" of Orcagna in the treatment of the same subject in the Campo Santo, at Pisa'.[46] He defended Michelangelo and ascribed the defects he saw in the figure of Christ to the indeed regrettable influence of Orcagna's work. He argued that had Michelangelo 'trusted to his own invention, it could scarcely have failed to supply a much better thought'.

Similarly, Leslie rejected the view that Raphael's Vatican frescoes and the Cartoons – the pinnacle of academic art – were inferior to his early work, because 'they had more of earth and less of heaven in them'. Instead he

claimed that Raphael had acquired his deep knowledge of human nature, which informed his work and made it the perfect academic role model, precisely because he 'went out of the church and into the world'. This, Leslie argued, had enabled Raphael to depict universal Christian values 'among men of like passions with ourselves'. He maintained that the 'shades of human character and passion' which Raphael represented with such mastery were superior to his straightforwardly devotional early works. He therefore rejected a reversal of values that placed the 'purity of feeling' displayed in the work of medieval artists above the representation of character and passion.

Leslie was deeply suspicious of devotional art, which he regarded as a Roman Catholic domain. His insistence that the worldliness of Raphael's work resulted in the true depiction of human character ensured that history painting embodied universal and non-sectarian values. Unlike Howard, Leslie did not consider religious painting to be the one unadulterated form of high art that deserved a category all its own. He repeatedly used examples such as Raphael's Cartoons, Rubens's *Descent from the Cross* and Veronese's *The Marriage at Cana* to illustrate general points of pictorial composition.[47] This wide selection of religious works together with Leslie's sympathetic reappraisal of Hogarth's scriptural subjects heralded a subtle shift in all areas of history painting towards genre. Through measured suggestions, Leslie effectively revoked his predecessor's very conservative interpretation of the academic discourse.

But Leslie identified one real threat to his more relaxed version of the academic orthodoxy. He detected distressing signs that some contemporary artists considered the achievements of early art no longer simply as a valuable developmental stage but as a suitable model for contemporary practice. Hence he categorically proclaimed 'that any attempt to revive particular styles of Art must always prove futile, since history shows us that Art has often revived, but styles never have'.[48] The otherwise moderate tone of Leslie's lectures was abandoned in the defence of fundamental academic conventions; a high-pitched note of moral indignation found expression in a charged religious terminology. He regarded the 'bigoted admiration of any one school or any one master ... to the exclusion of all the rest' as 'sectarianism in Art'. The reversal of academic values that he detected in recent artistic practice he emphatically called 'fanaticism': a deviation from the *via media* of academic synthesis:

The bigoted sectarian always admires in the wrong place, – clings to what is merely accidental, to that which belongs to the time and country in which the painter has lived; and ever fails to perceive that which is essential in the style, that which is catholic, and which therefore connects all the first-rate minds of all ages with each other.

In the face of total artistic relativism, Leslie upheld the universal validity of the academic paradigm and argued for a style that transcended both aesthetic and religious sectarianism.

While Howard's lectures represented a dated and dogmatic academism

that lacked the generosity of Reynolds's *Discourses*, Leslie attempted a subtle modification of the academic paradigm. On the whole, he no longer maintained a strict hierarchy of genres that distinguished between high art and low art, but argued for an appreciation of the qualities of art, irrespective of subject matter and style. Following Hazlitt, he promoted a form of history painting that – in its combination of the particular and the general – veered towards genre. In the final assessment, he shied away from acknowledging the subversive potential of his suggestions. Although the two professors held fundamentally different views on religious painting, they allocated a comparable degree of importance to it. Howard grudgingly conceded the necessity of period detail for the representation of historical scenes, but exempted scriptural subjects because they belonged to an epic sphere that was ahistorical. Thus, in his view, scriptural painting remained the one form of high art as yet untarnished by the increasing demands of historicity. For Leslie, on the other hand, religious painting formed an integral part of history painting, which he aimed to make more specific and to move closer to historical genre. This shift was also apparent in his assessment of religious painting, especially in his measured attempt to at least partly redeem Hogarth's scriptural subjects. He incorporated his generous praise for early art into a progressive art-historical narrative, but rejected it as a role model for contemporary practice. When faced with historical revivalism, which he regarded as antithetical to naturalism, Leslie retreated to a surprisingly traditional academic position and condemned any threat to the balanced progress of art as fanatical sectarianism.

The practice of religious painting and the periodical press

In an unsigned article entitled 'The progress of British Art', which appeared in the *Art-Union* in 1848, the writer made the following enthusiastic claim for the social powers of high art:

The disposition and the time are favourable; but it is only by right means adapted to right ends we can hope for success. High Art, for National purposes, – as a means of Education; as the annalist of our History; as the inculcator of Moral Truths; as the promoter of Commerce; the agent towards Social Refinement; – this only is worth promoting, worth struggling for to promote.[49]

This passage captured the optimism of a decade which finally saw the possibility of public patronage materialize. In this breathless and exaggerated listing, the merits of high art were seen to influence education and social refinement, promote commerce and establish moral truths: a cure for the ills of the age. The practice of high art not only seemed possible but was also seen to transcend the customary conflict between the spheres of commerce and art.

High art was the subject of an increasingly diverse theoretical discourse that had mainly evolved in the RA lectures. But due to the economic

circumstances governing artistic production in England, it lacked a strong and continuous tradition of practice. Hence it is not surprising to find that in their different recommendations for high art, Henry Howard and C. R. Leslie barely touched upon the reality of the art market. While Howard deplored the lack of public patronage and proposed to mothball history painting until more favourable times, Leslie implied a need for a redefinition of history painting that aimed to elevate historical genre painting. In a sense, both strategies were borne out by developments in the field. Traditional history painting of the kind promoted by Howard went into decline, never to see the desired resurrection. On the other hand, narrative genre – as Dianne Sachko Macleod has argued – 'succeeded where history painting had failed in reaching all segments of society with its moral lessons, not because it appealed to the lowest common denominator, but simply because it invited reflection'.[50] In promoting historical genre painting, Leslie realized its topicality and wider appeal. However, both proposals provided little guidance for the practice of high art – or indeed religious painting – which played only a minor role in the RA's annual exhibitions.

A close statistical evaluation of the RA exhibition catalogues of 1825 to 1870 shows exactly how small the number of religious paintings really was: it ranged from as little as 1.5 per cent in 1830 to a peak of 4.5 per cent in 1850; the average lay at about 2.5 per cent. These figures comprise all categories of paintings with religious connotations, such as scenes from the Old and New Testaments, historical scenes, domestic genre and allegory. Although the titles of pictures given in the catalogues can be misleading, and there is little hope of tracing the majority of paintings to correct the potential margin of error, the statistical evidence I have gathered demonstrates that the number of religious paintings displayed at the RA was indeed small.[51] However, some interesting observations can be deduced from this evaluation. The Graph 2.1 reveals a general rise in all categories of religious subjects from 1835 through the 1840s. The first half of the 1840s saw a surge in Old Testament subjects, while the second half of the decade was dominated by an increase in New Testament subjects (Graphs 2.2 and 2.3). The Graph 2.1 also shows a sudden reversal of this upward trend from 1850. Although it is impossible to identify any one single cause, it is tempting to speculate that the unprecedented controversy over John Everett Millais's *Christ in the House of His Parents* (1849–50) lessened the appetite for religious painting (Plate 7). It might be somewhat hyperbolic to ascribe this change to this notorious controversy, which I discuss at some length in Chapter 3. But the reverse is certainly true: the Pre-Raphaelites were attracted to religious painting because of the prominence it was given in the press, which repeatedly commented on both the noticeable increase in religious works exhibited at the RA and the importance of this branch of art. The graphs also display another noteworthy reversal. After the downward trend, which started in 1850 and lasted for the remainder of the decade, the number of New Testament subjects picked up again in 1860 and continued to rise until 1865. Once again, one is inclined to ascribe this change to a Pre-Raphaelite intervention: the well-publicized and

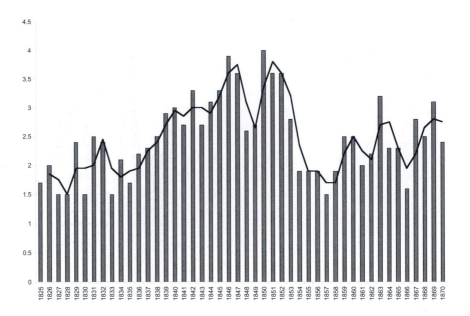

Graph 2.1 Religious paintings shown at the Royal Academy, 1825–70

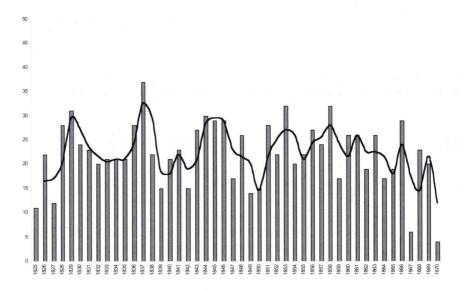

Graph 2.2 Old Testament subjects shown at the Royal Academy, 1825–70

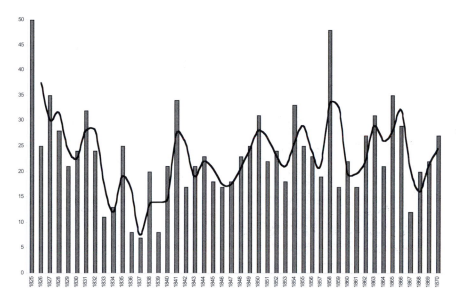

Graph 2.3 New Testament subjects shown at the Royal Academy, 1825–70

extremely successful one-man show of William Holman Hunt's *The Finding of the Saviour in the Temple* (1854–60) which opened in 1860 (Plate 10). The work established Hunt as a major force in the mid-Victorian art world. More importantly, it represented the first significant and commercially successful example of a Protestant biblical naturalism. The controversy over Millais's *Christ in the House of His Parents* and the display and marketing of Hunt's *The Finding of the Saviour in the Temple* a decade later constitute seminal events that shaped the course of religious painting in mid-Victorian England. They might even have registered on Graphs 2.1–2.3 charting the patterns of display of religious works shown at the RA.

The discrepancy between theory and practice that Sir Joshua Reynolds had already alluded to in 1770 continued due to the lack of state and church patronage. The British art market was mostly sustained by private patrons who tended to favour portraiture and small-scale genre painting. Such predilections were also reflected in the works displayed at the RA's annual exhibition. As the major showcase for art in Britain, it was widely reviewed and functioned as a barometer for the standard of artistic production, but it also attracted its share of criticism. Writing in 1845, *The Times* critic pointed out the travesty of the hierarchy of genres, in which portraits and genre paintings prevailed, and deplored that market forces discouraged the aspiring artist from the practice of high art:

It is a matter of course for portraits to predominate at the Royal Academy's exhibition. If inclination tempts the artist to the epic, the historic, or the landscape, commercial advantage pulls in the portrait direction, for there is many a patron of art who will go to the extent of seeing himself and his wife over his chimney-piece,

but who will never dream of laying out a penny for A Nativity, or a Death of Hector, or a Shady Lane. But this time the portraits seem to form even a more than usual portion of the entire collection.[52]

William Hazlitt also strongly criticized the quality of art exhibited at the RA:

The mass of the pictures exhibited there are *not* calculated to give the English people a true notion, not merely of high art (as it is emphatically called), but of the genuine objects of art at all … The vast majority of the pictures received there, and hung up in the most conspicuous places, are pictures painted to please the natural vanity or fantastic ignorance of the artist's sitters, their friends and relations, and to lead to more commissions for half and whole lengths – or else pictures painted purposely to be seen in the Exhibition, to strike across the Great Room, to catch attention, and force admiration, in the distraction and dissipation of a thousand foolish faces and new-gilt frames, by gaudy colouring and meretricious grace.[53]

Hazlitt maintained that the economy of supply and demand that dominated contemporary artistic practice prevented the production of true art. He deplored that commissions were widely available only for portraits and that most work had to rely on eye-catching bravura to attract attention in the crowded annual exhibition. His criticism highlighted the double discourse of value in operation at the RA, which depended on two respective metaphorical sites: the temple and the marketplace.[54] While the Professors of Painting continued to chant the Reynoldsian dogma of high art, the annual exhibition provided the prime venue for painting as commodity. Consequently, the RA had to project a public image in which the laws of the market did not desecrate the temple – a task made more difficult by the fact that its financial situation depended on the income generated from entrance fees. Since the economics of the marketplace helped to sustain the RA's role as guardian of high art, the correlation of the two separate discourses of value was indeed complex and somewhat uncomfortable.[55]

The discrepancy that resulted from the RA's double role as temple and marketplace served to legitimize contemporary art criticism. This was especially true for articles written in direct response to the RA exhibition, which dominated art reviewing in the periodical press.[56] The critics in publications such as *The Times*, the *Athenaeum* and the *Art Journal* took up a position from which to make value judgements that depended largely on the RA's own self-serving ideology. However, the voices of the press failed to capitalize fully on this potential for moral leverage. On the one hand, critics assumed a policing role to guard the transcendental value of art in the face of the material transactions of the marketplace, and on the other the extensive listing of individual works in the RA reviews provided summary descriptions for potential buyers.

The structure of the RA review itself reflected these two distinct functions of criticism, which were dictated by the conflicted dichotomy of temple and marketplace. A preliminary account of the exhibition, which considered the current state of British art and reported on the specific achievements of popular painters and Royal Academicians, was followed by brief discussions of individual works. These were arranged according to the traditional

hierarchy of genres, from history painting, which included historical genre and religious painting, the reviewer gradually working his way to the lower genres. To this general pattern shared by publications such as *The Times*, the *Athenaeum* and the *Art Journal*, the latter added a more extensive review section which listed individual works according to catalogue numbers and gave a short evaluative or descriptive paragraph on the highlighted works.

Despite their potential for moral leverage, the voices of the press remained fragmented and their comments ritualized, anonymous, 'cursory' and 'ill-informed'.[57] With the help of a limited stock of ideas and phrases derived from academic theory and philosophical criticism, the reviewers pronounced value judgements on individual works of art. They created a common art-speak shared by critics and readers.[58] The satirical magazine *Punch* commented on this highly ritualized shared vocabulary and pointed out its chief function: 'The language of pictorial criticism, like its subject, should be mysterious and unintelligible to the vulgar. It is a mistake to classify it as ordinary English, the rules of which it does not recognise.'[59] *Punch* drew attention not only to this limited vocabulary but also to its ritualistic use, remarking that the terminology is 'indispensable, and may be used pretty much at random'. However, despite art criticism's deliberately opaque language, its tone generally implied that it had a responsible social role. In the swiftly growing periodical press, art criticism represented the voices of an emerging middle class and charted the changing economic structures and aesthetics of the art world. As the discussion of art shifted to the pages of the periodical press it is important to realize that the ritualized and limited format of the RA reviews did not simply reflect cultural values existing in some wider context: the reviews themselves were sites for the construction, policing and reinforcement of such values.

The critics were divided on the merits of the market. The *Art-Union* hoped that the *laissez-faire* attitude of supply and demand was capable of producing discerning private patronage. In contrast, William Makepeace Thackeray argued for a practice of art that strove for moral values and sentiment, while recognizing the mercantile limitations.[60] He understood the demands of the market: 'Art is a matter of private enterprise here, like everything else: and our painters must suit the small rooms of their customers, and supply them with such subjects as are likely to please them.'[61] Paintings were not produced only according to the tastes of the individual patron, 'who is satisfied with the portraits of the domestic circle, and the pictures of "Genre" wherewith to decorate his Hall', but also to attract potential buyers in the exhibition.[62] However, Thackeray was merciless in his criticism of artistic speculation – inspired by the lottery-like practices of the Art Union – that aimed to attract buyers:

As one looks round the rooms of the Royal Academy, one cannot but deplore the fate of the poor fellows who have been speculating upon the Art Unions; and yet in the act of grief there is a lurking satisfaction. The poor fellows can't sell their pieces; that is a pity. But why did the poor fellows paint such fiddle-faddle pictures? they catered for the *bourgeois*, the sly rogues! they know honest John Bull's taste, and

simple admiration of namby-pamby, and so they supplied him with an article that was just likely to suit him. In the like manner savages are supplied with glass beads; children are accommodated with toys and trash, by dexterous speculators who know their market.[63]

The periodical press not only attacked the RA for its double standards but also called into question the conservatism of the art-theoretical values it promoted. Critics argued that traditional history painting with its notoriously obscure subject matter – derived from classical literature and mythology – held no significance for contemporary middle-class audiences. *Punch* volunteered the following advice to the organizers of the RA exhibition: 'The historical paintings might be placed at the back of the man who takes the umbrellas and walking-sticks, who could explain what the pictures mean, a desideratum which is not supplied generally by the artist.'[64] Other papers of course regarded the matter with more seriousness, but they all more or less agreed that the traditional subject matter of high art lacked contemporary relevance.

However, religious painting constituted the one notable exception. In 1840 the *Art-Union* critic wrote:

Let us remember that Michel Angelo, Raffaelle, and Titian did not usually choose such subjects, but, working *with* their age, selected those, chiefly from Holy Writ, which, according with the feeling of the time, appealed to general sympathies. Their works are still the admired of all who have hearts to feel; while those artists of a more modern school, who have ransacked the Greek and Roman historians and poets, have shown, as well by their own weakness, as by the want of what is interesting in their subjects, how utterly impotent they are to excite any lasting impression, or to advance the cause they desire to support.[65]

The value of religious painting lay in its ability to appeal to 'feeling' and 'general sympathies'. These qualities chimed with a generation of critics who 'consistently privileged the picture's emotional impact over its formal or visual qualities'.[66] This dominant trend in art criticism was responsible for articulating a clearly defined role for religious painting. Under the outspoken leadership of the *Art-Union*, whose editor, S. C. Hall, was committed to educating the public, the periodical press charged religious painting with the moral and educational role traditionally associated with the entire range of high-art subjects, thus claiming it as the new high art of middle-class culture. The following passage demonstrates the inseparability of the two discourses of value as well as the possible functions of religious painting:

Artists, like authors, are but caterers for the public appetite: and when critics complain of the slow advances of the English school in what is termed 'high art,' the class of subjects on which they are employed ought to be always borne in mind. On a reference to the pictures of the Italian and Venetian schools, we find that, through a long space, their genius was nourished, and strengthened by subjects such as the following, which not only demanded refined thoughts and the highest style of design, but engendered corresponding sensations in the artist, viz.: – 'The last Supper,' 'The Nativity,' 'The Resurrection,' 'Christ in the Garden,' 'The Holy Family,' 'The Entombment,' 'Peter Martyr,' 'The Adoration of the Shepherds,' 'The Transfiguration,' 'The Crucifixion.' While, on reference to the catalogues of the

present time, we find the genius of the English artists confined to the productions of such pictures as 'Look, Ma!' 'Grana's Specks,' 'Blowing Bubbles,' 'Smoking the Cobbler,' 'The Cat's Cradle,' 'The Tight Shoe,' 'The White Mouse,' 'Grandfather's Fairing,' 'The Broken Pitcher,' 'The Paper Lantern,' and a thousand others of the same stamp, where anything like style in either drawing or colouring, would be detrimental to the effect.[67]

Religious painting was seen as an instrument to elevate the tastes and moral faculties of painters and audiences alike. The periodical press promoted the production of religious painting for private consumption as the most suitable antidote to the art market's overtly materialist values. In 1846 the *Art-Union* commented on the positive relationship of the economics of the marketplace and the progress of British art by claiming that private patronage was discerning enough to support works of quality:[68]

There has never been a period, in the history of our country, when British Art had brighter prospects: there is no lack of private patronage; let any person who is doubtful on this head walk through either of our Exhibitions ... and he will find that *every work* of unquestionable merit is marked 'sold' ... we believe, when the various Galleries are closed, there will not be a single production of ability returned to its producer ... Already ... the middle class in England – the class in which there is large wealth to expend upon luxuries – has learned to appreciate the practical utility as well as the true enjoyment to be derived from Art ... Let the supply, then, increase; we have no fear but the demand will increase with it; to multiply artists is the very opposite of an evil, if the buyers of pictures are multiplied in proportion.[69]

During the 1840s, the magazine championed religious painting as the only creditable branch of high art. It repeatedly highlighted its ability to function as a moral and educational agent, which would help to elevate the standards of taste, foster enlightened private patronage and promote contemporary British art. The *Art-Union*'s optimistic campaign even played down those market forces which were unlikely to foster the production of religious works. It is important to note that this new role of religious painting was defined and discussed in the pages of the periodical press and not in the RA lectures.

However, the *Art-Union*'s enthusiasm was not entirely shared by other periodicals. While *The Times* critic noticed with some satisfaction 'that art itself was on the advance, and that the English school is not retrograding', he did not ascribe this achievement to religious painting but instead considered traditional history painting responsible for this trend.[70] The *Athenaeum* commented on the exceptional role religious painting played but also drew attention to the complex difficulties pertaining to a contemporary practice, observing that

a larger proportion than usual are either taken from Scripture, or have a religious tendency. Such subjects have the disadvantage of having been already well nigh exhausted by the elder painters, so that it is difficult to devise any novelty of treatment; and the advantage of dealing with effects and appealing to sympathies which are inexhaustible.[71]

There are many other pictures of sacred subjects (Nativities, and Annunciations, &c.), such as we are not used to see on the walls of the Academy, but all painted with such a vapid timidity, that it is as if the remembrance of the old masters had paralyzed hands no longer guided by the same devout spirit.[72]

In both instances the reviewer commented on the remarkable increase in religious painting. He also acknowledged its strong emotional appeal. Unlike the optimistic *Art-Union*, however, he admitted that religious painting faced a conceptual crisis. A long-standing pictorial tradition was seen to stifle contemporary practice, which lacked vigour and originality in style and iconography. And yet, the widely recognized potential for feeling and sentiment made it a popular choice for an art intended to speak to audiences with emotional immediacy and to provide moral elevation. As W. M. Rossetti had put it, the practice of religious painting was indeed 'at once sacred and stale': an impasse the young Pre-Raphaelites would seek to resolve. The strong moral and emotional investment of religious painting made it an ideal genre for the intervention of an ambitious and artistically ascetic group such as the PRB. They aimed to liberate the potential for emotional immediacy trapped in stale representations.

The *Athenaeum* reviewer's observation that the number of religious works on show at the RA had increased is borne out by my statistical analysis (Graph 2.1). This might have been prompted by the change that occurred in the themes set for the RA's biannual gold medal competition.[73] For the whole period from 1769 to 1840, only five religious subjects had been chosen. From 1840 onwards, however, biblical subjects started to outnumber those from classical mythology and literature. Out of the five subjects set during the 1840s, two were taken from the Old Testament; in the following decade the number of religious themes rose to three, of which two were from the New Testament.

During the 1840s, state patronage became a distinct possibility. The Westminster Cartoon Competitions held to decide the decoration of the new Houses of Parliament promised an unprecedented opportunity for history painting.[74] In 1841 the Fine Arts Commission was set up to manage the extensive decoration scheme. The first competition was held in 1843, inviting entries devoted to subjects from national history and literature, specifically from the works of Spenser, Shakespeare and Milton. This was a radical departure from a traditional definition of high art, which had favoured subjects from classical antiquity and the Bible – both still being promoted by the RA gold medal competition. While the first Westminster Cartoon Competition did not provide an obvious space for religious subject matter, which could only be accommodated via literary sources such as Milton's *Paradise Lost*, for subsequent competitions the rules were less stringent and invited the submission of works on religious subjects.[75]

The decoration scheme also demonstrated a strong belief in the social role of art, which Charles Lock Eastlake, Secretary of the Fine Arts Commission, expressed in this optimistic passage, written for Charles Knight's popular

Penny Cyclopedia: 'The tendency of the Arts, when rightly exercised, to purify enjoyment, to humanise and regulate the affections, constitutes their noblest use, and indicates the connection between the higher objects of taste and moral influences'.[76] Art's social role could be promoted in two different, yet related ways: public and private patronage. Elsewhere, Eastlake argued that 'the due encouragement of the higher branches of art may be "beyond the means of private patronage"'.[77] He therefore concluded that 'the decoration of public buildings, with a view to moral and religious purposes, has always been necessary for the complete establishment of a school of historical painting'. With this widely publicized campaign for state patronage, high art finally seemed to receive the support it had lacked for so long.

The press shared this optimistic view of state patronage – previously expressed by Henry Howard in his RA lectures – and was happy to report on the competitions' beneficial effect on contemporary artistic production.[78] The *Art-Union* critic regarded the RA exhibition of 1847 as 'the best that has ever been seen within the walls of the Academy', commenting on two factors in particular.[79] First, he highlighted the more imaginative choices in subject matter: 'there is evidence of reading, and, consequently, an absence of those senseless repetitions which we have so continually denounced'. The second 'remarkable feature of the Exhibition is that influence which has arisen out of the impetus given to our school by the decoration of the Houses of Parliament'. This view was shared by the *Athenaeum* critic who commented in more detail on the stylistic improvements evident in the works displayed at the RA exhibition:

The influences of the scheme for the decoration of a great national palace of assembly begin to be visible in these Exhibitions even more perhaps than in Westminster Hall. The inducement which this presented to the exercise of such care and vigilance as the precision of fresco-painting demands has acted advantageously in many cases where more facile materials were to be dealt with – and the qualities of abstraction in sentiment and severity in treatment have taken the place of literarity of view and picturesqueness of combination.[80]

The stylistic qualities the reviewer highlighted were those associated with contemporary German art. With its impressive record of public patronage and overt didacticism – expressed in the use of sharp outline and clear composition – contemporary German art provided a role model for monumental and public history painting.[81]

During the 1840s the feeling that the British school was progressing was repeatedly expressed in the reviews of the RA exhibitions. The reviewers detected sure signs of progress, especially in the work of a younger generation of artists. This prompted *The Times* critic to conclude in 1848, 'It will be impossible for any one to come away from the present collection without an established confidence in the steady growth and permanent elevation of British art.'[82] Critics widely acknowledged that contemporary art was advancing – even in the mercantile confines of the annual exhibition. Such an assessment seemed justified by individual works of outstanding quality as well as the improved general standard of artistic production. The

voices of the periodical press agreed that British art was undoubtedly improving both in pictorial mastery and choice of subject matter, noting with satisfaction that the prevalence of portraiture had abated somewhat in favour of serious historical subjects.[83]

The critics defined artistic progress in accordance with the academic paradigm and showed an acute awareness of stylistic change. Hence the discernable influence of contemporary German art was being closely monitored. The incorporation of new stylistic qualities was regarded as beneficial as long as British artists managed to combine them with their own traditional mastery of colour. Consequently, the reviewers argued for a balanced synthesis of new influences. Such classic terms of academic discourse were also used to articulate more general notions of progress that carried cultural and national ramifications.

The case of Benjamin Robert Haydon: the reform of tradition and the quest for public space

In the heated debates over the role of art during the 1840s, the death of Benjamin Robert Haydon served as a poignant reminder of the dangers the high-art practitioner might face when working without the support of patronage. Confronted with oppressive debts after the commercial failure of his one-man show at the Egyptian Hall in Piccadilly in 1846 the artist took his own life. Haydon – conceited, vociferous, stubborn – was devoted to the cause of traditional history painting on a large scale. He initially went through the established channels of art, studying and exhibiting at the RA, but he increasingly fell out with the establishment and struck out on his own, promoting history painting in financially precarious ventures such as his fatal one-man show of 1846. Contemporary analysis focused on the unswerving trajectory of Haydon's career, which the artist had pursued with a fanatical commitment right to the end. Much was made of the contrast between the two events that ran simultaneously at the Egyptian Hall: the crowd-pleasing display of Tom Thumb, the famous dwarf from Barnum's New York circus, and the exhibition of Haydon's grand-scale history paintings, which attracted only a few paying visitors. This juxtaposition not only seemed to confirm that interest in high art lacked a broad popular basis, but it also established Haydon as a martyr to the cause. While Tom Thumb's presence at the Egyptian Hall might have contributed to the fiasco, a more likely reason lay in the artist's old-fashioned notion of high art. The two works Haydon showed – *The Banishment of Aristides* and *Nero at the Burning of Rome* – were part of a series of six pictures that illustrated aspects of government. After failing to secure a commission in the first Westminster Cartoon Competition of 1843, the artist began to work on the cycle as a demonstration of his ability to participate in the projected decoration scheme.[84] In an advertisement for the exhibition, Haydon declared that 'These works are part of a series of six designs, made thirty-four years ago for the

old House of Lords.'[85] The artist claimed that his interest in decorating the Houses of Parliament predated the endeavours of the Fine Arts Commission and the sudden possibilities of state patronage – a view he reiterated in the accompanying catalogue.[86] Despite such robust claims, Haydon's art was decidedly old-fashioned in both subject matter and style. The debates generated by the Westminster Cartoon Competitions of 1843 and 1845 had shifted the emphasis away from classical themes to subjects of national interest. His work was typical of an older generation that was being superseded by such younger men as Charles West Cope, William Dyce, John Rogers Herbert and Daniel Maclise. Their styles were more in line with the current taste for German art.[87] In comparison with the well-received exhibitions at Westminster Hall, Haydon's public offerings must have seemed out of touch with the demands made of high art. This was also borne out by the fact that *The Banishment of Aristides* failed to attract the attention of the judging panel when submitted posthumously to the Cartoon Competition of 1847.[88] Even if his notion of history painting was dated by the 1840s, Haydon was a key figure in the long debates about art's role in society as well as about demands made for art education and state patronage.[89] Throughout his career, he attempted to revive and reform the practice of high art, first through private patronage and through exhibiting at the RA and other venues such as the British Institution. Failing that, he pursued an entrepreneurial approach. His was a single-minded mission: 'to create a new era in art, and to rouse the people and patrons to a just estimate of the moral value of history painting'.[90]

In his copious published writings, Haydon advocated a reform of high art that rested on two assumptions.[91] He maintained that imitation of nature was the basis of all true art; here Haydon's argument and his implicit criticism of the RA paralleled Hazlitt's. Secondly, he demanded a scientific approach to representation. The human body should not be contemplated from the outside alone but its mechanical functions disclosed by dissection.[92] Such anatomical insight, he argued, granted in-depth knowledge of the body and led to an understanding of form and expression. He maintained that Greek art – in particular the Parthenon sculptures which epitomized his ideal – was based on similar stylistic rules.[93] The two prerequisites for the reform of high art – knowledge of anatomy and close observation of nature – ran counter to the traditional teaching of the RA, where students were instructed to draw after casts and the living model. This practice refined an external view of the human body, striving for an idealized abstraction from nature.

Haydon did not explain the superiority of Greek art on stylistic grounds alone but also brought the social mechanisms of art production into play. Ancient Greece had provided generous state patronage: artists were employed by cities and public institutions and their art belonged to the people. Consequently, the reform of high art envisaged by Haydon required a change of style as well as wide-ranging social changes. He used the fragmentary literary record as evidence to parallel the indisputable achievements of Greek sculpture with the irretrievably lost achievements in

painting.[94] He regarded the notion of development in art on which the academic discourse depended as a fallacy. He rejected the supremacy of the Italian High Renaissance, traditionally regarded as the period of the highest artistic achievement, awarding this coveted position to the painting of Greek antiquity instead. Such a shift was hardly original: it derived mainly from the lectures of James Barry and Henry Fuseli, who had of course both operated within the institutional framework of the RA. Haydon did not fully acknowledge his intellectual debt, however, and instead focused his attacks on Reynolds's *Discourses*. They served as a foil for his highly polemical project, which depended on an academic discourse that could be presented as monolithic.

In Haydon's view the decline of art could only be halted by the power of unfettered genius. He argued that academies 'have existed for years – and yet not one of these nurseries for artists … have ever produced a painter who could approach Raphael, a sculptor who could rival Phidias, or an architect who could dispute the palm with Michael Angelo'.[95] He further maintained that true genius owed not 'one single principle of practice to the rules and regulations, state honours, or state emoluments, of these royal and imperial hot-beds of commonplace'. As John Barrell has shown, the social aspects of Haydon's theory were at odds with the notion of the artist-genius who would single-handedly bring about the reform of high art.[96] For Haydon, the Greek *polis* with its generous support for art represented the lost ideal. In contrast, the contemporary art scene was characterized by antagonism between true genius and institutions such as the RA – in Haydon's words, 'a dead body without a soul'.[97] The privileging of the individual over the institution was also evident in his indictment of academies: 'all the great discoveries in art, science, or literature, have been made by either opposed or unsupported individuals, in spite of their oppression, or without their assistance'. To some extent, this view, which found its most conclusive expression in his attacks on the RA, reflected the artist's own experience.[98] From the position of the radical outsider that he developed in his writings followed different demands for action.

Initially Haydon aimed to make a career through the RA. Shortly after his arrival in London in 1804, he joined the RA schools and also started showing his work at the RA exhibitions. In 1809 and 1810, he put his name forward for the election of associate members, but in both instances he was not successful. He therefore concluded that his ambition to revive history painting required a different venue. He had two important patrons at the time: Lord Mulgrave, who had commissioned *The Death of Dentatus* (1809) – the artist's first attempt to reconstruct the true style of high art – and Sir George Beaumont, who refused to accept the large format of his next work, a scene from *Macbeth*.[99] According to Haydon, the drawing rooms of his patrons simply did not provide a space big enough for his large-scale projects. This would be a recurrent problem throughout his career. In 1812 he was complaining 'How strange is the blind infatuation of the country! Nobody refuses portraits of themselves or their friends on canvases 8, 10, 12

feet long, but every one shuts his door against the illustrious deeds of our own and of other countries unless on the pettiest canvases.'[100] Haydon sent his scene from *Macbeth* to the British Institution, an important London display venue but less prestigious than the RA. When shown at the British Institution in 1810, *The Death of Dentatus* had won a prize of 100 guineas. However, Haydon failed to repeat this success with the scene from *Macbeth* the following year. He exhibited his subsequent large-scale work *The Judgement of Solomon* (1812–14), at the Watercolour Society. Although it was well received there and awarded 100 guineas by the British Institution, it failed to attract a buyer. Again the artist complained bitterly: 'No corporation, no public body, no church, no patron ever thought the picture worth inquiring after.'[101] Having tested the major marketplaces for art in Britain, and having found his patrons unsympathetic, Haydon sought a different route.

In 1820 the artist rented the Great Room of the Egyptian Hall to exhibit his monumental painting *Christ's Entry into Jerusalem* together with preliminary drawings and some of his earlier pictures. The show was a commercial success; it secured a net profit of approximately £1,300 from the one-shilling entrance fees and catalogue sales. It not only reached a wide audience, but also provided a new source of income.[102] *Christ's Entry into Jerusalem* (1814–20) was Haydon's most ambitious painting to date; it had taken six years to complete (Plate 1). Given his previous difficulties with both art institutions and private patrons it seems plausible that the artist conceived this work with a different form of exhibition in mind.

Surrounded by admirers and disciples who spread their cloaks on the ground before him, Christ is carried along by the masses that stretch to the horizon. Among the onlookers the artist included Voltaire, Newton and Wordsworth, who express different reactions to Christ: ridicule, belief and reverence. Their presence underscores the universal claims of Christianity. Thus, the moment of Christ's worldly triumph and popular acceptance not only assumes an ahistorical dimension, but also suggests Christ's 'conscious prophetic power'.[103] In the descriptive catalogue, Haydon explained the significance of this contrast: 'There is something sublime in the idea, that in the midst of the highest earthly triumph, surrounded by a devoted and shouting populace, he alone would see "into the seeds of time", and muse on his approaching sacrifice!' In his moment of public triumph Christ remains remote through divine foresight, both a truly heroic figure and a symbol for the artist. Here two important elements of Haydon's artistic beliefs come together: the social context epitomized in his reconstruction of the Greek *polis* and the concept of the artist-genius.

The picture itself was a rather incongruous work. The sublimity of the scene depended on the tension between the real and the visionary expressed in the face of Christ. This the artist found difficult to convey – a difficulty William Holman Hunt was to encounter some forty years on in *The Finding of the Saviour in the Temple*.[104] While the use of life-size repoussoir figures was thoroughly conventional, the vast sea of heads that filled the background was almost sensationalist. This clash in pictorial means may have been generated

by the artist's desire to appeal to a wider audience. Although immensely popular and greatly admired, the painting remained unsold. Consequently, the artist decided to send it on tour to Edinburgh and Glasgow where it secured further £900 in entrance fees and was favourably reviewed by *Blackwood's Magazine*:

nothing more can be necessary than a single glance at this wonderful performance itself ... It is quite evident, that Mr. Haydon is already by far the greatest historical painter that England has yet produced. *In time*, those that have observed this masterpiece, can have no doubt he may take his place by the side of the very greatest painters of Italy.[105]

Spurred on by such favourable reviews and the income generated from the show and tour, Haydon planned a further exhibition. For his next project, the artist chose *The Raising of Lazarus* (1821–23), which he showed at the Egyptian Hall in 1823 (Figure 2.1). This time the artist avoided the clash between traditional and sensationalist pictorial elements.[106] He presented a rather traditional interpretation of the subject that focused on the central figures and arranged the awed onlookers mostly in a frieze-like composition. The miracle has been performed: Jesus, whose right arm is extended in a commanding gesture, has raised the young man from the dead. Lazarus is standing erect, yet swaddled in a shroud which he is just pulling back to fix Jesus with an astounded gaze. The horrific subject matter, monumental scale and dramatic lighting enhanced the sublime atmosphere.

The work was well received by the public and the press, but although both exhibitions were a resounding success the artist failed to reap the full benefits. Once again, the painting remained unsold. Maybe due to lack of funds, the artist did not circulate engravings of his works, which would have yielded him a stable and continued source of income. In the long term, therefore, Haydon's commercial enterprise was unsustainable since the exhibitions alone did not generate enough surplus to keep him out of debtors' prison.

Despite such public success and critical acclaim reviewers deemed Haydon's art populist: 'I was accused of appealing to the passions of the million', wrote the artist in connection with the introduction of the Voltaire portrait in *Christ's Entry into Jerusalem*.[107] Although his work adhered to the conventions of high art, its gargantuan scale and theatrical rhetoric made it increasingly sensational. Sensationalism carried its own dangers, as William Hazlitt's assessment of *Christ's Agony in the Garden*, which Haydon showed in 1821, makes evident:

It does not occupy one side of a great room. It is the Iliad in a nutshell. It is only twelve feet by nine, instead of nineteen by sixteen; and that circumstance tells against it with the unenlightened many, and with the judicious few. One great merit of Mr. Haydon's pictures is their size. Reduce him within narrow limits, and you cut off half his resources. His genius is gigantic.[108]

The critic regarded the work 'as a comparative failure' because it is 'inferior in size to those that Mr. Haydon has of late years painted, and is so far a

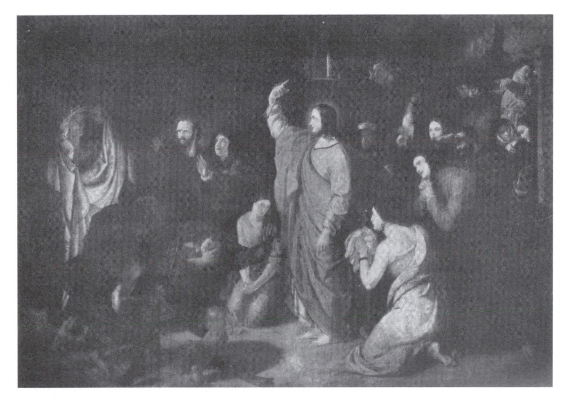

falling-off'. His reasoning was guided by an exaggerated bigger-is-better approach which suggested that the artist constantly needed to exceed his previous performances.

2.1 Benjamin Robert Haydon, *The Raising of Lazarus*, 426.7 x 632.5 cm, oil on canvas, 1821–23

Haydon's work formed part of a wide range of populist practices for the display of art. In 1820, the year in which Haydon exhibited *Christ's Entry into Jerusalem*, Theodore Géricault showed his spectacular and topical *Raft of the Medusa* (1818–19) at the same venue. In 1822 John Martin mounted a one-man show of his massive and sensationalist canvases – mostly of biblical subject matter – at the Egyptian Hall.[109] The show 'was a bid for fame and commissions rather than for sales', since most of the paintings on show had already been sold.[110] Unlike Haydon, Martin circulated engravings after his paintings, thus securing an important source of income.[111] From 1824 onward, Martin worked on both mezzotints – illustrating Milton's *Paradise Lost* – and oil paintings that were exhibited at the British Institution and the RA.[112] The immensely popular diorama shows which became a permanent fixture of London life during the 1820s provided another, if less immediate, context for Haydon's enterprise.[113] During the late 1820s and 1830s, John Martin's sensationalist paintings were regularly adapted for use in dioramas, as was the work of David Roberts, whose *The Israelites leaving Egypt* (1829) was the first to be used in this way.[114] Exhibited at the Scottish Academy in 1830, an enlarged version was shown at the British Diorama in 1833. However, such assimilations were not always done in collaboration with the artist. For

example, it is not clear precisely what part Roberts played in the adaptation of his work and whether he was remunerated. When the British Diorama next decided to stage Martin's *Belshazzar's Feast*, the artist was infuriated by the unauthorized appropriation of his work and, unsuccessfully, tried to stop the show. Despite such tensions between artists and the proprietors of dioramas and panoramas, there was also a degree of cross-fertilization. Martin catered for an immensely profitable market in which his paintings had to compete with diorama shows. At the same time, his work was also informed by the populist practices of this shared market.[115] Although Martin pursued a diversified practice and continued to occasionally exhibit scriptural and historical scenes at the RA and the British Institution, his financial position was far from stable. During the 1830s, his annual income depended primarily on the proceeds from his engravings, which dwindled from £1,842 in 1830 to a meagre £146 in 1837.[116]

Haydon's artistic enterprise was both radical and conventional: it remained wedded to the notion of high art. He did not capitalize on the commercial success of his two shows at the Egyptian Hall, nor did he explore the full potential of the populist market. Although his theoretical approach was ambitious and critical of the RA he never seemed quite capable of turning his doctrine into pictorial practice. His epic biblical scenes of the early 1820s were daring only in their insistence on size, which called for adequate, that is public, patronage. His increasing emphasis on the large-scale format showed Haydon's perseverance in 'the question of public support' of which he said, 'I had made up my mind to bring that about by storm'.[117] His imaginary reconstruction of Greek painting, however, resulted in a somewhat awkward combination of traditional and populist pictorial means. As a result, Haydon's call for reform was much more radical in its social than in its stylistic implications. His attempts to revive history painting were not confined to his canvases alone, but also included demands for a reform of the RA, for state patronage and for the education of public taste. As the recurring parliamentary inquests show, Haydon was not alone in his scrutiny of the RA.[118] He wanted to turn both the RA and the National Gallery into instruments of public patronage. Despite constant pressure during the late 1830s and 1840s, the RA held on to its ambiguous status and remained a forum for private patronage.

However, by the time state patronage finally became available, Haydon's work seemed antiquated and failed to attract a commission. In an attempt to publicly lay claim to his artistic achievements, he began to write his autobiography. In a dogged endeavour to gain public recognition, he continued to promote his planned decoration scheme for the Houses of Parliament. Two of the works for the scheme – *The Banishment of Aristides* and *Nero at the Burning of Rome* – formed part of the exhibition at the Egyptian Hall in 1846, which resulted not only in financial ruin but also in the artist's tragic death. *The Times*'s lengthy inquiry into the circumstances of the 'melancholy suicide of the late B. R. Haydon' implied a connection between the fiasco of his latest exhibition and the motivation for his suicide. But it was

careful not to draw any obvious conclusions or blame the art establishment for failing to accommodate Haydon's somewhat megalomaniac project.[119] According to Eric George, Haydon appealed to his contemporaries because he 'stood for art uncontaminated by commercialism, and for ideals for which he was prepared to starve'.[120]

This uncompromising figure also held some fascination for the young Pre-Raphaelites who put him on their eclectic 'List of Immortals'. However, with the posthumous publication of Haydon's *Autobiography* in 1853 this predominantly sympathetic view changed. The reviewer of the *Art Journal* 'expected to find much in his autobiography to lament, but we certainly were not prepared for such an exhibition of self-glorification and self-delusion as it records'.[121] Haydon's fate, which until then could be read as an undeserved victimization, had now to be re-examined. This led the *Art Journal* to the following conclusion: 'Abstractedly, his aim, to elevate the character of English Art, was noble and praiseworthy, but the means used to attain the end were derogatory to the end.' Haydon's constant demand for public employment was severely criticized, since 'neither a government nor individuals can be expected to pay for what they do not care to have'. The *Art Journal* maintained that an artist's success depended entirely on his ability to supply the demands of the market and concluded therefore that 'If a painter does not choose to make his art popular, he should submit unrepiningly to the consequences; the alternative lies with himself.' The *Art Journal* further pointed out that other artists painted large formats, which failed to attract buyers or public support, but that they managed to survive by painting 'portraits and smaller works for [their] bread'. In a long line of British painters who bemoaned the fact that their income was generated by small-scale work and portraiture, Haydon was exceptional since he vociferously demanded public support for high art, and continued to produce large-scale work despite the reluctance of the market to absorb his productions. However, the *laissez-faire*-driven criticism of Haydon was only a temporary response to the unwanted demystification of a heroic victim. In 1856 the *Art Journal* published an article that reinstated Haydon as a martyr for a noble cause – the quest for public space.[122] This remained topical since the high hopes for public patronage generated by the Westminster Cartoon Competitions had clearly not been fulfilled.

Although Haydon was once again regarded as the victim of high art, he provided no role model for future generations. In his biographical sketches charting the upward mobility of people from all walks of life, entitled *Self-Help* (1859), Samuel Smiles praised single-mindedness and dedication to a chosen career as essential ingredients for success. Although Haydon possessed a fair share of these characteristics, he featured prominently only in the section on debt.[123] In comparison with artists such as David Wilkie and Sir Joshua Reynolds, who had fulfilled their personal potential, 'Haydon's career was a warning example to the gifted'.[124] Smiles criticized its wasteful economy:

But Haydon failed to imitate Reynolds' laboriousness and practical prudence; and though he dreamt of favour, fortune, and honours, he did not take the pains, by diligent cultivation of his unquestionably great powers, effectually to secure them. Hence his life, not with-standing all the examples which artists had set him, proved an egregious failure.[125]

By 1859 Haydon's appeal was clearly limited; the successful artist needed to share the characteristics of the businessman, cultivating his talent and managing it with 'practical prudence'.

Charles Lock Eastlake and the undefinable arch-quality of sentiment

The career of Charles Lock Eastlake represents the complete opposite to Haydon's. Not only was he a successful painter favoured by patrons and critics but he also played an influential role in the art establishment. At various times during his life, he acted as Secretary to the Fine Arts Commission, Keeper of the National Gallery and President of the RA. Not surprisingly, the artist has been somewhat overshadowed by the competent administrator. Throughout his career, Eastlake's work combined a softened academic style – expressed in subtle tonality and delicate brushwork – with a popular choice of subject matter. This is also true of his religious paintings, which brought him critical acclaim and popular success.

Eastlake trained with Benjamin Robert Haydon for a short time before entering the RA schools in 1809,[126] but his formative years were spent in Rome. There he encountered the works of the High Renaissance and of the Nazarenes, a group of contemporary German artists who had settled in the city.[127] He developed an eclectic academism that drew mainly on the works of Raphael and Titian. During the 1820s he established his reputation with much-admired Italian landscapes and romantic pictures of *banditti*, some of which he sent to the RA exhibitions. Paintings such as *The Champion* (1824), *The Escape of the Ferrara Family* (1834) and *Pilgrims in Sight of Rome* (1835) show his fully developed style: he combined effective colouring, careful drawing and a meticulous attention to finish with a predilection for slightly sentimental subject matter.

These characteristics also applied to his religious paintings. In William Makepeace Thackeray's personal hierarchy of British painters, drawn up for *Fraser's Magazine* in 1838, Eastlake featured as archbishop 'because the rank is very respectable, and because there is a certain purity and religious feeling in all Mr. Eastlake does'.[128] Furthermore Thackeray claimed that the artist 'possesses … this undefinable arch-quality of sentiment to a very high degree'.[129] Eastlake's RA diploma picture, *Hagar and Ishmael* (1830), displayed all the chief characteristics of his early style (Figure 2.2). Outcasts in the desert, Hagar and Ishmael are in urgent need of water and nourishment. Hagar's pose, with eyes cast heavenward in despair, was modelled on Guido Reni's representations of saints. The languishing figure of Ishmael accentuated the sentimental rendering of the subject.

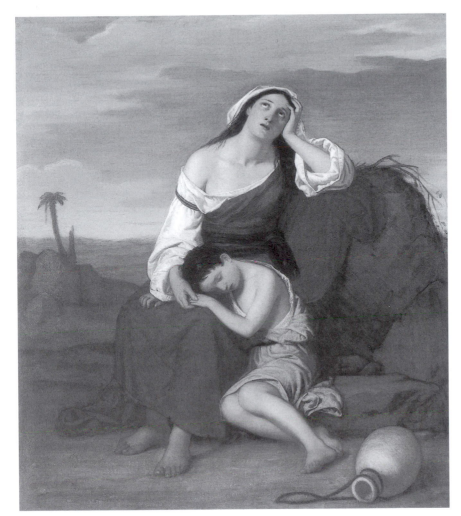

2.2 Charles
Lock Eastlake,
*Hagar and
Ishmael*, 58.4 ×
50.8 cm, oil on
panel, 1830

Christ blessing Little Children, which he showed at the RA in 1839, won him universal praise (Figure 2.3). He surrounded the seated figure of Christ with a charming arrangement of mothers and children in mildly Raphaelesque poses. Its eclectic style, which combined elements borrowed from Raphael with the tonal qualities associated with the work of Titian, and inherently sentimental subject were applauded by the *Art-Union*:

This is perhaps the most faultless picture in the exhibition; is most honourable to the British school; and one indeed of which the age and country may be justly proud. We do not apprehend a single dissenting opinion … The composition is perfect; the colouring admirable; and the incident it represents is touching in the extreme.[130]

Eastlake's work epitomized the type of religious painting that the *Art-Union* was eager to promote as the new high art. When reviewing an engraving of Eastlake's *Pilgrims in Sight of Rome*, its critic praised him as 'a painter for the mass as well as for "the select" – to the heart as well as to the mind; he does not scorn popularity, though he does not work for it; he achieves it by the

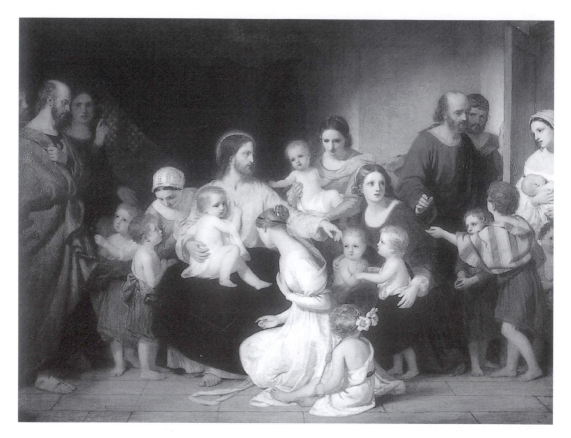

2.3 Charles Lock Eastlake, *Christ blessing Little Children*, 79 x 103.2 cm, oil on canvas, 1839

most legitimate and honourable course – by the selection of subjects which all may understand and feel'.[131] Eastlake's work appealed to the critics because it evoked an emotional response.

With his next religious subject Eastlake consolidated his outstanding reputation: *Christ lamenting over Jerusalem* was exhibited in 1841 and brought him lasting fame (Plate 2). Surrounded by a small group of apostles, Christ is meditating on the destruction of Jerusalem, which he has just prophesied. The faces of the five disciples reflect different reactions to the tragic prophesy, ranging from empathy and concern to resignation. To both sides of the central group the scene opens into a landscape background, which offers a glimpse of the doomed city on the right. Eastlake borrowed the tripartite composition from modern German works, where it was a common device. The *Athenaeum* critic was full of praise for the picture's melancholy and meditative subject matter; he also admired its execution, composition and subtle colouring.[132] The equally enthusiastic *Art-Union* critic valued the work 'as a lesson in practical wisdom, virtue, and beauty'.[133] Both critics grasped the main story but they were less confident about the sub-plot spelt out in the accessories that were prominently displayed in the foreground. The *Athenaeum* critic was clearly puzzled by the presence of 'autumnal and pastoral symbols – such as a sheaf of corn, a sickle, a few bright flowers, and

a pair of doves, picking up the shed grain'.[134] He confessed that he had difficulty reconciling '[a]ccessories of such a rural sweetness' with 'the prophecy of doom and desolation' until he was made aware of the fact that these accessories featured in 'one or other of the parables in which the destruction of the Holy City was foreshown'. He ascribed his difficulty in deciphering the picture's symbolic meaning to 'the novelty of such an arrangement'. His remark also pointed to the complexities of integrated symbolism. He rightly questioned the use of symbolic accessories that in their 'rural sweetness' seemed to distract from rather than illustrate the prophesy of the city's doomed fate. The critic's remarks also reflected the general poverty of symbolic connotations in contemporary religious painting.

On the whole, the value judgements of art criticism were based on the synthetic ideal inherent in academic theory. Consequently, the artist was praised for incorporating the virtues of pre-Renaissance painting – sincerity and earnestness – 'without the servility of a copy'.[135] The *Art-Union* proudly maintained that it 'will at once settle the question whether British artists may not surpass the best masters of the modern German school, in grace of composition and accuracy of drawing, as as [sic] far as they do certainly surpass them in vigour and brilliancy of colour'.[136] Eastlake's eclectic style testified to the progress of British art. Therefore the picture was regarded as both a source of national pride and as the fulfilment of the newly defined functions of religious painting. The comparisons with the old masters and highly esteemed contemporary German artists firmly established the work as high art. It was regarded as 'of the purest art', 'of the simplest grandeur' and at the same time it had the mercantile advantage of being 'merely of cabinet size'.[137] The picture was also commercially successful: the artist produced at least three versions for different patrons, and it was also engraved.[138] When a later version of the work entered the national collection as part of the Vernon bequest in 1847, the *Art-Union* commented on the merits of the painting:

As a great work of Mr. Eastlake, this picture will be a triumphant addition to the National Gallery – a work well qualified to hang side by side with those of the greatest men of any age ... Of the author of this invaluable picture it may be said, that he is the first of our school who has truly succeeded in popularizing high-class art.[139]

Although both Haydon and Eastlake illustrated events that occurred during the last few days of Christ's life, their different choices were significant. Christ's triumphal entry provided Haydon with a monumental subject that suited his obsession with the large format; in his worldly triumph Christ was both public hero and man of prophetic insight. Eastlake's chosen subject, *Christ lamenting over Jerusalem*, seemed similarly dictated by his stylistic predilections; its contemplative mood was suited to the small format. Christ is shown as a compassionate and thoughtful character surrounded by a small circle of faithful disciples. His prophetic power has gone beyond the realization of his own impending sacrifice to foretell the destruction of

Jerusalem. The melancholy and sentimental overtones reflected the artist's emotive approach to the subject through which he 'hope[d] to make others feel'.[140] Commercially successful and critically acclaimed, Eastlake's work was applauded as a sensible adaptation of the high-art ideal.

In 1843 Eastlake returned to the subject of *Hagar and Ishmael* (Figure 2.4). A comparison of the two works affords some insight into the subtle changes that his art had undergone in the course of the decade. While the earlier version combined traditional stylistic characteristics with an emphasis on the story's dramatic elements, the second favoured a more subdued approach. Here the narrative focuses on their meagre supply of water: Hagar administers the last drops to her son before heroically resigning herself to her fate. The reviewers again praised the artist for his sentiment and originality, decorum and didactic talent.[141] The picture was seen to possess 'a religious severity' reminiscent of the early Italian masters 'which no other artist of this age has achieved'. Such praise for the work's dramatic restraint was not simply a reflection of Eastlake's modified style, which showed stronger outlines and a lighter palette. It also suggested an increasing appreciation of the qualities of contemporary German art, best exemplified in the frescoes by Nazarene artists such as Friedrich Overbeck, Peter Cornelius, Julius Schnorr von Carolsfeld and Joseph Anton Koch for the Casa Bartholdi and the Casino Massimo in Rome, as well as in Munich and elsewhere.

In 1850 Eastlake showed *The Good Samaritan* at the RA (Figure 2.5). Both in subject matter and composition, it was indebted to the second version of *Hagar and Ishmael*; motherly love was replaced with an act of compassionate charity. Despite the fact that the artist's pictorial language remained virtually unchanged, the reviewers were no longer unequivocal in their praise. *The Times* and the *Art Journal* applauded the work as an outstanding production on a par with the *Christ lamenting over Jerusalem* of almost a decade earlier. *The Times* reviewer proclaimed that 'In design, in impression, in sentiment, it is of the highest order.'[142] His colleague from the *Art Journal* noted with satisfaction that it 'does not pronounce in favour of this or that style of art, the old or the new; in short, it is not a tribute to art so much as another legend of the Parable'.[143] Eastlake was praised because he approached his subject through the established terms of the academic paradigm. His synthetic style stood in stark contrast to the controversial pictorial conventions inherent in early Italian and in modern German art. The former shared a lack of understanding of human anatomy and the latter strongly emphasized character, expression, composition and didactic intent, characteristics alien to English painting which prided itself on colour and sentiment. Hence both were regarded as unsuitable when used as exclusive role models for contemporary practice.

The *Athenaeum* reviewer also commented on the traditional eclecticism of *The Good Samaritan*, which he called 'of the class academic', and admitted that the work possessed the hallmarks of Eastlake's style: 'sentiment and good intention'.[144] But he went on to note that 'these are not powerfully sustained by justness of proportion and accuracy of form'. He criticized the drawing of the wounded man, remarking in a tone reminiscent of Ruskinian values that

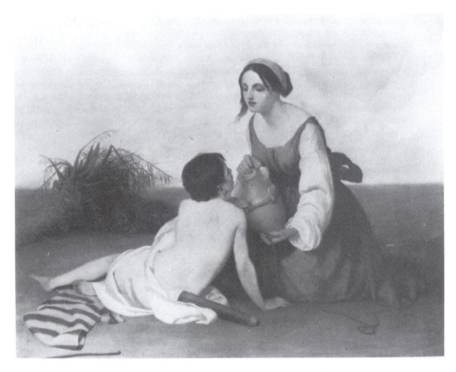

2.4 Charles Lock Eastlake, *Hagar and Ishmael*, 76 × 96.5 cm, oil on canvas, 1843

'no subtleties of execution can atone for departures from fact'. 'Timidity of apprehension and uncertainty of purpose', so the reviewer believed, had led the artist to 'generalize[d] individuality into vagueness'. This assessment chimed with the naturalist discourse that had been formulated as an alternative to academic art. Leslie had also argued for a redefinition of high art in the form of historical genre painting, offering an uneasy attempt to reconcile the opposing paradigms that inevitably generated tensions. These can be traced in the value judgements of the *Athenaeum* reviewer who – while recognizing 'the spiritualizing quality of expression' – criticized the painting's over-generalized handling of detail: 'In the particulars of local accessory there is wanting just that amount of reality which, without descending to the facts of topographic description, conveys the relations of objective truth and avoids the conventional generalities of the studio.'

These demands reflected general shifts. Previously conceived as inherently ahistorical and epic, religious painting was increasingly being judged according to the representational formulas of historical genre.

As a result, the critical reception of Eastlake's work changed substantially. In the course of just one decade, the undivided praise for *Christ lamenting over Jerusalem* which was hailed as *the* religious masterpiece of the age, gave way to the more ambivalent appreciation of *The Good Samaritan*. Similar criticism had already been voiced, albeit less sharply, in respect of a number of his non-religious subjects. In 1840, for example, *The Salutation of the Aged Friar* was criticized for 'some incorrectness of drawing'. But this remark – spoken as a bracketed aside – was still outweighed by the general admiration for

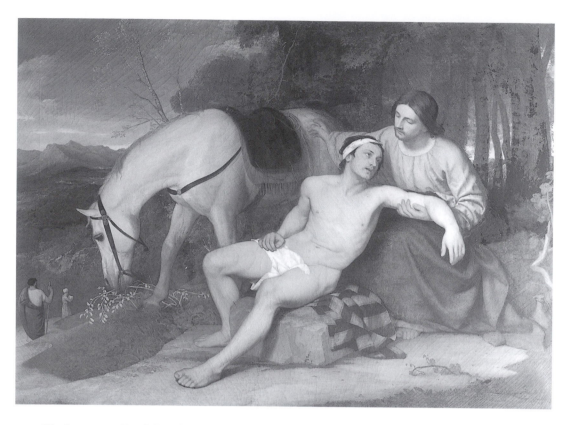

2.5 Charles Lock Eastlake, *The Good Samaritan*, 111.7 x 157.8 cm, oil on canvas, 1850

Eastlake's handling of sentiment.[145] A more astute critic, Thackeray, observed that the artist's choice of subject matter influenced the evaluation of the work's technical merits. Pictorial defects, so he argued, 'one does not condescend to notice when he is filled with a great idea, become visible instantly when he is only occupied with a small one'.[146] The tone of the *Athenaeum* review of *The Good Samaritan* marked a decisive turning point. This was also evident in *Blackwood*'s outspoken comments on *The Escape of the Carrara Family*, a later version of a work originally painted in 1834 and also on show in 1850: 'We should gladly see a little more nerve in Mr. Eastlake's style, and this we think might be advantageously combined with his beautiful transparency of colouring, and other excellent qualities.'[147] Although Eastlake continued to occasionally exhibit religious and non-religious subjects at the RA during the 1850s, from now on he would be mostly remembered as the painter of the outstanding *Christ lamenting over Jerusalem* rather than praised for his more recent productions. In 1853 the *Athenaeum* opened its review of his *Ruth at the Feet of Boaz* with the remark that Eastlake was past his best: 'Amongst these exhibitors of eminent standing the President, Sir Charles Eastlake, is entitled to precedence, not because of the particular examples exhibited by him, but because of his place generally in Art.'[148] In 1855 even the always favourable *Art Journal* pointed out rather spitefully that 'Sir C. L. Eastlake's Art has been, if it is not now, of a very high order and merit.'[149]

Throughout the 1840s the papers constantly referred to a new generation of painters who were taking their places alongside more established artists. On these, the press maintained, the future of British art depended. The decade also witnessed a shift in the appreciation of contemporary German art, which exerted a noticeable influence both on the submissions for the Westminster Cartoon Competitions and the paintings shown at the RA. Overall, the emphasis on outline and composition gradually grew stronger and the colour schemes got lighter. This general trend was also apparent in Eastlake's work, especially when comparing the two versions of *Hagar and Ishmael*.[150] Despite noticeable shifts, the artist's style remained indebted to the synthesis of the academic ideal. Such a practice no longer satisfied the critics, who not only advocated increased attention to historical detail but also demanded more rigour in composition and drawing. By 1850, Eastlake's successful popularization of high art, which combined a synthesized academic style with emotive scriptural subjects that held general appeal, seemed dated. The tide had turned in favour of a modified high-art ideal that was closer to historical genre painting. Increasingly, continental influences made Eastlake's paintings look tame in comparison with the widely publicized submissions for the Westminster Cartoon Competitions, the best of which seemed to promise a new era in British art.

Modification and innovation: continental influence and matters of genre

The year 1850 not only marked the turning point in the critical evaluation of Eastlake's work: it also heralded a general shift away from traditional eclecticism towards a greater appreciation of the influences exerted by continental art. William Dyce, Daniel Maclise and John Rogers Herbert – all three commissioned to execute murals in the newly rebuilt Houses of Parliament – were among the artists who negotiated these influences in their work.

In many ways, William Dyce's career most closely resembled that of Eastlake. Not only had he spent time on the continent and in Rome where he acquired first-hand knowledge of the old masters and modern German art, but he was also both an arts administrator and a painter. He was known mostly for his erudite treatment of scriptural subjects that – in the words of William Sandby – were 'addressed more to the educated and devout than to the multitude'.[151] Indeed, with his various pictures of the Madonna executed during the 1840s (see Figure 3.6, for example), and especially with his subsequent work on William Butterfield's High Anglican model church, All Saints in Margaret Street, London (1849–59), Dyce demonstrated his religious persuasion.

In 1850, Dyce showed *Jacob and Rachel* at the RA (Figure 2.6). The work not only won wide critical acclaim but was also a commercial success. The artist painted at least four versions of the subject and turned down several further requests.[152] While Eastlake's *Good Samaritan* was being slated by the critics,

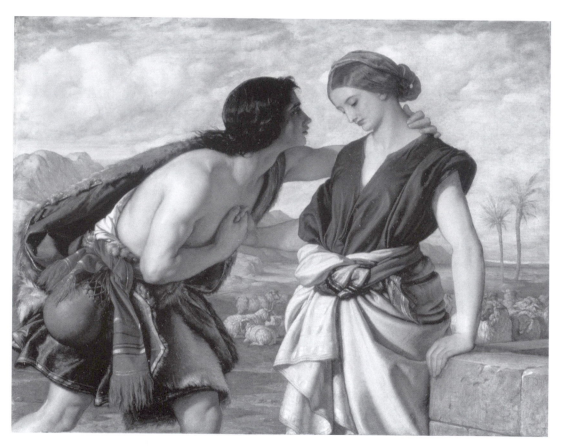

2.6 William
Dyce, *Jacob and
Rachel*, 70.4 ×
91.1 cm, oil on
canvas, 1850–53

Dyce's *Jacob and Rachel* was praised as being 'of this class by far the most perfect and successful'.[153] The reviewer warned that the work 'may even repel the first glance of the visitor by a certain dryness and flatness to which our eyes are not familiar in the English school'.[154] Such a reaction was ascribed to the spectator's inexperience in viewing early art. Dyce was praised for having 'caught that difficult art of following the dry and severe style of the elder painters without sacrificing the more important conditions of feeling and nature'.[155] According to the reviewers, the artist had managed to combine traditional demands for naturalism and sentiment with the stylistic severity of early art. This is particularly evident in the remarks made by *The Times* critic, who found that 'the loveliness of the female figure, with a fondness and a modesty equal to her resignation – the plaint of that Arab herdsman in the anguish of his passion, combine a very high degree of natural emotion and natural grace with ideal treatment and refinement'.[156] The painting was repeatedly singled out for its satisfactory combination of clear outline, vigorous drawing, oriental costume and local atmosphere. It was seen to have 'availed itself of some of the more popular modes of expression of the earlier masters of the fifteenth century, omitting the dryness and accidental peculiarity of their time'.[157]

Despite such praise for the work's successful eclecticism, it was primarily

its content that endeared it to the critics. The *Athenaeum* commented, 'The charms of the modest maiden – the "beautiful and well favoured" – are seen to have made their immediate impression on the youthful Jacob.' Dyce's painting drew on a pictorial tradition that had been recently updated by German Nazarene artists such as A. Strähuber, whose version – taken from the artist's series of illustrations of the life of Jacob – was engraved in the *Art Journal* of 1851 (Figure 2.7).[158] Dyce introduced a passionate love theme and period flavour into a composition that balanced the current demands for clear drawing and delicate colouring. An important innovative technique was the close-up, which focused on the decisive moment in the couple's encounter and courtship, Rachel accepting Jacob's proposal of marriage. The modest orientalist treatment was confined to the costumes and to two palm-trees in the background. In his perceptive essay, James Dafforne captured the differences between the styles of Eastlake and Dyce when he termed the painting 'a masterly production, full of fine feeling, and without the least approach to vapid sentimentalism'.[159] The precise handling of the composition and the crisp colour scheme were instrumental in deflating the sentimental impact that had played such an important part in Eastlake's work. The painting was seen to fit the academic notion of artistic progress, and with its pictorial severity, brilliant colouring and moderate sentiment it was hailed as 'a most masterly production, in all respects honourable to the British School of Art'.[160]

The degree of innovation inherent in Dyce's *Jacob and Rachel* becomes apparent when comparing the work with three pictures also shown at the RA exhibition of 1850: Eastlake's *The Good Samaritan* (Figure 2.5), Henry Nelson O'Neil's *Esther* (Figure 2.8) and F. R. Pickersgill's *Samson Betrayed* (Figure 2.9). All three were extremely conventional compositions. Both O'Neil and Pickersgill even relied on repoussoir figures, columns and flung-back curtains with tassels. The *Athenaeum* reviewer called O'Neil's work 'good as a composition, though not rich in the suggestion of Oriental climate'.[161] He thus identified the painting's shortcomings: token oriental trappings combined with a very traditional composition did little to evoke a realistic oriental atmosphere; they simply produced a costume piece. Pickersgill's reworking of the Old Testament subject was monumental and accomplished yet strongly indebted to the old master tradition. He limited orientalist details to the architectural setting and two dark-skinned figures, one cutting Samson's hair and the other looking on in trepidation. Pickersgill exploited the titillating potential of the subject: a semi-nude Delilah presided over the proceedings. The critics were quick to point out the influence of William Etty, who was well known for his erotically charged renderings of mythological scenes. But mostly they applauded the accomplished handling of the human figure apparent in the carefully staged sleeping Samson.[162]

Dyce's earlier work, *Joash shooting the Arrow of Deliverance*, shown at the RA in 1844, relied on essentially the same compositional elements as the *Jacob and Rachel*, but it was far more severe (Plate 3). The *Art-Union* was full of praise, in particular for the oriental atmosphere:

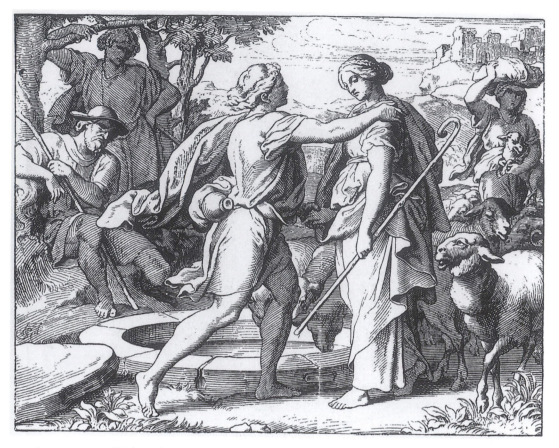

2.7 A. Strähuber, *The Meeting of Jacob and Rachel*, wood-engraving, *Art Journal*, 1851

We have long contented for Oriental character as a propriety in Scriptural art; and we are rejoiced to be enabled to point to a triumphant example of what we mean in these figures, especially in the King, in whom is assembled the best personal points of the Oriental – as he now is and as he was in the days of Solomon. Joash wears a girdle and short drapery, precisely in the manner of the figures in the Egyptian relics, a circumstance showing research after authorities for costume; without which an artist can never accomplish truth.[163]

The picture was applauded for its 'great power' and 'striking originality'.[164] Furthermore, critics remarked favourably on the work's response to such different demands as antiquarian realism (championed by painters of historical genre), severity in drawing and adherence to a brilliant colour scheme – the customary trademark of British art. *The Times* critic ascribed the figures' sculptural qualities and the naturalistic orientalist details – to which he objected – to the influence of contemporary French artists such as Paul Delaroche, Horace Vernet or Ary Scheffer. He maintained that knowledge of these could be acquired by any 'lounger in the streets of London, who has time to peep into the print-shops'.[165] However, he barely distinguished between the characteristics of modern French and German art. Compared to the prevailing British style, with its brilliant colour scheme and little attention to drawing, they indeed must have seemed rather similar as they shared an

2.8 Henry Nelson O'Neil, *Esther*, 102.5 x 76 cm, oil on canvas, 1850

emphasis on vigorous drawing based on neo-classicist conventions. While the critics took pride in the accomplished handling of colour as the one outstanding quality of the British school they were also acutely aware of its shortcomings. As a result, for them progress lay in the combined strength of contemporary British and continental art. Dyce's work, in particular the two pictures discussed here, was seen to bring these qualities together in a most satisfactory way. Such innovation moved within the flexible boundaries of the academic paradigm which strove for constant incorporation of new stylistic elements, thus effecting gradual modification and development.

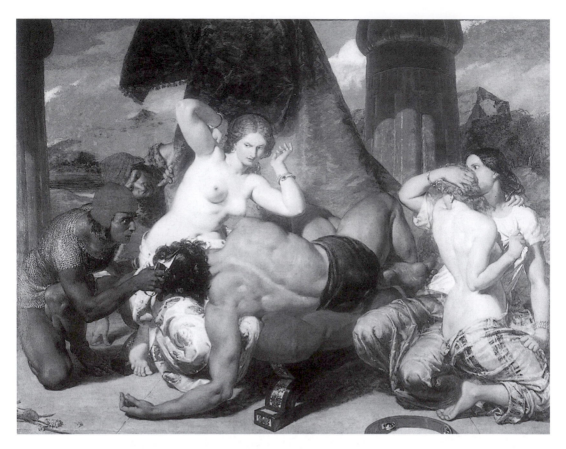

2.9 F. R.
Pickersgill,
Samson Betrayed,
243.8 x 306 cm,
oil on canvas,
1850

Daniel Maclise's *Noah's Sacrifice* (1847–53) reflected both modern German and classical French influences (Figure 2.10). The artist amalgamated different sources such as Poussin's *Noah's Sacrifice*, which was exhibited at the British Institution in 1828, and contemporary German prints such as Gustav Jäger's version engraved for the *Bibel mit Bildern* (1844) – both essentially classical representations of the subject (Figures 2.11 and 2.12).[166] Maclise executed a pen-and-ink sketch of Poussin's painting, which served as a starting point for his own work (Figure 2.13). He did make one significant change in omitting the figure of God, which left the gestures of Noah and the women on the right somewhat unfocused and empty-handed. By contrast, in Jäger's wood-engraving the divine presence was symbolized by the rainbow, the sign of the covenant. Its semicircle dominated the composition: it was not only echoed in Noah's outspread arms but also reflected in the arrangement of the figures. Maclise drew on both sources: he retained the circular composition of the German print but raised the figure of Noah to greater prominence. Positioned at the centre of the circle, the patriarch celebrates the sacrifice with the men busy helping and the women in various poses of adoration. Maclise turned Poussin's tentative still life of jugs and white cloth into a lavish display of colour and painterliness that counterbalanced the severe tonality of his own work. He further opened up the background to include a spectacular

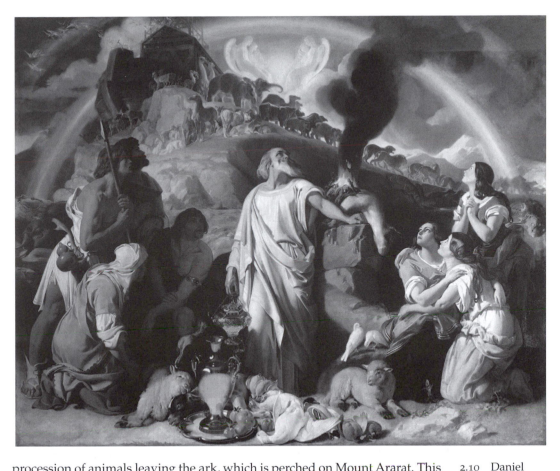

procession of animals leaving the ark, which is perched on Mount Ararat. This dramatic vista and the fact that Noah is facing the spectator diminished the sense of divine communication that dominated both the German and French versions. In fact, it turned the picture into a sublime set-piece focused on the spectator. In Maclise's painting the influences of German and French art merged. The adoption of these stylistic modalities was a deliberate choice, since he had very little regard for contemporary British art and believed 'that we in London are the smallest and most wretched set of snivellers that ever took pencil in hand'.[167] He admired contemporary French art and singled out the work of Paul Delaroche for particular praise. While on a study trip to Paris in 1845 where he prepared for his fresco in the House of Lords, he repeatedly visited Delaroche's *Hemicycle* in the École des Beaux-Arts. As William Vaughan has noted, this artist's work served as a useful exemplar for Maclise because it combined a rigour of composition with more sensual qualities.[168] This combination also echoed the current dilemma of British art, which was not only being judged according to the values of the academic *via media* but was also being encouraged to adopt a more rigorous sense of composition and drawing.

What did the reviewers make of Maclise's conscious recourse to the

2.10 Daniel Maclise, *Noah's Sacrifice*, 205 x 254 cm, oil on canvas, 1847–53

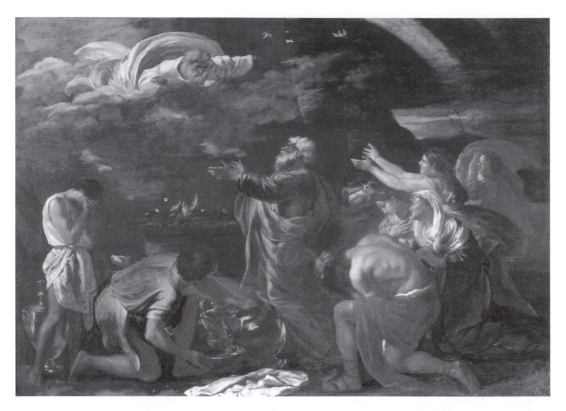

2.11 Nicolas
Poussin, *Noah's
Sacrifice*, 99 × 135
cm, oil on
canvas, n.d.

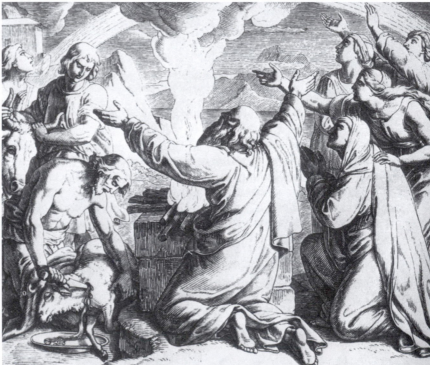

2.12 Gustav
Jäger, *Noah's
Sacrifice*, wood-
engraving from
Bibel mit Bildern,
1844

classically based styles of the leading continental schools? The *Art-Union* critic called it a painting 'presenting many passages of sublime conception' and predictably commented on its apparent lack of colour, which he regarded as an attempt to replicate 'the feeling of fresco' inspired by continental practice and the Westminster Cartoon Competitions.[169] Although the unfamiliar colour scheme did not go unnoticed, the critic's final verdict was positive: 'Upon comparatively unimportant defects of manner ... no one will dwell who can recognise the solemn grandeur of the entire conception. The subject has been often painted, but never before has it been set forth in a version so truly sublime as upon this canvas.' While the *Art-Union* had pointed out that the 'principle of the execution is that which exercises an influence more or less dominant in the continental schools', the *Athenaeum* critic recommended a predictable antidote to the lack of colour: 'The deficiencies of this picture are such as attentive readings of Venetian and Dutch Art might correct.'[170] These comments reassert two earlier points, namely the indiscriminate grouping together of French and German art, and the prevalent notion of artistic progress as a process of synthesis. In *Noah's Sacrifice* Maclise drew simultaneously on German and French sources, on old

2.13 Daniel Maclise, sketch of *Noah's Sacrifice*, 17.8 x 21.6 cm, pen and ink on paper, *c.* 1847

and new masters. The brilliant handling of colour in the luxurious still life was the one concession to British art. The painting was rather atypical for Maclise's *oeuvre*: it remained his one major excursion into the field of biblical subjects.[171] Although strongly indebted to continental influences, the painting operated within the flexible boundaries of the academic paradigm. The artist's choice of stylistic role models and subject matter suggested an affinity with Henry Howard's concept of biblical painting. He continued the tradition of the timeless, dramatic or – in the words of the *Art-Union* critic – sublime representation of scriptural subjects.

At the RA exhibition in 1847, John Rogers Herbert showed *Our Saviour subject to His Parents at Nazareth* (Plate 4). This work also strove to modify the traditional high-art ideal. It presented a New Testament subject in the stringent pictorial terms of the continental schools and introduced topographical veracity in the background landscape. The passage in the Gospel of St Luke on which the painting is based – 'the child grew and waxed strong in spirit, filled with wisdom' (2:40) – provided a rather unspecific theme for pictorial representation. However, the unattributed verse – reminiscent of John Keble's *Christian Year* – that accompanied the RA catalogue entry suggested a context in which to interpret the scene:

> Perhaps the cross, which chance would oft design
> Upon the floor of Joseph's homely shed,
> Across Thy brow serene and heart divine
> A passing cloud of Golgotha would spread.

Herbert's painting demands a symbolic reading. Despite the seemingly relaxed composition of the figures there exists a strong link between Mary and Jesus through an exchange of gazes. As Jesus, who has come with a basket to collect some wood-shavings, has paused in his work to look at the two planks that have formed a cross, Mary too has interrupted her work at the spinning wheel (a wonderful anachronism!) to pensively observe her son. The painting's symbolic meaning centres on the accidental cross – a sign of Christ's passion. The action of the young Jesus indicates the conscious acceptance of his fate and literally prefigures his 'bearing the cross'. The picture's deeper significance is hanging in the air between Mary and Jesus; Joseph who is busily sawing some wood, plays no part in the action. The artist based the relational pattern on the traditional type of the Holy Family, which he approached via the conventions of narrative genre – a route recently made popular by the Nazarenes. But in Herbert's painting the anecdotal dominated over the devotional. The workshop setting, loose arrangement of figures and implied narrative ran counter to the hieratic structure of devotional art.

Stylistically the painting reveals the typical influences of the continental schools. The figures conformed to the slick idealism of contemporary German and French art, without any traces of oriental naturalism in the costumes. But the catalogue entry announced that the 'background is painted

from a very careful drawing made at Nazareth'.[172] This claim to topographical veracity was a distinctly innovative trait widely reflected in illustrated editions of the Bible and travel literature of the 1840s. The growing interest in the topography of the biblical lands was popularized in a stream of influential publications, among them David Roberts's *The Holy Land*, published in parts between 1842 and 1849.[173] In the second half of the 1840s topographical illustrations began to appear in editions of the Bible, as we shall see in Chapter 4. Engravings after old master paintings conforming mainly to the traditional eighteenth-century canons of taste were contrasted with topographical illustrations, heralding factual exploration. In these Bible editions, the contrast between topography and traditional pictorial representation was analogous to that in Herbert's painting. The veracity of the landscape background was not reflected in the handling of the figures, which remained idealized and academic.

On the whole, the critical responses to Herbert's *Our Saviour subject to His Parents at Nazareth* were positive. The *Art-Union* identified the style as 'a deduction from early Italian Art, modified by more advanced experiences' and noted the landscape but thought it 'a matter of little consequence, and of no value'.[174] The reviewer criticized the harsh facial expressions of the figures. His judgement was once again based on the values of academic discourse that emphasized the measured negotiation of different stylistic influences and the representation of the human form. Most reviewers agreed with the verdict of *The Times* critic that 'although characterized by German hardness, [the picture] breathes the most profound thought'.[175] The *Athenaeum* went even further in its praise and called it 'one of the most poetical and imaginative in this collection'.[176] Herbert's intentions were compared to those of 'the old painters, – who wrought with the twofold incentive, devotion to their faith and devotion to their art'. The painting was seen to operate according to academic conventions, synthesizing a number of useful influences and combining the sincerity of the so-called early masters with the technical achievements of modern art: 'Spirituality is its high attribute; to which are united just expression, fine colour, and good drawing.'

All the examples discussed in this section shared the same concern: they aimed to modify and update the traditional notion of high art. Although this negotiation took different forms, it operated within the boundaries of the academic paradigm. This was recognized by contemporary critics, whose tacit assumptions and explicit value judgements, too, were based on the academic discourse. Despite the denominational motivations of painters such as Dyce, a High Anglican, and Herbert, a recent convert to Roman Catholicism, which critics occasionally hinted at (using terms such as 'spirituality' and 'devotion'), the reception of their work remained strictly focused on artistic concerns. Consequently, the reviewers analysed the various stylistic influences and commented on the measured degree of integration.

The changes in academic theory that took place during the 1840s resulted

in increased fragmentation that crystallized into two different and conflicting notions of high art. Henry Howard advocated a traditional high-art ideal which regarded scriptural subjects as epic and ahistorical, whereas Charles Robert Leslie implied a notion more akin to historical genre painting, encouraging attention to period detail and realistic setting. In his lectures, Leslie cautiously commented on significant aesthetic changes occurring in the 1840s, which clearly registered in the work of artists such as Dyce, Maclise and Herbert. For example, Dyce met the increasing demand for naturalist detail with a masterful display of colour which he combined with crisp drawing, a quality imported from continental art. Despite the incorporation of period detail applauded by the *Art-Union* critic, Dyce's *Joash shooting the Arrow of Deliverance* retained a degree of monumentality that was irreconcilable with the characteristics of historical genre painting. In this respect it was similar to Maclise's *Noah's Sacrifice* which, however, made no concessions to period detail. The artist selected a traditional subject, using the pictorial conventions of both modern and historical classicism. This seemed like an endorsement of Howard's ahistorical and epic notion of scriptural painting. By contrast, Herbert had chosen a far less canonical subject from the childhood of Jesus which lent itself to a genre-like treatment. According to the critics, the handling of the figures in *Our Saviour subject to His Parents at Nazareth* showed strong continental influences which were within the limits of the academic paradigm. Overall, the work seemed to be leaning towards Leslie's redefinition of history painting as genre. It seems surprising that the picture's only truly innovative claim – the topographical accuracy of the landscape setting – met with so little interest from the press, who either ignored or dismissed it as 'a matter of little concern'.

Given the inherent flexibility of the academic paradigm, which advocated moderate stylistic synthesis, different types of religious painting could operate alongside each other. Howard's traditional version of high art provided one model for practice, and Leslie's more genre-like type of history painting provided the other. Both were valued by the critics, who promoted religious painting as the new high art of middle-class culture. It was invested with the difficult task of promoting moral values, elevating the taste of middle-class patrons new to the market and generally raising the standards of contemporary art. During the 1840s, this renewed symbolic value not only turned religious painting into a barometer for the progress of British art but also made it an attractive field of artistic production.

The fascination of paradox: the Pre-Raphaelite challenge

The artistic beliefs of the Pre-Raphaelites challenged the most sacred credos of academic art. Their aesthetic combined a Ruskinian concept of truth to nature; a keen interest in modern forms of perception and scientific observation; and an appreciation of early art, valued mostly for its unaffected earnestness and simplicity. These rather incongruous ingredients contributed to a deliberate anti-academic stance, which represented the very life blood of the PRB. In his introduction to the 1901 facsimile reprint of *The Germ* (1850), the short-lived literary magazine containing essays, poems and illustrations by members of the PRB and its sympathizers, William Michael Rossetti outlined the Pre-Raphaelite position, which was characterized by pronounced dislikes:

They hated the lack of ideas in art, and the lack of character … They hated those forms of execution which are merely smooth and prettyish, and those which … are nothing better than slovenly and slapdash … Still more did they hate the notion that each artist should not obey his own individual impulse, act upon his own perception and study of Nature, and scrutinize and work at his objective material with assiduity before he could attempt to display and interpret it … They determined to do the exact contrary. The temper of these striplings, after some years of the current academic training, was the temper of rebels: they meant revolt and produced revolution.[1]

The Brotherhood's intention to free painting from the petrified academic conventions reflected a widely felt dissatisfaction with the standard of contemporary art. Hence their interest in religious subject matter was closely related to the current preoccupations of the artistic field: it was motivated by a desire to invest contemporary art with a fresh degree of earnestness and sincerity. In their attempt to forge a new and truly modern pictorial language, they combined a range of contradictory sources that not only created complex forms of visual expression but also left contemporary criticism struggling to classify their work.

In this chapter I focus on the PRB's controversial contribution to the reanimation of contemporary art and on the critical reception of it. I explore the construction of this new pictorial language and chart the emergence of a critical language that aimed to describe, judge, or – more often – openly

malign and ridicule their efforts. The at times almost hysterical response points to the conceptual problems which their religious works posed for the academic system of values governing the production and reception of this sub-genre of history painting. The Brotherhood's intervention has to be set against a growing uncertainty of stylistic signification which denoted religious beliefs even within the ideology of high art. In fact, their work indicated the breakdown of the implicit connections between pictorial styles and specific forms of belief.

In the critical reception of Pre-Raphaelite painting a new visual trajectory was invoked. As reviewers repeatedly pointed out the similarities with caricature they saw in it they acknowledged the anti-academic premise of Pre-Raphaelite art. John Everett Millais's *Christ in the House of His Parents* (1849–50) represents the best example. It transgressed academic laws and was seen to threaten the authority of the RA. Its overwhelmingly hostile reception was the most spectacular attempt to pathologize the Pre-Raphaelite aesthetic.

The vibrant and perplexing contradictions of Millais's painting, which a reviewer at the time termed the 'fascination of paradox', have continued to baffle modern scholars. I therefore propose a reading that fully acknowledges the picture's paradoxical nature and at the same time frees it from its long-lived and one-dimensional interpretation as a show-piece of Tractarian propaganda.[2] Instead, I present the work as the – idiosyncratic and limited, yet entirely logical – result of the Brotherhood's original and uncompromising anti-academic stance.

A kindred simplicity: the search for an expressive language of art

In 1848 the Pre-Raphaelite Brotherhood was founded with the intention of transforming the state of the arts in England. However, William Michael Rossetti's accounts indicate that the precise conceptual nature of the project and its relation to the dominant art-theoretical discourses were rather vague.[3] He aptly described the psychological make-up of his brethren as 'the temper of rebels'. Although they had clear ideas about what they disliked in previous and current art practice, such dislikes did not translate easily into a coherent artistic programme. Initially their stance was defined in relation to the academic discourse. It was strictly oppositional. As W. M. Rossetti had put it, 'They determined to do the exact contrary.' In a further attempt to reconstruct the original artistic aims, he gave the following – frequently quoted – definition of the Pre-Raphaelite project:

1, To have genuine ideas to express; 2, to study Nature attentively, so as to know how to express them; 3, to sympathize with what is direct and serious and heartfelt in previous art, to the exclusion of what is conventional and self-parading and learned by rote; and 4, and most indispensable of all, to produce thoroughly good pictures and statues.[4]

Although maddeningly unspecific, this four-point summary has acquired the

status of a Pre-Raphaelite mission statement. Rossetti delivered a declaration of artistic integrity and claimed originality for their project. The means of pictorial expression were derived from a close observation of nature. The Pre-Raphaelites' genealogy was based on vague notions of genuineness and sincerity, and the rejection of conventionality.

This emphasis on emotive qualities reflected a general interest in early art, which writers such as Anna Jameson, Lord Lindsay and John Ruskin had made available to a wider audience. The work of these writers and critics focused on transcendental values and symbolic complexities, and helped to establish the historical importance of early art. In their view, the meagre pictorial language of contemporary art stood to benefit from an understanding of the complex iconography of early art.[5] It provided the Protestant artist with a rich symbolic vocabulary unavailable to him since the Reformation, and helped to free painting from the stranglehold of academic conventions. In particular, the works of Anna Jameson 'resembled dictionaries of a forgotten language' that needed to be relearnt.[6] 'We are critical not credulous. We no longer accept this polytheistic form of Christianity', wrote Mrs Jameson in *Sacred and Legendary Art* (1848).[7] She thus maintained that an interest in the expressive structures of early art could be combined with modern, that is, unassailably Protestant, forms of belief. Accordingly, it was necessary to 'trust in the progressive spirit of Christianity to furnish us with new impersonations of the good – new combinations of the beautiful'. Similarly, Lord Lindsay proclaimed that

it is not by studying art in its perfection – by worshipping Raphael and Michelangelo exclusively of all other excellence – that we can expect to rival them, but by re-ascending to the fountain-head – by planting ourselves as acorns in the ground those oaks are rooted in, and growing up to their level – in a word, by studying Duccio and Giotto that we may paint like Taddeo di Bartolo and Masaccio.[8]

A similar metaphor of growth underlies the naming of the Pre-Raphaelite magazine *The Germ*.

The young artists celebrated the style of early art as sincere, fresh and mercifully free from academic conventions, which importantly it predated. One night in Millais's studio, they carefully perused a copy of Carlo Lasinio's engravings of the frescoes in the Campo Santo in Pisa.[9] William Holman Hunt remembered this seminal moment:

The innocent spirit which had directed the invention of the painter was traced point after point with emulation by each of us who were the workers, with the determination that a kindred simplicity should regulate our own ambition, and we insisted that the naïve traits of frank expression and unaffected grace were what had made Italian art so essentially vigorous and progressive ...[10]

Hunt's account shares the same terms that W. M. Rossetti had used to describe the Pre-Raphaelite project. The appeal of the Campo Santo frescoes was their attention to mundane detail in the representation of biblical events, that 'sense of random daily reality' which made them feel real and believable.[11]

Ruskin recorded the impact of the frescoes in similar terms: 'I never believed the patriarchal history before, but I do now, for I have seen it.' In his enthusiastic description of Benozzo Gozzoli's *Departure of Hagar from the House of Abraham* of 1472, he continued to explain how this conceptual transformation was achieved (Figure 3.1):

In spite of every violation of the common, confounded, rules of art, of anachronisms & fancies ... It is Abraham himself still. Abraham & Adam & Cain, Rachel & Rebekah, all are there, the very people, real, visible, created, substantial, such as they *were*, as they must have been – one cannot look at them without being certain that they have lived – and the angels, great & real, and powerful, that you feel the very wind from their wings upon your face, and yet expect to see them depart every instant into heaven; it is enough to convert one to look upon them – one comes away, like the women from the Sepulchre, 'having seen a vision of angels which said that he was Alive' ... Abraham sits *close* to you entertaining the angels – you may touch him & them – and there is a woman behind bringing the angels some real, *positive* pears, and the angels have knives and forks and glasses and a table cloth as white as snow, and there they sit with their wings folded – you may put your finger on the eyes of their plumes like St Thomas, and believe.[12]

The attention to everyday detail – expressed in the alliterative insistence on '*positive* pears' as opposed to negative, idealized or conventional ones – encapsulated the process of making the biblical history seem *real*. One senses Ruskin's excitement over the transformative power of those '*positive* pears': they made the scene and its players 'real, visible, created, substantial'. Ruskin recorded this extraordinary fact in a breathless stammer of adjectives. This deep sense of belief also extended to the supernatural aspects of the biblical narrative. Once again this is effected through the attention to mundane detail such as angels eating with knife and fork. Ruskin claimed that the viewer's astonishing transformation as both witness at the sepulchre and proverbial St Thomas was achieved *despite* the absence of established pictorial conventions. However, Hunt's assessment, quoted above, that 'the naïve traits of frank expression and unaffected grace were what had made Italian art so essentially vigorous and progressive', seems a far more astute recognition of the enormous appeal the Campo Santo frescoes held in nineteenth-century thought.

The young Pre-Raphaelites shared the critic's enthusiasm for the frescoes, which provided an important revelation. The crowded and noisy scenes framed the biblical events with a consideration for everyday domesticity absent from the academic style. As Hunt had observed, the stylistic characteristics of early art – understood as unaffected and sincere – were also seen to reflect the artist's attitude to work: a 'kindred simplicity', which drew inspiration from the everyday, was needed to invigorate artistic practice.

Contemporary historiography portrayed the medieval artist as a monastic figure whose religious belief was expressed in his art. His work was free from the rules of the market and invested with a quality akin to worship. In his contribution to *The Germ*, Frederic George Stephens noted the strong moral stance inherent in this paradigm of artistic practice: 'The modern artist does not retire to monasteries, or practise discipline; but he may show his

3.1 Benozzo Gozzoli, *The Departure of Hagar from the House of Abraham* (1472), detail of engraving from Lasinio's *Pitture a Fresco del Campo Santo di Pisa*, 1812

participation in the same high feeling by a firm attachment to truth in every point of representation.'[13] Consequently, the modern artist sought modes of representation that were based on close observation: 'By a determination to represent the thing and the whole of the thing, by enabling himself to the deepest observation of its fact and detail, enabling himself to reproduce, as far as is possible, nature herself, the painter will best evince his share of faith.' Stephens claimed that the advancement of art necessitated a departure from 'established principles'; close observation of nature combined with the procedures of modern science were to constitute the new:

If this adherence to fact, to experiment and not theory, – to begin at the beginning and not fly to the end, – has added so much to the knowledge of man in science; why may it not greatly assist the moral purposes of the Arts? … Truth in every

particular ought to be the aim of the artist. Admit no untruth: let the priest's garment be clean.[14]

Pre-Raphaelite practice was defined as both an act of faith and a scientific experiment, as modern techniques of the observer were combined with the ascetic stance of the artist-monk. This return to 'first principles' – in the words of W. M. Rossetti – 'reopened the question of what they ought to do, and how to do it'.[15] This insistence on originality and artistic integrity created a decidedly anti-academic stance, which is not unlike Pierre Bourdieu's evaluation of the deliberate asceticism of the artistic newcomer who opposes established art practices and thus seeks to transgress 'the boundary between the sacred and the profane'.[16] Herbert Sussman has read the 'monastic model adopted by the Brotherhood' as a rejection of bourgeois values: 'Ostensibly, though certainly not in practice, the Brothers saw their project as the revival of a religious, moralized art freed from commercial considerations.'[17]

Although the Brotherhood was emotionally responsive to early art and recognized in the romanticized figure of the monastic painter a kindred spirit, Hunt was adamant that the nineteenth-century notion of Christian art had nothing in common with the Pre-Raphaelite project. This he was keen to point out to Dante Gabriel Rossetti who 'retained the habit he had contracted with Ford Madox Brown of speaking of the new principles of art as "Early Christian"'.[18] Instead Hunt 'insisted upon the designation "Pre-Raphaelite" as more radically exact and as expressing what we had already agreed should be our principle'. Hunt's need to clearly demarcate the Pre-Raphaelite position from the term 'Early Christian' indicates some overlap and affinity. While both the 'Early Christian' and the Pre-Raphaelite positions shared an admiration for early art, the crucial difference lay in the Brotherhood's understanding of nature, largely derived from Ruskin's early writings. The critic combined reverence for the divine creation with a demand for scientific observation.[19] His concept of nature was grounded in the typological structure of Natural Theology, which regarded even the minutest natural details as 'adorable manifestations of God's working thereupon'.[20] The natural phenomenon and the spiritual truth it gestured towards were of equal importance. The faithful representation of nature's minutiae was therefore not simply a matter of aesthetic preference but motivated by a deep-rooted Protestantism.

In the second volume of *Modern Painters*, Ruskin gave his famous typological reading of Jacopo Tintoretto's works in the Scuola di San Rocco in Venice, deciphering every minute detail hidden 'in the wild thought of Tintoret'. His analysis of *The Annunciation*, worth quoting at length, provides a classic example of the critic's approach:

For not in meek reception of the adoring messenger, but startled by the rush of his horizontal and rattling wings, the Virgin sits, not in the quiet loggia, not by the green pasture of the restored soul, but houseless, under the shelter of a palace vestibule ruined and abandoned, with the noise of the axe and the hammer in her ears, and the tumult of a city round about her desolation. The spectator turns away at first, revolted, from the central object of the picture forced painfully and coarsely forward,

a mass of shattered brickwork, with the plaster mildewed away from it, and the mortar mouldering from its seams; and if he look again, either at this or at the carpenter's tools beneath it, will perhaps see, in the one and the other, nothing more than such a study of scene as Tintoret could but too easily obtain among the ruins of his own Venice, chosen to give a coarse explanation of the calling and the condition of the husband of Mary. But there is more meant than this. When he looks at the composition of the picture, he will find the whole symmetry of it depending on a narrow line of light, the edge of a carpenter's square, which connects these unused tools with an object at the top of the brickwork, a white stone, four square, the corner-stone of the old edifice, the base of its supporting column. This, I think, sufficiently explains the typical character of the whole. The ruined house is the Jewish dispensation; that obscurely arising in the dawning of the sky is the Christian; but the corner-stone of the old building remains, though the builders' tools lie idle beside it, and the stone which the builders refused is to become the Headstone of the Corner.[21]

In this brilliant *tour de force*, Ruskin offers a vivid description of Tintoretto's extraordinary pictorial imagination. He considers the work so powerful because the artist drew on his own immediate experience of a crumbling Venice – mildewed and mouldering. Although first perceived as coarse, the scene's aggressive realism, at once unconventional and contemporary, serves to unlock a complex typological structure. This is revealed only through close attention to the formal aspects, as Ruskin points out: 'the whole symmetry of it [the picture] depending on a narrow line of light'. This helps to guide the viewer's gaze across a sequence of seemingly unconnected objects and architectural features to finally grasp the profound typological symbolism embedded in all of this: 'the ruined house is the Jewish dispensation' and 'the dawning of the sky' heralds the Christian.

In Ruskin's reading, type and anti-type are brought together. *The Annunciation*'s unusual setting foretells the coming of Christ: he is the cornerstone of the new dispensation. The worlds of the Old and New Testament are evoked through a pictorial imagination inspired by the Venice of the artist's own day. Realism here serves both as an anti-academic mode of representation and as a means to convey the multiple temporalities of typology. This form of painting was not restricted by the need to articulate its story 'at one blow', as demanded by Reynolds,[22] but suggestively oscillated between several different time periods. In Ruskin's persuasive interpretation, Tintoretto's work laid claim to the real in ways very different from traditional history painting. Reynolds had insisted it was outright wrong 'to expect that the spectators should think that the events there represented are really passing before them, [any more] than Raffaelle in his Cartoons, or Poussin in his Sacraments, expected it to be believed, even for a moment, that what they exhibited were real figures'.[23]

For Hunt, the use of typology, which endowed realist representation with symbolic and transcendental meaning, presented an exciting way to configure a contemporary language of art.[24] He claimed that Ruskin made 'one see in the painter a sublime Hogarth', an artist well known not only for his intricate narratives, inventive iconography and moral messages but also

for his outspoken Englishness and his strong opposition to the foundation of the RA.[25] Consequently, a 'sublime Hogarth' represented a desirable role model for the Brotherhood. Even if the Pre-Raphaelites did not necessarily share the deep religiosity of Ruskin's original position, his belief in art as a 'noble and expressive language'[26] – capable of communicating spiritual and moral messages to a wide audience – was fundamental to their alternative aesthetic.

The typological habit of mind, most fully developed in Protestant biblical exegesis, pervaded mid-Victorian culture and inspired the whole gamut of Christian beliefs.[27] Typological thought also furnished the Pre-Raphaelites with the basis for a new pictorial language. It was a language that helped to enrich the meagre iconography of contemporary religious painting and ultimately transcended the worn-out conventions of academic art. In Ruskin's analysis of Tintoretto's work, symbolic realism figured as a mode of both representation and interpretation. A visual language built on symbolic realism provided a means to depict objective reality, minutely and accurately, and to give the underlying symbolic structures 'the authorative status of the real'.[28] It also helped to resolve what Sussman identified as the paradoxical nature of the Pre-Raphaelite project: 'the artist can express the "high feeling" or religious imagination of the past through the use of artistic modes characteristic of the present'.[29] Symbolic realism, which deployed the structures of typological thought, enabled the successful combination of the main operative modes promoted by the PRB: worship and experiment. The ability to combine the minute observation of nature with transcendental meaning led 'towards the revelatory remaking of reality itself'.[30]

This remaking of reality also entailed a close engagement with physiognomy and phrenology. In their search for a new pictorial language the Pre-Raphaelites turned to the Scottish surgeon-anatomist Charles Bell, whose work had previously informed Benjamin Robert Haydon's aesthetic.[31] Bell stressed the importance of expression and character over beauty, claiming that they possessed more emotive and evocative qualities: 'A countenance which, in ordinary conditions has nothing remarkable, may become beautiful in expression. It is expression which raises affections, which dwells pleasantly, or painfully on the memory … It is the evanescent expression, more than the permanent form which is painfully dear to them.'[32] Bell's *Anatomy* charted the expressiveness of the entire body and provided an alternative to the academic concept of beauty, based primarily on the 'permanent form' of antique sculpture. It offered the Pre-Raphaelites a system of interpreted anatomy that combined empirical observation with symbolic intent. This, as Julie Codell has argued, 'implied a redirection of the epistemology and function of painting'.[33] The vernacular of gesture and expression derived from Bell's treatise enabled the Pre-Raphaelites to focus on the representation of transitory emotions and the psychology of character. This shift was at odds with the conventional, idealized language of painting based on academic theory. Hunt articulated this antagonism in a footnote to the seminal anecdote of the PRB's naming. He justified his objections to

Raphael's *Transfiguration* with several quotations from Bell's *Anatomy* through which he sought to prove that the depiction of the possessed boy was not based on close observation of facts but represented a complete fiction.[34] Consequently, this work, for so long taken as exemplary by art academies across Europe, did not live up to the strict Pre-Raphaelite standards of representation. Despite the fundamental differences of their respective pictorial rhetorics, the Pre-Raphaelite and the academic practitioner both relied on selection to achieve maximum signification. However, their criteria for selection differed. According to Hunt, the Pre-Raphaelite painter chose his model so that it would 'be consistent with the character that he has in mind, exercising thus the same fastidious choice as in the theme he treats'.[35] In his contribution to *The Germ*, Ford Madox Brown, who figured as both Pre-Raphaelite precursor and unofficial fellow-brother, further emphasized the need to match the vision of his characters and their psychological complexities with external reality.[36] The artist therefore needed 'to enter into the character of each actor, studying them one after the other, limb for limb, hand for hand, finger for finger, noting each inflection of joint, or tension of sinew'.[37] Strict selection that was to result in the perfectly expressive specimen necessitated the fragmentation of the body; as Chris Brooks observed of the Pre-Raphaelites, 'Theirs is a realism of parts, not of wholes.'[38] In Brown's view, the artist's 'searching for dramatic truth internally in himself' depended not only on hard labour and 'patient endeavour' but also on 'utter simplicity of heart'. Once again the artist's studio was conceived as both church and laboratory.

The PRB also maintained a quirky connection with the militantly anti-academic figure of William Blake. In 1847 D. G. Rossetti acquired one of the artist's notebooks, which not only provided a glimpse into an immensely imaginative and private universe but also configured the poet-painter as a pivotal inspiration for the younger artist, who was still questioning his calling to pen or brush.[39] The notebook bristles with hearty invectives against academic values, most fully expressed in the marginalia jotted down in Blake's own copy of Reynolds's *Discourses*. The tone of the notebook – at once outspoken, angry and often viciously funny – must have appealed to the Brothers' sense of humour and reflected their own rebellious irreverence. Maybe in emulation of Blake, who had vented his particular hatred of Rubens in the notebook, Rossetti scribbled 'spit here' at each mention of that artist in his copy of Anna Jameson's *Sacred and Legendary Art*.[40] A similar irreverence characterizes D. G. Rossetti's two little sketches of Hunt and Millais, to whose derogatory remark, 'Slosh', Hunt replies, 'Of course' (Figures 3.2 and 3.3). 'Slosh' was PRB slang for bad art. The term also resonated with their dislike of academic art as they referred to Sir Joshua Reynolds as 'Sir Sloshua'.

Such unorthodox practices, which combined idiosyncratic and irreverent ingredients, fuelled the PRB stance. They represent an ironic inflection of the two controversial approaches to artistic production – spiritual worship and scientific experiment. The pictorial modes of archaism and realism could be

3.2 Dante
Gabriel Rossetti,
*William Holman
Hunt (caricature)*,
18 x 11.3 cm,
pen and ink on
paper, 1851–53

3.3 Dante Gabriel Rossetti, *Sir John Everett Millais (caricature)*, 18 x 11.3 cm, pen and ink on paper, 1851–53

3.4 Ford
Madox Brown,
*Our Lady of Good
Children*, 78.1 x
59.1 cm, pastel,
watercolour and
gold paint on
paper, 1847–61

united through an anti-academic rationale, which was at times ironic and humorous. They made it possible 'to begin at the beginning': a true return to 'first principles' that would produce 'hard rudimentary work', characterized as both 'student-like' or 'experimental'.[41]

During the 1840s, Ford Madox Brown's work had displayed a similarly self-conscious endeavour towards attaining stylistic purification. He wished 'to substitute simple imitation for scenic effectiveness, and purity of natural colour for scholastic depth of tone'. Finding it difficult to effect this change, he acknowledged that 'stepping backwards is stumbling work at best'.[42] These endeavours made him an uneasy Pre-Raphaelite precursor, drawn into the Brotherhood circle by D. G. Rossetti. Here, however, his position remained at once deliberately marginal and marginalized.[43]

Two of his works, *Our Lady of Good Children* (1847–61) and *Jesus washing Peter's Feet* (1852–56), represent the dominant yet different approaches to religious subject matter that the Pre-Raphaelites were to adopt: archaic and realist. *Our Lady of Good Children* impressed the young Dante Gabriel Rossetti and inspired his own *Girlhood of Mary Virgin* (1848–49).

Originally a cartoon in black chalk, *Our Lady of Good Children* was retouched several times and colour was added in 1861 (Figure 3.4). Despite this convoluted gestation process, the work occupies a special place in Brown's oeuvre. In the catalogue of his 1865 one-man show – where it was enigmatically entitled *Oure Ladye of Saturday Night* – the artist stated that the picture reflected the 'lasting impression' that the first-hand encounter with Italian art had made on him: 'for I never afterwards returned to the sombre Rembrandtesque style'.[44] However, Brown immediately played down this claim by calling the composition 'little more than the pouring out of the emotions and remembrances still vibrating within me of Italian art'. He further cautioned the viewer:

To look at it too seriously would be a mistake. It was neither Romish nor Tractarian, nor Christian Art (a term then much in vogue) in intention; about all these I knew and cared little, it was merely *fanciful*, just as a poet might write some Spencerian [sic] or Chaucerian stanzas.

In Brown's view, the picture represented an important change in style and artistic outlook. It not only carried emotive and personal resonances but also constituted a light-hearted exercise in archaism. The artist discouraged readings that sought to connect the work to the religious climate of the day. Its serious intention lay in the inflection and appropriation of stylistic formats, as the artist himself suggested: 'if imitative of Italian Art in certain respects, it is original in others'. He went on to point out this characteristic give and take: 'The defined effect of light intended for just after sunset, is not Italian. In idea the children are modern English, they are washed, powdered, combed, and bedgowned, and taught to say prayers like English Protestant babes.' Kenneth Bendiner has suggested a comparison with a work by Biago di Antonio da Firenze, *Virgin and Child with the Young Saint John and an Angel*

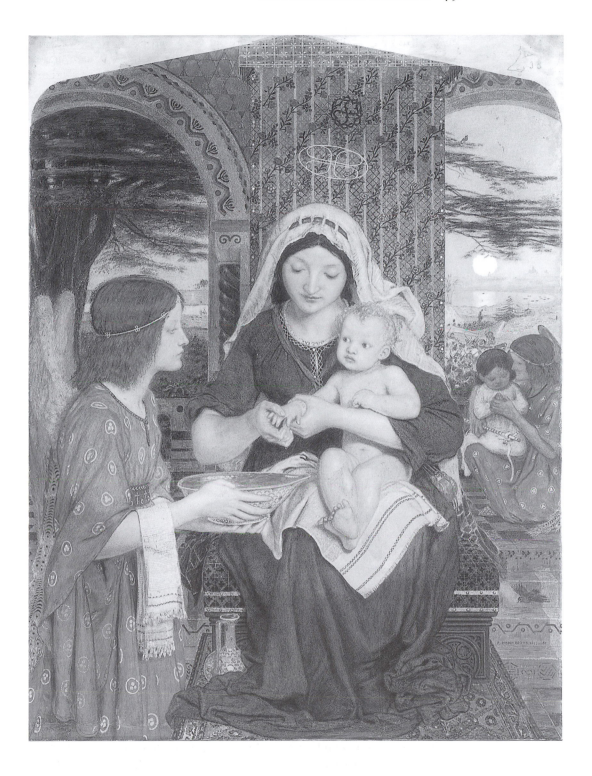

holding the Three Holy Nails (formerly attributed to Filippo Lippi), which has been in the collection of Christ Church College, Oxford since 1828 (Figure 3.5).[45] Irrespective of whether Brown knew this specific picture or not, it does serve as a useful comparison that highlights the subtle and playful changes the artist applied to the established pictorial formula. Brown retains key features such as the Madonna and Child with two attendant figures and the tripartite background wall, where arched windows frame landscape views to either side of the central group. But he subtly breaks the design's conventional symmetry and the hieratic arrangement. For all their archaic trappings, the central figures are engaged in a mundane domestic task: bathing the baby. Mary Bennett has noted the picture's 'informal conception of a gentle domesticity raised onto a religious plane'.[46] But, rather than elevating the subject, it seems that such a comparison as the one suggested by Bendiner and implied by Brown's own comments requires a 'naturalizing' of the conventional and hieratic conception of the subject. The changes that Brown made to the relationship between figures and setting, as well as between setting and landscape background, are instrumental in bringing about this Protestant appropriation. The image is freed from the hieratic and symbolic staging of the devotional subject that focuses on the Christ Child's benediction. This central gesture has been utterly domesticated: the Madonna pays close attention to washing the child's right hand. The conspicuously blond-locked boy wriggles in his mother's arms. He flexes one foot and keeps his left arm close to his body while scrutinizing the assisting angel with a wide-eyed and somewhat surprised gaze. The tree in the background, with its branches reaching across both window openings, and 'the effect of light' – as Brown informed us – 'intended for just after sunset' create a detailed naturalism that contrasts sharply with the picture's overtly archaic accessories. The ornamental halo prominently hovering above the Madonna's head, the angels with green wings and red hair, the profusion of sumptuously patterned fabrics and objects that dominate the interior, all seem to suggest an affinity with ritual. Despite such luxury and attention to archaizing detail, the sacred gesture of benediction is displaced as the ritual focuses on the domestic, at once mundane and everyday. If one wants to accept the specific comparison with the Christ Church picture proposed by Bendiner, the analysis gains a further ironic dimension. The prefigured baptism that symbolizes Christ's calling has been reconfigured as every Protestant baby's domestic ritual – 'washed, powdered, combed, and bedgowned, and taught to say prayers'. While the picture is both imitative and original, it not only disrupts established pictorial conventions but also destabilizes traditional devotional meanings. By discouraging the gallery-goer from applying a 'Romish' or Tractarian reading, the artist emphasized the picture's originality, which rested on imaginative play with a conventional pictorial formula.

In contrast, William Dyce's *Madonna and Child* – painted for Prince Albert in 1845 – presents a much more straightforward revival (Figure 3.6). This quattrocentoesque version exudes an atmosphere of quiet devotion. Both

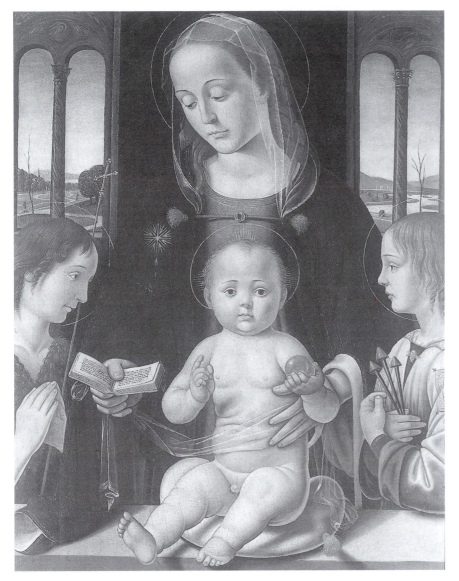

3.5 Biago di Antonio da Firenze, *Virgin and Child with the Young Saint John and an Angel holding the Three Holy Nails*, 64.8 × 50.2 cm, oil on panel, second half of the fifteenth century

mother and child are absorbed in reading the Bible. The strict profile of the Madonna enhances the picture's intense contemplative mood. Holding the child with one hand and the Bible with the other, the Madonna simultaneously attends to her maternal and her Christian duties. The hieratic arrangement remains unbroken and the naturalism is not ironically inflected. Both mother and child collude in the devotional act of reading. The child's left hand even suggests the traditional benedictory gesture so dominant in the Christ Church picture. Unlike Brown's fanciful play with historical stylistic conventions, the High Church man William Dyce emulates the work of quattrocento artists to capture or recast the devout spirit of religious painting. This brief comparison demonstrates that Brown's practice was at

3.6 William
Dyce, *Madonna
and Child*, 80.2 ×
58.7 cm, oil on
canvas, 1845

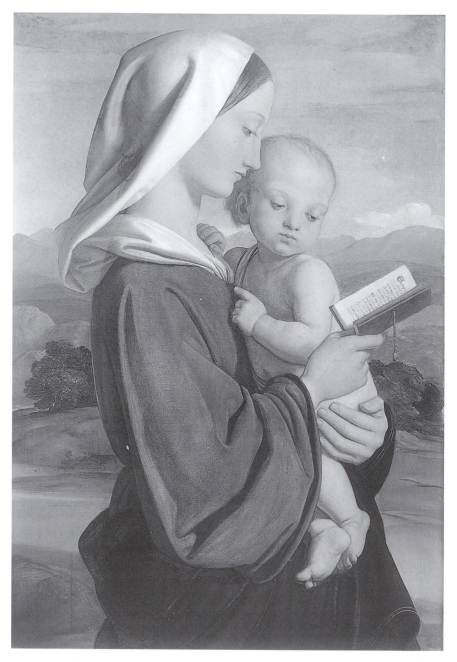

once subversive and ironic, and far more original than straightforward
archaism motivated by sectarian forms of belief. But it also contained a
danger that was to manifest itself fully in the critical reception of Millais's
original version of the Holy Family, *Christ in the House of His Parents*, shown
at the RA in 1850.

In fact, the 'informal conception of a gentle domesticity' noted by Bennett
became a prominent feature in the Pre-Raphaelite engagement with religious

subject matter. It informed both the playful interpretations that continued in the vein of Brown's *Our Lady of Good Children* and the historically charged reconstructions of scenes (mostly) from the life of Christ, of which Brown's *Jesus washing Peter's Feet* is a significant example (Plate 5). When first shown at the RA in 1852, the picture was accompanied by the following verses from the Gospel of St John (13:4–5 and 15):

He riseth from supper and laid aside his garments; and took a towel and girded himself. After that he poureth water into a basin and began to wash the disciples' feet, and to wipe them with the towel wherewith he was girded ... For I have given you an example, that ye should do as I have done to you.

The image closely follows this detailed description, a fact somewhat obscured by the later repainting of the figure of Christ, originally conceived as a semi-nude.[47] The focus lies on the Saviour's action, encapsulated in the ritualistic use of the washbasin and towel and in the close-up of hands and feet. Christ is concentrating on the task, while Peter's pose indicates his acute embarrassment, repeatedly expressed in the biblical episode (although not included in the passage quoted in the RA catalogue). Concentration on the humble worker is enhanced through placing the main action close to the picture plane and adopting a low viewpoint which forces the beholder to kneel alongside Christ.

The frieze-like arrangement of the disciples who watch from behind the table at which they are seated also helps frame the action. The picture's attempted veracity depends not only on the scrupulous attention to the scriptural source, but also encompasses 'very simple traditional costume ... warranted by modern research'.[48] Furthermore, Brown adhered to such common knowledge as 'the traditional youthfulness of John, curly grey hair of Peter, and red hair of Judas', thus acknowledging long-standing pictorial conventions. These he 'combined with such truths of surroundings and accessories as I thought most conducive to *general truths*'. The creative process described here reflects the methodologies Brown had developed in his article, 'On the mechanism of a historical picture', published in *The Germ*. Importantly, he subordinated the historical and documentary aspects to the supernatural. Although Christ retains his halo, the artist remarked on its function: 'This, however, every one who has considered the subject must understand, appeals *out* from the picture to the *beholder* – not to the other characters *in* the picture.' Brown distinguishes between an internal and an external reality, one that applies to the protagonists and one that applies to the viewer.

For William Holman Hunt the question of the halo was also to become important. But instead of resorting to the construction of these different spheres of reality, he considered the halo's pictorial naturalization in, for example, the backlighting effected by the full moon in *The Light of the World* (1851–53) or by the bright sunlight of the East in *The Finding of the Saviour in the Temple* (1854–60) (Figures 4.10 and Plate 10). Despite these various degrees of historical veracity, the picture gives little indication of the detailed

historical reconstruction that characterized Hunt's orientalist biblical scenes of the following decade. However, it does demonstrate attention to detail and rejection of idealized form: both characteristics of the Pre-Raphaelite credo. The disciples in *Jesus washing Peter's Feet* were drawn from individual models, mostly members of the PRB; and Stephens sat for the figure of Christ.[49]

The critics commented on the picture's clumsy realism. The warm copper reflection in the basin and Peter's unidealized, sturdy feet – details at the centre of the image – were most repeatedly ridiculed. The *Art Journal* critic commented, 'It is possible that the feet of Peter were not like those of the Apollo, but it is also probable, if severe truth be insisted upon, that they were proportionable to the figure.'[50] Despite invoking academic conventions as a reference point, the critic seems to suggest that there might indeed exist a narrow and necessary path between the picture's unadorned realism, which is deemed so exaggerated as to render parts of the human anatomy out of proportion, and the academic ideal embodied in the Apollo Belvedere. W. M. Rossetti, who regarded the artist as 'a tried fellow-captain and colleague' pointed out the parallel strategies that aligned Pre-Raphaelite work with that of Brown: 'a determination to realize incident, and especially expression … to make the thing as intense and actual as he could, quite careless whether the result would be voted odd, *outré*, horrid, frightful'.[51] Brown's work combines archaism and realism in ways similar to the Pre-Raphaelite aesthetic. Equally importantly, the artist cautioned against making simple connections between representation and belief. Instead he invites us to consider a playful engagement with stylistic precedents that naturalizes archaism, or presents us with a thoughtful conceptualization of a biblical scene that combines several forms of veracity.

The PRB drew inspiration from a wide range of ideologically contradictory sources. This not only resulted in a fundamentally anti-academic aesthetic but also contributed to a total breakdown of stylistic signification. As Lindsay Errington has shown, during the 1840s two distinct styles emerged whose characteristics signified Protestant and Catholic convictions respectively.[52]

The work of the Scottish artist David Wilkie, who claimed in 1835, 'I have considered the question of Catholic and Protestant a theme for art', became symptomatic of the Protestant approach.[53] According to Errington, Wilkie's work represented 'a mixture of historical pageant, genre, and religious and national sentiment, designed to assert a seminal occasion in the Protestant faith'.[54] This assertion was further enhanced through the ideological implications inherent in the style, which was based on seventeenth-century Dutch painting. However, this mainly concerned scenes of historical genre rather than biblical subject matter. In 1840, David Wilkie did travel to the Holy Land with the express wish to lay the foundations for Protestant scriptural painting, but he died on the return journey without having realized his ambition.[55]

Overtly Catholic convictions were also expressed in historical rather than

in biblical subjects. John Rogers Herbert's picture *Pope Gregory teaching the Boys to sing* illustrated an episode in the history of the Catholic Church. Shown at the RA in 1845, together with the artist's portrait of the prominent Roman Catholic advocate A. W. N. Pugin, the work tallied with the artist's religious affiliations. Even if these were not always quite as obvious as in this particular example, they were inherent in Herbert's style, so different from Wilkie's chiaroscuro-laden interiors. The colour scheme was always light and reminiscent of fresco, the settings historically researched yet uncluttered, the narrative moment precise and evocative. These characteristics also featured in Herbert's ideologically more ambiguous works such as *Thomas More and his Daughter* (1844), whose protagonist tended to be appropriated by Catholics and Protestants alike. Similarly, *Our Saviour subject to His Parents at Nazareth* also represented less of a Catholic certainty because it combined a predilection for genre with a premonitory symbolism at once easily legible and rooted in the narrative context (Plate 4).

Although not invariable, these two stylistic trajectories existed simultaneously and allowed an equation between content, style and belief that created a fairly stable network of significations shared by producers, consumers and critics. However, in the press coverage of the RA exhibitions denominational differences and motivations, while not entirely unnoticed, were mostly overwritten by art-critical concerns. The art reviews' ritualized and limited language remained governed by assumptions of the academic paradigm.

By the late 1840s, however, this tacit system of signification was becoming less stable, as the case of Herbert's *The Acquittal of the Seven Bishops* demonstrates.[56] The artist, a recent convert to Roman Catholicism, showed this heroic moment in English Protestant history at the RA in 1844. The subject of the painting was the event which precipitated the Glorious Revolution of 1688. King James II had authorized a declaration of indulgence, suspending the penal laws directed against non-Anglicans. This move was widely regarded as favouring English Catholics, hence the seven bishops signed a petition asking that the dispensation be revoked. Their imprisonment, trial and acquittal intensified the religious tensions that characterized King James's short reign. In 1844, critics did not remark on the incongruity; the press coverage of the RA exhibition, ritualized and limited as it was, did not provide the forum in which to deal with such questions.[57] But in 1847 the *Art-Union* reported gleefully that two Anglican clergymen had used Herbert's picture – by then widely available in reproductions – as a basis for their sermons.[58] Once the picture had begun to function in a non-art context, the connection between the subject matter and Herbert's Catholicism was being made explicit and resulted in the accusation of insincerity. Herbert was here being criticized for undermining the established network of signification. However, only outside the limited rhetoric of the art review could the implicit desire for a meaningful and sincere connection between representation and belief be fully voiced.

In late May 1849, W. M. Rossetti noted in the *PRB Journal*, an informal and

intermittent record he kept of the Brotherhood's artistic activities, that James Collinson was working on 'a smoky picturesque little interior' and 'has thought of a capital Wilkie subject, sure to sell'.[59] Some nine months on, Rossetti recorded that the artist 'has made up his mind to cut the Wilkie style of Art for the Early Christian'.[60] These entries not only demonstrate the general currency of the two dominant styles but also suggest the popularity of the 'Wilkie style'. Most importantly, however, they imply that the Pre-Raphaelites attached little significance to the fact that the artist was planning to give up the one in favour of the other.

Whereas W. M. Rossetti described this change of style as firmly situated within the existing dichotomy, Hunt chose to remember Collinson's artistic development in somewhat different terms: 'I agreed to submit to Millais the acceptance of James Collinson, who had already distinguished himself by paintings of the *genre* kind, and was now writing poetry in the highest Church spirit. He promised now to paint in the severe style, declaring himself a convert to our views.'[61] Hunt replaced the widely accepted framework with a less specific reference to genre and described the new style simply as 'severe'. Thus he not only avoided the term 'Early Christian' to which he had objected on previous occasions, but also claimed Collinson's new-found stylistic purity as a true Pre-Raphaelite conversion. While these two accounts reflect the ambiguous position of the Pre-Raphaelite project in relation to the pictorial styles that dominated the artistic field, they also reveal a fundamental difference between their modes of narration. Hunt's definitive act of remembering entailed a degree of narrative teleology absent from the immediate, fragmented and somewhat chaotic record of the *PRB Journal*.

Unlike the apparent ease of his artistic conversion, Collinson's religious beliefs were far from certain. He repeatedly embraced and rejected Roman Catholicism. During this time of indecision, however, he continued to work both on Wilkie-esque genre scenes and on religious subjects in the early Christian style. Interestingly, his second conversion to Catholicism also brought about his resignation from the PRB. In May 1850, Collinson wrote to D. G. Rossetti, 'I feel that, as a sincere Catholic, I can no longer allow myself to be called a P.R.B. in the brotherhood sense of the term.'[62] Religious and artistic affiliation are here presented as incompatible. Hence the serious Catholic refused to belong to a brotherhood whose members did not share his belief. Collinson's justification rested mainly on the assumption that engagement with religious imagery presupposed the believing practitioner. While the artistic integrity and sincerity of his fellow PRBs was not called into question, the absence of shared religious motivation made his continued affiliation impossible:

Whatever may be my thoughts with regard to their works, I am sure that all the P.R.B.s have both written and painted conscientiously; – it was for me to have judged beforehand whether I could conscientiously, as a Catholic, assist in spreading the artistic opinions of those who are not.

This somewhat over-zealous reaction highlights the fact that there did exist an implied connection between the spheres of art and of religion.

The oeuvre of the PRB contained a high percentage of religious works and the members also shared a genuine admiration for the figure of Jesus Christ, who headed their eclectic 'List of Immortals', followed by the author of the Book of Job and Shakespeare.[63] However, their preoccupation with religious subjects did not stem from strongly held religious beliefs; it represented a logical choice for a group of young artists who wanted to reform contemporary art.[64] In the current artistic debates, religious painting had been invested with precisely the qualities the PRB sought: sincerity, earnestness, moral elevation and contemporary relevance. With its unusual mixture of archaism and realism – in Pierre Bourdieu's terms a 'return to the sources' of the kind which formed 'the basis of all heretical subversions and all aesthetic revolutions'[65] – the Pre-Raphaelite aesthetic challenged the established value system and transgressed the cardinal rules of academic art.

This was true of all the works of the Brotherhood, religious or not. But when its members engaged with religious subject matter the transgression became immensely problematic. As part of the redefinition of high art, religious painting embodied a closely guarded cluster of values. Certain stylistic characteristics also signalled denominational difference. Although the connection of style and belief was played down in the academic discourse, engagement with religious subject matter presupposed the believing practitioner. Religious painting became itself a moral pursuit, in which unequivocal signification was desirable and needed protecting.

However, the Pre-Raphaelite project was not bound by the tacit system of signification operating in the Royal Academy. Instead, it promoted a deliberate asceticism that contrasted sharply with the frivolity of contemporary art production.[66] The ideology of early art, as reconstructed by nineteenth-century writers, together with the severity of its style, provided a powerful means to boost the PRB's anti-academic stance. Consequently, their alternative aesthetic – at once deeply earnest, idiosyncratic and playful – not only represented the collapse of a significatory system but also posed an unprecedented challenge to the academic paradigm.

Early Pre-Raphaelite work: Giottesque or grotesque?

Modern scholarship has identified archaism and realism – tendencies at once retrogressive and aggressive – as the defining criteria of early Pre-Raphaelite art. For Bendiner archaism figured 'as a necessary prelude to Pre-Raphaelite realism' as both aimed 'to present the world without conventional mannerism'.[67] In his characterization of the Pre-Raphaelite aesthetic, J. B. Bullen has drawn attention to 'its retrogressive tendency and … its aggressive realism'.[68] Significantly, his phrase seems to resonate with Ernst Kris's definition of caricature which depends on 'the joint policy of aggression and regression'.[69] While contemporary critics used caricature as a visual referent in their attempts to describe or pathologize Pre-Raphaelite art, they did fail to fully grasp the conceptual aptness of that comparison.

Caricature functions as the antithesis of high art, a fact also pertinent to understanding the work of the Brotherhood years.

In its lengthy deliberation on 'The Pre-Raffaelites', the *Art Journal* complained that 'In criticising pictures of this class, it seems impossible to get a starting point; they defy the rules, or any affinity to the progress of painting.'[70] Attempting to make sense of such rule-breaking works, contemporary criticism developed a new evaluative economy. The *Art Journal* described the aesthetic tight-rope act of the Pre-Raphaelites in the following terms: 'Narrow indeed is the way they have chosen, because truly between the Giottesque and the grotesque there is but a step.'[71] This nicely alliterative remark encapsulates the typical response to early Pre-Raphaelite art. 'Giottesque' provided a short-hand expression for the archaizing tendencies that had become so noticeable during the 1840s, both in the submissions for the Westminster Cartoon Competitions and in the works shown at the RA exhibitions. However, the PRB's radical rejection of pictorial conventions called for a different register: no longer simply archaic but outright 'grotesque'. This multifaceted term had several connotations. According to Tindall Wildridge it signified 'an idea of humorous distortion or exaggeration', and furthermore described everything that 'provokes a smile by a real or pretended violation of the laws of Nature and Beauty'.[72] This definition of the grotesque – bar the smile-provoking aspect – also perfectly describes the staple ingredients of the Pre-Raphaelite aesthetic. As Frances Barasch has shown, this very general definition, which encompasses the strategies of caricature and satire, had also acquired a more specific meaning. During the eighteenth century, the term 'grotesque' was equated with 'gothic' and thus became 'a synonym for the licentious, the indecorous, and the obscene, especially in catholic art' – connotations that accompanied subsequent medieval revivals.[73] In contrast, caricature – so clearly included in Wildridge's definition of the grotesque – depends on stylistic experimentation that has the potential to provide art with fresh and courageous impulses.[74]

For mid-Victorian audiences, these different yet related and overlapping meanings of the grotesque found their clearest expression in the pages of the satirical magazine *Punch*. Originally known for its radical political stance, *Punch* gradually became the satirical voice of the establishment, promoting a mixed agenda that contained conservative and liberal elements.[75] This was noted by the American writer Ralph Waldo Emerson, who commented during a visit to England in 1847, '*Punch* is equally an expression of English good sense, as the *London Times*. It is the comic version of the same sense. Many of its caricatures are equal to the best pamphlets, and will convey to the eye in an instant the popular view which was taken of each turn of public affairs.'[76] Although the aims of *The Times* and of *Punch* varied greatly, they increasingly addressed a shared readership.

Throughout the 1840s, the magazine commented on the high-art crisis. The Giottesque and the grotesque came together most strikingly in the gleeful lampooning of medieval revivalism. Its satirical remarks were mainly

directed at the Westminster Cartoon Competitions. In the course of this campaign the term 'cartoon' acquired a new meaning – that of visual satire. *Punch* had little sympathy for the Westminster project; it criticized the long-winded selection procedures and disapproved of the medievalizing tendencies of the proposed designs.[77] It frequently ridiculed the work of William Dyce and Daniel Maclise who – having won commissions for the decoration of the new Houses of Parliament – had become prominent exponents of high art.[78]

In 1845 *Punch* commented on a *Design for Justice*, one of the six subjects set for the competition held that year. It described the style as 'approaching caricature' and compared it to 'the Art of the middle ages' (Figure 3.7).[79] Such comparisons combined several meanings of the grotesque and centred on the artist's inability (or resistance) to coin idealized representations of the body. Despite the satirical tone, the article's fundamental assumption rested on the academic credo that the body functioned as the site of meaningful representation: as both an outward sign of character and an ideological indicator.[80] Hence revivalist contortions were deemed inappropriate for reliably suggesting the concept of justice. In addition to satirizing the deliberate stylistic archaism, *Punch* continuously ridiculed the religious connotations of the medieval revival made visible in the ascetic body.

Cartoons such as this belonged to the wider cultural context of anti-revivalism and anti-Catholicism, vividly invoked in Charles Kingsley's *Yeast* (1848). In the novel, a Catholic convert discusses contemporary church decoration and voices his dissatisfaction with the return of '[t]hat vile modernist naturalism' and 'wished that the artist's designs for the windows had been a little more Catholic'. When asked what exactly that meant, the Protestant interlocutor ventured to explain 'that the figures' wrists and ankles were not sufficiently dislocated, and the patron saint did not look quite like a starved rabbit with his neck wrung'.[81] This exchange highlights a general understanding of the represented body: it was ideologically charged and its contortions indicated sectarianism, specifically Catholicism.[82]

The magazine's satirical stance relied on a shared knowledge of such ideological currencies. Hence couching its frequent comments on the high-art debate in academic rhetoric – at once antithetical and unsympathetic to revivalism and sectarianism – provided a further barb. Academic resonances spiked even Mr Punch's vivid nightmares about the omnipresence of high art in the designs for the House of Lords, 'from the top of the wall … down to the lowest depth of the skirting board'.[83] In his nightmarish dreams, he imagined 'eccentric' lions and 'meagre' unicorns which 'are not exactly the materials for the *beau idéal* of a vision of sleep'.

Punch's criticism of medieval revivalism also encompassed the RA. In 1848, Richard Doyle, one of the magazine's chief artists, devoted a short notice to 'High art and the Royal Academy' that juxtaposed two paintings of 'Prince Henry striking Judge Gascoigne in Court', another of the six subjects that had been set for the competition of 1845.[84] Both were the work of the same painter, one executed in the 'Mediaeval-Angelico-Pugin-Gothic, or Flat

3.7 *Design for*
Justice, wood-
engraving,
Punch, 9 (1845)

Style', the other of the 'Fuseli-Michael-Angelesque School' (Figure 3.8). The illustrations contrasted the stylistic characteristics of medieval revivalism with those of an inflated academism. The captions further denoted the specific stylistic and ideological heritage; the mention of Pugin, of course, indicated the revivalist affiliation with Catholicism. Both representations focused on the body. The medievalizing version displayed the by now well-rehearsed twisted, distorted and flattened body. The equally exaggerated depiction of the academic style emphasized the pictorial conventions of neo-classicism and the importance of the nude.[85]

However, *Punch*'s attack was not primarily directed at the conflicting styles as such, but at the exchangeability with which they were used. This versatility, which aimed to gratify 'the admirers of both periods of Art', was driven by 'the hope … that in case one was rejected, the other would be certain of a place' at the RA exhibition. *Punch* censored such blatant pandering to prevailing tastes: a painter whose work so clearly lacked sincerity deserved to have both works rejected. The article's evaluative economy shared the general desire for straightforward signification that had motivated the debate over Herbert's *Acquittal of the Seven Bishops*. *Punch* here

MEDIÆVAL-ANGELICO-PUGIN-GOTHIC, OR FLAT STYLE. FUSELI-MICHAEL-ANGELESQUE SCHOOL.

not only supported an artistic practice free from extremes but also suggested that a significant connection between style and meaning should be ensured.

Despite strong stylistic similarities, different *Punch* cartoons displayed varying degrees of satirical intent. While caricature helped to visualize the chief characteristics of the medieval revival, albeit in an exaggerated form, the deliberate breaking of pictorial rules also provided an expressive, experimental and playful approach to representation. This was particularly true of Richard Doyle's immensely popular series 'Manners and Customs of ye Englyshe'.[86] It played on prevalent affectations and archaisms – both visually and verbally – and displayed a far less ferociously satirical approach to its subject matter than was typically encountered in the pages of *Punch*. Doyle's cartoon *Punch presenting Ye Tenth Volume to Ye Queene* (1846) documented the magazine's growing success (Figure 3.9). Although clearly celebratory, its style was not dissimilar to that regularly used to satirize the medieval revival. Such stylistic ambivalence was further complicated by the fact that, as a Catholic, Doyle found it impossible to endorse the magazine's anti-Catholic agenda. In fact, he resigned from *Punch* in November 1850, at a time when attacks on the Papacy were at their height.[87] Even in the meaning-driven art of caricature the relationship between message and style at times eluded precise definition.

In the pages of *Punch* the characteristics of both the Giottesque and the grotesque were abundantly and vividly visualized. Satire and caricature, in

3.8 *High Art and the Royal Academy,* wood-engraving, *Punch,* 14 (1848)

3.9 Richard
Doyle, *Punch
presenting Ye
Tenth Volume to
Ye Queene*,
wood-engraving,
Punch, 10 (1846)

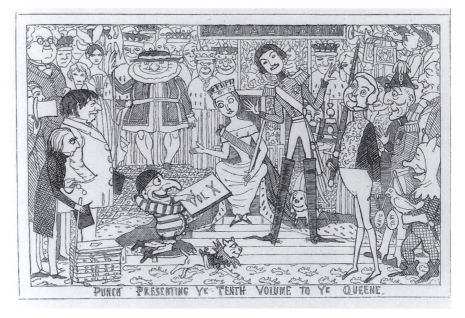

themselves strategies of the grotesque, were deployed to ridicule the forms
and ideologies of revivalism that relied on the gothic – a style also associated
with the grotesque. But such complex conceptual overlaps, together with the
subtleties inherent in *Punch*'s ambiguous and anarchic significations, were of
little consequence when contrasted with high art.

In his incisive analysis, Ernst Kris has termed 'controlled regression' a
key element of caricature and pointed out its 'aggressive nature': the
charging or overcharging with distinctive features that seeks to 'discover a
likeness in deformity'.[88] Such pictorial strategies were of course opposed to
the academic notions of the synthesized ideal and of mimesis as progress.
High art and caricature constituted antithetical systems of representation
that also expressed quite different attitudes to religion. These two pictorial
trajectories were not only bound together dialectically but also closely
related historically. Founders of the academic tradition, the Carracci have
also been credited with the invention of caricature, which implied 'the
deliberate or incidental renunciation of academic skill'.[89] Seen somewhat less
seriously, caricature simply 'relaxes the stringent standards of academic
art'.[90]

All these qualities appealed to the young Pre-Raphaelites, who
worshipped Richard Doyle as 'a special idol of our Brotherhood'.[91] Especially
the prominent and popular 'Manners and Customs' series, which appeared
in *Punch* during 1849 – a formative time for the PRB – provided an alternative
to the worn-out conventions of academic art. They drew inspiration from its
anarchic playfulness, charged expressiveness and overall flaunting of
pictorial rules.

References to caricature not only informed the Pre-Raphaelite aesthetic

but also registered in the critical reactions to it. When trying to assess and judge early Pre-Raphaelite work, the critics almost intuitively responded to its anti-academic stance. As a way of describing the stylistic characteristics and the highly charged signification, they frequently compared it to caricature. This comparison not only captured the Pre-Raphaelite strategy of 'regression and aggression' but also provided a useful means of denying the work the coveted status of high art.[92]

In 1845 *Punch* ran an article entitled 'Advice to aspiring artists', which in some ways prefigured the critical response to Pre-Raphaelite art.[93] It contrasted academic art with contemporary German art, regarding the canonical role models, Raphael and Michelangelo, as 'very poor daubers', their 'style being a great deal too free and easy, and not at all cramped, stiff and wooden enough for high art'. It further cautioned against the 'bad knack for foreshortening, a process very allowable in a caricature, but which in all grand or serious subjects, ought to be avoided'. The article not only connected the visual rhetoric of revivalist art with caricature, but it also presented high art and caricature as antithetical. However, the topsy-turvy logic of satire inverted the traditional characteristics of both.

The article also set up several visual contrasts. A cartoon of *A Young Man about Town (Gothic)* was juxtaposed with an angry-looking and childlike illustration representing the letter 'A': a comment on the retrogressive elements of the 'gothic' mode evident in the young man's awkward and angular body (Figure 3.10). A further cartoon – *A Scene from Gothic Life* – depicted a bishop and a young woman who exclaimed: 'I wonte bee a nonne!' (Figure 3.11). Here the affected body language was underscored by the speech bubble. Medievalist mannerism and deliberate Germanism, as well as the emphatic longing indicated by the spelling and the exclamation mark, denoted sectarian fervour. Behind the unsuspecting young man about town – with his exaggerated grin and pose more grotesque than Giottesque – lurked the chimeras of infantile regression and sectarianism, themselves classic manifestations of the grotesque. Thus evaluations of the Giottesque and the grotesque – and of any manifestation that occurred on the narrow field bounded by these terms – also related to the larger question of defining and protecting the practices of high art.

A similarly complex set of interdependent assumptions was mobilized in the critical reception of early Pre-Raphaelite work. Rossetti's two pictures showing scenes from the life of St Mary, *The Girlhood of Mary Virgin* (1848–49) and *Ecce Ancilla Domini* (1849–50), represent the Brotherhood's most archaic engagement with religious subject matter. The critics read these two important works as representative of the Giottesque, that is the archaic and revivalist tendencies in contemporary art.

The Girlhood of Mary Virgin, shown at the Free Exhibition in March 1849, was the first PRB picture to be seen by the public (Plate 6). This imaginary scene depicts Mary embroidering a white lily on a red cloth that rests on an ingeniously anachronistic worktable. St Anne is closely observing her daughter's work while St Joachim is tending a vine suspended from a trellis –

ADVICE TO ASPIRING ARTISTS.

T the Palace of Westminster a clever artist has now a chance of a good job or two ; and we especially address those who are desirous of that sort of employment. Painting being an imitative art, it behoves every painter to cultivate his faculty of imitation. He can do nothing without a model, and the best models that he can choose are the Germans. Accordingly, let him allow his hair to grow long, and let him also wear mustaches and a great beard. He will likewise do well to dress in the style of the middle ages ; or if his clothes are not middle-aged, they should at least be old, and the dirtier and shabbier they are, consistently with common decency, the better. This is that judicious kind of imitation which, if not tantamount to originality, is the next thing to it, and is sure to gain credit for it at any rate.

As to copying RAPHAEL and MICHAEL ANGELO, he need take pattern from them in no respect except in his personal costume. It is now admitted that those individuals were very poor daubers, their style being a great deal too free and easy, and not at all cramped, stiff, and wooden enough for high art. They had, in particular, a certain bad knack of foreshortening, a

A YOUNG MAN ABOUT TOWN.
(*Gothic.*)

an activity that recalls the harvesters in Lasinio's engraving of Benozzo Gozzoli's Campo Santo fresco of 1470, *The Drunkenness of Noah*. Mary is working directly from nature: a long-stemmed white lily in a red vase serves as her model. In a quaint archaizing gesture, the three protagonists are endowed with haloes that bear their names. Rossetti infused this domestic scene with a range of symbolic accessories and prefigurative resonances. The lily that Mary so carefully embroiders of course prefigures the annunciation. The vase is placed on a stack of heavy tomes, which – as the inscriptions on the spines inform us – represent the virtues. A little red-winged angel standing next to the books watches over the lily's precarious poise. A haloed white dove sits on the trellis behind the angel, and, on the floor in the foreground, a palm-branch and a briar form a bouquet suggestive of Christ's triumph and

3.11 *A Scene from Gothic Life*, wood-engraving, *Punch*, 9 (1845)

suffering. Here quaint naturalism is framed and elevated through the deployment of symbolic accessories, which contribute to the picture's intense spiritual mood. Unlike Brown, who had inflected and naturalized the hieratic formula of a devotional image – the Madonna and Child with attendant figures – Rossetti did in fact raise 'gentle domesticity … onto a religious plane'. He combined an imaginative naturalism, evident in the actions of the three figures, with a rich symbolic language retrieved from texts such as Jameson's *Sacred and Legendary Art*.

With *Ecce Ancilla Domini* Rossetti presented a startlingly unconventional version of the annunciation (Figure 3.12). In the following entry in the *PRB Journal* his brother William described the artist's initial conception: 'The Virgin is to be in a bed, but without any bedclothes on, an arrangement which may be justified in consideration of the hot climate, and the Angel Gabriel is to be presenting a lily to her. The picture … will be almost entirely white.'[94] This brief account reveals an idiosyncratic mixture of truly original pictorial and aesthetic concerns, and a superficial interest in historical veracity invoked to explain the setting. The picture's symbolism was intense but secondary to the remarkable colour scheme and the psychological characterization of Mary. Surprised and frightened by the unexpected presence of the angel, she cowers defensively on the bed. Rossetti here moved away from the immediate influence of early art – apparent in the symbolic accessories – to present an erotically suggestive and psychologically intense version of the annunciation that prefigured the concerns of the

3.12 Dante
Gabriel Rossetti,
*Ecce Ancilla
Domini*, 72.4 ×
41.9 cm, oil on
canvas, 1849–50

Aesthetic Movement. On the whole, the picture's spiritual mood depends on the innovative rather than the archaic elements.

In his lengthy review for the *Athenaeum*, fellow-artist Solomon Hart praised *The Girlhood of Mary Virgin* as a 'manifestation of true mental power'.[95] He contrasted the 'mass of common-place' in the exhibition with this picture, which demonstrated sincerity, earnestness and feeling – the staple qualities of the reincarnated artist-monk. He applauded Rossetti's attempt to revive the spirit of early art as an antidote to the insipidity of most contemporary production. He praised the picture's invention and noted the extensive, if archaic, symbolism. The emphasis on 'every detail which might enrich or amplify the subject' was considered instrumental in bestowing on painting a 'dignified and intellectual purpose'. In addition to general references to 'early masters', Hart compared the work to Herbert's *Our Saviour subject to His Parents at Nazareth*, thus indicating a context suggestive of both stylistic and ideological resonances but operating within academic parameters (Plate 4). He placed the picture firmly within the existing system of values and the general climate of reform.

Although on the whole positive, the review revealed an unease with the Pre-Raphaelite aesthetic. The work's stylistic peculiarities and insistent archaism were not considered as a deliberate rejection of established pictorial conventions, but attributed to the artist's immaturity. In his critical evaluation, Hart sharply distinguished between idea and execution. This fragmentation, coupled with labelling nonconformist characteristics as immaturities, not only protected the established value system but also denied the possibility of reading Rossetti's picture as a coherent and deliberate artistic statement.

The enigmatic and unusual *Ecce Ancilla Domini*, again shown at the Free Exhibition, received only short and inconsequential notices that continued to operate according to the established value system.[96] This might be taken as an indication that reviewers found this original work more difficult to place than Rossetti's earlier picture. Unlike most, *The Times* critic was clear in his judgement: he regarded the work as an example of the 'most primitive style of Christian art'.[97] He contrasted Rossetti's 'flat Catholicism' with Edward Armitage's 'hard Paganism', criticizing both as exaggerated types of high art. This juxtaposition echoed *Punch*'s satire on artistic practice, which had compared the 'Mediaeval-Angelico-Pugin-Gothic, or Flat Style' and the 'Fuseli-Michael-Angelesque School' (Figure 3.8). Similarly, *The Times* critic also aimed to resolve this contrast of exaggerated styles with a plea for moderation and conformity to the academic credo. In conclusion, the reviewer remarked that 'Rossetti's picture … is the work of a poet, and the frozen character of the style is counterbalanced by the visible fervour of the artist'.[98] Here the distinction between artistic intention and execution is again invoked but given a religious inflection. Despite its ambiguous genealogy, Rossetti's work seemed to suggest the possibility of reform because it was felt to be earnest and sincere, truly poetic and spiritual if immature.

On the whole, the reviews of early Pre-Raphaelite work display a similarly

uneasy mixture of praise and blame. Critics repeatedly identified a tension between artistic intention and execution. In 1849, for example, Hart complimented Hunt and Millais on their choice of serious subjects but also cautioned them for their use of 'so much that is obsolete and dead in practice'.[99] Despite such reservations most critics situated the first Pre-Raphaelite works within the boundaries of academic practice. But they located them dangerously close to those boundaries. When discussing Millais's *Lorenzo and Isabella* (1848–49), Hart called the ungainly pose of Isabella's brother, who is attempting to kick the dog, an 'absurd piece of mannerism' – 'carried almost to the verge of caricature'. Here the painting's expressive and overcharged visual language was read as grotesque. However, this remark was entirely descriptive: it referred to stylistic peculiarities, again ascribed to youth and inexperience. Furthermore, the seriousness of the young artists – evident in their choice of subjects and awkward stylistic asceticism – was compared with the endeavours of medieval artists, who had been reconfigured as essential forerunners in the myth of art's constant progress. Hence their work was not recognized as an attempt to coin an inherently anti-academic pictorial language, but seen simply as a somewhat juvenile effort to contribute to the reform of high art. Initially Pre-Raphaelite regression was read only as immaturity – equivalent to the childish squiggle that framed revivalist traits in *Punch*'s 'Advice to aspiring artists'.

However, two events brought about a fundamental change in critical perception. The publication of *The Germ*, the Brotherhood's short-lived literary magazine, and the disclosure of the meaning of the initials PRB triggered the realization that this formal regression was deliberate and paired with aggression.[100] Not surprisingly, their chosen *nom de guerre*, which depended on an understanding of the complex and unstable term 'Pre-Raphaelite', concentrated the debate on forms of revivalism rather than on modern modes of perception.[101] The term 'brotherhood' implied secrecy and sectarianism, regardless of whether this concerned the dogma of the church or of the RA.

With this recognition, criticism itself became grotesque as it deployed the strategies of satire to pathologize the Pre-Raphaelite aesthetic. This is particularly evident in the *Illustrated London News*'s short notice that first exposed the meaning of the '[t]he hieroglyphics in question':

To this league belong the ingenious gentlemen who profess themselves practitioners of 'Early Christian Art,' and who – setting aside the Mediaeval schools of Italy, the Raffaelles, Guidos, and Titians, and all such small-beer daubers – devote their energies to the reproduction of saints squeezed out perfectly flat – as though the poor gentlemen had been martyred by being passed under a Baker's Patent – their appearance being further improved by their limbs being stuck akimbo, so as to produce a most interesting series of angles and finely-developed elbows. A glance at some of the minor exhibitions now open will prove what really clever men have been bitten by this extraordinary art-whim, of utterly banishing and disclaiming perspective and everything like rotundity of form. It has been suggested that the globe-shape of the world must be very afflicting to the ingenious gentlemen in question. Sidney Smith said that Quakers would, if they could, have clothed all

creation in grey. The 'P.R.B.' would be bolder still, for they would beat it out flat, and make men and women like artfully-shaped and coloured pancakes.[102]

Angus Reach not only invested his description with *Punch*-like exaggeration and irony but also seemed to reference its frequent cartoons of 'saints squeezed perfectly flat' and of the work of contemporary practitioners in the 'early Christian' style.

The critic had here established the fundamental dichotomies that subsequently echoed through the pages of the periodical press. He highlighted this new school's excellence in representing distorted bodies and expressive joints: a contagious 'art-whim' spreading among the artistic community. Set against this ironic description, established values are rehearsed in the traditional litany of academic masters that included Raphael, Reni and Titian. Belief in the progress of art was invoked with reference to the mimetic qualities of painting: 'perspective' and 'rotundity of form'. In keeping with the article's satirical tone, Reach invested these academic concepts with a mythical naturalness that made the Pre-Raphaelite project look not only unforgivably retrogressive but outright absurd.[103] The stylistic criteria together with the secretive initials 'PRB' suggested a genealogy comparable to that of *Punch*'s 'Mediaeval-Angelico-Pugin-Gothic, or Flat Style' which resonated with Tractarian or Catholic motivations. However, Reach's final comparison inflected this into a more general sectarian motivation: he was equally as critical of the Quakers clothing 'all creation in grey' as of the Pre-Raphaelites' immoderate and colourful tampering with creation.

The article's satirical tone should not distract us from its underlying argumentative structure, which functioned according to classic axiology. Reach couched painting's increasing mimetic qualities in what may seem merely an ironic reference to the 'globe-shape of the world'. However, he thus posited the dominant academic discourse as natural and sought to pathologize the dissenting position.[104] The art criticism of the periodical press protected a cluster of values that linked the academic discourse with those of nationalism and progress. Therefore outright rejection of the traditional values of art also seemed to threaten its ideological ramifications. Following the strong and suggestive lead of Reach's notice, the different voices of the periodical press were called upon to fulfil their policing function.

The realization of the transgressive qualities of Pre-Raphaelite art triggered the defence mechanism of classic axiology, whose asymmetrical binaries are at their most effective when enlisting nature and morality. Reach pathologized the Pre-Raphaelite project by naturalizing academic concepts, and the *Art Journal* critic transformed the evaluation of art into a moral issue.[105] Such unusually explicit asymmetrical binaries protected – in Bourdieu's words – 'their orthodox discourse … only ever wrung from them by the need to rectify the heresies of the newcomers'.[106] The naming of the PRB constituted a conscious act of position-seeking in the established field of cultural production.[107] Hunt acknowledged that the symbolic act incited

outrage 'in the bosom of Englishmen': 'in our imputed hostility to this master [Raphael] we had put ourselves outside the pale of toleration'.[108] Consequently, the severe style of early art no longer functioned as a signifier of reform. As the hallmark of an alternative aesthetic its implicit sectarianism was mustered in defence of the dominant value system. The need to defend the established paradigm revealed the close connection between academic notions of artistic value and the prevailing discourses of progress, religion and nationalism. The complex process of cultural signification inherent in artistic value judgements was brought out by the 'joint policy of regression and aggression' that characterized the Pre-Raphaelite aesthetic, and forced the voices of the establishment to drop their 'silence, discretion and secrecy'.[109]

A step too far: the signal for a perfect crusade against the PRB

Exhibited at the RA in 1850, Millais's *Christ in the House of His Parents*, drew the most vitriolic attacks from the press (Plate 7). As W. M. Rossetti observed, 'Millais's picture has been the signal for a perfect crusade against the P.R.B.'[110] The small but crucial step that separated the Giottesque from the grotesque had finally been taken.

The *Ecclesiologist*, a popular High Church periodical, summed up the situation in the following terms:

Mr. Millais, a very young man, has exhibited a mystical Holy Family at Nazareth: while however adopting the style of the early German school, he has unhappily produced its grotesqueness, so that in spite of the great merits of his picture, we should be very sorry to see it quoted as a type of the revived Christian school in England.[111]

While promising spirituality and mysticism, the emulation of early art (here in its German revivalist form) also harboured the dangers of the grotesque, which the young Millais had not escaped.

Such a recognition triggered disclaimers and allegations from various quarters. On the one hand, the *Ecclesiologist* reviewer rejected *Christ in the House of His Parents* as an exponent of High Church revivalism and, on the other, the art-critical press repeatedly attacked the picture for its allegedly sectarian tendencies. Such groping for denominational signification should not obscure the central fact of the controversy: the artist had chosen to depict a religious subject in the PRB's distinctive and anti-academic mode. Its attention to realist detail made the picture a far more aggressive example of Pre-Raphaelite nonconformism than the religious works shown previously, which had combined innovative and archaizing characteristics with a gentle naturalism and spirituality.

The stunningly precocious and successful John Everett Millais had been exhibiting at the RA since 1846. With a string of medals for drawing to his name, as well as the RA school's gold medal which he won in 1847 for his

picture *The Tribe of Benjamin seizing the Daughters of Shiloh in the Vineyard*, he seemed to represent the future of the RA. However, in 1850, he exhibited *Christ in the House of His Parents*, which seemed to disrupt the trajectory of his promising career.[112] Millais's first New Testament picture shows the Holy Family in Joseph's workshop. A small incident has disturbed the daily routine: Jesus has cut his hand on a nail. All attention is focused on the boy, on whom the figures' suspended actions and intense gazes converge. John's thoughtful look and Mary's sorrowful posture contrast sharply with the pragmatic safety measure of Anne, who reaches for the pliers to remove the nail, and with Joseph's scrutiny of the injured hand.

When first exhibited, the work had no title, but was accompanied by the following quotation from Zechariah (13:6): 'And one will say unto him, What are these wounds in thine hands? Then he shall answer, Those with which I was wounded in the house of my friends.' The traditional relationship between title and image was here replaced by the strategies of the sermon: the painting provided an exposition of the biblical quotation. Despite discrepancies concerning the precise interpretation of the passage,[113] the relationship between image and text was typological and aimed to construct meaningful interdependencies between the Old and New Testaments. Millais experimented with typological structures to invigorate the symbolical language of contemporary religious painting. Typology provided an important key for reading the everyday objects pictured in Joseph's workshop. They take on strong symbolic resonances and orchestrate the central theme: the prefiguration of Christ's death. The three nails on the workbench and the pliers are traditional instruments of the passion; the injured palm and the blood dripping onto Christ's foot symbolize the wounds inflicted by the crucifixion. Further details also carry symbolic meaning. The dove and the triangle on the wall of the shop signify the Holy Spirit and the Holy Trinity; the bowl of water helps identify the boy as John the Baptist. The flock of sheep not only represents the congregation but also refers to Christ as the good shepherd and as the sacrificial lamb.

A number of features made *Christ in the House of His Parents* a very unlikely representative of the redefined high art that the periodical press aimed to promote. The angular and hieratic figures, the detailed realism and the suspended action clearly indicated a pictorial language that did not conform to academic conventions. The overwhelming majority of reviews was outright hostile. Papers such as *The Times*, the *Athenaeum* and the *Art Journal* presented surprisingly similar arguments. All three agreed that Millais possessed great talent. The sheer quality of his work made it impossible to ascribe its stylistic peculiarities to immaturity or simply youth. But they lamented the fact that he exerted his talent in a wrong pictorial economy, wasting it on the representation of wood-shavings. The *Athenaeum* critic argued that the members of the PRB were aiming for notoriety rather than for lasting fame. 'Their trick is', he wrote, 'to defy the principles of beauty and the recognized axioms of taste.'[114] While he acknowledged the stance of defiance the critic was also bewildered by it: 'It is difficult in the present day

of improved taste and information to apprehend any large worship for an Art-idol set up with visible deformity as its attribute.' Here cultural refinement, progress and modernity were juxtaposed with worship and idolism, which implied retrogression and a misguided form of belief. The critic's use of binary oppositions echoed those of high art and caricature, resulting in the equation of the Pre-Raphaelite aesthetic with deformity.

Once again, mock-religious language pitched an established notion of art against that of the Pre-Raphaelites. This juxtaposition was also apparent in the critic's remarks on *Christ in the House of His Parents*:

Mr. Millaïs [*sic*], in his picture without a name (518) which represents a Holy Family in the interior of the carpenter's shop, has been most successful in the least dignified features of his presentment, – and in giving to the higher forms, characters and meanings a circumstantial Art-language from which we recoil with loathing and disgust. There are many to whom his work will seem a pictorial blasphemy. Great imitative talents have here been perverted to the use of an eccentricity both lamentable and revolting.

The charge of 'pictorial blasphemy' was founded on Millais's deliberate mismatch of style and subject matter. The critic's description of Millais's nonconformism using highly emotive language studded with religious terms, reaffirmed the moral powers of the established orthodoxy. As Bourdieu suggested, the establishment's clandestine strategies are only made explicit by 'the need to rectify the heresies of the newcomers'.[115] *The Times* critic adopted a similar stance:

the mediaeval tastes of the day have led some of their more enthusiastic brethren to adopt a style taken … chiefly from the Bayeux tapestry or 'ye Manners and Customs of ye English.' Mr. Millais … has sunk into extravagance bordering in one instance on irreverence … till nothing remains of chiaroscuro, perspective, nature, and truth.[116]

The Pre-Raphaelite style was denied the status of high art and compared to the applied arts of the Middle Ages and to contemporary caricature, both configurations of the grotesque. Such associations not only denoted the absence of academic conventions but also made more fundamental insinuations, which labelled the Pre-Raphaelite aesthetic as other: sectarian and unnatural. The *Art Journal*, which had so persistently promoted religious painting in the 1840s, was even more outspoken. Its review was couched in traditional anti-Catholic rhetoric.[117] The critic felt that Millais's undeniable 'ability is here exerted in the production of a remarkable example of the asceticism of painting; for there was a time when Art was employed in mortification of the flesh; and of that period is this work, for few ordinary observers there are who can look at it without a shudder'.[118]

Given the PRB's declared anti-academic stance, stylistic references to early art no longer functioned as signifiers of reform but were read ideologically. They implied a parallel between the PRB and Catholicism if not religious motivation *per se*. In the aftermath of the heated religious controversies of the 1840s – with John Henry Newman's secession to Rome, the Maynooth Grant and the Gorham case still imprinted on public consciousness, and the

anxieties over 'Papal Aggression' mounting – anti-Catholic rhetoric furnished the debate over the PRB with a shrill and morally charged language. Nineteenth-century critics understood style as indicative of the state of society. As the *Athenaeum* critic put it, 'The quaintness and formal-looking character of Art in the schools of Siena, Pisa, or Florence were the results of a primitive condition of society.'[119] Hence the unbridled archaism that critics detected in early Pre-Raphaelite work engendered a fear of cultural retrogression. The blatant transgression of academic values summoned a defence that centred on notions of progress and nationalism. Given such close ideological connections, which had recently surfaced in the debates over the Westminster decoration scheme, it is hardly surprising to find *The Times* critic protesting 'against the introduction of such a style [Pre-Raphaelite] into English art'.[120]

The anxieties over cultural retrogression were most vehemently expressed in Charles Dickens's satire, 'Old lamps for new ones'.[121] For the author, who was not particularly interested in or knowledgeable about the fine arts, *Christ in the House of His Parents* represented a potent symbol of 'the great retrogressive principle', which was affecting not only the fine arts but all walks of life. He aimed to expose the absurdity of Pre-Raphaelite art which to him seemed symptomatic of the revivalist climate of the age. His frantic exploration invoked some of the same axiologies that Angus Reach had introduced in his short notice in the *Illustrated London News*. On the model of the PRB, similar brotherhoods were being founded, Dickens claimed, such as the Pre-Perspective Brotherhood, the Pre-Newtonian Brotherhood, the Pre-Harvey Brotherhood or the Pre-Galileo Brotherhood. Collectively they defied the laws of perspective and gravity, denied the circulation of the blood or the earth's revolution round the sun. Such exaggerated manifestations of cultural retrogression orchestrated an ironic transgression of fundamental laws seen as unassailably scientific and natural. Such paradoxical and wilful retrogression also implied the threat of the dark ages: unenlightened, barbarous and Catholic. According to Dickens, Mr Pugin was designing illegible lettering for the Pre-Laurentius Brotherhood, which promoted 'the abolition of all but manuscript books'.[122] The Pre-Henry-the-Seventh Brotherhood would return to a cultural climate reminiscent of 'the time of ugly religious caricatures (called mysteries) … thoroughly Pre-Raphaelite in its spirit'.

The critical discussions centred on the representation of the body, repeatedly referenced through medieval art and contemporary caricature. Millais's depiction of the Holy Family was not only hieratic and stiff but also extremely unidealized and bristling with realistic detail. The *Athenaeum* critic rightly inferred intentionality. In the work of early artists, so he observed, 'the absence of structural knowledge never resulted in positive deformity. The disgusting incidents of unwashed bodies were not presented in loathsome reality; and flesh with its accidents of putridity was not made the affected medium of religious sentiment in tasteless revelation.'[123] Most reviewers shared this response to the picture's aggressive realism, which stood in

marked contrast to the academic ideal.[124] The critics also objected to Millais's selection of models; the *Art Journal* commented that the figure of Joseph 'seems to have been realised from a subject after having served a course of study in a dissecting-room'.[125] The connection between social class and the unidealized depiction of the body was made abundantly clear by Charles Dickens: 'Such men as the carpenters might be undressed in any hospital where dirty drunkards, in a high state of varicose veins, are received. Their very toes have walked out of Saint Giles'.'[126]

In a spectacular rhetorical conceit, Ralph Wornum connected Pre-Raphaelite studio practice with the laboratory of Dr Frankenstein, whose attempts at 'galvanising dead bodies' symbolized the ultimate heresy. Similarly, Wornum argued, Pre-Raphaelite obsession with the particular turned painting into 'the handmaid of morbid anatomy'.[127] Both projects were characterized by outdated and freakishly heretical methodologies. He argued from a position Reynolds had developed in his fourth discourse, that 'we do not infer a superior soul or sentiment from a deformed, imperfect, or diseased body, how can such an idea possibly obtain recognition in Art'.[128] Over the past half-century, Wornum maintained, the continent had seen the monstrous erosion of this fundamental academic credo. 'It has been rather somewhat late', he wrote, 'in crossing the channel, and we will hope that it has crossed it only to pass onward to the ungenial north, and there for ever lose itself in the arctic regions.' But the 'Creature' had come to stay and, contrary to the literary source, it would not destroy its creator. Wornum's was just the most elaborate, if somewhat opaque, demonization of the Pre-Raphaelite project.

Yet this hyperbole would have been unthinkable had the critical responses not abounded with references to pathology. This is also true for *Punch*'s short article entitled 'Pathological exhibition at the Royal Academy', which relocated the debate over *Christ in the House of His Parents* to the sphere of medicine. This ploy recast the entrenched positions, which hinged on the irreverent and transgressive representation of the body, as matters of life and death.[129] The article satirized the alternative aesthetic of the PRB; it particularly objected to the aggressive realism and the choice of models, calling them 'mere portraits, taken from life at the Orthopaedic Institution'. Less expectedly, it also provided a trenchant comment on art criticism's frenzied defence strategies. However, this proved no consolation for Millais, who complained to Stephens about 'the awful cut Punch has given me'.[130] The sober language of medicine not only accentuated Millais's special skill '[t]o render the phenomena of morbid anatomy', but it also exposed the mechanism of classic axiology. The article's argumentative structure echoed that of the art review. Following the logic of its satirical conceit, it reached the same conclusion. *Punch* finally remarked of Millais's painting that 'The figures in question are … transgressing the laws of health.' Transgression of laws was precisely the issue that had triggered the general pathologization of the Pre-Raphaelite project. Whilst art criticism had repeatedly labelled the transgression of academic laws unnatural and untruthful, the exaggerated

language of satire recast such transgression as a matter of truly universal relevance.

Punch's take on the pathologized body of Pre-Raphaelite art acquired a further dimension in Dickens's famous satire. Here religious painting such as *Christ in the House of His Parents* was seen to threaten the authority of the RA. In a frenzied *tour de force* Dickens brought together all the metaphors of pathology so fiercely deployed in the periodical press. He introduced the Pre-Raphaelites with a series of clever moves: recourse to the transcendent value of religious painting, equation of the RA with the temple and the resulting visitor response to the holy site of art:

You come – in this Royal Academy Exhibition, which is familiar with the works of WILKIE, COLLINS, ETTY, EASTLAKE, MULREADY, LESLIE, MACLISE, TURNER, STANFIELD, LANDSEER, ROBERTS, DANBY, CRESWICK, LEE, WEBSTER, HERBERT, DYCE, COPE and others who would have been renowned as great masters in any age or country – you come, in this place, to the contemplation of a Holy Family. You will have the goodness to discharge from your minds all Post-Raphael ideas, all religious aspirations, all elevating thoughts; all tender, awful, sorrowful, ennobling, sacred, graceful, or beautiful association; and to prepare yourselves, as befits such a subject – Pre-Raphaelly considered – for the lowest depths of what is mean, odious, repulsive, and revolting.[131]

The temple had been desecrated. To demonstrate this, Dickens gave his well-known description of *Christ in the House of His Parents*, in which he compared the Virgin Mary to a specimen in a freak show:

a kneeling woman, so horrible in her ugliness, that (supposing it were possible for any human creature to exist for a moment with that dislocated throat) she would stand out from the rest of the company as a Monster, in the vilest cabaret in France, or the lowest gin-shop in England.[132]

The alternative aesthetic of the PRB was not only seen to challenge established academic conventions but also to threaten the problematic position of the RA, precariously poised between the rituals of the temple and the rules of the market. Dickens argued that the RA, which he persistently called the 'National Academy', jeopardized its role as the guardian of art by allowing this monstrous picture to be displayed. The painting's main characteristics, which had repeatedly been described as 'positive deformity', made it fit only for the freak show. Dickens's article was studded with references to popular entertainment: 'Walk up, walk up', he exclaimed, inviting his readers to consider the implications of the Pre-Raphaelite project.

Such references echoed the satirical strategies deployed by *Punch*, which had recurrently drawn attention to the parallels between art exhibitions and popular entertainment. In 1847, *Punch* juxtaposed a short piece on 'The ensuing exhibition of the Royal Academy' with the 'Smithfield Market prize show' (Figure 3.13).[133] The placing of both items on the same page implied some connection between the two events. The RA's tendency to admit large numbers of portraits to the annual exhibition was recurrently lampooned by *Punch*.[134] This time *Punch* resorted to the use of a seemingly unrelated event, the imaginary 'Smithfield Market prize show', not only to satirize the

THE Great Room at the National Gallery will soon become an object of interest to those who are fond of self-contemplation. Our Trafalgar Square Correspondent has put us in possession of the fact, that nearly one thousand portraits have passed over the pavement, and the physiognomist will soon have an opportunity of studying those endless varieties of the "human face divine" which are to be seen every year at the Royal Academy. A statistical account of the principal features embraced in one of these Exhibitions would be very curious; and we wish some MACCULLOCH of art would take the trouble to frame some tables showing the relative proportion of pugs and Grecians in the numerous noses which will stand forward, in a few days, as prominent objects of art, to challenge the criticism of the connoisseur, and the admiration of the public. We understand that some of the portraits sent in for exhibition during the ensuing season were private speculations of certain fashionable tailors, who hoped to smuggle a glowing description of a magnificent vest, or a registered Paletot, into the Catalogue.

SMITHFIELD MARKET PRIZE SHOW.

THE defenders of this flagrant—by no means fragrant—nuisance have discovered that it is conducive to public health and public morals, while the female population who complain of it are more frightened than hurt; and as to the drovers, though many of them are gored and tossed, still the treatment does them no permanent harm, for the very simple reason that they are used to it. We understand that the friends of the abomination intend to advertise a number of prizes for the best specimens of objects likely to prove the view of the question to which the advocates of the continuance of Smithfield Market seriously incline. For this purpose they will shortly advertise for the best specimen of an old lady who is in the habit of walking about London on a Smithfield Market day, and whose nerves have been so completely preserved that she can not only say " 'bo' to a goose," but can look an ox-eyed monster in the face without blinking—as if, in fact, her nerves were braced with the oxide of iron.

There will be a second prize offered for a drover whose whole life has been a toss up, and who is none the worse for the ups and downs he has experienced. There will be a third prize offered in support of the moral view of the question for the production of a prize parent, who, having been all his life in the habit of attending Smithfield, has passed through the ordeal not merely uncontaminated, but positively improved in all the noblest attributes of human nature by the *genus loci*, the atmosphere of the market. The salubrious properties of the place will be proved by the production of a prize butcher's boy, whose weight and age, when compared, will afford the most substantial evidence that public health is not sacrificed by an attendance at Smithfield Market; and as what is true with respect to a part must be true in reference to the whole, the market must have a salutary influence upon all the inhabitants of London.

3.13 *The Ensuing Exhibition of the Royal Academy* and *Smithfield Market Prize Show*, wood-engraving, *Punch*, 12 (1847)

dangers of Smithfield Market but also to suggest a comparable degree of absurdity pertaining to both. The acute satirical tone of the 'prize show' article, which proposed prizes for some rather hilarious human specimens courageously frequenting the market, lent a further ironic dimension to the abundant display of portraits at the RA.

In a short notice entitled 'The deformito-mania', *Punch* established even closer connections between art exhibitions and popular entertainment (Figure 3.14).[135] It fondly remembered the days when Haydon 'in vain invited attention to the creations of his genius' and deplored 'the now prevailing taste for deformity' evident in the shows at the Egyptian Hall, whose recent programming it criticized for exploiting the monstrous to attract audiences. In this and similar articles, *Punch* implied that the tendency to present the public with monstrosity and deformity was intimately connected to the forces of the market.[136] Dickens perceived a similar threat. He ironically remarked on sensationalist display strategies, which also referenced the monstrous, 'that it is by no means easier to call attention to a very indifferent pig with five legs, than to a symmetrical pig with four'. He feared that the false economy of Millais's picture would reduce the art of painting 'to a narrow question of trade-juggling with a palette, palette-knife, and paint-box'.[137]

Repeated references to caricature, medieval art and the freak show – all configurations of the grotesque – and the exaggerated rhetoric of satire ensured that the Pre-Raphaelite aesthetic – best exemplified in *Christ in the House of His Parents* – was pathologized. However, these strategies almost spiralled out of control as the virulent controversy was itself satirized. John Ruskin found it hard to believe 'that mere eccentricity in young artists could have excited an hostility so determined and so cruel; hostility which hesitated at no assertion, however impudent'.[138] The total mobilization of defence mechanisms on behalf of the established orthodoxy demonstrated just how destabilizing the Pre-Raphaelite intervention was. On some level, however, caricature also proved an unconscious means to fathom – both visually and conceptually – the awkwardly retrogressive and aggressive qualities of the early work.

The expressive charge and fundamentally anti-academic stance of early Pre-Raphaelite work foiled *Punch*'s attempt at parody. The exaggerated rhetoric of caricature had little to add to the stiff and awkward body language of Millais's *Mariana* (1850–51) or of Charles Allston Collins's *Convent Thoughts* (1850–51) (Figures 3.15 and 3.16).[139] The reverse, however, was also true. The *Illustrated London News* was among the few papers to favourably review *Christ in the House of His Parents*.[140] The critic regarded it as 'a picture painted, it is said, on a wrong principle, but with a thousand merits, and many intentional defects'. He concluded that 'What is called, somewhat slightingly, the *pre-Raphaelism* of this picture, is its leading excellence.' Such praise, however, was partly undermined by the accompanying illustration (Figure 3.17). The attempt to represent the key features of the Pre-Raphaelite style resulted in an image whose awkward figures and expressive charge were closely associated with caricature. If it

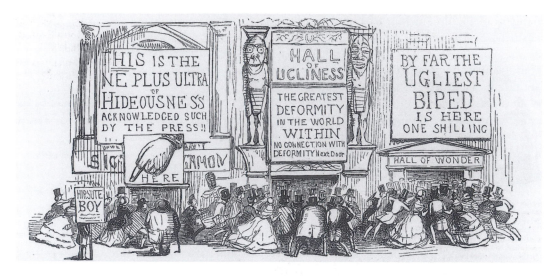

3.14 *The Deformito-Mania*, wood-engraving, *Punch*, 13 (1847)

were not for the complimentary text, one might be inclined to read the image as parody. The idiosyncratic pictorial language of the PRB proved not only almost impossible to parody, because it shared some of the key features of caricature, but it was also difficult to represent in a fashion that did not suggest satirical subversion.

This is equally true for an illustration of Ford Madox Brown's design for *Justice* submitted to the Westminster Cartoon Competition of 1845 (Figure 3.18). The wood-engraving appeared in F. K. Hunt's *The Book of Art*, which celebrated the proceedings of the Westminster project. While it adequately captured Brown's highly charged and expressive pictorial mode, it would not look out of place in a very different type of publication. It could quite easily serve as an illustration to one of *Punch*'s frequent lampoonings of that grand decoration scheme. In some ways, such visual comparisons show the full extent of the liminal and unstable qualities inherent in the Pre-Raphaelite aesthetic: not only were these difficult to characterize, both textually and visually, but they also threatened to destabilize the established economies of artistic value.

The redefined role of high art remained inextricably linked with forms of representation based on the academic dogma. Therefore any violation of those pictorial conventions immediately called the social functions of painting into doubt. The recent symbolic investment of religious painting left precious little room for stylistic deviation or experimentation. As Ralph Wornum noted, 'It is the high ground, in point of subject generally … which renders their mistaken treatment so much the more to be deprecated.'[141] Consequently, the obvious stylistic nonconformism of Millais's *Christ in the House of His Parents*, together with the ideological resonances it triggered, made it impossible to consider the work an agent of reform and spiritual elevation. However, comparisons with caricature – noted for its penchant for innuendo and riotous signification – also seemed to suggest aberrant political and religious connotations in Pre-Raphaelite art. Within the limited rhetoric of the art review, which provided no space for overt political or religious comment, linguistic insinuation was the

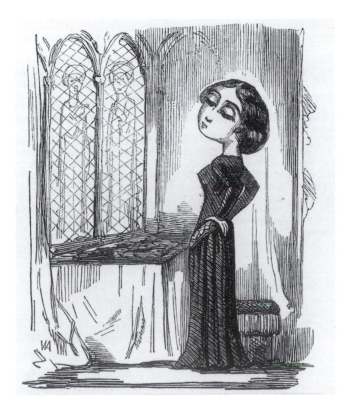

3.15 Caricature of John Everett Millais's *Mariana*, wood-engraving, *Punch*, 20 (1851)

3.16 Caricature of Charles Allston Collins's *Convent Thoughts*, wood-engraving, *Punch*, 20 (1851)

3.17 John Everett Millais, *Christ in the House of His Parents*, wood-engraving, *The Illustrated London News*, 11 May 1850

3.18 Ford Madox Brown, *An Abstract Representation of Justice*, wood-engraving, reproduced in Frederick Knight Hunt, *The Book of Art: Cartoons, Frescoes, Sculpture and Decorative Art*, 1846

only possible means to orchestrate the multiple cultural anxieties evident in the critical reception of *Christ in the House of His Parents*. The *Guardian*, a High Church magazine that commented positively on the picture, neatly summarized the debate that the Pre-Raphaelite aesthetic had generated: 'By some these works are regarded as a retrograde step in art, an attempt to revive an exploded and obsolete style. Others admit the force and truth of their execution, but look upon them as a clever mistake.'[142] Contemporary criticism did indeed regard the novel and idiosyncratic Pre-Raphaelite strategies of conscious archaism and aggressive realism as a 'retrograde step' or as a 'clever mistake'. While modern scholars have generally overcome the perception that the Pre-Raphaelite project represented a retrograde step in art, some share the Victorian critics' opinion that it was a clever mistake.

Reading *Christ in the House of His Parents*: a gesture of defiance

Writing in the catalogue of the Millais retrospective held at the Grosvernor Gallery in 1886, F. G. Stephens presented *Christ in the House of His Parents* as an important milestone in the history of the Pre-Raphaelite movement. Its hostile reception, so Stephens argued, encapsulated not only the hardships of the artistic newcomer but also the novelty of the enterprise.[143] However, he deliberately underplayed the significance of the work. In his triumphant account of Millais's career, the PRB years featured as a youthful and brief interlude of inconsequential stylistic experimentation superseded by the artist's mature style of the late 1850s.

This view is also reflected in Stephens's description of *Christ in the House of His Parents*. He acknowledged that 'Painted under the original inspiration of Pre-Raphaelitism … it reveals a stubborn purpose backed by the uncompromising technical system.'[144] He described the result of this relentless application as 'touching in its directness and simplicity of invention, grave purpose, and inconsequent and incongruous features of all sorts'.[145] He finally summed up the work as a 'mixture of pathetic poetry, simple symbolism and almost irrelevant whims and fancy'. He called attention to the picture's aggressive and purposeful stance and, at the same time, dismissed it as inconsequential and incongruous.

Contemporary reviewers had already noticed the 'fascination of paradox' which *Christ in the House of His Parents* embodied, and described it as a painting 'with a thousand merits, and many intentional defects'.[146] Among modern scholars, Lindsay Errington has commented on its unsatisfactory 'multiplicity of purpose', which she held responsible for the painting's lack of coherence. In a detailed description, she pointed out its stylistic and conceptual inconsistencies, and suggested three possible ways of avoiding those:

There are several methods that he might have employed. He might have studied archeological information and set the workshop in the East amongst correctly garbed Jews or Arabs. He might – though this is essentially a twentieth century notion –

have translated all, along with the tools, into terms of modern life. He might have created every part and person in a pastiche of fifteenth century Italian or Flemish style. In the event he tried to do all these things at once, and the picture suffers from his multiplicity of purpose.[147]

Errington regarded the intentional complexities and unorthodoxies as the result of youthful enthusiasm, inferring – just like nineteenth-century critics – that Millais's artistic strategies were immature. I want to take the inquiry a step further and read the picture's deliberate inconsistencies as indicative of the artist's considered intentions rather than merely of his unbridled ambition.

The PRB's aversion to the conventions of academic art was mythologized in Hunt's autobiography. In the first volume, Hunt restaged one of the frequent long conversations on art and the nature of the Pre-Raphaelite project: 'In the midst of my talk Millais continually expressed eagerness to get away from the conventions denounced, and adduced examples of what he agreed were absurdities, declaring that often he had wondered whether something very interesting could not be done in defiance of them.'[148] This statement demonstrates a general stance of rebellion rather than a specific artistic concept. Embedded in Hunt's careful narration of the discussions that framed the artistic project of the PRB, Millais's somewhat vague interjection served to present the author as the intellectual force behind the Brotherhood and secure his eminent place in the movement's history. Compared, though, with W. M. Rossetti's definition of the PRB discussed earlier, the tone of Millais's utterance sounds familiar and genuine. It reflects the rebel quality of their artistic project, which both Hunt and W. M. Rossetti recalled. The original ideology of the PRB was defined in relation to the academic discourse, even if this position was one simply of defiance and not necessarily one of coherence.

Although it was not a frequent subject in the history of art, *Christ in the House of His Parents* continued a tradition of showing the Holy Family at work. Three such examples belonged to its specific genealogy: Antonio Correggio's *Madonna of the Basket* (c.1534, in the National Gallery since 1825), Annibale Carracci's *The Holy Family in the Carpenter's Shop* (Suffolk Collection; Figure 3.19) and Herbert's *Our Saviour subject to His Parents at Nazareth* (Plate 4).[149] Of these, only Herbert invested the scene with a poignant moment of revelation. In all other respects, however, Millais's picture seems strongly indebted to the Carracci, which was available as a print.[150] An additional and in some ways more immediate source of inspiration for *Christ in the House of His Parents*, however, was the PRB's general interest in religious subject matter, manifest in, for example, Rossetti's projected and executed scenes from the life of the Virgin. In particular, *The Girlhood of Mary Virgin* showed members of the Holy Family in an imaginary yet quotidian moment that was invested with symbolical meaning (Plate 6).

An unusually strong symbolic charge lies at the centre of Millais's work: the ambivalent relationship of mother and son represented in the somewhat

stilted pose of the touching cheeks, which Millais borrowed from early Italian art. A strikingly close example is Sano di Pietro's mid-fifteenth-century *Virgin and Child with Six Saints*, in the collection of Christ Church College, Oxford, since 1828 (Plate 8).[151] Yet Millais has inverted the relationship between mother and child. In Sano di Pietro's work, Jesus seems to solicit his mother's affection. It is he who presses his face up against hers, a pose underscored by the way his right hand reaches around the Virgin's head. Millais eliminates every hint of an embrace between his two figures. Instead, their gestures are exceptionally self-contained. Mary, kneeling before her son, seems to proffer her cheek for the filial kiss. This has wider ramifications: it shifts the pictorial format from a Madonna and Child with attending saints to a genre picture of Jesus in the carpenter's shop. And yet the genre scene resonates with the hieratic structure of the devotional image. The six attending saints, neatly grouped in a semi-circle around the Madonna and Child, have been transformed into plausible witnesses of the domestic incident: a workshop assistant and members of the household. However, this hieratic resonance differs markedly from the mood of the surviving preliminary sketches, which show a much more straightforward interaction between the two figures (Figures 3.21–24). Jesus is kissing the kneeling Mary: he needs no consolation, instead he comforts his mother. This is further corroborated by the following entry in the *PRB Journal*, which records the first description of the design: 'Christ, having pricked his hand with a nail (in symbol of the nailing to the

3.19 Annibale Carracci, *The Holy Family in the Carpenter's Shop*, wood-engraving from *The Illustrated London News*, 8 November 1856

cross) is being anxiously examined by Joseph, who is pulling his hand backwards, while he, unheeding this, kisses the Virgin with his arm round her neck.'[152] This natural action, which seems well captured, is obscured in the finished painting. Here Mary – grief-stricken yet adoring – is cast in a pose that recalls the intensity of a lamentation. This change kept the composition free from any hint of maudlin sentiment and heightened the sense of premonition, also suggested in St John's thoughtful expression. These reactions stand in stark contrast to those of St Anne and St Joseph, which are exceedingly pragmatic. Despite the quite different levels of consciousness, all the responses centre on Jesus. Millais refrained from prioritizing them: they intermingle and overlap. It is the viewer's role to disentangle and hierarchize the levels of response, ranging from pragmatism to premonition. Thus the viewer occupies the central position from which the painting can be read: a careful process that pays close attention to significant details and that gradually unlocks its meaning.

The demands this picture makes of the viewer are diametrically opposed to those traditionally associated with high art. Millais inverted Reynolds's famous dictum of painting's inferiority to the linearity of poetry: 'What is done by Painting, must be done at one blow.'[153] The extensive use of typology stretched the single moment and transformed painting's traditional notion of temporality. Compared with the versions by Herbert and Carracci, Millais's is ambiguous and demanding. The artist deployed a range of strategies that contributed to the complexities of the image, and constructed an active viewing position. Its intricate system of signification relies on the combination of text and image and places strong emphasis on the typological reading of pictorial detail. Millais did not aim to reconstruct one particular historical moment. Instead the artist juxtaposed highly eclectic details such as the modern workbench and the oriental loincloth of the apprentice, or the Flemish-looking figure of Mary, who recalled late-medieval donor figures, and the unconventional attire of Jesus. Taken together, these accessories created a sense of timelessness that not only enhanced the picture's symbolism but was also fundamentally opposed to the conventions of academic idealism. These juxtapositions invoked a notion of period that depended on fragmentation rather than synthesis. Consequently, Millais's Holy Family occupied an undefined moment, which oscillated between the medieval, the oriental and the blatantly modern. This shifting perspective is encapsulated in one detail: the apprentice's oriental loincloth is worn over what looks like a pair of trousers, rolled up to the thighs. With *Christ in the House of His Parents* Millais created a truly anti-academic painting: it defied not only the stylistic conventions of the grand style but also its all-pervasive concepts of representing time and place.

The artist's strategy had an important parallel in Anna Jameson's analysis of the character of devotional as opposed to historical art. In the introduction to *Sacred and Legendary Art* (1848), Jameson described 'the so-called *anachronisms* in devotional subjects, where personages who lived at different and distant periods of time are found grouped together' as 'the noblest and

most spiritual conceptions of poetic Art'.[154] She scorned the eighteenth-century critic's inability to comprehend the importance of this representational mode: 'Even Sir Joshua Reynolds had so little idea of the true object and feeling of such representations, that he thinks it necessary to apologise for the error of the painter.' Jameson's emphasis on 'feeling' recalls W. M. Rossetti's insistent remark on the need 'to sympathize with what is direct and serious and heartfelt in previous art'. Her observations on devotional art suggested a way that painting could deploy a fundamentally anti-academic pictorial language and at the same time resonate with a deeply spiritual and poetic significance – qualities that reflected the moral integrity of the artist. This crucial distinction between devotional and historical representation created a conceptual space for the redefinition of religious painting, so important to the artistic debates of the 1840s, providing Millais with a pictorial strategy through which the Brotherhood's alternative aesthetic could be articulated. He combined deliberate anachronisms with an aggressive realism that flew in the face of academic conventions. The narrative moment itself was to be understood as 'real' in the prefigurative sense offered by typology.

A similar strategy characterized James Collinson's *The Child Jesus*, which appeared in the second issue of *The Germ*. The poem narrated a series of imaginary events from Jesus's childhood – mostly incidental and domestic – which served as typological prefigurations for seminal moments such as the agony in the garden, the crowning with thorns and the crucifixion. These imaginative typological readings contrasted sharply with the poem's accompanying illustration (Figure 3.20). In his attempt to represent the boy Jesus as the future Saviour, Collinson used extremely traditional iconography. He relied on staple signifiers such as the halo and the cross, with a banner bearing the inscription 'Ecce Agnus Dei'.

Despite their shared interest in typology, Millais rejected the iconography which linked Collinson's illustration to the revivalist tradition. Instead, he aimed to integrate the typological signification of most objects with the function they fulfilled in the workshop setting. The three nails and the pliers lying on the workbench symbolized the instruments of Christ's passion, just as his injured hand and the blood dripping onto the foot prefigured the wounds of the crucifixion. Millais relied on Christian iconography, which read the dove perched on the ladder as the Holy Spirit or the sheep in the pen as Christ's followers, and identified St John the Baptist by the furry loincloth and the baptismal bowl. The more loosely constructed typological significations, such as the woven willow basket standing unfinished in the corner, or the red cactus flower in the background, gain meaning not from an established iconographical tradition but through the associative empathy of the spectator.[155] Through the combination of the devotional and the historical modes, Millais achieved a form of representation which George Landow has called meditative.[156] The absence of a title when it was first exhibited, the complex entanglement of the figures and the extensive use of prefigurative symbolism all contributed to its contemplative mode. The combination of

3.20 James
Collinson,
illustration to his
poem, *The Child
Jesus*, wood-
engraving, 1850

traditional iconographical references and imaginative inventions further
emphasized the meditative quality of the painting, which could only be fully
unlocked and re-enacted from a central and active viewing position. The
importance of the spectator echoed Lord Lindsay's belief that art
communicates 'the conception by the artist and expression to the spectator of
the highest and holiest spiritual truths and emotions'.[157] Hunt was aware of
the picture's complexities. On first seeing it, he called it 'truly marvellous' but
also stated: 'it is so many sided that I really don't know how to express
myself till I have taken it all in'.[158]

Modern scholarship has considered Millais's Oxford connection as an
important ingredient in the genesis of *Christ in the House of His Parents*.
According to standard Pre-Raphaelite mythology, Millais was inspired by a
sermon he heard in Oxford in the summer of 1849. Some scholars have
speculated that this might have been delivered by E. B. Pusey, Dean of Christ
Church Cathedral at the time and the leading Tractarian after Newman's
secession to Rome in 1845.[159] Regardless of what Millais might have heard at
Christ Church Cathedral, I suggest that he saw Annibale Carracci's *The
Butcher's Shop*, which was then displayed in the library of Christ Church
College (Plate 9). This monumental painting had come to the college in 1765
and was believed to be a family portrait of the Carracci. This interpretation,
long since refuted, was widely accepted during the nineteenth century.[160] In
his widely read *Treasures of Britain*, Gustav Friedrich Waagen gave the
following account of the painting, which he had seen when visiting Oxford
in 1850: 'A picture by ANNIBALE CARRACCI, painted in a masterly manner,

offended me by the vulgarity of the idea. The artist has here represented himself, and the other Carracci, as a family of butchers.'[161] It is therefore not unreasonable to assume that Millais would have been given a similar account while sight-seeing in Oxford.

Even a brief comparison strongly suggests that Millais knew the Carracci picture when he painted *Christ in the House of His Parents*. In addition to an overall compositional correspondence, which might simply result from the fact that several figures are arranged around a workbench or counter, there also exists a number of striking similarities. These are located in details such as the notable position of Christ's arms; the final pose of the assistant, which reflects that of the butcher slaughtering the ram; or the head-dress of St Anne. Her gesture appears to be based on the old woman in the background of *The Butcher's Shop*, who is reaching for a piece of meat on display. In his satirical description of *Christ in the House of His Parents*, Dickens referred to St Anne as an 'old woman who seems to have mistaken that shop for the tobacconist's next door, and to be hopelessly waiting at the counter to be served'.[162] The derogatory image that Dickens conjured up inadvertently echoed the nature of the pictorial source that might have inspired Millais's representation of St Anne: not a tobacconist's but a butcher's shop.

An analysis of the extant preliminary drawings for *Christ in the House of His Parents* allows one to identify the moment at which I believe the Carracci painting began to have a direct influence (Figures 3.21–3.24). In the detailed third drawing the figure of St Anne was introduced to serve as a counter-weight to the woman in the right background folding a cloth, who had appeared in the second compositional stage (Figure 3.23). By this time, Millais was using his knowledge of the Carracci picture to achieve a more balanced composition. Another important if less noticeable feature in the third study is the position of Christ's hands, which echo the pose of the butcher who is weighing a piece of meat. This change contributed to the final resolution of the central motive: the intense encounter between Jesus and Mary.

In a drawing which focused on the right half of the composition, Millais made further adjustments (Figure 3.24). He left out St Joseph, whose posture had hardly changed since the original design described in the *PRB Journal*, and replaced the woman in the background with the awkward figure of a boy. The fact that they both represent recurrent motives in the artist's oeuvre underscores Millais's ongoing difficulties in finalizing the composition.[163] At the same time, the pose of the apprentice's upper body, whose arm had been sticking out so exaggeratedly, came to resemble that of the kneeling butcher.

In his painting Millais transformed the uncertain figure of the boy into little St John. Though he is clearly not derived from the Carracci painting, his position to the extreme right of the foreground and the greenish colour of his waistcloth faintly resonate with the figure in *The Butcher's Shop* that occupies the same space. The introduction of St John satisfactorily completed the composition. His presence also added a further typological meaning, referencing both Christ's baptism and the sacrament of baptism more generally.

3.21 John
Everett Millais,
sketch for *Christ
in the House of
His Parents*, 11.6
x 19.2 cm, pencil
on paper,
1849–50

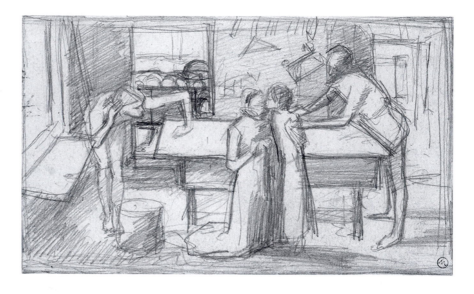

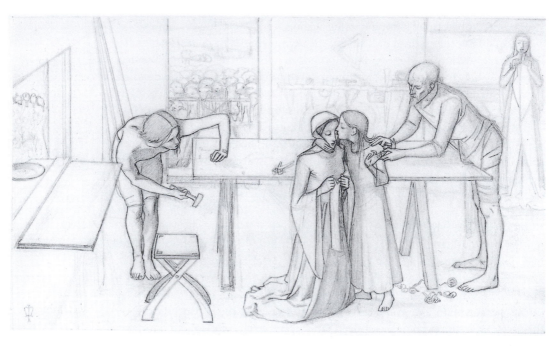

3.22 John
Everett Millais,
sketch for *Christ
in the House of
His Parents*, 19.5
x 33.6 cm, pencil
on paper,
1849–50

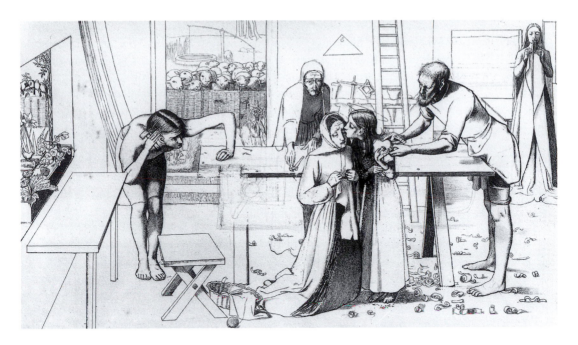

3.23 John Everett Millais, sketch for *Christ in the House of His Parents*, 19 × 33.7 cm, pen on paper, *c.* 1849

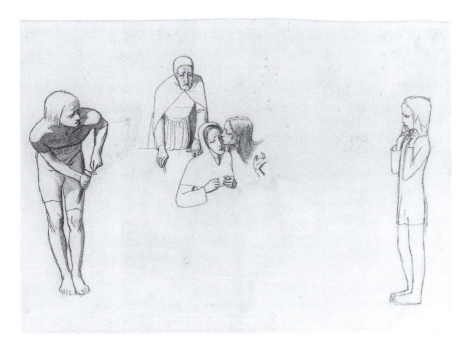

3.24 John Everett Millais, sketch for *Christ in the House of His Parents*, 19 × 28.9 cm, pen and ink and wash on paper, *c.* 1849

Does Millais's probable dialogue with Annibale Carracci's *The Butcher's Shop* have any meaning beyond the merely formal? This grandiose work represented an enigmatic genre scene, raising the depiction of everyday life to almost epic scale. The composition referenced a traditional high-art theme, Noah's sacrifice, and was based on two particular versions of the subject located in the Vatican: Michelangelo's in the Sistine Chapel and Raphael's in the Loggia.[164] The conscious incorporation of such high-art prototypes contributed to the painting's monumentality, so strikingly at odds with the subject matter. Although it is rather unlikely that Millais was aware of this eminent pictorial lineage, the work must have appealed to him as an extremely unusual and powerful genre painting, which subverted traditional academic hierarchies. He responded to the history-painting origins of this genre painting, which he used to resolve the formal problems of his own work: a history painting as genre scene. Millais's interest in the relationship of history and genre painting also reflected the cautious attempts that C. R. Leslie, RA Professor of Painting, had made to promote historical genre as history painting. Millais's simultaneous engagement with Sano di Pietro's *Virgin and Child with Six Saints*, also at Christ Church, further invested this genre scene with the formal severity of the hieratic mode.

An additional attraction of *The Butcher's Shop* lay in the fact that it was believed to be a portrait of the Carracci family. This echoed the pictorial practice of the Pre-Raphaelites, who frequently used family members and friends as models. Moreover, J. G. Millais described the production of *Christ in the House of His Parents* as a genuine family enterprise: 'From the intellectual point of view this picture may be said to be the outcome of the combined brains of the Millais family. Every little portion of the whole canvas was discussed, considered, and settled upon by the father, mother, and Johnnie'.[165] Understood as a representation of the artist's family, *The Butcher's Shop* embodied two important Pre-Raphaelite tenets: the favouring of the particular over the general and the challenging of the traditional hierarchy of genres. In his contribution to *The Germ*, the sculptor John Tupper defined fine art – or what Hazlitt had previously called true art – no longer according to the established categories of high and low mostly predetermined by subject matter.[166] But he advocated the viewer's response, in particular the degree of emotional receptiveness, as the measure for the genuine quality of art. Such demands were similar to those Millais made on the viewer of his meditative and complex picture. Considered on its own, *The Butcher's Shop* – both alleged family portrait and assertively monumental genre scene – could easily be recruited to the PRB cause.

There is an apparent problem, however, for Millais's visual espousal of the Carracci. The Bolognese painters represented the arch-enemy: founders of the academic tradition that the Pre-Raphaelites rebelled against. But nineteenth-century historiography also conjured up an attractive image of the Carracci, which in fact bore certain similarities to the Pre-Raphaelite project.[167] For example, in Luigi Lanzi's influential history of Italian art, which was known to Hunt, the Carracci figured as important reformers of art

'employed in overthrowing the ancient maxims'.[168] Lanzi presented Ludovico Carracci as the archetypal Pre-Raphaelite-type rebel who solicited the help of his family in a joint venture to reform art:

It was now that the Caracci [sic], more than ever confident in their style, answered the voice of censure only by works full of vigour and nature, opposed to the works of older masters, feeble and void of truth. By such means that revolution of style which had so long been meditated, at length took place …[169]

According to Lanzi, the success of the Carracci was underpinned by their teaching, which relied on the study of anatomy and perspective. Although Lanzi outlined their artistic practice as undeniably academic, he emphasized the fact that they drew immediate inspiration from nature. This was seen as the means for reforming the stagnant art practices of their day. He represented the Carracci as a tight-knit family whose artistic enterprise was sincere, committed and successful, yet they were sufficiently relaxed 'to draw landscapes from nature, or to sketch caricatures'.[170] Lanzi conjured up an alluring image of carefree and hard-working newcomers who made a strong impression on the field of artistic production, revolutionizing its dynamics and founding their own school. Despite the fact that they were instrumental in the establishment of the academic tradition, the Carracci of Lanzi's narrative, with their interest in landscape and caricature, did not seem at odds with the Pre-Raphaelite project. Whether Millais knew or cared about such details of historiography is less important than his pictorial and conceptual engagement with *The Butcher's Shop*. The blurring of the boundaries between high and low art – so difficult to define according to Tupper and yet apparent in both works – was one of the main points of criticism that the periodical press raised in the assault on *Christ in the House of His Parents*. Waagen had criticized Carracci's painting for similar reasons. While acknowledging the 'masterly manner' of execution, he took offence at 'the vulgarity of the idea'. Although the two pictures are indeed very different, the responses of nineteenth-century viewers reflected similar aesthetic and moral judgements, which implies that the degree of nonconformism represented by both was regarded as similar.

Resonances of carnage and sacrifice further linked the two paintings. This stands in marked contrast to the 'official' pictorial genealogy to which *Christ in the House of His Parents* belongs. The symbolically charged domesticity of, for example, Rossetti's *The Girlhood of Mary Virgin* or Herbert's *Our Saviour subject to His Parents at Nazareth*, which in both cases – more or less directly – foreshadows the crucifixion, suggests none of the violence that the moment of laceration depicted in *Christ in the House of His Parents* contains. For a representation that contains a comparable degree of violence one has to turn from the visual to the textual. Collinson's typological poem *The Child Jesus* offers this vivid description of a lamb's death struggle:

> ... It was dead
> And cold, and must have lain there very long;
> While, all the time, the mother had stood by,
> Helpless, and moaning with a piteous bleat.
> The lamb had struggled much to free itself,
> For many cruel thorns had torn its head
> And bleeding feet; and one had pierced its side,
> From which flowed blood and water.[171]

This passage prefigured the suffering of the crucified Christ, which, however, found no visual equivalent in the scene Collinson had chosen to illustrate (Figure 3.20). Rossetti too had concentrated on the domestic idyll, reflecting revivalist preoccupation with such themes. But Millais's pronounced emphasis on Christ's wound – the blood on hand and foot, and the blood-smeared nail – disrupted the idyll and resonated with the foreground scene of slaughter in Carracci's *The Butcher's Shop*, with the lamb and Christ occupying similar positions in the respective paintings. The detailed naturalistic representation also threatened the spiritual investment religious painting had undergone during the 1840s.

During the frequent Oxford visits that I believe saw Millais's engagement with *The Butcher's Shop*, the young artist also produced quite different works, which share similar preoccupations. Two small portraits, *James Wyatt and his Granddaughter Mary Wyatt* (1849) and its pendant *Mrs James Wyatt Jnr and her Daughter Sarah* (c.1850) belong to the pictorial context that helps to frame the fascinating paradox of *Christ in the House of His Parents*. *James Wyatt and his Granddaughter Mary Wyatt* was in fact one of the three pictures Millais submitted to the RA exhibition in 1850 (Figure 3.25). Both portraits represent secular versions of the gentle domesticity which preoccupied the young Pre-Raphaelites at the time. The settings are extremely detailed and overtly modern, yet the handling of the figures is outright awkward. In both works, Millais set his complex pictorial language against several visual referents. On the wall behind the stiff duo of Wyatt and his doll-like granddaughter hangs a portrait of Wyatt's daughter-in-law, Eliza, Mrs James Wyatt Jnr. This picture by William Boxall offers a reference to the conventional practices of portraiture as well as Raphaelesque resonances, so apparent in its tondo format.

The stylistic differences are further played out in Millais's own portrait of Mrs James Wyatt Jnr, which contrasts sharply with Boxall's work and the Raphael Madonnas that inspired it (Figure 3.26). On the wall behind mother and daughter hang three engravings; Leonardo's *Last Supper* is flanked by Raphael's *Madonna della Sedia* and the *Alba Madonna*. They index the normative, here embodied in the Raphaelesque. Against this, Millais invokes a set of pictorial referents both directly, such as in the dolls and the coloured book-illustration, and indirectly, such as in the mother's profile pose, which suggests portraiture conventions prevalent in fifteenth-century Italian and Northern European art. Toys, popular prints and early art are here indicative of the Pre-Raphaelite. They invite the viewer – as Elizabeth Prettejohn has observed – 'to think about the differences between naïve and

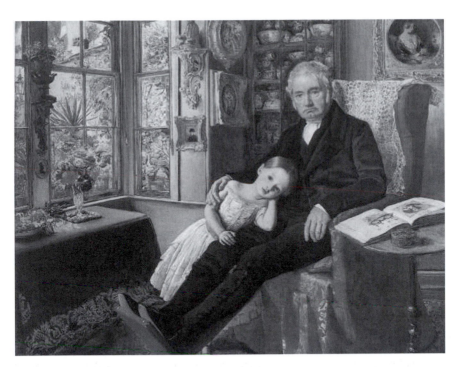

3.25 John Everett Millais, *James Wyatt and his Granddaughter Mary Wyatt*, 35.5 × 45 cm, oil on panel, 1849

sophisticated, archaic and modern, childlike and mature'.[172] The picture's various archaic modes are couched in a detailed realism that indicates unabashed modernity. Its pictorial strategies are both playful and deliberately oppositional to academic values. They vindicate Millais's statement questioning 'whether something very interesting could not be done in defiance of them'.[173] The two small portraits display the hallmark combination of archaism and realism characteristic of early Pre-Raphaelite work. The overt inclusion of visual referents makes the portrait of Eliza Wyatt and her daughter – as Malcolm Warner has claimed – 'a kind of Pre-Raphaelite manifesto'.[174] Here Millais openly used the Raphaelesque as a normative referent for his defiant pictorial language. In another more playful instant he even caricatured it. A sketch of a typical Raphael Madonna and Child exaggerates the dainty poses of the Raphaelesque and discloses them as conventional (Figure 3.27). Millais's satirical stance is not, however, confined to this one mode: the sheet shows equally spirited caricatures of Italian high-Baroque and of mundane Dutch genre painting. He thus exposes three prevalent types of pictorial language as inherently conventional. In contrast, his own representation of the Holy Family shunned any suggestion of conventionality. It displayed the same rigorous and multivalent archaism and aggressive realism that characterized his portrait of Eliza Wyatt and her daughter. While Hunt heaped learned abuse on the boy in Raphael's *Transfiguration* – footnoted with references to Bell's *Anatomy* – Millais's response to the Raphaelesque was equally irreverent but entirely visual. W. M. Rossetti had made a similar distinction between the practices of the two Pre-Raphaelite brethren, calling the 'faculty of the one

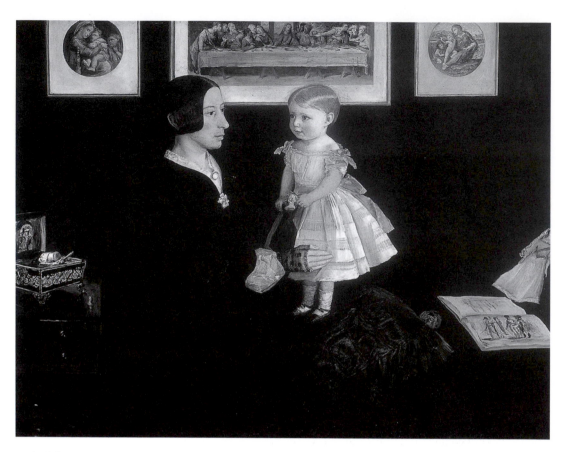

3.26 John
Everett Millais,
*Mrs James Wyatt
Jnr and her
Daughter Sarah*,
35.3 × 45.7 cm,
oil on panel,
c. 1850

… in its nature reflective – of the other intuitive. Mr. Hunt thinks out his subject – invents and individualizes it: Mr. Millais sees, or, as we may say, creates his.'[175] Consequently, Rossetti remarked of *Christ in the House of His Parents*, 'the agency for explaining it … [is] sometimes inadequate: and you feel the thing at once, or not at all'. What critics repeatedly referred to as the work's 'intentional deformities' is revealed as a multifaceted and playfully anti-Raphaelesque mode – most clearly brought out in the manifesto-like contrasts set out in the portrait of Eliza Wyatt. Millais's intuitive dialogues with *The Butcher's Shop* and with Sano di Pietro's devotional work inflected the common genealogy of gentle domesticity typically invoked in symbolically charged representations of the Holy Family. They helped to bring out the aggression inherent in the prefigured subject so often glossed over in the domestic settings and invested the genre mode with a grandeur and gravitas absent in most mid-Victorian examples. They also highlighted the 'stubborn purpose' of Millais's defiance.

The virulent critical reception of *Christ in the House of His Parents* represents a short if highly significant episode in the history of Pre-Raphaelite art. It highlighted the moment at which the academic paradigm was challenged and vociferously defended. Once the hysteria over *Christ in the House of His*

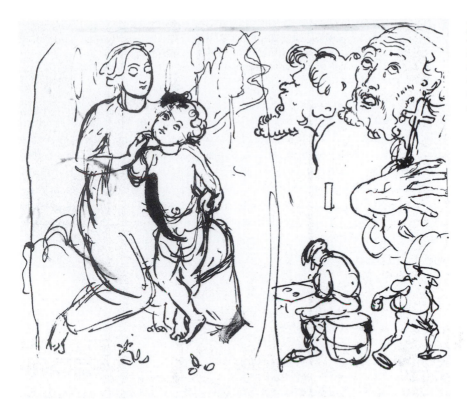

3.27 John Everett Millais, *Sketch of Madonna and Child*, 18.8 x 18.6 cm, pen and ink, *c.* 1853

Parents had abated, the *Athenaeum* recognized the value that the aggressive Pre-Raphaelite challenge had for the reform of art:

one of the effects of their fanaticism is seen in the greater earnestness of the younger men. Every schism, though itself tarnished by error, shows some flaws in the system from which it springs, and there is already a re-action, from the slovenly scene-painting and the impertinent *bravura* which were formerly so baneful a hindrance to the junior members of the English school.[176]

In one of the *Athenaeum*'s subsequent RA notices, the critic made an interesting distinction when commenting on the abilities of 'a promising artist of Pre-Raphaelite finish; but no sharer of PRB distortion or eccentricity'.[177] By then the adjective 'Pre-Raphaelite' denoted a specific, positive quality, whereas the more aggressive characteristics remained associated with 'the Brotherhood'. By the late 1850s, the art critics of the periodical press actively promoted Pre-Raphaelite qualities such as close observation of nature, attention to detail and careful finish. The Pre-Raphaelite aesthetic found acceptance in lesser genres such as landscape painting. Its application in the higher branches of art, however, remained contested. In a surprising inversion of values that recalls the topsy-turvy world of *Punch*, the *Athenaeum* critic admitted that academic practice had gone stale and was in fact in need of the potent tonic the PRB offered. Academism was described as conventional, plagiarist and idolatrous – 'bow[ing] down to Raphael as their prophet' while 'forgetting and deserting Nature herself'. But salvation was at hand:

The modern Art Reformation affects to aim at upsetting this idolatry, and leading once more to the earnestness and simplicity of truth. A twig long warped in a wrong direction must before it is again straightened be bent the other way: – and so, this violent effort of the ardent and inexperienced has, in the spirit of opposition, led to extravagance and caricature.[178]

The PRB intervention was perceived as a necessary, albeit temporary, over-reaction. Out of the initial extravagance and caricature – terms intended to both depreciate and capture the PRB's unusual pictorial language – the much-needed reform of high art was to emerge. The original Pre-Raphaelite impulse, which relied on symbolic charge, expressiveness and rigorous anti-academism, was best exemplified in *Christ in the House of His Parents*: at once a robust statement of defiance and a conceptual dead-end. With regard to religious painting, it fell to William Holman Hunt to fully develop the implications of 'the modern Art Reformation'.

The making of William Holman Hunt as the painter of the Christ

The 1850s saw the dissolution of the Brotherhood and the almost simultaneous vindication of the Pre-Raphaelites. Their spectacular and controversial appearance on the art scene, hotly contested at first, led to genuine appreciation and intelligent support from critics such as John Ruskin and David Masson, and eventually to a more general acceptance of their artistic values. This manifested itself in the proliferation of Pre-Raphaelesque works at exhibitions and in the marked change of tone adopted by most reviewers. In part, this transformation depended on the Pre-Raphaelites' response to the vitriolic criticism of 1850 and 1851: reticent, cautious and clever. For Millais these early years represented a rebellious interlude. *The Huguenot* (1851–52) brought him critical acclaim, while the immensely popular *Order of Release* (1852–53) secured his election as an Associate of the RA. After the severe attacks on the Brotherhood in 1850, Rossetti ceased to exhibit and instead began to build up a small circle of patrons for whom he produced drawings and works in watercolour and body-colour. In terms of subject matter too there was a noticeable change: Millais virtually stopped painting religious subjects after 1851. Of the Brotherhood's three painter members, Hunt remained closest to its original artistic trajectory. According to the critical judgement of a later generation who evaluated the Pre-Raphaelite project at the turn of the twentieth century, he had emerged as its unwavering beacon. 'Mr. Holman Hunt was pre-Raphaelitism, and what he was he has remained', wrote Mrs Meynell approvingly in the Christmas supplement of the *Art Journal* of 1893.[1] In *Five Great Painters of the Victorian Era* of 1902, Sir Wyke Bayliss used another epithet to distinguish Hunt's contribution to the art of the period from that of Leighton, Millais, Burne-Jones and Watts: Hunt was termed 'the Painter of the Christ'.[2]

These remarks exemplify two widely held, but by no means uncontested, opinions regarding the artist's career, a fact Hunt himself was acutely aware of, when he wrote, 'the consequence of my persistence was that I was greeted by critics with pity and derision as incorrigible and incapable of profiting by admonition'.[3] In his monumental two-volume autobiography, *Pre-Raphaelitism and the Pre-Raphaelite Brotherhood* (1905), Hunt was keen not only

to consolidate these two epithets – 'the Painter of the Christ' and the true Pre-Raphaelite – but also to present them as inextricably linked and inject them with positive values.[4] In this chapter, I chart the redefinition of Hunt's artistic identity and the transformation of his aesthetic project that began to emerge during the 1850s. This was mainly in response to the by then obsolete monastic model originally adopted by the Brotherhood, which not only coincided with a more general condition Herbert Sussman has termed 'the lability of the monastic at mid-century' but which also proved too ambiguous to generate critical approval.[5] I investigate the strategies used to present a different formation of artistic identity. These aimed to define the processes of artistic production by simultaneously drawing on Carlyle's concept of history as biography and the figure of the hero, the Smilesian ideology of self-help and Ruskin's economy of art. Not surprisingly, such diverse sources generated a complex and hybrid identity. As Julie Codell has shown, Hunt adopted multiple voices, simultaneously masquerading as 'martyr, professional, rebel, Englishman, male, businessman, sage – all combined in a constantly shifting, unstable role for the modern artist'.[6] His deliberate self-fashioning culminated in his quest for Christ, which manifested itself in a number of seminal works such as *The Light of the World* (1851–53), *The Finding of the Saviour in the Temple* (1854–60) and *The Shadow of Death* (1870–73). Thus the artist in effect became the self-styled saviour of the original Pre-Raphaelite impulse. Furthermore, he made a significant contribution to the pressing mid-Victorian debates that strove to understand the figure of Christ in the sharp light cast by the recent historical and philological inquiries of biblical higher criticism. William Vaughan has identified the problem of how 'to reconstruct the historical Christ in a way that asserted rather than damaged his divine stature' as the central concern of Hunt's career, and Marcia Pointon has argued that this tallied with the need of the age to find a new solution for the figure of Jesus Christ.[7] Hunt's career indeed offered one paradigmatic response to this problem. I investigate how Hunt not only used the key characteristics of the Pre-Raphaelite style in the pursuit of a modern Protestant painting that was 'able to look science and history in the eye',[8] but also managed the concomitant re-fashioning of his artistic self to become both the true Pre-Raphaelite and 'the Painter of the Christ'.

Reconfiguring Christ: history, biography, myth

The fundamental problem of Hunt's career was also a major preoccupation of the age: how to reconfigure Christ in a culture riven with religious uncertainties and struggling to articulate what Alfred Tennyson so memorably termed 'honest doubt'. The poet's emblematic and often-quoted lines from *In Memoriam* – 'There lives more faith in honest doubt, / Believe me, than in half the creeds' – captured the prevalent mid-Victorian state of mind, bestowing some hope on the struggle with faith and proclaiming it the thinking person's burden. The publication of David Friedrich Strauss's *Das*

Leben Jesu, kritisch bearbeitet in 1835 represented the first landmark in the century's search for the historical Jesus.

In the preface to the first volume of *Das Leben Jesu*, the author claimed that 'the inquiry must first be made whether in fact, and to what extent, the ground on which we stand in the Gospels is historical'.[9] He regarded this question as 'not only justifiable, but even necessary', and ventured to answer it with exemplary Germanic thoroughness. This prompted the young George Eliot, who prepared the first English edition in 1846, to remark, 'I do really like reading our Strauss – he is so klar und ideenvoll but I do not know one person who is likely to read the book through, do you?'[10] In true Hegelian fashion, the impressive three-volume *Das Leben Jesu* dissected and destroyed both of the established, deeply antithetical readings of the gospels – the supernatural and the rational – to propose a third, synthetical interpretation that sought to understand the underlying mythical structure. According to Hans Frei, the reason for Strauss's enormous success lay in the fact 'that he explained the supposedly miraculous incidents of Jesus's life as "myths" with a hitherto unheard-of sceptical consistency and elegance'.[11]

The publication of *Das Leben Jesu* brought Strauss instant and lasting fame, but such relentless dismantling of the gospels made his position as lecturer at the Tübingen Seminary untenable, and he was asked to resign. Although his promising academic career was cut short, he continued to operate as an influential and prolific scholar. Since Strauss went on revising his text (at times quite substantially) in subsequent editions, critical engagement with his work also carried on unabated for more than thirty years.[12]

In 1864, just a year after the publication of Ernest Renan's equally controversial *Vie de Jésus*, Strauss presented a completely reworked version, entitled *Das Leben Jesu für das Deutsche Volk bearbeitet*.[13] In some ways, the debate over the figure of Jesus Christ climaxed with the almost simultaneous publication and reworking of these two provocative and outstanding contributions, followed by yet another attempt at a life of Jesus – John Seeley's *Ecce Homo*, published anonymously in 1865.[14] These publications generated a new form of comparative criticism that aimed to analyse, vituperate against or vindicate the works of Strauss and Renan (and sometimes Seeley) in tandem.[15]

Seeley's book, which also historicized the figure of Christ, albeit less vividly and radically than its German and French predecessors, constituted the first major English contribution to the multifaceted debate. In the British context, *Ecce Homo* generated a wealth of reviews; it divided opinions and raised tempers, with responses ranging from William Gladstone's unreserved support through to such heated invectives as the frequently cited phrase 'the most pestilential book ever vomited from the jaws of hell'.[16] One of the more moderate critics succinctly summed up his concern regarding the book's basic historicist premise:

I cannot hesitate to say that the spirit which most pervades and characterises it is that of *intense rationalism* – an undisguised if not directly avowed principle of making human reason rather than divine revelation the measure and judge of

religious truth; and that this is the real source of whatever is most erroneous and dangerous in its teaching.[17]

By the early 1870s, 'these monstrous forms of unbelieving belief',[18] as one critic called Strauss's explication of the gospels, were so prevalent that Archdeacon Frederic William Farrar felt obliged to point out in the preface to his highly successful and often reprinted *The Life of Christ* (1874) that it was unequivocally the work of a believer.

Writing in 1866, Eduard Zeller, Strauss's friend, one-time pupil and earliest biographer, discussed the relative merits of David Friedrich Strauss's and Ernest Renan's versions of the life of Jesus.[19] The intense rationalism of his inquiry into the gospel accounts is obvious in his discussion of the resurrection narrative:

But if the case were considered historically, this revival would only appear probable if we had before us evidence of its reality of a more original and less contradictory character than we actually have. Moreover, the circumstances of his execution are of such a character as to make a natural revival as good as impossible. That any one, who, after long and exhausting abuse was at last crucified, left on the cross at least six hours, and taken down with all the symptoms of death having occurred – that under such circumstances, after being shut up in a sepulchre without any care and without food for two days and a half, he should have revived in virtue of the restorative power of nature after about thirty-six hours, and have been at once in a condition to undertake a pedestrian excursion either to Galilee or to Emmaus, one and a half miles distant – this is so exceedingly improbable that we are compelled to call for the most irrefragable proofs in order to believe it. Instead of this, not only are the accounts of the resurrection far removed from authenticity in point of origin, and, as regards their immediate substance in conflict with each other, but the general tenor of them is such that a natural continuation of the life of the Crucified is inconceivable.[20]

The tough logic of Zeller's reasoning, together with careful attention to geographical detail (one and a half miles to Emmaus) and the trenchant irony of suggesting that Christ might not have felt up to a 'pedestrian excursion' after the ordeal of the crucifixion and the uncomfortable stay in the tomb, documented just how far biblical criticism had come in dismantling the divine truths of Scripture. Decades of careful scholarly scrutiny had revealed the historical palimpsest of the textual record. Unlike the unsettling but limited threat that science posed to the veracity of the biblical account, which was mainly confined to the book of Genesis, the application of historical and philological methodologies to Scripture proved all-pervasive. Consequently, belief in some of the Bible's most fundamental aspects was not only made difficult but also met with almost irreverent irony.

Strauss's incisive inquiry was taken up by an international community of scholars prepared to engage with the pressing dilemma of the age, which Renan's English translator – writing in the preface to the 1864 edition of *The Life of Jesus* – formulated thus: 'The great problem of the present age is to preserve the religious spirit, whilst getting rid of the superstitions and absurdities that deform it, and which are alike opposed to science and common sense.'[21] This proposed rescue mission was both delicate and

radical: it required the peeling-away of 'superstitions and absurdities' while leaving the core of belief intact. Strauss felt that his mythical rereading of the gospels had achieved precisely that when claiming in the preface to the first German edition of *The Life of Jesus*, 'The author is aware that the essence of Christian faith is perfectly independent of his criticism.'[22] Renan was more worryingly outspoken about his own position and identified two steps crucial to a historical understanding of religion:

To write the history of a religion, it is necessary, firstly, to have believed it (otherwise we should not be able to understand how it has charmed and satisfied the human conscience); in the second place, to believe it no longer in an absolute manner, for absolute faith is incompatible with sincere history.[23]

The age was indeed characterized by an absence of absolutes as historical inquiry ushered in a new and unsettling relativity. As Joseph Hillis Miller has pointed out: 'Historicism, which begins as an interest in the past, ends by transforming man's sense of the present.'[24] Although a commonplace, the choice between absolute faith and sincere history necessitated not only a complex rewriting of the past, but also led to a questioning of the present state of Christianity.

Consequently, as Miller concluded, 'Historicism … transforms God into a human creation. And as soon as a man sees God in this way he is effectively cut off from the living God of faith.'[25] Therefore Friedrich Nietzsche's claim that 'God is dead' might have been the century's ultimate pronouncement on the fate of Christianity; however, it was God's gradual disappearance – manifested in the anxious fictional and historical reclaiming of Jesus Christ – that proved far more complex, controversial and engaging.[26] Even if slow, the death of God, like that of the author, increasingly placed the onus on the reader to make sense of the Scriptures. Hence the exegete, historian and biographer presented their versions of the once absolute biblical truth.

Authors such as Strauss and Renan began to ask – in the words of Zeller – 'what was possible, psychologically and morally, for such a character as Jesus was'.[27] They also challenged the text's blatant inconsistencies. For example, Strauss succinctly summed up the dilemma of the resurrection: 'either Jesus was not really dead, or he did not really rise again'.[28] If the Bible was to be read just like any other book, as Benjamin Jowett, Regius Professor of Greek at Oxford, famously declared in his contribution to the controversial volume *Essays and Reviews* (1860), it also invited scrutiny of its narrative form.

The search for the historical Jesus not only necessitated the scholarly identification of fact and fiction but also led to the reconfiguration of narration and representation. For example, Zeller was convinced that 'the unheard of success of Renan's work' lay in its narrative charm, which he characterized as 'that thorough-going individualisation, that freshness of representation which though leading us in detail upon uncertain ground, does still in its general impression, like a successful historical painting, not seldom place in a striking light the scene of Evangelical history and the spirit of the acting personages'.[29] Unlike Strauss, who compared gospel accounts,

dismantled different readings and established what has been termed a
'negative theology', Renan – although a self-avowed lapsed Catholic –
produced a sketch of Jesus that possessed the immediacy and persuasiveness
of an eye-witness account, or – in the words of his English translator – 'a
work so admirable for its style and beauty of composition'.[30] Even critics such
as the Reverend John Cairns, who sternly refuted either approach to the
gospels, presented their respective characteristics with great clarity:

The chief differences in these otherwise kindred works are, *first* and chiefly, that
Strauss everywhere forgets the biographer in the critic, and leaves the actual Jesus a
pale and dim shadow, while Renan strives by every dramatic art to give his creation
life and colour, employing for this purpose, not only the resources of imagination,
but of personal experience in travel amidst the scenes of the Gospel history … If his
life of the Saviour has more of the interest of a romance, it has more in proportion of
its fugitive character.[31]

Renan's description of Jesus also reminded Zeller 'of a hero of romance'.[32]
While such perceptions confirmed the fictitious nature of biography, Strauss
– although he might have forgotten 'the biographer in the critic' – fully
understood the problematics of writing a 'Life of Jesus': 'this phrase', he
claimed, 'is an idea emphatically modern'.[33] Strauss further maintained that
making Jesus Christ the subject of biography automatically rendered him
entirely human:

The hero of a biography, according to modern conceptions, should be entirely and
clearly human. A personage half human, half divine, may figure plausibly enough in
poetry and fable, but is never at the present day seriously chosen as the subject of
historical narrative. The human hero of a biography is a being partly natural, partly
spiritual; one, whose lower impulses and selfish aims ought in duty to be held in
subordination to the universal law of reason, not one whose tendencies are already
and necessarily so controlled in consequence of a union of humanity and divinity.[34]

The historical subject was of course open to changing interpretations, as
Strauss's life-long rewriting of Jesus testified, which somewhat ironically
culminated in a *new* life of Jesus (an irony absent from the original German
title). He furthermore identified the danger inherent in the biographical
mode, which harboured inevitable change of a quite different nature:

When the biography was seriously taken up, the fate of the theological conception
was sealed; if the latter was to survive, the biography should never have been
attempted … The significance of Christ in relation to modern times could only be
substantiated by making his career biographically intelligible, and by treating his life
as a pragmatical sequence of events on the same footing as that of other illustrious
men.[35]

But attempted it was, consequently 'sucking Christianity into history' with
unprecedented force and uncertain results.[36] The turbulences this generated
were – according to one contemporary commentator – best met by 'those …
having in their own persons undergone the terrible ferment of doubt and
conflict which now-a-days besets a reasonable faith'.[37] The incompatibility of
absolute faith and sincere history pointed out by Renan and evident
throughout biblical Higher Criticism necessitated states of 'reasonable faith'

and of Tennysonian 'honest doubt'. These allowed for a much more nuanced, psychologized and even fictionalized understanding of the figure of Jesus Christ.

In his autobiography, Hunt invoked the authority of Thomas Carlyle, the century's sage, to voice the concerns over the image of Christ that dominated Protestant thought at mid-century. During a visit to the artist's studio, which Hunt claimed to have recalled in minute detail, the figure of Carlyle severely criticized *The Light of the World* (Figure 4.10), and delivered the famous and often-quoted diatribe:

> You call that thing ... a picture of Jesus Christ. Now you cannot gain any profit to yourself ... in putting into shape a mere papistical fantasy like that, for it can only be an inanity, or a delusion to every one that may look on it. It is a poor misshapen presentation of the noblest, the brotherliest, and the most heroic-minded Being that ever walked God's earth. Do you ever suppose that Jesus walked about bedizened in priestly robes and a crown, and with yon jewels on his breast, and a gilt aureole round His head? Ne'er crown nor pontifical robe did the world e'er give to such as Him. Well – and if you mean to represent Him as the spiritual Christ, you have chosen the form in which He has been travestied from the beginning by worldlings who have recorded their own ambitions as His, repeating Judas' betrayal to the high priests. You should think frankly of His antique heroic soul, if you realised His character at all you wouldn't try to make people go back and worship the image the priests have invented of Him ... this is only empty make-believe, mere pretended fancy, to do the like of which is the worst of occupations for a man to take to.[38]

Hunt's Carlyle objected to the use of allegory based on imaginative exegesis, and instead demanded a suitable means to represent the 'heroic-minded Being'. He was engaged in tracking down representations of important people who had contributed to the progress of civilization, a venture that informed the foundation of the National Portrait Gallery in 1856.[39] In some ways the project was also related to the idiosyncratic 'List of Immortals' drawn up by the members of the PRB, a quirky pantheon of cultural heroes with Jesus Christ at the top.[40] Carlyle regretted that 'a veritable contemporary representation of Jesus Christ' did not exist, whose metonymic quality, he claimed, would make it possible to conjure up the lost past. He deplored that 'the greatest of all beings ... I have no means whatever of raising up to my sight with any accredited form'.[41] This attempt to raise up the true image of Christ – asking the spirit to materialize – is reminiscent of the séance. He positively longed for a 'faithful' representation of the 'Son of Man,' which would show 'what manner of man he was, what His height, what His build, and what the features of His sorrow-marked face were, and what His dress'.[42] Carlyle was particularly interested in the exact details of Christ's appearance: a true likeness depended on facial features as much as on costume and geographical setting. He surveyed the history of art to prove that so far no one had succeeded in painting a faithful portrait. Finally, Carlyle gave his own sketch of Christ:

> I see the Man toiling along in the hot sun, at times in the cold wind, going long stages, tired, hungry often and footsore, drinking at the spring, eating by the way,

His rough and patched clothes bedraggled and covered with dust, imparting blessings to others which no human power, be it king's or emperor's or priest's, was strong enough to give to Him …[43]

This passage not only explained why Carlyle's response to *The Light of the World* was so hostile but it also captured the demands of the age for a historically informed image of Jesus. The desire for a portrait of Jesus placed the emphasis on the human aspects of his nature since portraiture, like biography, only applied to human beings. Carlyle in Hunt's account concluded that it was simply impossible to paint a true image of Christ because the historical distance could not be bridged and pictorial conventions stifled innovative artistic expression.

On publication of Hunt's autobiography, Carlyle's visit to the artist's studio was immediately recognized as an important set-piece. Thanking Hunt for a copy of the tomes, Maurice Hewlett, who had given the artist technical advice during their preparation, made particular mention of that episode: 'What a picture … you give of Carlyle – haranguing you before the Light of the World!'[44] Hunt had shrewdly framed the problem of how to represent Jesus Christ, which was central to his artistic enterprise and a crucial concern of the age, as a dramatic encounter between a young artist and a wise old man who imposes a difficult quest. Thus his search for artistic identity became part of a broader discourse at the heart of nineteenth-century Protestantism. Hunt shared liberal Protestantism's view 'that much of the teaching of Christ's life is lost by history being overlaid with sacerdotal gloss', but the artist also engaged in a form of séance similar to Carlyle's conjuring up of the departed spirits as he aimed 'to make the [biblical] story live as history'.[45] Hunt's project was driven by a desire for both historical fact and meaningful fiction: narrative modes that the historicization of Jesus had enabled.

These new forms of narration were most controversially played out in the arena of biography encapsulated in that emphatically modern idea: the Life of Jesus. While Jesus became the hero of romance, Hunt deliberately refuted that role for the artist. He insisted that artistic 'excellence … can be won only by incessant labour', and went on to equate it with 'a passion which ever leaves him [the artist] unhappy when not wrestling with some besetting sin discovered in his own practice'.[46]

Illustrating the Bible: a context for Hunt's pictorial concerns

Carlyle's damning verdict of *The Light of the World* addressed a general concern for a historical understanding of Jesus. Hunt was keen to break free from artistic conventions and reinterpret the figure of Christ in ways that would appeal to contemporary audiences. He looked to popular forms of imagery for inspiration. We know that Hunt possessed a copy of Knight's *Pictorial Bible*, which has been called 'a prefiguration not only of the artist's

entire career but also of the particular nature of that career'.[47] Hunt's artistic concerns evolved in tandem with some of the key issues articulated in the illustrated Bibles of the period, which provide a readily available yet so far neglected visual archive.[48]

Charles Knight's publication of the lavishly illustrated *Pictorial Bible* (1836–38) transformed the established format of illustrated Bibles.[49] The project was driven by a desire for popular education and reflected Knight's wider editorial concerns, evident in the *Penny Magazine* and his involvement with the Society for the Diffusion of Useful Knowledge.[50] During the 1830s, the typical illustrated Bible contained on average thirty illustrations. Their selection followed a pattern that had been established in the 1790s and included engravings after works by canonical masters such as Raphael, Rosa, Reni, Domenichino, the Carracci, Rubens and Poussin. While in Knight's *Pictorial Bible* the selection of illustrations showing biblical events remained virtually unchanged, the volumes were teeming with completely new types of illustration, which were broadly speaking scientific and historical. These showed the fauna and flora, architecture, customs and dresses and the landscapes of the Bible. *The Pictorial Bible* was intended 'to make the objects described or referred to in the Holy Scriptures familiar to the eye of the general reader'.[51] These simple wood-engravings illustrated every aspect of the biblical landscape, and the scriptural narratives were put into historical context. While the topography had remained virtually unchanged, biblical times were visibly historical: they could be reconstructed out of archaeological remains. Furthermore, the ethnographical illustrations implied that the past could be understood through the study of contemporary customs in countries such as Egypt and Syria. These types of illustration strengthened the assumption that the Middle East had changed little since biblical times. Here the classic trope of orientalist discourse – the timelessness of the Orient – was employed as an aid to visualizing the biblical setting. However, this concept also reflected an acute awareness of the passing of time that dominated Western consciousness. This 'historical-mindedness'[52] – to use Stephen Bann's term – resonated with a romantic sense of loss heightened by the realization that the Orient was itself beginning to change and hence needed to be recorded for posterity.[53] This feeling was shared by Hunt, who observed during his final journey to the Middle East in 1893 that the picturesque conditions which had enabled his orientalized representations of scriptural subjects had disappeared in the wake of the region's relentless modernization.[54]

The new types of illustration suggested an almost artless affinity with the subject matter. The timelessness claimed by the very specific depiction of oriental everyday life was antithetical to that of high art, which conceived biblical narrative as essentially ahistorical and universal. The classical notion of history as a series of timeless moral exempla was superseded by a specifically nineteenth-century notion concerned with the detailed reconstruction of past events. These two antagonistic concepts came head-to-head in the pages of *The Pictorial Bible*. Through their sheer number, modest

pictorial rhetoric and high educational value, the scientific and historical illustrations challenged the universal truth proclaimed by traditional biblical representation. The absence of narrative involvement – with illustrations simply showing things such as a flax plant or locusts – further increased their seeming authenticity (Figures 4.1 and 4.2).[55] The credibility of the high-art mode was also undermined by the crudeness of the wood-engravings. The general lack of artistic quality encountered in most illustrated Bibles was deplored by John Ruskin, who wrote, 'I do not know anything more humiliating to a man of common sense, than to open what is called an "Illustrated Bible" of modern days.'[56] Art in the service of religion – Ruskin was particularly inveighing against Evangelical practices here – should not be made to forfeit its aesthetic qualities: 'it is certainly in nowise more for Christ's honour that ... His miracles [be] painted discreditably'. The low artistic quality of illustrated Bibles was in part due to the haphazard and mercenary modes of production; and Knight's *Pictorial Bible* was no exception in this regard. It incorporated a wide range of visual material originally produced for other publications. As T. S. R. Boase has shown, the editors took great liberties in adapting the pictorial material to suit their purposes.[57] Consequently, the edition lacked visual coherence, and sometimes the connection between illustration and text was tenuous, as in the wood-engraving of modern *Sicilian Women grinding in a Mill* used to represent a custom of biblical times (Figure 4.3). Despite such shortcomings, *The Pictorial Bible* was highly innovative and commercially successful, even if it remained untypical.[58]

Of the new types of illustration *The Pictorial Bible* had introduced, the topographical sketch was the one to establish itself alongside traditional biblical scenes. Wood-engravings such as *Jerusalem with the Mount of Olives*, a typical example of topographical illustration, familiarized readers with the landscapes of Scripture (Figure 4.4). The swift incorporation of topography was hardly surprising. Not only was it an established genre practiced by well-known artists such as J. M. W. Turner and David Roberts.[59] It also tied in with the immensely popular genre of travel literature which had followed the gradually expanding itinerary of the Grand Tour to include Greece, Turkey and the Middle East.[60] The buoyant markets in travel literature and topographical prints, exemplified in the popular genre of the illustrated travel book, made such prints readily available for inclusion in illustrated editions of the Bible. However, the close relationship of traditional scriptural illustrations and topography also disclosed the fundamental unease besetting biblical representation. This was made explicit in the address of John Marius Wilson's highly successful volume *Landscapes of Interesting Localities Mentioned in the Holy Scriptures* (1852), which claimed that topography was the most useful form of biblical illustration and the least controversial: 'These form real illustrations of the text; and addressing themselves to the perceptive powers are interesting and intelligible to young and old, – the simplest child as well as the profoundest sage.'[61] Accordingly, topographical illustration conveyed an immediacy that appealed to all types

4.1 *Flax (Linum usitatissimum)*, wood-engraving from *The Pictorial Bible*, 1836–38

4.2 *Locusts*, wood-engraving from *The Pictorial Bible*, 1836–38

4.3 *Sicilian Women grinding in a Mill*, wood-engraving from *The Pictorial Bible*, 1836–38

4.4 *Jerusalem, with the Mount of Olives*, wood-engraving from *The Pictorial Bible*, 1836–38

of readers. It was also regarded as superior to verbal description because it enabled 'an accurate conception of interesting scenes and localities'. Yet, the combination of traditional high-art images and topography was not seen as the definitive solution to the problem of biblical representation. This was unequivocally stated in the preface to John Kitto's *The Gallery of Scripture Engravings* (1846–47):

It would have been better, doubtless, had the Painter's idea of the historical action been combined, in the same picture, with the true and natural landscape. Modern artists may be able to realize this object from the materials which the present landscapes, and those contained in others publications, supply.[62]

The call for integration was also reflected in a work such as Herbert's *Our Saviour subject to His Parents at Nazareth*, which combined a fairly conventional genre scene with a background landscape based on a sketch made 'on the spot' in Nazareth, although this highly topical and innovative trait did not fully register with the RA critics who found it odd at best (Plate 4).

During the 1840s, work by contemporary artists began to be included in the illustrated Bibles. This raised the important question of conflicting stylistic idioms: idealism modelled on German precedents and realism based on French art.[63] The realist idiom, which hardly figured in the RA exhibitions and hence received little attention in the periodical press, came to play a major role. Although it presented a powerful alternative to the idealist mode that dominated academic discourse, it was also fraught with the dangers of the banal. This was apparent in Horace Vernet's work, which focused on the picturesque and sensuous potential of Old Testament subjects such as *Rebekah and Abraham's Servant* (Figure 4.5).[64] In his autobiography, Hunt recalled a conversation with D. G. Rossetti in which they discussed the functions of historical veracity in art. Referring to Vernet's biblical pictures, Rossetti was of the opinion 'that attention to chronological costume, to the types of different races of men, to climatic features and influences, were of no value in any painter's work, and that therefore oriental proprieties in the treatment of Scriptural subjects were calculated to destroy the poetic nature of the design'.[65] Hunt, too, rejected Vernet's uninspired realism but defended the principle of historical veracity on which it was based: 'My contention was that more exact truth was distinctly called for by the additional knowledge and longings of the modern mind.'[66] He argued that biblical representation had to express the increase in historical knowledge in order to be meaningful for contemporary audiences, a concern reflected in most illustrated Bibles.

The third edition of *The Pictorial Bible* (1847–48) responded to the constant increase in information that biblical scholarship had generated by substantially augmenting the number of scientific and historical illustrations. To guarantee both scholarly usefulness and continued popular appeal, it was considered essential to omit the traditional high-art images – 'admirable, no doubt, as works of art, but imperfect as representations of manners and costume'.[67] In 'an edition of the Bible which aimed at the accurate illustration

4.5 Horace
Vernet, *Rebekah
and Abraham's
Servant*, steel-
engraving from
*The Imperial
Family Bible*,
1844

of such particulars', so the writer of the preface claimed, the use of works of
art as illustration was considered problematic. Consequently, the two modes
of representation were separated. Each part of the serialized publication
included 'a beautifully executed Engraving on Steel, from subjects selected
from the finest specimens of the ancient and modern schools', giving
preference to 'those masters who have combined accuracy of detail with high
invention'. Most of the steel-engravings were based on the work of German
Nazarene artists whose idealist mode of representation was celebrated as an
apt approach to scriptural subjects, at once spiritual, academic and less
fanciful than some of the old master representations included in earlier
editions. Their high quality of production and autonomy from the text
ensured their status as art, which also helped to differentiate them from the
small-scale scientific and historical illustrations. This practice demonstrated
an astute awareness of the current problems in biblical illustration. By

separating the spheres of art and research, the increased demand for historical accuracy could be met without undermining the more traditional visual record. It furthermore suggested that both represented different but equally valid kinds of truth. The effort to establish both spheres as independent and equally valid represented a truce rather than a long-term solution. As the high-art mode continued to be challenged by the wealth of historical accessories, the attempt to integrate both seemed not only logical but inevitable.

With *The Illustrated Family Bible* (1859–63) John Cassell, who shared Knight's belief in the value of popular education, revived the original concept of *The Pictorial Bible*.[68] The wealth of historical and scientific illustrations so characteristic of the earlier enterprise was restored and juxtaposed with representations of biblical scenes. Once again the different types of illustration were printed together with the text. For the first time, however, this sense of integration also extended to the modes of representation deployed in the biblical scenes. A new generation of engravers responded to the growth in historical and scientific knowledge. In addition to original designs by engravers such as William James Linton, work by contemporary artists who favoured the realist idiom was also reproduced, most prominently among them Gustave Doré. Instead of following established high-art conventions, they 'orientalised' biblical scenes: for example, the burial of Joseph became *The Embalming of Joseph* (Figure 4.6). Such a thorough application of the orientalist mode was mostly reserved for Old Testament subjects. The treatment of scenes from the New Testament varied according to subject matter. While *Judas Iscariot bargaining with the Chief Priests* displayed the same degree of oriental detail in both costume and setting, the representation of Christ remained rather conventional, as the example of *The Sick laid in the Streets to be healed* shows (Figures 4.7 and 4.8). Orientalizing features were restricted to the architectural setting and the occasional head-dress; the figure of Christ remained traditional – classically draped, bearded, with shoulder-length hair. Despite such hesitation, *Cassell's Illustrated Family Bible* achieved an unprecedented degree of pictorial cohesion. It displayed a distinctly nineteenth-century notion of history which sought to historicize, particularize and orientalize the biblical event.

As Hunt had told D. G. Rossetti when discussing how to approach biblical painting in their day and age, a 'more exact truth was distinctly called for by the additional knowledge and longings of the modern mind'.[69] Both theological realism and biblical illustration faced some of the same challenges in the need to respond to the constant increase in historical and scientific knowledge. In his desire to address the 'longings of the modern mind', the artist sought to establish a pictorial language that would capture the hearts of ordinary viewers and also overcome the problem of applying strict Pre-Raphaelite naturalism to the representation of biblical narrative.

Christ and the two Marys, begun in 1847, was the first manifestation of Hunt's life-long engagement with the figure of Christ (Figure 4.9). In this

4.6 *The Embalming of Joseph*, wood-engraving from *Cassell's Illustrated Family Bible*, 1859–63

early work, the artist chose to illustrate the most immediate version of the resurrection narrative (Matthew 28:9–10). He intended to make 'unaffected people … see this Christ with something of the surprise that the Maries themselves felt on meeting Him as One who has come out of the grave'.[70] This remark captures the nature of his artistic enterprise. He aimed to create a form of religious imagery, free from exhausted academic conventions, that would speak to an artless audience of all classes. His image of Christ strove to elicit an immediate and emotional response. It also tallied with his demand for art generally: 'What I sought was the power of undying appeal to the hearts of living men.'[71]

Although the picture presented the artist with such technical and conceptual problems that he abandoned it, Judith Bronkhurst has

4.7 *Judas Iscariot bargaining with the Chief Priests*, wood-engraving from *Cassell's Illustrated Family Bible*, 1859–63

persuasively argued that he 'regarded it as a key work in his artistic development'.[72] This is also borne out by the way in which Hunt presented the work in his autobiography, where it functioned as a means to articulate his artistic concerns.[73] In a conversation with Millais that was carefully recorded in the autobiography, he admitted having serious difficulties with 'the whole treatment of the Saviour's figure'.[74] When Millais suggested that he look 'at some of the Old Masters to be found in the Print Room [of the British Museum]', Hunt replied that this problem required an innovative solution, and he called his approach 'nothing less than irreverent, heretical, and revolutionary'.[75] While Millais of course was to follow his own suggestion in the truly original *Christ in the House of His Parents*, Hunt presented himself as the one determined to explore new paths, refusing to turn to the old masters for inspiration: 'The language they used was then a living one, now it is dead: though their work has in it humanly and

4.8 *The Sick laid in the Streets to be healed*, wood-engraving from *Cassell's Illustrated Family Bible*, 1859–63

artistically such marvellous perfection, for us to repeat their treatment for subjects of sacred or historic import is mere affectation.'[76] Not surprisingly, he chose the image of Christ to support his argument for a contemporary and expressive language of art: 'In the figure of the risen Lord, for instance ... the painters put a flag in His hands to represent His victory over Death: their public had been taught that this adjunct was a part of the alphabet of faith'. Such fragments of an erudite pictorial symbolism long dead and beyond resurrection needed to be replaced with a fresh language that would speak to a wide audience that had not necessarily been trained in the artistic conventions of bygone ages. Hence Hunt claimed enthusiastically that 'with the New Testament in our hands we have new suggestions to make': a claim he attempted to realize with *Christ and the two Marys*.[77]

The picture's significance was not confined to iconography alone; it also

4.9 William
Holman Hunt, *Christ
and the two Marys*,
117.5 × 94 cm, oil on
canvas over wood
panel, 1847
(completed in 1897)

extended to the technique. It was the first work Hunt painted in a fresco-like method. The artist claimed to have been introduced to this technique through a chance encounter in the National Gallery. While he was copying David Wilkie's *The Blind Fiddler*, a former pupil of Wilkie told him about his master's method of painting, which was 'without any dead colouring, finishing each bit thoroughly in the day'.[78] Hunt claimed that this episode 'in some ways determined a great change in the course of my artistic life':

> I began to trace the purity of work in the quattrocentists to the drilling of undeviating manipulation with which fresco-painting had furnished them, and I tried to put aside the loose, irresponsible handling to which I had been trained, and which was nearly universal at the time, and to adopt the practice which excused no false touch.

The highly charged language Hunt used to describe his artistic 'illumination' was informed by the current debates surrounding fresco painting: a technique of true national importance and indicative of the state of a national school of painting. Hence the introduction of a fresco-like technique invested Hunt's own artistic practice not only with a wholesome discipline but also with a degree of national significance that was to be fully played out later in his career.

Hunt's work on *Christ and the two Marys* also displayed another Pre-Raphaelite quality: truth to nature. Since 'it was important to make studies of palm-trees to be introduced into my picture' the artist went to Kew Gardens to draw.[79] His diligent application caught the attention of the curator, who gave him a branch to take home. Hunt carried the twelve-foot branch over his shoulder to Turnham Green station, stoically bearing the cross of the Ruskinian dogma. However, this burden extended much further than to the detailed depiction of a palm-tree. It concerned the representation of Christ himself: a challenge that Hunt found impossible to meet successfully at this stage. Since he completed the abandoned painting towards the end of his career it is difficult to give a detailed assessment of his original conception of the figure of Christ, which does show a marked degree of originality in emphasizing the sheer physicality of the body, but which is also clearly indebted to the much later work *The Shadow of Death* (1870–73).

However, it is important to differentiate between the painting and Hunt's description of the difficulties involved in its production. Despite his claims to the contrary, *Christ and the two Marys* has to be regarded as a fairly typical religious image of the 1840s. The endeavour to mildly orientalize a composition that displayed relatively strong academic conventions also characterized the religious works by artists such as J. R. Herbert and William Dyce, as we have seen. Nonetheless, Hunt adopted the stance of the irreverent revolutionary and presented his inability to complete *Christ and the two Marys* as tough 'mental wrestling'.[80] The abandoned picture also functioned as a sign for the hardships ahead that characterized and ultimately vindicated the artist's career. As the first attempt in the fresco-like technique it played a crucial role in Hunt's account of the formation of the PRB. In his remembered discussions with Millais, Hunt emerged as the

leading figure of the PRB: both the true Pre-Raphaelite practitioner who introduced key elements of the group's hallmark technique and the era's painter of the Christ who strove to innovate religious subject matter.

Private motivations: suppressing the religious experience

In many respects *The Light of the World* (1851–53; Figure 4.10) continued what Hunt had begun with *Christ and the two Marys*. He again represented the risen Christ; the main difference lay in the relationship with the textual source. This was no straightforward illustration but an allegorical representation based on several biblical quotations.[81] The allegory emphasized the Saviour's eternal validity in a somewhat sentimental and comforting way. Hunt presented a timeless, visionary image of Christ roaming the earth, knocking on doors and patiently waiting to be admitted to the human soul, provided the exhortation of the verse from Revelation (3:20) is heeded: 'Behold, I stand at the door, and knock: if any man hear my voice, and open the door, I will come in to him, and will sup with him, and he with me.' The attempt to communicate the eternal appeal of the Saviour through an ahistorical orchard setting and intricate symbolism – manifested in Christ's attire and every pictorial detail – gave the image a fairy-tale flavour.[82] Some of the picture's appeal lies in the fact that the viewer is kept in suspense as to whether Christ's knock will be answered. The artist fully realized the importance of the spectator's involvement in the open-ended narrative. Hence he said he dissuaded Millais from painting a pendant, in which the door is opened and the repentant sinner falls at Christ's feet.[83] In *The Awakening Conscience* (1853–54) Hunt opted for a more subtle 'material counterpart'.[84] Christ's knock has been heard; the kept woman has leapt up from her seducer's lap and is about to heed the still small voice of her conscience.[85] The narrative ambiguity of both paintings concentrates on moments of anticipation and revelation suggestive of change. Only when they are read together is the transformative impulse of Christ's allegorical knock at the door of the human soul translated into the awakening conscience of the decidedly contemporary female protagonist, the fallen woman. While in *Christ and the two Marys* the spectator was invited to emulate the women's reaction to the risen Christ, the open-ended narratives of the two later works – far more ambitious both as individual achievements and in their dialectical relationship – demanded a more complex participation, at once active and emotive.

In a letter to his friend the painter and writer William Bell Scott, Hunt explained the picture's deeply personal motivation:

> I painted the picture with what I thought, unworthy though I was, to be divine command, and not simply as a good subject. When I found it I was reading the Bible, critically determined if I could to find out its flaws for myself, or its inspiration ... I came upon the text, 'Behold ...' ... the figure of Christ standing at the door haunted me, gradually coming in more clearly defined meaning, with logical enrichments, waiting in the night – every night – near the dawn, with a light

4.10 William Holman Hunt, *The Light of the World*, 125.5 x 59.8 cm, oil on canvas over panel, 1851–53

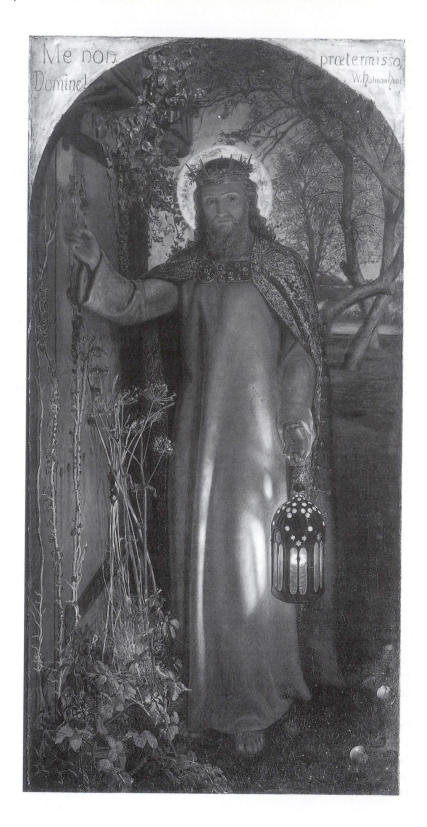

sheltered from chance of extinction, in a lantern necessarily therefore, with a crown on His head bearing that also of thorns; with body robed like a priest, not of Christian time only, and in a world with signs of neglect and blindness. You will say it was an emotional conversion ...[86]

Hunt's confession was made in a letter to a close friend and in response to the news that the picture was being used in a devotional context.[87] Hunt did not mention the experience of his 'emotional conversion' in any of his published writings. It is particularly surprising to find no mention of it in the autobiography which appeared some thirteen years after the letter had been published in Scott's posthumous *Autobiographical Notes* (1892), although Hunt repeatedly referred to his friend's reminiscences.[88] The picture's deeply personal significance is further borne out by the hidden inscription situated under the arched top of the frame – 'Me non praetermisso, Domine!' ('Don't pass me by, Lord') – which was discovered during repairs carried out to the frame in 1919.[89] Mark Roskill has speculated that 'it represents a personal spiritual avowal which was deliberately put in a place where it would remain hidden from the realm of public knowledge'.[90]

It is interesting to speculate why Hunt did not publicly avow the picture's intensely private motivation, or the fact that he felt it had been painted by 'divine command'. It is therefore useful to return to the pages of the autobiography to inspect the way in which he presented the picture's gestation. During a painting trip to Ewell in the summer of 1851, the artist made several sketches for *The Light of the World*, which he explained to Millais:

there is a text in Revelation, 'Behold I stand at the door, and knock.' Nothing is said about the night, but I wish to accentuate the point of its meaning by making it the time of darkness, and that brings us to the need of the lantern in Christ's hand, He being the Bearer of the light to the sinner within, if he will awaken. I shall have a door choked up with weeds, to show that it has not been opened for a long time, and in the background there will be an orchard (I can paint it from the one at the side of this house.)[91]

The sketch Millais saw at Ewell was presumably the sheet that shows the worked-up drawing of *The Light of the World* and two light pencil-sketches of a young couple, reproduced in the autobiography and now in the Ashmolean Museum, Oxford (Figure 4.11). The description of the sketches in the autobiography differs markedly from the account Hunt had given to Scott. In both instances the passage in Revelation provided the initial impetus for the image. However, in the first, Hunt was the more or less passive witness of a vision that gradually grew more clearly defined in meaning. By contrast, the second version showed him as the artist who developed a textual clue into a rich and legible subject. To enhance the meaning he added the night-time setting, lantern and weed-choked door, and invented an idiosyncratic pictorial language that depended on a bizarrely compelling logic. Hunt here demonstrated a fundamental characteristic of Victorian art: the active search for original subject matter. In his conversation with Millais, he discussed *The Light of the World* as 'simply a good subject' and shifted with ease from this to

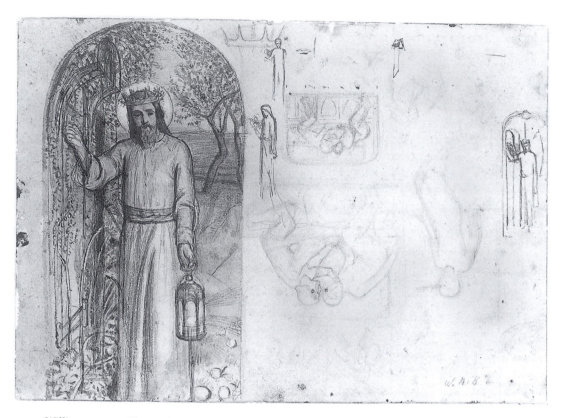

4.11 William
Holman Hunt,
sheet of sketches
for *The Light of
the World*, 24.5 x
34.6 cm, pen and
brown ink over
graphite on
paper, 1851

talking about the theme of the star-crossed lovers that had caught Millais's attention. The discussion remained entirely professional, and Hunt did not mention the subject's deep personal significance.

However, the subject's supernatural dimension found several quite unexpected echoes in his autobiography. These were framed and refracted in complex ways.

During a night-time walk to Kingston station, where Hunt had promised to meet a friend, two memorable incidents occurred. He discovered a hut whose door was 'overgrown with tendrils of ivy, its step choked with weeds' and therefore perfect for his planned picture.[92] As he 'dwelt upon the desolation of the scene, and pictured in mind the darkness of that inner chamber, barred up by man and nature alike', the artist affords us another brief glimpse of himself in the role of Christ. Lantern in hand, Hunt was once again on a mission to act out the Ruskinian dogma as he stood in front of the door to gather empirical evidence of how to render the details of his night scene. Preoccupied with thoughts about his picture, he remembered an incident that had occurred several years earlier, when he saw a ghost. The circumstances were similar. Hunt was walking back from the station at night, accompanied by the station-master and the light of his shaking lantern, when suddenly he noticed 'some white creature':

Yet I kept my eyes riveted on the approaching being. When we had come nearer I interrupted our idle chat, saying, 'But it is steadily coming towards us.' ... The mysterious midnight roamer proved to be no brute, but had the semblance of a

stately, tall man wrapped in white drapery round the head and down to the feet. Stopping within a few paces from us, he seemed to look through me with his solemn gaze. Would he speak? I wondered. Was his ghost clothing merely vapour? I peered at it; it seemed too solid for this, and yet not solid enough for earthly garb.

The apparition disappeared as quietly as it had come, and the narrative switches back to the episode that framed the recollection of the supernatural encounter.

If we examine Hunt's account of this 'unexplained experience' alongside that of the genesis of *The Light of the World* given in the letter to Scott, similar descriptive patterns emerge which suggest a reading of the 'ghost story' as a coded, displaced and alienated version of Hunt's conversion experience, a displacement necessitated by the fact that painting by 'divine command' could not be made to carry any references to the labour-intensive toil characteristic of Pre-Raphaelite work. A subject that simply 'haunted' him and 'gradually [came] in more clearly defined meaning' not only erased all traces of labour but also suggested the controversial role model of the inspired artist-monk. Instead, the narrative privileges an artist who searched for an original subject, discouraged work on a pendant because it threatened to diminish the original impact and overcame immense difficulties in finally realizing his idea. As Herbert Sussman has noted, 'Masculine knowledge is not conferred in moments of revelation, but acquired through hours of hard work, not absorbed through wise passiveness but achieved through strenuous activity.'[93] The lengthy and detailed descriptions of that strenuous activity have served their purpose. What reader of the autobiography does not recall Hunt's description of his midnight painting sessions in late November, his feet stuck in a sack of straw to keep the cold at bay? There is also the astounding lengths he went to in securing the right accessories for his Christ, which range from the expensive brass lamp he designed to requisitioning his mother's heavy linen tablecloth as just the right material for the robe. Featuring prominently in both popular accounts and scholarly interpretations, such details provide some of the most enduring Pre-Raphaelite anecdotage in the history of a movement rich in constantly retold anecdotes.

Hunt's elaborate descriptions of his work on *The Light of the World* also served another important purpose. They charted the difficulty of translating his personal experience of the divine into a detailed, material representation destined to function in the Victorian art world. The picture's insistence on the 'real' was not merely the result of the diligent application of the Pre-Raphaelite style, but also an essential prerequisite for grounding Hunt's transcendental vision in lived experience. In the second volume of *Modern Painters* (1846), Ruskin had sketched some of the problems of representing the 'superhuman ideal'. The spiritual being should not be imagined to function 'through impulse of bone and sinew; its power is immaterial and constant'.[94] Hence he recommended that the spiritual creature be depicted clothed 'with severe and linear draperies, such as were constantly employed before the time of Raffaelle' – and one might add – such as Christ wears in

The Light of the World. Thus the figure's physicality was not just hidden from view; with little to suggest an anatomical body underneath the drapery its material presence was reduced. Ruskin had also advocated reducing the material appearance of any depicted accessory and suggested 'taking away its property of matter altogether' and replacing it with the ethereal textures of cloud, light or vapour. This is reminiscent of Hunt's interest in the exact textural nature of the ghostly apparition, and is also reflected in the use of the full moon to endow Christ with a radiance suggestive of a traditional halo. Ruskin had recommended 'retaining the actual form in its full and material presence, and ... to raise that form by mere inherent dignity to such pitch of power and impressiveness as cannot but assert and stamp it for superhuman'.[95] This suggestion was echoed in Hunt's description of the 'tall man wrapped in white drapery', in which he had recurrently pointed out the figure's solemn and majestic appearance.[96] Although the artist used the means of abstraction and substitution proposed by Ruskin, he framed the figure with the most meticulously painted details. The tension generated by those contrasting pictorial strategies emphasized the visionary power of the image and contributed to its fairy-tale qualities, which were further enhanced by the timeless orchard setting and Christ's rich symbolic attire.

The picture's tensions were echoed in the mixed reviews *The Light of the World* received when first shown at the RA in 1854. For example, the *Athenaeum* critic called it 'a most eccentric and mysterious picture'.[97] He dwelt on its fairy-tale quality, picking out the 'fantastic magic-lantern', the dewy pallium 'spangled with jewels' and the 'glow-worms' in the foreground. His main criticism was reserved for the face of Christ, which he called a 'wild fantasy, though earnest and religious'. He proclaimed the picture '[a]ltogether ... a failure' because it occupied a difficult position as both intensely personal image and aesthetic object. The reviewer implied that Hunt's style was not equal to the intense feeling that motivated the image: 'The manipulation, though morbidly delicate and laboured, is not so massive as the mute passion displayed in the general feeling and detail demands.'

Objections were also voiced by the *Art Journal* critic who considered the subject matter 'too sublime for representation by available forms'.[98] He argued that 'The knocking at the door of the soul is a spiritual figure of such exaltation that it must lose by any reduction to common forms.' The reviewer not only queried whether any of 'the spiritual texts of scripture' lent themselves to representation but also criticized the literalness and materiality of Hunt's style. He regarded the pictorial language as a tired imitation of early art that had originally been designed to instruct audiences 'in a state of ignorance as to scriptural knowledge'.

The discussion of traditional academic notions that had dominated the critical reception of Millais's *Christ in the House of His Parents* was replaced by an interest in the communicative powers of pictorial representation. This shift seemed motivated by the fact that the painting was considered a 'theological discourse' rather than a work of art. The mere mention of a

religious context served to deny the picture any aesthetic value meriting serious consideration. In invoking the religious dimension, the *Art Journal* critic inadvertently also reacted to the painting's fundamental tension. Once again, the profoundly private experience of Hunt's emotional conversion proved too strong to escape notice. It asserted itself as an unexplained presence, exposing the fact that his efforts of aesthetic containment and objectification had been unsuccessful. The pictorial tensions repeatedly prompted a critical reception that failed to consider the aesthetic value.

However, the picture also came under attack from a strictly art-historical perspective. The eminent German art historian Gustav Friedrich Waagen also questioned whether the subject was suitable for pictorial representation and objected to the picture's literalness. He discussed its iconographical muddle, which resulted from the attempt to combine two distinct iconographical traditions: the *Ecce Homo* and 'the glorified Lord of the world'.[99] Waagen detected yet another contradiction: the combination of the idealist and the realist modes of representation. Christ's 'golden glory', he argued, 'belongs altogether to the idealistic and conventional tendency and time of Art', whereas 'the effect of light from the lantern is rendered with all that skilful reality with which the knowledge of the present day represents such effects'. He therefore concluded that the painting represented an incongruous mixture: 'Thus we see two distinct conceptions of the same Person, two widely separated periods, and two utterly opposite tendencies of Art arbitrarily united in the same picture.' Most critics voiced similar objections; they focused on the painting's confusing pictorial rhetoric.

John Ruskin's response differed drastically from the general critical reception. His letter to *The Times* of 5 May 1854 was prompted by the audience's alleged incomprehension of this important work of sacred art. In his opinion, their general lack of appreciation was 'founded on what appeared to them the absurdity of representing the Saviour with a lantern in his hand'.[100] This was, in fact, an 'absurdity' also noticed by the *Athenaeum* reviewer, who had commented on the 'fantastic magic-lantern'. Ruskin seems to have been oblivious to the painting's undeniable pictorial tensions and so he endeavoured to enlighten a public who 'have been so long accustomed to see pictures painted without any purpose or intention whatever, that the unexpected existence of meaning in a work of art may very naturally at first appear … an unkind demand on the spectator's understanding'.[101] In contrast to some critics, who had regarded the pictorial language of the work as naïve and out of touch, Ruskin concluded that it was the audience that was in need of education.

He pointed out that he had not discussed the work with the artist. He thus made a strong claim for the universal legibility of the image, implying that it could be understood by anyone who was willing to consider it carefully. He subjected the painting's complex symbolism to a typological reading and delivered a perceptive interpretation encoded with further biblical references. His careful analysis grasped the picture's underlying symbolic structure, which depended on the notion of painting as language and the

extended typological symbolism that Ruskin had developed in the first two volumes of *Modern Painters*. His understanding of the image was founded on Evangelical thought – fostered by his upbringing and evident in his aesthetic theories – which privileged personal engagement with the biblical text. Hence Ruskin could respond to *The Light of the World* as both a pertinent image of Christ and a serious work of art meriting aesthetic investigation. The tensions detected by other critics were irrelevant in his analysis, which accounted for the intense religious feeling of the image as well as for the painstaking realism through which that feeling was made 'real'.

For a younger generation of critics who evaluated the painting some thirty years on, it had become inseparable from Ruskin's reading. Reviewing the exhibition of Hunt's work held at the Fine Arts Society in 1886, George Bernard Shaw argued that when looking at the picture 'You must become as a little child with a Ruskinised nurse if you wish to enjoy yourself genially.' Shaw clearly noticed the conceptual idiosyncrasies of the image and drew an ironic if logical conclusion, declaring that the appreciative viewer had to possess a certain degree of *naïveté*:

Behold my childish conception realised – the man in the white garment; the stable-lantern (a madly expensive one, but a stable-lantern still); the garden-door; and the still night, with everybody in bed! It is astonishing that a grown-up man – a contemporary of Spencer, Comte and Darwin – should have painted that; but there it is; and whilst England is Evangelical and children are children, it must remain a treasure of English art, faithfully copied from a picture that every English child makes for itself and never quite forgets.[102]

Shaw focused precisely on those details that Hunt had laboured over with such dedication. The endeavour to render the apparition real, to materialize the immaterial, represented the most distinctive feature of the picture and contributed to its enduring appeal. Its immense popularity also rested on the fact that – as Michael Wheeler has observed – 'it defeats sectarian readings by presenting a Christ who appeals to every human heart and by making no overt reference to the contentious issues of church authority or biblical authority'.[103] Unlike any of Hunt's other religious images, two of the three versions have found permanent homes in devotional settings: Keble College Chapel, Oxford, and St Paul's Cathedral, London. With the large version (begun in 1899), which toured the British colonies in 1905–1907 and was donated to St Paul's Cathedral in 1908, *The Light of the World* finally achieved truly iconic status.

However, neither the critics' incomprehension nor their irony fostered Hunt's case for a new and legible pictorial language that sought to reinvigorate the tired traditions of religious painting. It was the preamble to Ruskin's interpretation that provided a useful way of marketing Hunt's art. By asking his readers to consider the amount of time, thought and labour that had gone into the production of *The Light of the World*, Ruskin had called for a balanced economy of art. In his new equation, the beholder was expected to work equally hard by giving due consideration to an image whose complex symbolism was challenging but legible. The Pre-Raphaelite artist

emerged from Ruskin's review as a thoughtful and hard-working labourer of art.

Public narratives: work, art and the figure of Christ as hero

In the memorable scene from Hunt's autobiography in which the figure of Carlyle delivered the damning assessment of *The Light of the World*, the artist attempted to defend his work. Hunt tried to explain that he did 'firmly believe in the idea that [he] had painted' and was convinced that it reflected Carlyle's views.[104] However, the sage was not interested in hearing the explanation of the young artist. Hence there is an unfortunate lacuna in the autobiographical account where one would have wished for Hunt's further response. A similar reticence characterizes Carlyle's six lectures *On Heroes, Hero-Worship, and the Heroic in History* (1841). Although Christ was not featured, his presence permeated the entire text. He was clearly the implicit super-hero and Christianity 'the highest instance of Hero-Worship'.[105] Carlyle gave this awe-inspired description of Christ: 'The greatest of all Heroes is One – whom we do not name here! Let sacred silence meditate that sacred matter; you will find it the ultimate perfection of a principle extant throughout man's whole history on earth.'[106] It does seem likely, though, that Hunt had in mind far more specific passages in *On Heroes* such as the following: 'the Hero can be Poet, Prophet, King, Priest or what you will, according to the kind of world he finds himself born into'.[107] In *The Light of the World* Christ is presented in more than one heroic function by combining those of prophet, priest and king. This combination of roles was recognized by Ruskin who, in his letter to *The Times*, described 'Christ in his everlasting offices of prophet, priest, and king' and interpreted his attire as symbolic of these three functions.[108] Hunt himself was remarkably reticent and never explained the exact relationship between the picture and Carlyle's writings. However, he clearly approved of Ruskin's interpretation, quoting it in full in his autobiography and commenting: 'It could not but gratify and encourage me to read these words of high appreciation.'[109] In the catalogue that accompanied the exhibition of Hunt's *The Finding of the Saviour in the Temple* in 1860, Stephens remarked that Ruskin's intervention did 'justice to the artist and his work'.[110]

Even if Carlyle – in the words of Richard Salmon – 'supplant[ed] the one truly exemplary life of Christ with a multiplicity of biographical narratives', logical deduction still rendered him the *primus inter pares* in a panoply of heroic characters that had forged human history.[111] Carlyle thus contributed to the historicization of Christ, albeit less radically than Christ's early biographer, David Friedrich Strauss.

Carlyle collapsed history and biography in the figure of the hero, claiming that the 'History of the world is but the Biography of great men.'[112] In his lecture on the hero as poet, Carlyle defined the artist as being totally absorbed by the processes of artistic production, which resulted in the

equation of true work with worship.[113] This close connection between biography and the process of production also led to the claim that an artist's character was reflected in his work. Consequently, style was regarded as indicative of character and not merely as subject to changing fashions or artistic conventions. This view was subsequently reiterated by Ruskin, who advocated a similarly holistic concept of the artist: 'He who habituates himself, in his daily life, to seek for the stern facts in whatever he hears or sees, will have these facts again brought before him by the involuntary imaginative power in their noblest associations.'[114] This moral discipline of the personal life – or in Ruskin's words, 'the sense of self-control of the whole man' – furnished the prerequisite for an artistic practice able to fulfil the true ideal of naturalism.

Carlyle's view of the artist undoubtedly influenced Hunt's notion of artistic identity. However, Carlyle's essentially romantic, heroic figure might have been a somewhat lofty role model to aspire to. The genre of populist biography supplied a range of more likely types. For example, Samuel Smiles's *Self-Help* (1859) demonstrated the application of manly character traits such as courage, perseverance, energy and industry – all deployed in the grand pursuit of forming national identity. In the chapter on 'Workers in art', Smiles maintained that 'Art is indeed a long labour.'[115] He further stated that the artist's gift needed to be 'perfected by self-culture, which is of more avail than all the imparted education of the schools'.[116] This model of artistic production, which relied on self-culture, 'painful labour and incessant diligence',[117] was doubly attractive to Hunt. It lay outside the dominant academic dogma with its near-mythical qualities such as genius and originality, as well as its traditional notions of style and prescriptive hierarchy of genres. Furthermore, it placed strong emphasis on the hardship of the working process. This of course not only tallied with the painstaking efforts embodied in early Pre-Raphaelite technique but furthermore it helped reframe the considerable technical problems that Hunt experienced throughout his career.[118]

These related concepts of artistic production also provided a means of validating the Pre-Raphaelite project, once it had relinquished the controversial monastic model. Thus Hunt could present the PRB as a successful newcomer to the artistic field whose style was not just a quirk to attract attention and shock the art establishment but was a sincere expression of the Brotherhood's heroic 'fight for art'.[119]

The general proliferation and diversification of biographical narratives – from the modern invention of the Life of Jesus to Carlyle's pantheon of heroes and Smiles's formulaic success stories – not only helped conceptualize history as biography but also offered one unbroken continuum, which encompassed both Jesus Christ and everyman. If history was biography, then the opposite was true as well: biography as history is what Hunt deliberately practised in his monumental account of his life.

Hunt's detailed description of his encounter with Carlyle served as a lesson in the impossibility of painting a historical likeness of Jesus Christ.

Hunt's Carlyle craved 'a veritable contemporary representation' that would give detailed information about the Saviour's character, appearance and dress.[120] This kind of historical effigy, he suggested, was conducive to the writing of history as it would enable the re-imagining of the true Christ even across the temporal and spatial divide: an act that Carlyle himself had emphatically refrained from in his lectures on heroes. Having dismissed past and present efforts to paint Christ (including Hunt's *The Light of the World*), Carlyle presented the following rather unglamorous but manly vision of Jesus as both human and divine: 'toiling along in the hot sun', 'hungry often and footsore', 'imparting blessings to others which no human power, be it king's or emperor's or priest's, was strong enough to give to Him'.[121] He felt that the traditional means of representing Christ's majesty, deployed by Hunt and others, had not done justice to the Son of Man, in his actual historical circumstances. He concluded that it was impossible to paint a true, historically accurate image of Christ and gave Hunt one final piece of advice: 'Take my word for it, and use your cunning hand and eyes for something that ye see about ye … and, above all, do not confuse your understanding with mysteries.'[122] The Carlyle who spoke in the pages of Hunt's autobiography was of course conjured up by the authorial voice. But to what purpose did the artist ventriloquize Carlyle's rather unfavourable opinions without allowing himself to have the final word?

The encounter with Carlyle, which was rightly recognized as one of the autobiography's key scenes, functioned on several levels. It presented the quest for Christ as the central problem of the age, a problem that even the great Carlyle found impossible to resolve in his own writings, where Christ had remained that reverently invoked hero between the lines, too sublime to fully sketch. The episode also gave focus and narrative drive to Hunt's description of his Eastern travels, an idea he had toyed with for some time but that was in no way as clearly determined as autobiographical hindsight made it appear.[123]

According to the romantic emplotment of the autobiography, the encounter between the wise old man and the young artist served to encode Hunt's imminent journey to the Holy Land as the quintessential heroic quest,[124] a quest characterized not only by a long history of past failures but by the inevitability of failure. When Hunt decided to travel, the risk he was about to take was not confined to the realm of art, though. As he seemed by 1853 to be gaining a foothold in the Victorian art world the risks involved in his Eastern travels were both professional and physical. Well-meaning friends kept voicing concerns about his health and reminded him of the fate of David Wilkie who had died on his return journey from Palestine in 1841, where he had been working on biblical subjects in an attempt to establish a truly contemporary Protestant painting. Thus Hunt staged his journey and its artistic result – the immensely successful *The Finding of the Saviour in the Temple* – as the belated fulfilment of this near-impossible and dangerous task. The laconic hero was to be vindicated through the deed and not through a prolix argument conducted in the comfort of his studio. He seems to have shared

with Wilkie not only technique and artistic endeavour but also – according to Smiles – a dislike of talking artists: 'Talkers may sow, but the silent reap.'[125]

There is evidence to suggest that his trip was not primarily motivated by a desire to paint biblical subjects. Two pendant pen-and-ink sketches, produced in the summer of 1852, contrasted modes of artistic production (Figures 1.4 and 4.12).[126] The soggy, wind-swept English scene shows the artist uncomfortably hunched over his sketch pad, with a wrecked umbrella billowing overhead and his hat taking flight. In comparison, in the other sketch artistic pursuits in the East are positively idyllic. Here Hunt is seen working on a portrait commission, which he is executing in oils on canvas. Unruly accessories and bleak scenery are replaced by a tasselled parasol, attentive servants and a fountain, set in an arcaded courtyard. The fantasy of the Orient is expressed in the luxurious conditions, which extend to the mode of artistic production.

When Hunt finally turned his long-cherished idea of Eastern travel into reality, he seems to have given little actual thought to the type of work he would produce. Shortly after his departure he wrote to Millais:

your account of my intention as understood by my friends generally, to employ myself in the illustration of scriptural subjects, which I learn is announced publicly in the *Daily News* as the object of my travels, is most amusing when considered with the fact that I have not a single intention formed about work of any kind.[127]

Even Hunt's first biographer F. G. Stephens, who mostly presented a determined and loyal narrative, resorted to an ambiguous formulation when talking about the motivation for the Eastern trip: 'our subject had a foretaste of the difficulties that were to be encountered in carrying out such a subject as that of the "Finding of the Saviour in the Temple," to execute which his inclination, and indeed, previous studies, most seriously inclined him'.[128] The circular argument, the tautological use of noun and verb and the awkward parallel of 'our subject' (the artist) and the subject of the picture (Jesus Christ) make this a less than convincing statement of artistic intent.

In the autobiography, Hunt remedied this ambiguous account. Here he offered the reader several furtive parallels between himself and Christ, which all occurred in the pursuit of work as worship. He presented his Eastern travels as both a 'project … [that] had originated when I was a boy at school when the lessons from the New Testament were read' and a part of an important artistic lineage.[129] The figure of Wilkie – accidental and posthumous purveyor of the fresco-like technique and doomed fellow-quester – served as a potent reminder of the dangers involved in the quest for Christ. Equipped with the key to a new form of representation, Hunt succeeded in the endeavour to create a new form of Protestant painting. The acceptance of Carlyle's challenge to paint a true representation of Jesus Christ not only necessitated first-hand experience of the East but also generated truly heroic narratives of artistic production. Hunt braved 'real' dangers and enacted not just the role of the plodding Smilesian art-worker but increasingly also that of the glamorous Carlylean hero-artist dedicated to the gospel of work.[130]

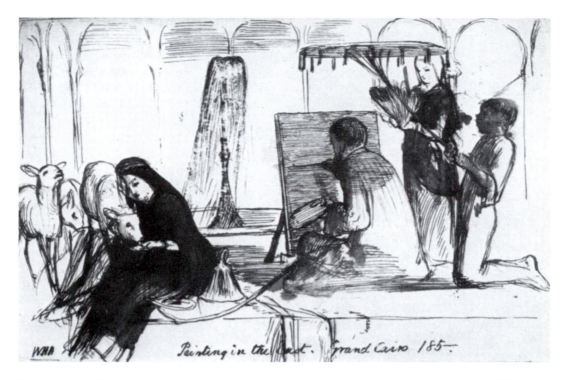

Experiencing the East

Hunt's Eastern project was typical of a contemporary culture of travel and exploration manifested in a wide range of illustrated travel books and endeavours. Edward Robinson's research trip of 1838 led to the foundation of the Palestine Exploration Fund, and the publication of John Murray's *Handbook for Travellers in the Holy Land* in 1854, followed by Thomas Cook's Nile cruises in the 1860s, marked the beginnings of commercial tourism.[131] Hunt was following in the footsteps of other artists. David Roberts had made a successful career out of presenting the impressive topography of far-away places such as Egypt and the Holy Land to mid-Victorian audiences. And as we have seen David Wilkie travelled to the Middle East to paint biblical subjects but died before bringing his work to fruition. In his autobiography, Hunt invoked this line of succession and simultaneously distanced himself from it. In true Pre-Raphaelite fashion, he intended to paint on the spot rather than amass a portfolio of sketches to work from at home.[132]

Hunt's trip functioned according to the classic trope of orientalist discourse, in that – in the words of James Thompson – 'exploring the "otherness" of the East was and is an act of self-definition'.[133] This process of self-definition registered differently in the artist's actual experience, as documented in diaries and letters written to correspondents in England during his stay in the Middle East, and in the much later public retellings of that experience.[134] Far away from home, Hunt lacked the mutual support of the PRB that had sustained its members during the first years of their

4.12 William Holman Hunt, *Painting in the East, Grand Cairo 185—*, 12.3 x 18.3 cm, pen and sepia wash on paper, 1852

professional struggle; he felt isolated and displaced and was plagued by self-doubt, anxiety and loneliness.[135] His diaries show that he found the encounter with the East deeply unsettling; he was also unsure about his artistic vocation and constantly doubting the quality of his work. He reported on the marred progress of *The Scapegoat*: 'No! *my work* of yesterday is n*ot satisfactory*. and can only be corrected by erasure … [emphases in the original]'.[136] To relieve such worries he sought direct communication with God. The following passage represents a typical example from the diary:

I walked out to night alone and laid all [my (illegible) weakness (crossed out in Hunt's own hand)] my unworthiness before God and prayed Him to guide me in truth and keep me in all peace in this world in His service being strengthened for a higher service in that which is to come, and the comfortable assurance *I felt that he heard me*. wake often through the night from anxiety to get ready for my sketch before Sunrise [emphasis in the original].[137]

However, the 'official' accounts of his Eastern adventures – published in the *Contemporary Review* and in the autobiography – are free from such anxious moments. They possess a truly heroic dimension. Through rigorous editing and the application of Smilesian and Carlylean ideologies, the true Pre-Raphaelite artist emerged: the intrepid Englishman who – trusting in God – braved dangers and difficulties to achieve his mission of duty and devotion.

This was indeed a 'double-act' of self-definition: both private survival and public re-imaging. In the autobiography's definitive account, this was already apparent in the framing narratives of arrival and departure. During his voyage across the Mediterranean, which he passed in the company of colonial officials returning to India, Hunt meditated on the state of the arts in Britain, bemoaned the lack of state patronage and defined himself as an art-worker whose project depended on the 'sinews of art as well as of war'.[138] On his homeward journey, he shared a ship with British soldiers returning from the Crimean War. He drew a bleak comparison between 'the difference of our nation's regard for their work and mine'.[139] Although both had been working for the benefit of the nation, he was as yet unsure about the outcome of his artistic campaign. This truly combative and imperialist act of self-definition also marked his encounters with the native culture. Shortly after his arrival, Hunt surveyed urban life from the window of his Cairo hotel room: 'looking down upon mortal interests as much apart as the gods might survey mankind from the clouds'.[140]

Once established in Egypt, Hunt was struck by the Orient's legendary timelessness. This classic trope of orientalist discourse seemed to suggest a way of depicting biblical subject matter and at the same time following Carlyle's advice to 'use your cunning hand and eyes for something that ye see about ye'.[141] In a letter to John Lucas Tupper written from Jerusalem in July 1854, Hunt described how the landscapes of Palestine made biblical history come alive:

it is most interesting to read the Bible and Gospel history. the course of the events seem so much more comprehensible – the journeys of the Saviour in the last days of his ministration, from Bethany to Jerusalem to the Temple around the Mount of Olives and his rejection of the city from this road seem so real as to appear like an

event of the day, and one can imagine Him ... walking with dusty feet along this way, wondered at by some, hated by some, and laughed at by others, and this dream turns into reality as it becomes more vivid ...[142]

In its attention to detail this description echoed Carlyle's vision of a historical Jesus. It also reflected a common reaction to the landscapes of the East, most clearly expressed by Arthur Penrhyn Stanley, a leading figure of the Broad Church party, who believed in the educational value of 'Sacred geography'.[143] In *Sinai and Palestine in Connection with Their History* (1856), Stanley wrote that 'it is one of the great charms of Eastern travelling, that the framework of life, of customs, of manners, even of dress and speech, is still substantially the same as it was ages ago'.[144] He maintained that the factual evidence available to the traveller 'contain[s] a mine of Scriptural illustration which it is an unworthy superstition either to despise or to fear'.[145] Consequently, he considered such information vital for a modern form of belief, and warned his readers not to dismiss it as 'superfluous or trivial' or 'derogatory to their ideal or divine character'.[146] Hunt too was charmed by Palestine's sacred geography, as the following diary entry reveals:

Sweet *Nazareth of Galilee* never did I imagine thee so lovely in all the many times that I have tried to picture the abode of our Lord. The sight of it this night crowds into my mind a thousand remembrances from the days of my school time when I first read the history of the Master who lived humbly and in sorrow [emphasis in the original].[147]

In addition to such moving moments that Hunt committed to his diary or shared in letters to friends, F. G. Stephens described the artist's encounter with the East as an opportunity for historical and ethnographical research:

In the first case, he went to Egypt as the best portal to the regions of the Oriental world ... he remained in Egypt several months, familiarizing himself with the Oriental character, studying Eastern life as it was to be found round about him, and visiting many historically famous localities ... he made studies of the people, at one time in the cities, and at another in the desert. This afforded leisure to go over all the subjects of a Scriptural kind, and, if we may so phrase it, *Orientalize* himself, and divest his mind of the conventional ideas incident to a northern education.[148]

In the process of mining this wealth of empirical evidence – 'the manners and customs of a people that have preserved the same unchanged from age to age'[149] – Hunt also initiated his refashioning as explorer-artist. This is particularly evident in his article 'Painting "The Scapegoat"', which appeared in the *Contemporary Review* in 1887. Hunt fully understood the compelling power of a good story, writing to Mary Millais, 'I should think no picture was ever painted under such romantic circumstances, and so it seemed only right to tell the story.'[150] Here he presented himself as the intrepid explorer who negotiated with cunning Arabs and braved physical discomforts and outright dangers to produce *The Scapegoat* (1854–55; Figure 4.13).

The painting's subject was taken from Leviticus, where Chapter 16 describes the ancient Jewish ritual of Atonement. Two goats were chosen to symbolize the annual expiation of sin. While one was sacrificed in the

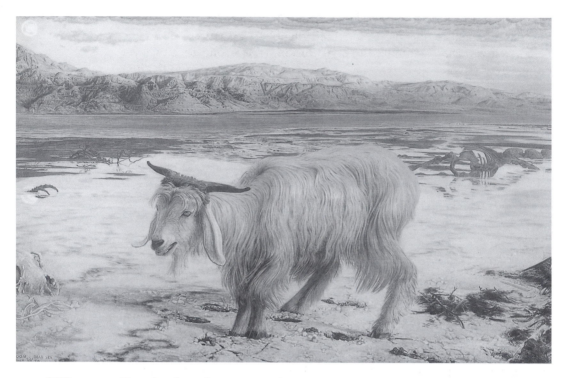

4.13 William
Holman Hunt,
The Scapegoat, 87
x 139.8 cm, oil
on canvas,
1854–55

Temple, the other was made to carry 'all the iniquities of the children of Israel, and all their transgressions in all their sins … into the wilderness' (verse 21). A filament of red wool symbolizing this sinful burden was tied around the goat's horns; when it had been bleached by the desert sun all the transgressions would have been atoned for. Although Hunt was actively searching for biblical subjects to paint while in the East, the scapegoat was suggested by his first-hand experience of the Dead Sea's desolate shores, the site of Sodom and Gomorrah that evoked memories of sin and destruction.[151] In making this the scapegoat's final destination Hunt deviated from the biblical account, offering instead his own powerful and imaginative reinterpretation of sacred geography. Despite the immediate inspiration of the Middle Eastern landscape and its biblical resonances, his pictorial strategies remained those first deployed in *The Light of the World*. The picture's system of signification depended on a complex web of related biblical quotations: the scapegoat figured as a type of Christ, foreshadowing his suffering. Unlike the former picture, which depended on a pictorial logic that mostly could be read off the canvas (as Ruskin had demonstrated with such panache), *The Scapegoat* required erudite biblical knowledge, which Hunt felt the need to supply when discussing the painting in his autobiography.[152] Furthermore, it was almost without precedent in the history of art. Although biblical, the subject matter seemed to challenge the boundaries of well-established but low genres – landscape and animal painting. Such factors made this a highly unusual religious image. Even 'a great picture-dealer' – Ernest Gambart, in fact – who called on the artist was

baffled by this recent work: according to Hunt, 'he objected to the subject as unsuitable, and also as unknown and unintelligible'.[153]

When it was shown at the RA in 1856, Ruskin wrote a long, sensitive, yet ultimately unfavourable review, the gist of which was contained in the first sentence: 'This singular picture, though in many respects faultful, and in some wholly a failure, is yet the one, of all in the gallery which should furnish us with most food for thought.'[154] Ruskin had previously argued for a balanced economy of art and demanded the viewer's attention for a work that was so full of thought. This time he also demanded admiration for an artist who 'pursues his work with patience through months of solitude': 'we cannot … esteem too highly … the temper and the toil which have produced this picture for us'. Its importance lay in the artist's attitude to work: 'He travels, not merely to fill his portfolio with pretty sketches, but in as determined a temper as ever mediaeval pilgrim, to do a certain work in the Holy Land.' The pilgrim, whose religiously motivated determination is akin to that of the explorer, has replaced the ambiguous figure of the artist-monk. Ruskin praised the young painter who had forsaken the relative comforts of the Victorian art world for the uncertainties of the desert. He was in fact the first to present Hunt as an art-worker of the Empire, drawing a memorable parallel between the white tents in the Crimea and 'one peaceful English tent … pitched beside a shipless sea; and the whole strength of an English heart spent in painting a weary goat, dying upon its salt sand'. While emphatically praising 'the self-denial and resolve needed for its execution', the critic had strong reservations about the painting's aesthetic and technical merits, however: 'Mr Hunt has been blinded by his intense sentiment to the real weakness of the pictorial expression.' Ruskin concluded that 'I hold it to be good only as an omen, not as an achievement.' Other critics saw no promise in the work. Their main objection concerned the relationship between the signifier and the signified: 'the goat is but a goat, and we have no right to consider it an allegorical animal'.[155] Hunt's continued and increasingly radical use of allegory, first applauded in Ruskin's insightful reading of *The Light of the World*, seemed to have resulted in failure, just as the figure of Carlyle was to prophesy in Hunt's autobiography.

Indeed, *The Scapegoat* is a paradoxical and complex image that does test the limits of a pictorial language based on imaginative and typological exegesis. However, the exceptional circumstances under which the work had been produced were generally noted with admiration. This mode of reception informed Hunt's deliberate self-fashioning, apparent not only in his subsequent autobiographical writings but also in populist accounts of the artist's life in which this narrative of artistic production was to be perfected, in both its sublime and ridiculous aspects. The latter are particularly apparent in a photograph – published to accompany Mrs Meynell's hagiographic account in the Christmas supplement of the *Art Journal* of 1893 – in which Hunt restaged the painting of *The Scapegoat* in his back garden (Figure 4.14).

4.14 *Mr. Holman Hunt in his Costume when painting 'The Scapegoat'*, photograph reproduced in Farrar and Meynell, *William Holman Hunt: His Life and Work*, 1893

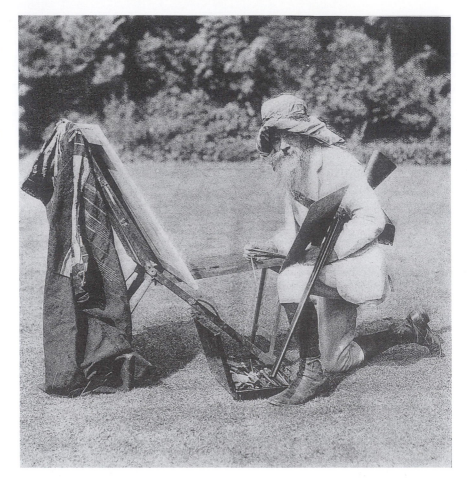

Finding the Saviour, at last

Begun in Jerusalem in 1854 and finally exhibited at the German Gallery in London in 1860, *The Finding of the Saviour in the Temple* was the key work of the artist's first Eastern trip and his most important so far. In order to reclaim the considerable expense accrued during its long period of gestation, Hunt showed genuine Smilesian business sense. He sold the picture and the copyright to the art dealer Ernest Gambart for the unprecedented sum of 5,500 guineas.[156] Gambart sought to recoup this expense through admission charges, catalogue sales and engravings.[157] The format of the commercial one-artist show had thus lost the potential for financial ruin that had destroyed Haydon's career and threatened Martin's. However, it retained the lure of a possible anti-academic stance that was attractive to the art rebel who saw himself as Haydon's heir-apparent.[158] The picture's enormous success, which marked Hunt's artistic breakthrough, was partly due to its controlled and thoughtful presentation. For the first time, the artist managed every aspect of his work: display, interpretation and reception. This enabled the persuasive presentation of Hunt's heroic enterprise. In the pamphlet accompanying the

exhibition and written with the approval of the artist, Frederic George Stephens presented a populist, contemporary narrative of artistic production that emphasized the continuity of Hunt's engagement with the figure of Christ.[159] As George Landow has noted, Stephens's detailed description of the picture and its complex symbolism – published in several lengthy reviews and in the pamphlet – was paraphrased in most subsequent reviews.[160] The pamphlet also reprinted the majority of positive reviews in its appendix, thus reiterating and vindicating the unusual artistic project. This suggests that the artist and his dealer left nothing to chance to influence the picture's critical reception: a cautious strategy necessitated by the lukewarm reception of Hunt's previous religious works exhibited at the RA, a venue whose mechanisms of critique were beyond the control of the individual artist.[161]

The Finding of the Saviour in the Temple depicts a scene from the youth of Christ. On a trip to Jerusalem to attend the Passover festival, Jesus got separated from his parents. They searched for their son in the streets of Jerusalem and finally found him in the temple, in deep discussion with the rabbis. Hunt's picture is based on a passage from the Gospel of St Luke (2:47–9; Plate 10). The three verses are elliptical and offer little narrative detail. Hunt's interpretation of the scene was highly unusual in that he chose to illustrate the moment when Christ becomes fully aware of his divine mission. The boy rejects his mother's fretting embrace, and to his parents' admonition that they have been looking for him all over the city for the past three days, he replies: 'How is it that ye sought me? wist ye not that I must be about my Father's business?' (Luke 2:49). Judith Bronkhurst has noted that Hunt chose to make Christ's discussion with the doctors 'a scene of confrontation between the Old and New Dispensations' rather than depicting it in the more traditional form of a dialogue.[162] This observation is corroborated by Stephens's detailed description of the blind rabbi: 'He is the type of obstinate adherence to the old and effete doctrine and pertinacious refusal of the new. Blind, imbecile, he cares not to examine the bearer of glad tidings, but clings to the superseded dispensation.'[163] The use of typological symbolism provided a means of transcending the immediate time-frame to express a more general idea of resistance to Christ's teaching. The confrontation between Christ and the rabbis – between old and new systems of belief – not only reflected Hunt's experience of the East as 'them' and 'us' but also encapsulated the confrontational position of the artistic newcomer – the true Pre-Raphaelite who intended to continue the group's controversial artistic mission.

Hunt's picture grounded Christ's realization of his divine mission in an historical moment, captured by the painstaking Pre-Raphaelite technique. Stephens compared the artist's working methods to those of the historian and the ethnographer:

Mr. Hunt of simple necessity discarded the old-fashioned blanket draperies, because he found that description of costume had never been adopted in the country of our Lord. Dealing with an incident of Jewish history, he could not avoid painting those

concerned therein as Jews … His actors are therefore costumed in various and brilliant fabrics of Oriental character, much like those worn in Syria to this day …'[164]

For this historical re-enactment, Hunt had also studied the exact topography of the landscape background and the architectural history of the temple setting.[165] Despite orientalist inaccuracies such as using the Alhambra Court at the Crystal Palace as a model for the interior of the Temple – the experience of spiritual awakening was framed as a specific historical moment. Overall, the precision of the research is conveyed in the work's meticulous execution and corroborated by the accompanying written accounts. In fact, the manner of the execution reminded Edmund Gosse of natural specimens rather than of a work of art. In his reminiscences, *Father and Son*, he recalled going to see *The Finding of the Saviour in the Temple*:

the exact, minute and hard execution of Mr Hunt was in sympathy with the methods we ourselves were in the habit of using when we painted butterflies and seaweeds, placing perfectly pure pigments side by side, without any nonsense about chiaroscuro. This large, bright, comprehensive picture made a very deep impression upon me, not exactly as a work of art, but as a brilliant natural specimen.[166]

By staging the scriptural account using the pictorial means usually associated with the representation of natural history, Hunt not only lent a scientific dimension to the picture but also authenticated the story *as* history. Free from what Gosse had termed the nonsensical conventions of art, the picture constructed both the scene itself and its mode of representation as fact rather than fiction, offering itself up for microscopic scrutiny.

However, the image also relied on an intricate web of typological references, which intertwined Old and New Testament events in a very traditional form of exegesis. Typological symbols transcended the actual scene: for example the doves entering the temple, the lamb taken to sacrifice and the cornerstone being prepared in the yard – most probably a reference to Ruskin's memorable interpretation of Tintoretto's *Annunciation* which had made a lasting impression on the artist. They recalled Christ's divinity and mission as well as the wider framework of Christianity.[167]

Hunt sought to control the strong proliferation of meaning inherent in *The Finding of the Saviour in the Temple* with the help of a number of different texts. Together with the painting's title, the verses from the Gospel of St Luke inscribed on the ivory flat of the frame enabled the viewer to identify an unusual rendering of the scene. A quotation from Malachi (3:1) – 'and the Lord, whom ye seek, shall suddenly come to this temple' – forms part of the actual picture. Inscribed on the temple door in both Latin and Hebrew, it induces a prefigurative reading of the image and signals the complex web of typological referents. These two textual sources allowed a deciphering of both subject matter and symbolism. In Barthes's terms, they functioned as textual anchors 'intended to *fix* the floating chain of signifieds in such a way as to counter the terror of uncertain signs'.[168] However, the artist aspired to historical veracity; therefore the inscription has to blend in and is given in Latin and Hebrew. While the textual elements that are external to the picture

(the title and the New Testament quotations) help to fix its meaning, the signal deployed to unlock the picture's typological ramifications remains muted because it is submerged in the realist mode of representation.

The realist mode is similarly dominant in the representation of Christ's internal revelation, expressed through the position of his body and the halo-like glow of his backlit hair. The posture implies a forward movement that leads outside the historically defined space. Christ's gaze is also directed outside the frame yet remains strangely unfocused. The detailed representation of the material world could only suggest the divine as a sphere that lies beyond the frame. The theme of conversion was of course central to both *The Light of the World* and *The Finding of the Saviour in the Temple*. Yet the picture's visual lacuna enabled a personal engagement with the transcendental moment, which the visionary Christ of *The Light of the World* prevented.

Hunt conceived Christ as the Carlylean hero who recognized his calling and accepted his self-sacrificing mission. According to the narrative logic of Hunt's autobiography, *The Finding of the Saviour in the Temple* constituted a deferred answer to Carlyle's criticism and a coded vindication not only of the artist's Carlylean view of Christ but also of his own artistic quest. The heroic qualities implied in the biblical narrative were fully brought out in the depiction of the youth girding his loins and submitting to the task ahead. Stephens complimented Hunt on his conception of Christ, especially for 'not rendering this a simple type of passive holiness or asceticism' and for 'the fine Englishness of his idea of the splendid body of our Lord'.[169] The contrast between the dynamic upright figure and the seated rabbis was further emphasized through the juxtaposition of blindness and vision. Framed by two blind figures – the old rabbi who clutches the Torah reassuringly and the beggar sitting on the steps of the temple – Christ's mode of seeing not only transcended the material reality of the painted surface, but was also reminiscent of the Carlylean hero's ability 'to see the awful *truth* of things'.[170] An analogous kind of visual truth also governed the Pre-Raphaelite aesthetic. It had rejected the laws of the old, academic dispensation and instead introduced a new pictorial language, at first criticized as quaint and revivalist. Hunt modified this visual language through combining fully developed orientalist strategies – detachment and the transparency of realistic representation – with historical research and typological symbolism.[171] He also successfully reframed his personal religious experience as a public spectacle that reflected the growing historical and scientific interest in the Bible.

In lengthy and detailed reviews that appeared in the *Athenaeum* and *Macmillan's Magazine* in April and May 1860 respectively, F. G. Stephens set out to promote Hunt's artistic project. He developed the by then well-rehearsed Ruskinian argument that since the artist 'had spared neither time, labour, study, nor expense in order to put before the world a picture produced exactly in his own ideal' the work merited the viewer's full attention.[172] Furthermore, he emphasized the fact that 'Mr. Holman Hunt is essentially an English painter, and has taken a thoroughly national idea of his

work'.[173] This, so he argued, was manifest in the artist's representation of Christ, 'expressing the English idea of duty to be performed'. In his praise, Stephens invoked the Carlylean notion of the artist who in total devotion to his work produces images that seem to make history come alive:

The unflinching devotion shown by the painter, and the inherent nobility of his principles of art have, then, this great merit in them, that the result stands before us almost with the solemnity of fact. It seems life that has been lived, and a potent teaching for us all, not only to show the way in which our labours should be performed, – by that by which Mr. Hunt has executed his, – but, by the vividness and vitality of his representation, the first step of Christ's mission produces a fresh, and, it may be, deeper impression upon the mind, than that which most men have to recall the memories of their youth to enter on.[174]

Here devotion to art was no longer conceived according to the suspect and strongly criticized monastic model of the Brotherhood years, but was characterized as a truly personal and national endeavour. The universal call to duty was inherent in the picture's subject matter and its flawless execution: 'a modern instance of applicability to the life of every man'. The value of Christ's moral exemplar was evidenced in the meticulous and heroic execution of the work itself. Here Christ as the subject of a new Protestant painting and the artist as the subject of a critical and biographical narrative were featured in parallel. Stephens thus set the complimentary tone that was echoed by the majority of reviewers.

Fraser's Magazine, for example, praised Hunt's approach to biblical painting as thoroughly modern because it incorporated the current state of knowledge about the East: 'For us who can study the East, and know how unbroken a tradition the arts of life and manners have there persisted [*sic*], to return to that earlier phase of feeling would be really anachronistic.'[175] The critic commended the artist for having shown 'not that religious art is exhausted, but rather that it has never yet reached its full and fair perfection', a sentiment Ruskin had voiced in the third volume of *Modern Painters*.[176] Other critics also increasingly valued the intense conceptual and physical labour apparent in the painting. One reviewer even invoked the Carlylean concept of labour as worship and classified the picture as one of those 'unconscious[…] acts of prayer and praise'.[177] The critic for *Once a Week* raised a further important issue relating to the Pre-Raphaelite approach to scriptural painting:

It is curious to observe how this adherence to truth of detail has led the Pre-Raphaelites to create a principle in religious painting opposed to previous methods. Great religious painters hitherto have striven to attain their aim through idealization … to mark the divineness of the subject the surrounding accessories were generally of a purely conventional character … by making the picture *unearthly*, it was sought to make it divine. With the Pre-Raphaelites the reverse; their principle is realization: in showing us as truly as possible *the real*, we are to behold the wonder of the divine.[178]

Here the critical reception of Hunt's work finally broke free from the dominant academic paradigm to fully appreciate the realistic mode of

representation.[179] The critic for *Once a Week* stated unequivocally 'that the picture, to be fairly judged, must be judged by the principle of realization – not hastily condemned because it does not follow the commonly adopted method of idealization'.[180] The realist mode was further defended on grounds of truthfulness: 'In his earnest desire to represent our Saviour with the greatest possible truthfulness, Mr. Hunt has attained by his method a result which, in holiness of feeling and depth of tenderness, rivals the efforts of the greatest masters of religious art.' In conclusion, the critic argued for an artistic broad church, in which Hunt's earnest realism would be allowed to coexist with the idealist art of Raphael. Another critic offered even more enthusiastic praise, claiming that Hunt's depiction of the rabbis 'deserve[d] to be compared with the Athenian listeners in Mars Hill, in Raffaelle's cartoon of "Paul Preaching at Athens"'.[181] While this was a surprisingly traditional if powerful comparison, W. M. Rossetti, reviewing for *The Critic*, singled out the artist's immense pictorial innovations: 'Running in none of the old grooves, helped or impeded by none of the old familiar conventions of historic or religious art, Mr Hunt's conception … is in a new convention of its own.'[182] He credited the artist with 'attaining a wholly fresh and original realization of themes at once sacred and stale'.

However, Hunt's unconventional and extremely detailed realization did raise the question of legibility. Although most reviewers admired the fact that the artist had 'toiled hard to make this a faithful representation of the scene in its historical completeness',[183] some found the comprehensive data overwhelming. One argued that: 'We are in danger of … failing to read the sublime meaning in the face of Christ, already occupied with his divine mission.'[184] The *Manchester Guardian* critic gasped that the 'picture is replete with meaning from the foreground to the remotest distance. Indeed, it absolutely overflows with significance. There are symbols everywhere … Nay, the symbols have overflowed the picture, and expanded themselves all over the frame.'[185] The reviewer contended that the meaning was obscured by this plethora of signification.

The problem of how to unravel the visual conundrum that Hunt's painting represented is also evident in Stephens's pamphlet. He went to some lengths to explain the painting's obscure typological and symbolic references, embedded in its many details.[186] He aimed to confirm both its historical accuracy and its symbolic structure. However, the demands of historical explication do not sit well with the pervasive symbolism. In a historical-realist mode of representation, what cannot be authenticated, and thus represented, is the supernatural dimension of the scene. The emphasis on realistic depiction creates an internal logic that seems to work against the successful construction of symbolic meaning. This degree of realization, of course, jarred with the academic ideal so rigorously upheld by Henry Howard, who had regarded religious painting as truly epic and timeless. Nevertheless, Stephens enthusiastically enlisted the positive characteristics that the periodical press had associated with academic history painting – such as education, moral values, progress and nationalism – for Hunt's

work, which he regarded as a continuation of the original Pre-Raphaelite project.[187] One reviewer echoed Stephens's claims that the picture 'brings a real addition to our knowledge; that it refines, elevates, and invigorates our tastes'.[188] Reviewers frequently cited 'the evidence of historical research' and the picture's unconventionality as indicative of a modern religious art that was not endeavouring 'to accommodate special religious opinions'.[189] The 'depth of its realism' also seemed to indicate that the picture was 'serious and high in feeling without pietism, or asceticism, or sectarianism'.[190] Both Stephens and the majority of reviewers welcomed *The Finding of the Saviour in the Temple* as a new departure that combined the established values of history painting with a modern approach to biblical scholarship to create a truly contemporary Protestant art. In this context, Pre-Raphaelite attention to detail was no longer just a stylistic quirk that threatened the established relationship between subject matter and style; it manifested the artist's earnest labour and authenticated the picture's historical dimension.

The vindication of the Pre-Raphaelite project depended to a large extent on a persuasive narrative of production that was both heroic and contemporary. Its chief emphasis was on the importance of labour, mostly hidden from view. Stephens claimed, 'We should need to write a bulky volume to illustrate fully all the recondite and diversified labours which the artist has brought to bear upon the accessories of this work.'[191] The pamphlet Stephens wrote for the exhibition of *The Finding of the Saviour in the Temple* is by no means a 'bulky volume'. But it authenticated the process of the painting's production and cited the authority of learned scholars in regard to particular pictorial details, thus validating the work in the same way that footnotes support the writing of history.

Stephens represented Hunt as the dedicated, hard-working, truth-loving artist who braved the dangers of the East to produce a representation of Christ that reflected increased knowledge in all aspects of the Bible. In his account of the picture's production, the critic identified the meticulous Pre-Raphaelite style as a symbol of 'a thoroughly English principle' which manifested itself in workmanlike execution, relentless historical reconstruction and 'the idea of devotion to duty ... inculcated by the very action of the chief figure'.[192] Overall, Stephens's biographical sketch drew on Samuel Smiles's populist and topical notion of self-help that promoted characteristics such as courage, perseverance and determination as the basis for both individual success and national character. This romantic portrayal of the artist's struggle, marked by poverty and adversity, distinctly displeased Hunt's relatives, who regarded it as exaggerated and untrue.[193] One of the Smilesian traits that Stephens promoted was the artist's keen business sense, which characterized his entire Eastern project.[194] In a letter to W. M. Rossetti written from Jerusalem in 1855, Hunt described his artistic mission as a commercial venture and identified a shared market in which he endeavoured to stake his claim:

I am not satisfied with the thousand books of travel that come out every year, but even these in all their trivialities and superficialities are a keen reproof to painters. I have a notion that painters should go out two by two, like merchants of nature, and bring back precious merchandise in faithful pictures of scenes interesting from historical considerations or from the strangeness of the subject itself.[195]

The mercantile language Hunt used to describe his Eastern project reflected the notion of art as enterprise that Ruskin advanced in *The Political Economy of Art* in 1857. Here the critic refined a well-established line of argument previously invoked in defence of the Pre-Raphaelites and of Hunt's work in particular. In addition to emphasizing the artist's intense labour and demanding a comparable investment on the part of the viewer, Ruskin regarded artistic talent *per se* as precious raw material: 'You can find him [the artist], and refine him: you dig him out as he lies nugget-fashion in the mountain-stream; you bring him home; and you make him into current coin, or household plate, but not one grain of him can you originally produce.'[196] In Ruskin's view, the same considerations applied when determining the market value of art: 'a perfect work can't be hurried, and therefore it can't be cheap beyond a certain point'.[197] In attempting to validate and popularize his artistic enterprise, Hunt too focused on both artist and product. The highly successful one-picture show provided a forum for the recalibration of the artist's role that the traditional format of the RA exhibition and its critical reception precluded. It supported a popular re-imaging of the Pre-Raphaelite project that presented the pursuit of art not only as a sensible economic investment but also as a national enterprise. Stephens commented on the value of the engravings after *The Finding of the Saviour in the Temple* and *The Light of the World*:

Indeed, a national service is rendered by the publication of really noble transcripts from noble pictures like these. Where the pictures cannot go, the engravings penetrate. Their appeal is infinitely extended … and all the good which such thoughtful and purposeful art can effect … is multiplied a thousand-fold.[198]

He endowed the prints with an educational mission similar to that associated with the illustrated Bibles. With *The Finding of the Saviour in the Temple* Hunt proposed a complex solution to some of the problems facing contemporary religious representation. His detailed historical research invested the depiction of a biblical scene with the metonymic qualities Carlyle had demanded. The strategies of orientalism helped to integrate the wide range of detailed knowledge which had been so apparent in illustrated editions of the Bible. There, however, the different modes of representation remained separate and at odds with each other. Hunt presented biblical scenes no longer as timeless and epic but as historical and scientific. According to Stephens, this approach to art was 'the gist of Pre-Raffaelitism; this is what really distinguishes the movement … It has dignified the mere actor into the thinker and the poet'.[199]

The various published narratives presented Hunt's motivation as primarily artistic and Protestant, not driven by intense personal experience

or riddled with anxieties and doubt. In the following passage from his autobiography, Hunt stressed the roles of the independent thinker and the relentless seeker after historical truth:

From the beginning of my attempt till this time many thinkers of various schools have devoted themselves to elucidate anew the history treated in the gospels, and the desire for further light cannot be quenched. The conviction I started with, that much of the teaching of Christ's life is lost by history being overlaid with sacerdotal gloss, is widely shared by others ... I have established my claim as a pioneer for English art in study of historic truth ... To exercise original thought on sacred story must, it seems, ever be a *challenge* to the world. Carlyle, it will be remembered, saw in 'The Light of the World' only a proclamation of ecclesiastical dogma, and so denounced it ... On the other hand, the extreme High Church party regarded my humanistic treatment of the life of Christ as wanting in reverence. Fortunately the unprejudiced public instinctively felt an interest in the attempt to make the story live as history, and their demand for engravings from my pictures induced the publishers to give me that support which enabled me to persevere ... In liberal quarters the clergy distinctly gave their approval to my purpose, for they did not fail to see that my work was done with reverence ...[200]

Reminiscing about his life-long pictorial engagement with Christ, Hunt not only emphasized the widely felt need for a modern reinterpretation of Scripture, but also claimed intellectual independence and originality for his representation of Christ. Furthermore he insisted on the emotive quality of his art, which should appeal to everyone, regardless of social rank and education.

The success of the Saviour: a contemporary reaffirmation of faith

The Finding of the Saviour in the Temple clearly demonstrated Hunt's affinity with liberal Protestantism; however, its genuine originality can be more fully grasped when discussed in connection with the publication of *Essays and Reviews* (1860), which provided a controversial arena for the reconfiguration of belief. As Hunt's picture went on show at the German Gallery in the spring of 1860, this unassuming and blandly titled collection of essays on biblical Higher Criticism was published. Victorian audiences 'knew of the Higher Criticism as an avalanche that was gathering in distant mountains'.[201] It had been gathering for decades, but with the publication of *Essays and Reviews* it finally came crashing down. The controversy that ensued over the volume by far outstripped the hostile reception of Charles Darwin's *The Origin of Species* (1859). Its publication not only sparked a pamphlet war but also resulted in a church trial for heresy and an acquittal by the Privy Council; in short, it was 'the greatest religious crisis of the Victorian age'.[202]

Six of the seven contributors were men of the Church of England and some were influential educators, among them Frederick Temple, the rector of Rugby School, and two Oxford professors, Baden Powell and Benjamin Jowett. The contributions reflected the current positions in biblical Higher Criticism. The authors rigorously applied the methodologies of scientific,

linguistic and historical investigation to the Bible, focusing on contentious issues such as the historicity of the text, the impact of geology on the interpretation of Genesis and the exact nature of the supernatural in the biblical narrative. None of the opinions entertained by the seven authors were, strictly speaking, particularly new. Honest doubt was no longer a private matter but had also pervaded the hearts and minds of prominent men of the church. Despite the disclaimer in the preface, the collection came to be regarded as an important manifesto for the Broad Church movement.[203] Never before had such views been put forward in one volume mostly written by important members of the established church who were also influential educators. Thus *Essays and Reviews* finally brought biblical Higher Criticism to the attention of a wider public.

Frederick Temple's essay set the tone for the entire collection. He viewed the Bible as a historical document: 'It is a history; even the doctrinal parts of it are cast in a historical form, and are best studied by considering them as records of the time at which they were written.'[204] This approach released Temple from the intellectual contortions that many contemporary interpreters undertook in their attempts to reconcile the biblical narrative with current scientific knowledge. However, Temple created a different double-bind. On the one hand he claimed that the Bible was a historical document and on the other he granted it the power 'to evoke the voice of conscience'. So the Bible was historicized yet not entirely stripped of its special status – an ambivalent stance adopted by all the Essayists that was to attract strong criticism from both radical and conservative quarters, because such a stance glossed over the question of the supernatural in the Scriptures and their claim to be divine revelation. He applied the same progressive sense of history to revelation. Temple argued that Christ had revealed himself to humankind at precisely the right moment in time. He felt that the jadedness of his own age would have prohibited the recognition of Jesus Christ: 'we have lost that freshness of faith', he wrote, 'which would be the first to say to a poor carpenter – Thou art the Christ, the Son of the living God'.[205] He urged the intrepid pursuit of knowledge for a deeper comprehension of the Bible: 'He is guilty of high treason against the faith who fears the result of any investigation, whether philosophical, or scientific, or historical.'[206]

The most radical contribution to the volume was Benjamin Jowett's essay. As befitted the Regius Professor of Greek at Oxford, Jowett put forward a means of interpretation developed in the reading of classical texts. He called into question most forms of interpretation because of their lack of rigorous methodology: 'The book in which we believe all religious truth to be contained, is the most uncertain of all books, because interpreted by arbitrary and uncertain methods.'[207] Consequently he argued that the main aim in interpreting the Bible should be to recover the original meaning: 'the meaning, that is, of the words as they first struck on the ears or flashed before the eyes of those who heard and read them'.[208] He endeavoured to strip back the accumulated layers of interpretation to reveal the text's original meaning by placing it in its historical context. This process also required the interpreter

to make allowances for cultural differences: 'it is a book written in the East, which is in some degree liable to be misunderstood, because it speaks the language and has the feeling of Eastern lands'.[209] Jowett's central argument was contained in the following lines:

Interpret the Scripture like any other book. There are many respects in which Scripture is unlike any other book; these will appear in the results of such an interpretation. The first step is to know the meaning, and this can only be done in the same careful and impartial way that we ascertain the meaning of Sophocles or of Plato ... No other science of Hermeneutics is possible but an inductive one, that is to say, one based on the language and thoughts and narrations of the sacred writers.[210]

Jowett's approach marked 'the passage from a sacred hermeneutic to a secular one' and has rightly been described as 'the great sea-change of nineteenth-century theology'.[211]

Overall, the Essayists were more comfortable dealing with the textual, factual and historical aspects of the Bible than with the divine, revelatory or supernatural elements. Although they repeatedly conceded that the Bible was a special book, Jowett was not alone in finding it difficult to define exactly what that special nature was. Leaving the exploration of its 'inner life' to individual analysis, the seven authors were primarily concerned with the 'outward body or form' of Scripture, which they scrutinized rigorously[212] – so rigorously, in fact, that Charles Kingsley, the writer and novelist, wrote to Arthur Penrhyn Stanley, one of the leading figures of the Broad Church movement who was sympathetic to the stance that the seven authors had adopted:

Doubts, denials, destructions – we have faced them till we are tired of them. But we have faced them in silence, hoping to find a positive solution. Here comes a book which states all the old doubts and difficulties, and gives us nothing instead. Here are men still pulling down with far weaker hands than the Germans and building up *nothing* instead.[213]

While Kingsley's private comment was echoed in most reviews, for some critics the Essayists had simply not gone far enough in demolishing the system of Christian belief.[214]

In the October issue of the *Westminster Review*, Frederic Harrison, who was to become one of England's leading positivist thinkers and followers of Auguste Comte, put forward a radical attack on the Essayists. He regarded their attempts to dispose of the divine aspects of the Bible while continuing to uphold it as *the* guide to individual conscience as outright absurd and criticized the authors for lacking the courage of their unspoken convictions:

Let them be assured that there exists no middle course, that there is no inspiration more than natural, yet not supernatural; no theory of history agreeable to science, though not scientific; no theology which can abandon its doctrines and retain authority. The position of Scripture either rests on external authority, or is a thorough perversion of a sound estimate of literature. The Bible can hold its place either by a divine sanction or by glaring injustice to the other writings of mankind.[215]

For Harrison the authors had shied away from the inevitable conclusion of their investigation. This radicalization of the debate cast the threat of atheism inherent in the volume into sharp relief.

The Bishop of Oxford, Samuel Wilberforce, who had recently been involved in a widely publicized debate over the theories presented in Darwin's *Origin of Species*, again rose to the challenge of defending the beliefs of the established church. In his review – both a critique of *Essays and Reviews* and a reply to Harrison's incitement to atheism – Wilberforce took the Essayists to task for their insistence that the Bible was to be read just like any other book. He further criticized the substitution of external for internal revelation. Placing the Bible in a historical context and investigating its textual production with the methods of literary criticism, Wilberforce maintained, reduced its divine aspects to a residuum 'embedded in the crust of earlier legends, oral traditions, poetical licenses, and endless parables', from which it had to be freed through the 'verifying faculty' of the individual.[216] He further warned that 'to have the dividing line between the operation of the Divine and the Human in the inspired Word marked sharply out so as to meet all objections and answer all questions' would inevitably lead to atheism.[217] Just like the radical Harrison, he fully realized the precarious balance that the Essayists had attempted to strike when he characterized the volume as 'the hopeless attempt at preserving Christianity without Christ, without the Holy Ghost, without a Bible, and without a Church'.[218]

Nowhere, of course, is the paradox of the dividing line between the divine and the human more apparent than in the figure of Christ. But on this subject *Essays and Reviews* was strangely reticent. None of the authors explicitly dealt with the consequences their reconfiguration of the Christian framework involved for an understanding of Christ. Although – as Ieuan Ellis has noted – 'the seven shared all the motivations of the nineteenth-century quest for the historical Jesus', Christ himself remained the crucial lacuna at the centre of the collection.[219] This omission was perhaps partly due to the haphazard way in which the volume was put together, but it also reflects Kingsley's view that the contributors 'are men still pulling down ... and building up *nothing* instead'. Josef Altholz has characterized their project as 'a negative theology, seeking to destroy false ideas and attitudes; only in hints and implications can its positive elements be found'.[220]

The Finding of the Saviour in the Temple shared with *Essays and Reviews* the complex problems of representation based on historical research. The artist's decisive orientalist reinterpretation of Christ was both radical and original. As a result, Hunt emerged as the true innovator – intrepid historian, explorer and ethnographer – who presented mid-Victorian audiences with a fully orientalized image of Christ that was both realistic and seemingly authentic. Hence the success of *The Finding of the Saviour in the Temple* depended on strategies of display and marketing that emphasized the heroic mode of production as well as on the fact that it redefined the figure of Christ for the current age – an urgent need both popular imagery and liberal Protestantism failed to meet.

William Dyce's religious works of the 1850s and 1860s represented an equally outstanding engagement with the figure of Christ. In his autobiography Hunt recalled Dyce's reaction to *The Finding of the Saviour in the Temple*: 'he was generally appreciative of the work, but objected that it was "three pictures in one."'[221] This comment encapsulated the very different approaches apparent in their works.

Dyce's *The Man of Sorrows* (1860) provides an illuminating contrast to Hunt's painting (Plate 11).[222] It shows Christ sitting in a bleak landscape, which contemporary reviewers recognized as the Scottish Highlands. The picture was accompanied by the passage below from 'Ash-Wednesday' – part of John Keble's popular cycle of poems, *The Christian Year*. This text not only indicated the painting's High Church leanings, but also suggested a narrative context:

> As when upon His drooping head
> His Father's light was pour'd from Heaven
> What time, unsheltere'd and unfed,
> Far in the wild His steps were driven.
>
> High thoughts were with Him in that hour,
> Untold, unspeakable on earth …

While the verses elaborated the theme of Christ in the wilderness, the painting's title, however, countered such a straightforward identification of the subject because it implied a deliberate reinterpretation of Christ as the Man of Sorrows. Traditionally, this subject has focused on the resurrected body of Christ, which bears the marks of the crucifixion, offered up for devotional meditation. It does not depict any event in the life of Christ and is detached from any spatial and temporal contexts. In its aim to express a living form of belief that takes 'its character from mystical contemplation rather than from theological speculation', Christ is traditionally represented as 'dead as man and living as God'.[223]

The two textual anchors – the title and the accompanying verses – which pulled the picture in different directions were indicative of its complexities. Dyce carried this tension into the picture itself: he contrasted an idealized and traditional image of Christ, dressed in red and blue, with a Scottish Highland landscape, at once contemporary and timeless, thus defying any attempt to locate the scene in one historical moment. In his RA review for the *Athenaeum*, Stephens clearly registered the unresolved tension in the painting when he asked: 'But why – with all this literalness – not be completely loyal to the rendering of Christ himself in the land where he really lived?'[224] He implied that Dyce's attention to realistic detail was a baffling stylistic choice, given that the picture in no way strove to represent a coherent moment of biblical narrative. Unsurprisingly, he suggested a resolution of the kind which Hunt had chosen in *The Finding of the Saviour in the Temple*. However, Stephens failed to realize, or chose to ignore, the fact that the jarring juxtaposition between figure and landscape was essential to the meaning of the painting.

Its conflation of two distinct subjects – one devotional, the other biblical – and its deliberately incoherent notions of time and place enabled the negotiation of Christ's divine nature. His forty days in the wilderness were, of course, a time of temptation and self-questioning brought on by the public confirmation of his divinity revealed during baptism. Although Dyce's choice to render the wilderness local surprised Stephens, who found it idiosyncratic, Marcia Pointon has argued that 'his native scenery had far more to offer an artist who valued the emotive and symbolic qualities of a landscape as a means of conveying a specific religious conviction'.[225] This transformation undeniably gave the picture an immediate appeal which was in part due to the contrast between figure and landscape.

The Man of Sorrows belongs to a small group of religious works that Dyce produced during the 1850s and early 1860s. This and *The Good Shepherd* (1859; Figure 4.15) were among the few to be exhibited during the artist's lifetime. Here the claim for Christ's divine presence in the modern world was made even more forcefully. Dyce placed the traditional figure of Christ as the good shepherd in a setting that contemporary reviewers recognized as a 'landscape with a sheepfold paled in, trees, and a cultivated country, such as might be seen in any rural district round London'.[226] The *Art Journal* critic approved of the picture's incongruity as a means of intensifying its spiritual feeling – a strategy he considered akin to 'the simple conceptions of early Florentine painters'. By contrast, the *Athenaeum* critic judged the picture at face value and objected to the 'sheep's wool look[ing] sooty, as if they were sheep of the neighbourhood of London, where wool is apt to get black'.[227] The realistic mode of representation might have intensified the critic's literal reading and obscured the symbolic meaning. Despite such misreadings, the critics did notice the intentional incongruity inherent in these two pictures.

Dyce defied the integrating totality of a historical approach that strove to recreate a particular time and place. With their transcendence of such categories both pictures made an urgent plea to believe in the contemporary relevance of Christ's divine nature despite modern approaches to biblical studies. Dyce's images of Christ opposed the liberal forms of belief put forward by the Essayists and reflected in Hunt's work. *The Man of Sorrows* seemed to resonate with Wilberforce's High Anglican criticism of *Essays and Reviews*, encapsulated in the admonition to refrain from defining the dividing line between the divine and the human aspects of Scripture but to accept both in 'humble faith'. In the face of the doubt and anxiety characteristic of the age, Dyce offered an incongruous image of Christ and invited his viewer to make a leap of faith, which demanded the acceptance of Christ's divinity notwithstanding such questioning.

The spheres of art and religion

When Hunt showed *The Finding of the Saviour in the Temple*, liberal Protestantism and popular biblical illustration had not yet formulated an

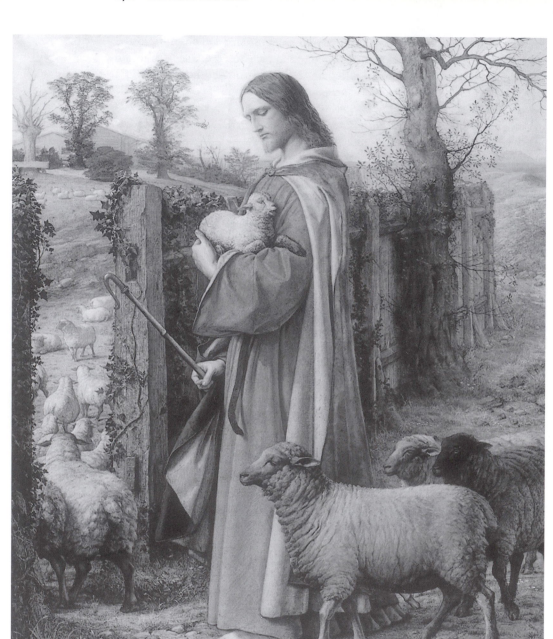

4.15 William
Dyce, *The Good
Shepherd*, 78.9 ×
63.5 cm, oil on
paper mounted
on canvas, 1859

image of Christ comparable to that presented by the artist. He acknowledged this when writing to John Graham to thank him for lending the small version to his retrospective held at the Fine Arts Society in 1886:

It would have been a terrible gap in my representative works had not the first figure subject illustrating scripture history which I painted in the East been seen in the exhibition. It is not only the first of mine actually done in Palestine, but the first which any European painter executed there, and it therefore has an interest of a kind illustrating more than a personal new departure.[228]

During the 1860s, however, the historicization and consequent fictionalization of Jesus Christ gained widespread momentum. As we have seen, Ernest Renan's radical *The Life of Jesus* (1864) and Strauss's almost simultaneous *New Life of Jesus* (1865) were followed by John Seeley's *Ecce Homo* (1865). This was the most significant British contribution to the debate, even if it lacked both Strauss's argumentative rigour and Renan's earthy poetics which paid particular attention to the customs of the Orient and brimmed over with accurately observed descriptions of the sacred geographies. Despite their fundamental differences, all three versions of the life of Christ generated heated debates about the appropriateness and limitations of biographical representation.

Such debates also affected Hunt, who aimed to make the biblical story 'live as history'. Although the artist was dismantling traditional forms of biblical representation, he was also supplying his own complex vision of an historical, yet divinely inspired Christ. Hunt aimed to historicize Jesus Christ without stripping him of his divine status. Thus the historicity of his biblical paintings stopped short of Renan's demystification of Christ, which Hunt repeatedly rejected in his private and published writings. However, his orientalist renderings of Scripture might have encouraged a mode of representation that lacked a carefully circumscribed symbolic content. William J. Webb's *The Lost Sheep* of 1864 provides one such example (Figure 4.16). This realistic representation of an oriental shepherd seems to resonate with symbolic meaning, yet cannot be unequivocally read as a representation of Christ. Here the orientalist and realist modes of representation manifested their ability to obfuscate the picture's symbolic intent.

During his second trip to the East in 1869–72, Hunt actively engaged with Ernest Renan's controversial *The Life of Jesus*, which had negated all of Christ's divine qualities and rendered him entirely human.[229] In *The Shadow of Death* (1870–73) the artist not only represented Christ as the Son of Man but also insisted on his revealed divinity (Plate 12). An everyday action is arrested in a fleeting instant that prefigures the crucifixion. At the end of a long day which Jesus has spent at work in the cluttered carpenter's shop, he is standing with arms outstretched, praying. Even the position of his legs, with the uneven distribution of the body's weight, recalls the pose of the crucified Christ. His shadow falls onto the back wall of the shop where a horizontal plank, to which a neat array of tools is fixed, serves to reinforce that impression. This brief moment of premonition is witnessed by Mary, who is

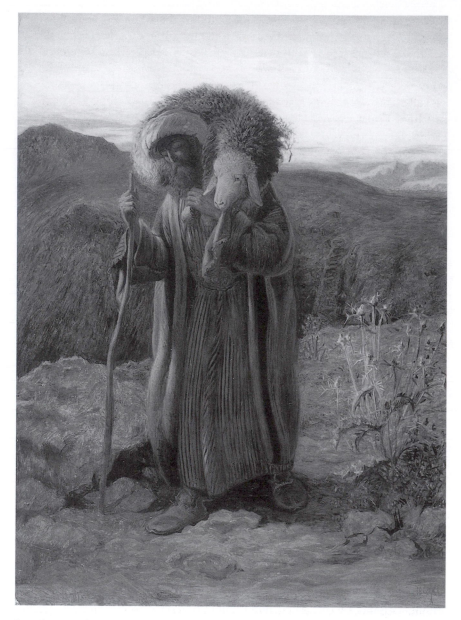

kneeling in front of a chest that contains the Magi's gifts. Almost forgotten harbingers of Christ's greatness, they look decidedly out of place in the mundane workshop setting. This incongruity might have triggered Mary's need to reassure herself of the prophecy. Instead of reassurance, however, the opening of the chest seems to have unleashed a vision of her son's violent death. She is startled by this unexpected and painful association. Although Mary has her back turned towards the viewer, one senses her tension in the abruptly suspended action. The physical brutality of Christ's death is also suggested by the saw's glistening blade, which only a moment earlier has

been used to saw a plank in half and which now points menacingly at Jesus's chest. The chisels hanging on the back wall evoke the nails of the crucifixion. Resonances of the crown of thorns and the scapegoat's red filament are to be found in the discarded headband lying on the ground. Although Christ's body is offered up to the viewer's gaze intact – muscular and semi-clad – visually it is under attack from everyday objects which evoke the instruments of Christ's martyrdom. The clutter of the everyday reveals its typological significance, which helps to orchestrate the picture's central motive.

The artist had simultaneously answered Carlyle's call for an image of Christ as 'the Man toiling along in the hot sun' and refuted Renan's radical interpretation.[230] The picture highlights both the physical hardship and the divine connotations of work: a veritable representation of the gospel of work that not only reflected Hunt's own Smilesian approach but also his admiration for Carlyle. It thus shifted the emphasis from the moment of conversion and spiritual awakening which had dominated his previous representations of Christ. Contrary to Frederick Temple, who wrote in *Essays and Reviews* that 'we have lost that freshness of faith which would be the first to say to a poor carpenter – Thou art the Christ, the Son of the living God',[231] Hunt suggested that Christ's divinity, mission and prefigured death were all apparent in the carpenter's daily toil. Contemporaries such as Mrs Meynell also drew an explicit parallel between the carpenter's toil and the artist's labour:

He spent his life and strength over 'The Shadow of Death.' Painting Christ over-wearied with labour, he did not spare himself. Working men in the North of England, who went in numbers to see the picture and to subscribe for reproductions for their own walls, were no doubt sensible of this.[232]

Hunt's work was here validated in relation to both Christ and the working man: all three are connected through the continuous trajectory of labour. Not only did Hunt manage to capture an audience mostly located beyond the traditional reach of the art market, but his meticulous technique also suggested a process of production reflected in the pose of the work-weary Christ. Thus the artist both pictured and embodied Carlyle's gospel of work.

In many ways, the promotion of *The Shadow of Death* followed the pattern established with Hunt's first orientalized biblical scene of the previous decade. This time the artist sold the picture and the copyright to the dealer Thomas Agnew. Once again the investment was recouped through admission charges to the one-picture show and through print sales. While less romantic and dramatic than the story of 'Painting the Scapegoat', the accounts of the picture's production again supplied the familiar tales of trials and tribulations. The two classic tropes – relentless pursuit of minute realism and oriental otherness that helped define the self – came together in a defining episode. Before leaving Jerusalem, Hunt invited friends to his house to view *The Shadow of Death*.[233] The incessant coming and going excited the curiosity of neighbours and locals alike, who were finally allowed to view the picture. They behaved like the incredulous Thomas who could not quite fathom the

miracle of the resurrection and would trust touch over sight. They wanted to touch the picture in order to feel the different textures of the materials represented. Another group voiced a different concern; after having contemplated the picture for some time they wanted to see the back of it. When the puzzled artist demanded to know what had prompted this request, he was told: 'we have been here twenty minutes looking at the front of the Messiah and the back of the Sit Miriam; is it not natural that now we should wish to see the face of Sit Miriam and the back of the Christ?' Thus the image of Christ truly had come alive in the minds of viewers unfamiliar with pictorial conventions. Hunt had reworked the classic trope of transparent realist representation: the birds fooled into pecking at the cherries painted by Zeuxis had turned into ingénue natives demanding to see the back of the life-size Christ. Just as Ruskin had marvelled that the Campo Santo frescoes in Pisa made one witness the biblical accounts as a *believer* – 'you may put your finger on the eyes of their plumes like St Thomas, and believe' – so Hunt's visitors displayed a similar belief in the veracity of representation.[234]

Hunt was also pleased to report that when the picture was shown in the North of England 'it was hailed by artisans and other working men as a representation which excited their deepest interest'.[235] They subscribed to the two-guinea print, paid for in weekly instalments, 'that the idea might always be before them in their own homes'. Hunt felt he had connected with the audience he wanted to attract: 'This was exactly what I most desired, the dutiful humility of Christ's life thus carrying its deepest lesson.' Hunt had striven for an art that had 'the power of undying appeal to the hearts of living men'.[236] The strategies deployed in bringing biblical history to life not only justified Pre-Raphaelite realism but also supplied heroic narratives of production that helped draw together and validate the two claims the artist tried to reinforce.

The Christmas supplement of the *Art Journal* of 1893 – in which Mrs Meynell proclaimed that 'Mr. Holman Hunt was pre-Raphaelitism, and what he was he has remained' – also contained an essay on 'The principal pictures of William Holman Hunt' by Archdeacon Frederic Farrar, who held a string of prestigious clerical positions and was renowned for his preaching and writing.[237] He was a friend of Hunt and held similar Broad Church views. In 1874 he had published the immensely popular and influential *The Life of Christ*, which ran into some thirty editions in the author's lifetime. In the preface, Farrar had rejected the basic premise of Ernest Renan's *The Life of Jesus* and stated that his own book was 'avowedly and unconditionally the work of a believer'.[238] He argued for an historical understanding of Christianity that embraced 'all that is divine and mysterious and supernatural'.[239] Hunt contributed the only two illustrations in the entire work, which served as frontispieces to the two-volume edition. The first showed the interior of a carpenter's shop in Nazareth, 'drawn on the spot' (Figure 4.17). Farrar had given the artist detailed instructions for this subject, as is evident from Hunt's response: 'I remember the passage you refer to in Renan, and when I go to

HOLMAN HUNT, *Del.*

Nazareth I will look out for an interior of the kind.'[240] The sketch captured the everyday of the trade: a journalistic snapshot that elicited none of the symbolical resonances Hunt was to deploy in the setting for *The Shadow of Death*. Its documentary style sat well with Farrar's measured reconstruction of Christ's early life that carefully unpicked conflicting and apocryphal accounts. While presenting a likely narrative, the historical palimpsest remained visible in the extensive footnotes that accompanied the text.

Writing to Farrar from Jerusalem in 1893, the artist claimed that 'to illustrate scripture with historical truth' had been 'the task I set myself in the East'.[241] This statement is subtly different from the claim presented in the autobiography that he wanted to make 'the story live as history'. This distinction is also evident when comparing Farrar's *Life of Christ* and Hunt's imaginative reinterpretations of scriptural scenes. For all their historical backing, they are persuasively staged *tableaux vivants*.

In *The Shadow of Death*, the realization of the premonition depends on a complex choreography unconsciously acted out between the two protagonists. Enraptured in his evening prayer, Jesus is oblivious to the fact that his body is casting a foreboding shadow on the back wall of the shop. Both Mary and the viewer witness the premonition, but their realization is not shared. Instead the Virgin's pose draws the viewer into the depth of the image to contemplate Christ's future sacrifice. The picture not only constructs a symbolically charged moment but also seems to erase the time that has

4.17 William Holman Hunt, *Interior of a Carpenter's Shop*, wood-engraving from F. W. Farrar, *The Life of Christ*, 1874

elapsed between the actual event and its viewing, inviting total absorption. Out of the carefully observed chaos of the carpenter's shop, which in his illustration for Farrar's *Life of Christ* remained just that, Hunt distilled a significant and highly symbolic narrative embodied in the one moment of viewing.

The *Shadow of Death* builds on an eclectic tradition of depicting members of the Holy Family in the carpenter's shop that includes Herbert's *Our Saviour subject to His Parents at Nazareth* and Millais's *Christ in the House of His Parents*. All three images centre on the premonition of the crucifixion. In Herbert's work the premonition was embedded in the exchange between Jesus and Mary, which revolved round the accidental cruciform made by the discarded pieces of wood (Plate 4). Despite a background landscape 'painted on the spot' – as the catalogue entry proclaimed – the picture followed established academic conventions, rendering the premonition rather banal and benign. In *Christ in the House of His Parents*, Millais simultaneously drew on the hieratic forms of early art and on the realism of the Bolognese school (Plate 7). These traits were combined with the relentless attention to detail characteristic of early Pre-Raphaelite work to produce a stark image that defied academic conventions.

Hunt's approach to the subject was altogether different. Choosing to depict the adult Jesus, he rejected the more traditional format of the Holy Family in the carpenter's shop. Furthermore, he opted for a thoroughly orientalist rendition, endowing the Saviour with unequivocally Jewish features. Unlike Millais, who had deliberately fragmented the picture's time-frame by inserting contemporary, orientalist and medievalizing elements, Hunt strove for a seamless historicism which aimed 'to realise the actual history of the Divine man'.[242] Both Millais and Hunt had found it essential to study the interiors of carpenter's shops in the preparation of their work. In order to be able to correctly depict the expressive anatomy of a working man, Millais even drew the forearms of a carpenter for his St Joseph. While Millais freely used London specimens as models, Hunt relied on the inspiration of the East:

I could not settle how to overcome the difficulties of arranging the details of my picture, until I had made it my business to visit many native carpenters at work, and had been over to Bethlehem, and searched out the traditional tools, fast being abandoned for those of European form.[243]

Hunt's pictorial imagination seemed to depend on ethnographical research that furnished detailed knowledge of local customs. With his 'dread of unmeaning fact',[244] he converted the actual eastern carpenter's shop – encountered in his research and conveyed in the illustration to Farrar's *Life of Christ* – into the deeply resonant setting for his picture.

The *Shadow of Death* also conclusively brought together the at once human and divine nature of Christ which had preoccupied the artist since the early and ill-fated *Christ and the two Marys*, temporarily abandoned in 1847. In *The Light of the World*, Hunt had again attempted to render visible

Christ's divine presence. Its companion piece, *The Awakening Conscience*, demonstrated the reassuring possibility of inviting Christ into one's life, pictured here as the result of listening to the 'still small voice'. *The Finding of the Saviour in the Temple* steered clear of such an allegorical representation. Instead it offered a fully historicized scene from the gospel narrative: the moment at which Jesus realized his divinity and accepted the self-sacrificing call to duty. This moment of spiritual awakening, however, is internalized, apparent only in Jesus's detached and unfocused gaze, halo-like hair and the general movement of his body towards the viewer. Although the work displayed Hunt's 'dread of unmeaning fact', its detailed realism led a fellow-artist to comment that 'it was only a representation of a parcel of modern Turks in a café'.[245] The more explicit premonitory narrative of *The Shadow of Death* made such a matter-of-fact reading impossible.

The work also implied a parallel between artist and Christ. This theme in Hunt's work was first evident in *The Finding of the Saviour in the Temple*, which showed the confrontation of old and new forms of belief – rightly interpreted as both religious and artistic. With *The Shadow of Death*, Hunt continued to make explicit this parallel: artist and Christ are united in their daily toil and devotion. The Carlylean concept of labour was again visualized and its physical aspects highlighted. The picture seemed to echo a comment a reviewer had made when discussing *The Finding of the Saviour in the Temple*: 'There are works of men's hands and of men's minds which are unconsciously acts of prayer and praise.'[246] Having laid aside his daily work, Christ is totally absorbed in his prayer. This seamless fusion of work and devotion is here enacted by both Christ in the picture and the artist making the picture.

Just as Millais's work represented a 'Pre-Raphaelite manifesto', *The Shadow of Death* best exemplified Hunt's artistic concerns. It finally balanced the historical and the divine nature of Christ. The staging of the premonition was dramatic and legible, and did not depend on erudite exegesis. The life-size figures gave the image an immediacy Hunt had struggled to achieve in *Christ and the two Marys*. Furthermore, the emphasis on toil and devotion amounted to a very personal manifesto which Hunt corroborated in his published writings. It also answered Carlyle's desire to 'see the Man toiling along in the hot sun'. To this he had added: 'I see Him dispirited, dejected, and at times broken down in hope … I see Him unflinching in faith and spirit … This was a man worth seeing the likeness of, if such could be found.'[247] With *The Shadow of Death* Hunt again fulfilled the sage's near-impossible task, even meeting some of the exact specifications. In an age where history was biography, Christ and the artist existed in a continuum of heroic endeavour. In his two important orientalist images of Christ, Hunt presented a historical reconstruction that tallied with his own artistic mission: its call to duty and unremitting toil. His personal vision resonated with the need of the age for a historically acceptable and emotionally immediate image of Christ.

In his *Art Journal* essay of 1893, Farrar described and analysed all of Hunt's major paintings in strict chronological order. His remarks contained very little that was not gleaned from either Stephens's pamphlet or from the articles that the artist had published in the *Contemporary Review*. The latter is not surprising, since Hunt had suggested that he read them.[248] However, Farrar's discussion of the artist's work was also informed by his own approach to biblical research so clearly reflected in his sober retelling of the life of Christ. Through such a discussion, although in itself it was not particularly original or analytical, the more fictional and symbolic elements in Hunt's historicizing works were authenticated by the wider framework of liberal Protestantism.

However, Farrar's advocacy was twofold. Not only could he authenticate the wilder flights of fancy in the orientalist works but he could also openly discuss the haunting quality of *The Light of the World* which erupted so uncomfortably in Hunt's autobiography. He described the picture's characteristics in a way that foreshadowed the artist's description of the supernatural apparition: 'Who that saw it with open and unprejudiced eyes in the Royal Academy exhibition forty years ago, has not been haunted ever since by the pathetic majesty of that awful figure'.[249] This remark signified an important reversal of roles. The professional clergyman writing about art alluded to the haunting and supernatural quality of an image that the professional artist found difficult to admit because it conflicted with his carefully constructed identity as the true Pre-Raphaelite, 'the thinker and poet' labouring over his work.

Farrar's analysis also drew on Ruskin's 5 May 1854 letter to *The Times*, from which he quoted freely. Thus the validity of that reading which referred to Christ as prophet, priest and king – incarnations of the Carlylean hero – was once again reinforced. Farrar's affinity with Hunt was apparent in his comments on *The Finding of the Saviour in the Temple*: 'He has himself told us … that his hold on the simple faith of Christ was in all respects strengthened, not loosened, by familiarity with the earthly surroundings of climate, landscape, and custom amid which the earthly life of the Saviour of mankind was passed.'[250] This shared conviction that belief was strengthened through a careful investigation of the historical circumstances, which informed Farrar's own research, made him an ideal advocate of Hunt's artistic project. In thus guiding public understanding of the religious images, his essay in the *Art Journal* fulfilled a role similar to that of Stephens's pamphlet. The detailed commentaries provided by the professional art critic and the clergyman explained and validated the artist's work in the separate spheres of art and religion.

Hunt himself regarded this separation as crucial. In a letter dated 5 June 1893, the artist asked Farrar to make some minor changes to his essay as 'it will save me from the charge of caring for the religious, instead of the art spirit of the picture [*The Scapegoat*]'.[251] He continued to justify his suggestion in the following way:

I always maintain that the best art has ever, and will ever, be that which has the highest purpose for its training, but I would not give ground for the accusations that I think because a purpose is a religious one the work of art must be good – for of course much very bad art is employed on religious subjects.

Such determined upholding of artistic quality was paramount because the success of his religious works depended on the forces that governed the highly competitive Victorian art market. In Hunt's case ecclesiastical patronage failed to materialize – a fact he deplored in his letters to Farrar and in his autobiography.[252] Despite the lack of ecclesiastical patronage, Hunt's religious works were highly successful. They fetched record prices and drew large crowds when displayed in the UK and abroad, and prints of the works sold in large numbers. *The Light of the World* achieved the status of a Protestant icon; two versions of it were permanently displayed in ecclesiastical settings, as we have seen.

To a large extent, the success of his religious works depended on shrewd marketing that hinged on the reconfiguration of Hunt's artistic identity. Worship-like work, which Hunt never failed to emphasize, and the endeavour to make the biblical story live as history defined the figure of the heroic art worker, who combined his clandestine conversion with a missionary zeal akin to a national enterprise. The controversial and highly exacting technique of Pre-Raphaelite painting seemed to have found a new validity because it paralleled the methods of historical research favoured by liberal Protestantism. In the various public narratives that he either authored himself or carefully controlled, Hunt emerged as both the true Pre-Raphaelite and the painter of Christ, successful in the spheres of art *and* religion.

Epilogue: ideal subjects glowing with poetry

Realism in religious painting was still a burning issue, even years after W. M. Rossetti first claimed that the learning of the age could not be ignored.[1] In the early 1880s, John Everett Millais mused about the possibilities for a contemporary religious painting. The artist contended that strict historical naturalism had deprived religious painting of its most valuable quality because it obscured the poetry inherent in the biblical narratives:

There is a slight interest … in works of a devotional character; but the passionate, intensely realistic, and Dante-like faith and worship which inspired the old masters is extinct, or nearly so. It is the difficulty of giving agreeable reality to sacred subjects which daunts the modern artists, living in a critical age and sensitive to criticism. I should like very much to paint a large devotional picture, having for its subject 'Suffer little children to come unto me,' I should feel the greatest delight in painting it; but the first question that occurs to me is, what children do we care about? Why our own fair English children, of course; not the brown, bead-eyed, simious-looking children of Syria. And with what sense of fitness could I paint the Saviour bare-headed under the sun of Palestine, surrounded by dusky, gipsy-like children, or, on the other hand, translate the whole scene to England? The public is too critical to bear this kind of thing now, and I should be weighed down by the sense of unreality in treating a divinely beautiful subject.[2]

Millais implied that it had become impossible to paint subjects such as Christ blessing little children with an immediacy that spoke to the heart. The artist's somewhat wistful response seemed to suggest that the learning of the age had stifled the poetic impulse in religious painting.

Millais here painted a bleak picture of realism's all-pervasive hold over religious subject matter, a view that even his sympathetic biographer Walter Armstrong found unacceptable so he interjected that the German painter Fritz von Uhde had recently updated the subject of Christ blessing little children. Armstrong explained that the picture showed 'the flaxen-haired, heavy-limbed little maidens of Bavaria, and was setting them not against the blue skies and yellow plains of the East, but under a German cottage roof, among German fathers and mothers, and with every surrounding Teutonic except the figure of Christ himself'.[3] The critic cited Uhde's work as a powerful example of a thoroughly modern religious painting and regretted that Millais had not attempted something similar.

In his description of the theme of Christ blessing little children, Millais conjured up a detailed vision of biblical orientalism that was not borne out by the visual record. Even Gustave Doré, the leading exponent of French poetic orientalism, refrained from abundant orientalist detail in his version of *Christ blessing Little Children*, produced for a landmark edition of the Bible which contained well over 200 mostly heavily orientalized illustrations (Figure 5.1).[4] Here orientalism's sway was evident only in a few palm-trees in the background and the head-dresses worn by the mothers, whose children, while curly-haired and dark-eyed, remained inspired by the Raphaelesque ideal. Despite concessions to the old master tradition, the image lacked the sentimental and poetic appeal Millais had craved when expressing the desire to see 'our children' blessed.

Although Millais had expressed concern at the seemingly inevitable necessity to lumber biblical imagery with the trammels of historical detail, his own work *The Parables of Our Lord* (1864) demonstrates that the learning of the age could well be ignored when interpreting biblical subject matter. While Millais was working on the illustrations of the parables, Hunt was finishing his first fully orientalized scriptural subject, *The Finding of the Saviour in the Temple* (1854–60). It is therefore tempting to read Millais's bleak remark on the dominance of realism – made in 1886 – as a comment on his own discontinued engagement with religious subject matter.

Millais's two illustrations for the parable of the ten virgins, for example, interpret the subject matter in a contemporary and original way.[5] The young women are wearing a pared-down version of mid-Victorian fashion. Their dresses are girded at the waist and fall in wide heavy folds that simultaneously suggest the flow of the crinoline and the classical drapery of old master paintings. Also, in *The Foolish Virgins*, the setting and atmosphere, marked by the cottage door and the driving rain, seem both contemporary and British (Figure 5.2). This is also true of the girls' facial features. They recall those of the girls and young women in Millais's *Spring (Apple Blossoms)* (1856–59), who are shown picnicking in an apple orchard. Here the clearly contemporary subject matter reveals a deeper symbolical resonance. The frieze-like, ornamental arrangement of female figures is ruptured by a scythe's blade rammed into the lawn. This violent interruption, a visual coda occurring at the right margin of the image, invites the spectator to meditate on the transience of life. These distinct works seem linked by formal inversion: the quotidian genre scene is symbolically charged while the biblical illustrations are deliberately brought up to date.

In December 1863, the *Athenaeum* reviewed *The Parables of Our Lord* at some length. F. G. Stephens is the likely author of this anonymous review. He criticized Millais's work on the parables for its inconsistency. While praising a high number of individual illustrations, he regretted the absence of a coherent conceptual framework. According to the critic, 'Mr. Millais had two courses open to him, both legitimate in Art': 'either he might treat the Parables with the richest local colouring and fidelity to oriental costumes and accessories', or alternatively the artist could focus on the text alone.[6] The

5.1 Gustave Doré, *Christ blessing Little Children*, wood-engraving from *The Holy Bible*, 1866–70

latter mode of representation 'called for no eastern tour, for no previous study in authorities beyond the text itself that was to be illustrated'. It depended on a poetic and imaginative interpretation. The critic cautioned artists against representing scriptural subjects in a contemporary poetic form, using 'the costumes, and accessories, and characteristics of the times in which they lived'.[7] He feared that this practice might subject their work to 'ridicule' and harbour the danger of 'anachronisms'. Although the critic shared W. M. Rossetti's concern over *faux naïveté*, he offered both the orientalist and the contemporary as legitimate modes of interpretation. He objected to Millais's work because the artist had indiscriminately mixed the two distinct modes, a fact in keeping with the idiosyncratic roots of the Pre-Raphaelite aesthetic.

5.2 John
Everett Millais,
*The Foolish
Virgins*, wood-
engraving from
*The Parables of
Our Lord and
Saviour Jesus
Christ*, 1864

Early Pre-Raphaelite work combined detailed realism with imaginatively and poetically conceived subjects. It thus contained the germ of both realist and poetic modes of representation. Ruskin best summed up these different strands in 1883 when comparing Hunt's and Rossetti's vastly different approaches to biblical subject matter:

To Rossetti, the Old and New Testaments were only the greatest poems he knew; and he painted scenes from them with no more actual belief in their relation to the present life and business of men than he gave also to the 'Morte d'Arthur' and the 'Vita Nuova.' But to Holman Hunt, the story of the New Testament … became what it was to an old Puritan, or an old Catholic of true blood, – not merely a Reality, not merely the greatest of Realities, but the only Reality.[8]

While Hunt, who had dedicated his career to making Scripture live as history, drew on a wealth of historical detail to furnish his vision, Dante Gabriel Rossetti regarded biblical subjects as on a par with literature's canonical works. Ruskin was extremely generous in his assessment of Rossetti's artistic gift and poetic imagination. However, one also senses some reservation: after all, the artist's approach to scriptural subjects lacked 'actual belief'. For Ruskin, who had rejoiced that the Campo Santo frescoes made one *believe* the patriarchal history, this was a serious regret.

When artists painted the Bible, the idealist and the realist modes had traditionally dominated. Consequently, the emphasis on the poetic, which emerged more fully during the 1860s, constituted a fresh departure. Rossetti's poetic engagement with biblical subject matter – apparent in his few exhibited pictures such as *The Girlhood of Mary Virgin* (1848–49) and *Ecce Ancilla Domini* (1849–50) – also pervaded his monochromatic works and watercolours such as *Mary in the House of St John* (1858; Figure 5.3). The tight and brooding composition shows Jesus's mother and his favourite disciple performing routine everyday tasks. The Virgin has risen from her work at the spinning wheel to refill the oil lamp hanging from the window frame, which forms a prominent cross. The seated St John has interrupted his writing and is 'kindling some tinder to light the lamp the Virgin is feeding with oil'.[9] The two figures appear close together, their upper bodies sharply outlined against the window yet separated by the cross-shaped frame. The cross dominates the composition. It makes visible the figures' shared inner thoughts which revolve around the poignant and painful absence of Jesus, the son and master. The shared domestic action and the close proximity of the figures contribute to the melancholy atmosphere. This moment of quietly shared grief and memory is orchestrated by the artist's exceptional use of symbolism, which is not premonitory but commemorative. Rossetti's intense and intriguing small-scale works on paper received relatively little exposure because they were mostly produced for private patrons. However, they inspired important Pre-Raphaelite associates including Edward Burne-Jones, Arthur Hughes, Frederick Sandys and Simeon Solomon.

Hughes's *The Nativity* (1858) and its pendant piece *The Annunciation* (c. 1858) demonstrate the influence of Rossetti's work (Plate 13). The interior of the stable seems out of scale, crowded and permeable. The spatial arrangement together with the colour scheme and use of light contribute to the picture's intense spirituality. A roof-opening reveals a host of angels watching the claustrophobic scene. Mary is kneeling to swaddle the infant Jesus. She is assisted by two angels. Ruskin saw in one angel's mundane task of holding the stable lantern 'the highest of all dignity in the entirely angelic ministration which would simply do rightly whatever needed to be done'.[10] Mary's concentrated and yet naïvely unpractised act of motherhood exudes a spirituality reminiscent of William Blake.

Blake's version of the subject, here illustrated in an evocative reinterpretation by William Bell Scott, seemed to combine nativity and annunciation (Figure 5.4). The birth of Jesus takes place in the familiar stable

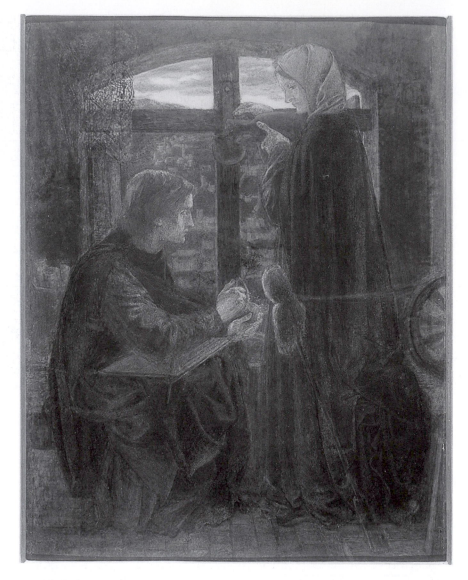

setting but, as Scott observed, it is staged 'as an entirely miraculous and supernatural event'.[11] The figure of Mary – slumped, fainted, almost entranced – is supported by a concerned and helpful Joseph. The divine infant seems to have sprung from Mary's body and is floating in a pool of light. Elizabeth's outstretched arms are ready to receive him. The beam of light falling through the open window on the rear wall underscores the mystical event. It is aimed at Mary and recalls the miraculous conception of the annunciation: a miracle continued and concluded in this spiritual interpretation of the nativity.

The development of this poetic mode also formed part of a more general shift associated with the rise of the Aesthetic Movement. During the 1860s, the brothers Dalziel supported two ambitious ventures: *The Parables of Our Lord* illustrated by Millais and a lavish Bible edition illustrated by

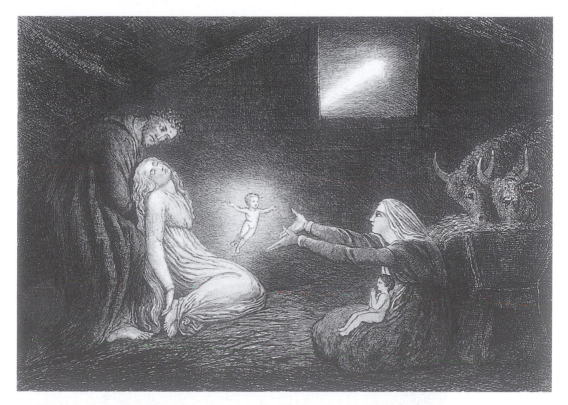

contemporary British artists. Although the latter did not materialize as planned, in 1880 *Dalziels' Bible Gallery* was published, containing over sixty illustrations to the Old Testament.[12] The work combined the whole gamut of stylistic modes, ranging from Frederic Leighton's monumental and Nazarene-inspired illustrations, E. J. Poynter's detailed recreations of Ancient Egypt and the varied orientalist interpretations of Hunt and Brown, to the poetic conceptions of Sandys, Solomon and Burne-Jones.

In *The Parable of the Boiling Pot*, Burne-Jones interpreted a rarely illustrated passage from the book of Ezekiel (24:1–14) which referred to the Chaldeans' siege of Jerusalem (Figure 5.5). The cryptic but evocative biblical text, spiked with references to boiled bones and vengeance, commented on the bloody fate of the city's inhabitants. It lent itself to the artist's imaginative interpretation which resonated with the emotionally charged, poetic medievalism of Rossetti. In Burne-Jones's hands the boiling pot of the Old Testament parable is transformed into a wizard's cauldron; the biblical theme carries atmospheric overtones of Arthurian fantasy. A bearded and sinister figure is stoking the flames which menacingly seem to be taking on a life of their own, leaping off the spoon. A group of people are seen lounging and drinking in the background. The relative obscurity and complex metaphorical language of the biblical passage gave the artist wide scope for interpretation, a freedom the viewer seems invited to share when contemplating the suspenseful scene.

5.4 William Bell Scott, *The Nativity*, engraving after William Blake from William Bell Scott, *William Blake: Etchings from his Works*, 1878

5.5 Edward
Burne-Jones, *The
Parable of the
Boiling Pot*,
wood-engraving
from *Dalziels'
Bible Gallery:
Illustrations from
the Old
Testament*, 1880

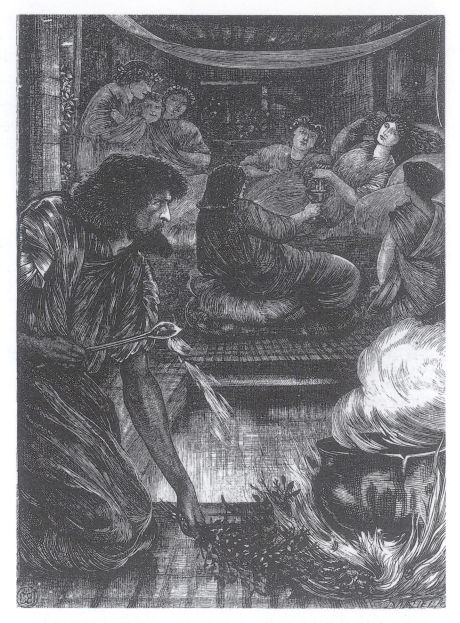

When *Dalziels' Bible Gallery* was finally published in 1880, its innovative poetic impetus had been superseded by a recent edition of *The Illustrated Family Bible*. The publisher's notice advertised the use of illustrations in ways that were simultaneously old and new. The innovative note, however, was 'suggestiveness': this conjured up the seductive notion of illustrations 'glowing with poetry'. Such poetic investment was meant to transcend the welter of facts to reveal the Bible's spiritual truths:

They excel at once in freshness of character, embodiment of truth, force of expression, breadth of suggestiveness, and brilliance of execution … The object kept

in view has been not merely to charm the eye, but to carry out the teachings of Scripture by illustrations addressing themselves to the understanding and the heart … The larger number are ideal subjects, replete with thought, glowing with poetry, fired with lofty conception, lifting meditative minds through the outward material of Bible facts to expatiate on their inward spirit.[13]

This desire to address both mind and heart sounds familiar. The mantra of key characteristics, too, had remained virtually unchanged since the 1840s: the illustrations combined character, truth and expression with brilliant execution. Hunt's *The Light of the World* served as the frontispiece. Its mixture of realism and poetic spirituality conveyed some of the edition's concerns.

Overall, the selection of well-known artists drew on nineteenth-century idealist and realist traditions, including Johann Friedrich Overbeck, Peter Cornelius, Ary Scheffer, Paul Delaroche and Horace Vernet. In particular, the illustrations by William Bell Scott – specially commissioned for this edition – seemed to fulfil the publisher's claims. The majority of the illustrations were infused with a deep sense of the supernatural and spiritual. For example, Scott's interpretation of *Moses bringing down the Tables of the Law* combines orientalist detail with the drama of divine presence (Figure 5.6). Almost apparition-like, the figure of Moses emerges out of the dark, clutching the tables with both hands. His radiant calm contrasts sharply with the animated gestures of the three onlookers.

The edition's most striking feature, however, concerned the illustrations which deal with Christ's passion. The representation of physical suffering was conspicuously absent. It either remained invisible or was deflected, as in Scott's illustration of the crucifixion, which represented the moment of Christ's death by showing the miraculous rending of the veil in the Temple, with the three crosses on Golgotha visible in the far distance. This approach was noticeably different to Doré's illustrations, produced for the Bible edition of 1865, which depict Christ's physical suffering in great detail. Scott's and Doré's interpretations of the resurrection were also diametrically opposed. Doré used a traditional format in which the angel appears to the two Marys in the empty sepulchre. In contrast, William Bell Scott focused on the intensely spiritual moment of the actual resurrection (1st Corinthians 15:4).

Scott's unusual interpretation showed an affinity with the spirituality of Blake's work which he had so sympathetically reinterpreted in 1878 (Figure 5.7). Inside the dark sepulchre, two angels are guarding the dead Christ. From the cave's ceiling a beam of light is falling on Christ's face. He has opened his eyes and raised his arms to pull back the shroud: we are witness to the risen Christ. The mournful angels with downcast eyes are yet to notice the transformation. This is not the awkwardly triumphant Christ who appeared to the two Marys, in the composition Hunt temporarily abandoned because he could not find a way to reconcile the supernatural event with a realist mode of representation (Figure 4.9). Scott had claimed that the influence of photography 'made *realism* absolutely necessary to the canvas of the painter'.[14] Indeed, it also made itself felt in biblical representation. Different artists such as Hunt and Dyce negotiated their understanding of

5.6 William
Bell Scott, *Moses
bringing down the
Tables of the Law*,
wood-engraving
from *The
Illustrated Family
Bible*, n.d. [1876]

Christ's divinity by casting it in a realist mode. The 1870s registered a return
to Blakean spirituality. The dominant grip of realism was lessening and
interest in Christ – whether strictly historical, human or divine – took on a
spiritual or deeply poetic expression.

Artists painting the Bible had to grapple with subjects which W. R.
Rossetti had labelled 'at once sacred and stale'. The Pre-Raphaelite
intervention, best represented in Millais's controversial *Christ in the House of
His Parents*, overthrew every existing convention of religious painting. The

imaginative poetics of the everyday, the ascetic return to the sources and the aggressive realism opened up new avenues that were to be explored during the second half of the nineteenth century. Hunt's radical orientalist approach to biblical subject matter offered an original updating of the image of Christ that chimed with the principles of liberal Protestantism. The various strands of Pre-Raphaelite work demonstrated a vigorous belief in representation, at once challengingly modern and informed by tradition. Biblical subjects were repeatedly rethought: historicized, orientalized, or spiritualized until they were 'glowing with poetry'; in short, they were resurrected in various ways to face the learning of the age.

5.7 William Bell Scott, *The Resurrection*, wood-engraving from *The Illustrated Family Bible*, n.d. [1876]

Notes

1 Introduction

1. W. M. Rossetti, 'The externals of sacred art', in his *Fine Art, Chiefly Contemporary: Notices Re-Printed, with Revisions*, London: Macmillan, 1867, pp. 40–50, p. 47.

2. Typescript of Alexander Dyce's unpublished biography of his father, William Dyce, p. 503 (Tate Archive, London, Dyce Papers).

3. Herbert L. Sussman, *Fact into Figure: Typology in Carlyle, Ruskin, and the Pre-Raphaelite Brotherhood*, Columbus: Ohio State University Press, 1979, p. 47.

4. Walter Armstrong, *Sir J. E. Millais, Bart., RA: His Life and Work*, Art Journal: Art Annual series, London: J. S. Virtue & Co., 1885, p. 3.

5. W. M. Rossetti, 'The externals of sacred art', in his *Fine Art*, p. 45.

6. John Ruskin, *Modern Painters*, vol. 3 (1856), in *The Works of John Ruskin*, ed. by E. T. Cook and Alexander Wedderburn, 39 vols, London: George Allen, 1903–12, vol. 5, p. 87.

7. William Holman Hunt, *Pre-Raphaelitism and the Pre-Raphaelite Brotherhood*, 2 vols, London: Macmillan and Co., 1905, vol. 1, p. 85.

8. Ralph N. Wornum, 'Romanism and Protestantism in their relation to painting', *Art Journal*, 1850, pp. 133–6, p. 133.

9. 'Nazarene' artists such as Peter Cornelius, Friedrich Overbeck and Julius Schnorr von Carolsfeld were working in Rome and several German cities, where they produced frescoes for museums, royal residences and churches. See William Vaughan, *German Romanticism and English Art*, New Haven and London: Yale University Press for the Paul Mellon Centre for Studies in British Art, 1979.

10. Wornum, 'Romanism and Protestantism', p. 133.

11. *Ibid.*, p. 136.

12. *Ibid.*, p. 135; likewise the following quotations.

13. *Athenaeum*, 1850, p. 590.

14. Nicholas Wiseman, 'Art. X.—1. *Sketches of the History of Christian Art*. By Lord Lindsay. 3 vols. Murray, 1847', in *The Dublin Review*, 22 (1847), pp. 486–515, p. 493.

15. *Ibid.*, p. 491.

16. *Ibid.*, p. 490.

17. *Ibid.*, p. 503.

18. *Ibid.*, p. 491.

19. *Ibid.*, p. 493.

20. *Ibid.*, p. 489.

21. *Ibid.*, p. 498.

22. *Ibid.*, p. 495.

23. *Ibid.*, p. 498.

24. *Ibid.*, p. 506.

25. *Ibid.*, p. 495.

26. *Ibid.*, p. 505.

27. *Ibid.*, pp. 506 and 507.

28. *Ibid.*, p. 508.

29. John Ruskin, *Modern Painters*, vol. 3 (1856), in *Works*, vol. 5, p. 77 (italics in the original).

30. *Ibid.*, p. 78.

31. *Ibid.*, p. 50.

32. *Ibid.*, p. 83.

33. *Ibid.*, p. 85.

34. *Ibid.*, p. 79.

35. *Ibid.*, p. 82, likewise the following quotation.

36. *Ibid.*, p. 83; likewise the following quotation.

37. *Ibid.*, p. 87.

38. *Ibid.*, p. 85.

39. *Ibid.*, p. 86.

40. *Ibid.*, pp. 86–7.

41. *Ibid.*, p. 126.

42. W. M. Rossetti, 'The externals of sacred art', in his *Fine Art*, p. 40.

43. *Ibid.*, p. 41; likewise the following quotation.

44. *Ibid.*, pp. 49–50.

45. *Ibid.*, p. 42; likewise the following quotations.

46. *Ibid.*, p. 44; likewise the following quotation.

47. Ruskin, *Modern Painters*, vol. 3 (1856), in *Works*, vol. 5, p. 83.

48. W. M. Rossetti, 'The externals of sacred art', in his *Fine Art*, p. 45; likewise the following quotations.

49. *Ibid.*, p. 46; likewise the following quotation.

50. *Ibid.*, p. 48; likewise the following quotations.

51. *Ibid.*, p. 49.

52. Review in *The Critic*, 5 May 1860; quoted from Frederic George Stephens, *William Holman Hunt and His Works: A Memoir of the Artist's Life, with Descriptions of His Pictures*, London: James Nisbet & Co., 1860, pp. 104–106, p. 104.

53. See Pierre Bourdieu, 'The field of cultural production, or: the economic world reversed', in his *The Field of Cultural Production: Essays on Art and Literature*, ed. and introduced by Randal Johnson, Cambridge: Polity Press, 1993, pp. 29–73, and Pierre Bourdieu, *The Rules of Art: Genesis and Structure of the Literary Field* [1992], trans. by Susan Emanuel, Cambridge: Polity Press, 1996.

54. Randal Johnson, 'Editor's introduction: Pierre Bourdieu on art, literature and culture', in Bourdieu, *The Field of Cultural Production*, pp. 1–25, p. 14.

55. Bruno Foucart, *Le Renouveau de la peinture religieuse en France 1800–1860*, Paris: Arthena, 1987; Michael Paul Driskel, *Representing Belief: Religion, Art and Society in Nineteenth-Century France*, University Park: Pennsylvania State University Press, 1992.

56. Dianne Sachko Macleod, *Art and the Victorian Middle Class: Money and the Making of Cultural Identity*, Cambridge: Cambridge University Press, 1996.

57. Lord Lindsay, *Sketches of the History of Christian Art*, quoted from Wiseman, 'Art.X.—1. *Sketches of the History of Christian Art*', p. 497.

58. Ruskin, *Modern Painters*, vol. 3 (1856), in *Works*, vol. 5, p. 50.

59. Giorgio Vasari, *The Lives of the Artists* [1550], trans. by Julia Conaway Bondanella and Peter Bondanella, Oxford: Oxford University Press, 1991, pp. 174 and 171.

60. Ruskin, *Modern Painters*, vol. 3 (1856), in *Works*, vol. 5, pp. 86–7.

61. Pierre Bourdieu, 'The production of belief contribution to an economy of symbolic goods', in his *The Field of Cultural Production*, pp. 73–111, p. 84; likewise the following quotation.

62. W. M. Rossetti, 'The externals of sacred art', in his *Fine Art*, pp. 49–50.

63. F. W. Farrar and Mrs Meynell, *William Holman Hunt: His Life and Work*, London: Art Journal Office, 1893, p. 4.

64. Stephens, *Hunt and His Works*, p. 79.

65. Letter to John Graham, 3 August 1886 (Getty Research Institute, Los Angeles, Hunt Family Papers 860667-3).

66. William Hazlitt, 'Farington's Life of Sir Joshua Reynolds', in *The Complete Works of William Hazlitt*, ed. by P. P. Howe, 21 vols, London and Toronto: J. M. Dent and Sons, 1930–34, vol. 16, pp. 181–211, p. 206; likewise the following quotation.

67. Bourdieu, 'The market of symbolic goods', in his *The Field of Cultural Production*, pp. 112–41, p. 123.

68. *Ibid.*, p. 119.

69. *Athenaeum*, 1850, p. 591.

70. Letter to James Hall, Jerusalem, 4 April 1841, quoted from Allan Cunningham, *The Life of Sir David Wilkie: With His Journals, Tours, and Critical Remarks on Works of Art, and a Selection from His Correspondence*, 3 vols, London: John Murray, 1843, vol. 3, p. 445; likewise the following quotations.

71. Letter to William Collins, RA, Jerusalem, 2 April 1841, quoted *ibid.*, vol. 3, p. 427.

72. Letter to Thomas Phillips, RA, Jerusalem 4 April 1841, quoted *ibid.*, vol. 3, p. 443.

73. W. M. Rossetti, 'The externals of sacred art', in his *Fine Art*, p. 47.

74. Ruskin, *Modern Painters*, vol. 3 (1856), in *Works*, vol. 5, p. 87.

2 Religious painting and the high-art ideal

1. Robert R. Wark, 'Introduction', in Sir Joshua Reynolds, *Discourses on Art*, ed. by Robert R. Wark, New Haven and London: Yale University Press, 1975, p. xvi. Reynolds pointed to the relationship between the institution and his statements: 'I thought it indispensably necessary well to consider the opinions which were to be given out from this place, and under the sanction of a Royal Academy', *ibid.*, p. 268.

2. See for example Henry Fuseli, *Lectures on Painting*, vol. 2, London: T. Cadell and W. Davies, 1820, p. xviii.

3. William Hazlitt, 'Introduction to an account of Sir Joshua Reynolds' Discourses', in his *Complete Works*, vol. 18, pp. 62–4, p. 62.

4. Ralph N. Wornum (ed.), *Lectures on Painting by the Royal Academicians: Barry, Opie, and Fuseli*, London: Henry G. Bohn, 1848.

5. Reynolds, *Discourses*, pp. 59–60.

6. *Ibid.*, p. 238; likewise the following quotation.

7. Henry Howard, *A Course of Lectures on Painting, Delivered at the Royal Academy of Fine Arts*, ed. with a memoir of the author by Frank Howard, London: Henry G. Bohn, 1848, p. 263.

8. *Ibid.*, pp. 47–8.

9. *Ibid.*, p. 45.

10. *Ibid.*, p. 248.

11. See Helmut von Erffa and Allen Staley, *The Paintings of Benjamin West*, New Haven and London: Yale University Press, 1986, pp. 55–86.

12. See Roy Strong, *And When Did You Last See Your Father? The Victorian Painter and British History*, London: Thames & Hudson, 1978, pp. 30–42; see also Stephen Bann, *Romanticism and the Rise of History*, New York: Twayne Publishers, 1995, pp. 17–29.

13. Howard, *A Course of Lectures*, pp. 51–2; see also Fuseli, *Lectures on Painting*, vol. 1, pp. 142–4. A similar view was expressed by John Flaxman in his *Lectures on Sculpture, As Delivered Before the President and Members of the Royal Academy*, 2nd edn, London: Henry G. Bohn, 1838, p. 153.

14. Howard, *A Course of Lectures*, p. 197.

15. *Ibid.*, pp. 238–40.

16. *Ibid.*, pp. 43–4; likewise the following quotations.

17. *Ibid.*, p. 265.

18. *Ibid.*, p. 282.

19. *Ibid.*, p. 286.

20. *Ibid.*, p. 287; likewise the following quotation.

21. *Ibid.*, p. 288.

22. *Ibid.*, p. 289.

23. *Ibid.*, p. 285.

24. Hazlitt most consistently voiced his opinions in four essays written for *The Champion* in 1814–15: 'Introduction to an account of Sir Joshua Reynolds' Discourses', in *Complete Works*, vol. 18, pp. 62–4, 'On genius and originality', vol. 18, pp. 64–70; 'On the imitation of nature', vol. 18, pp. 70–77; and 'On the ideal', vol. 18, pp. 77–84. In the early 1820s, Hazlitt wrote two more essays on the *Discourses*, launching an even sharper attack which, however, contained no new arguments: *Table-Talk*, essay 13, 'On certain inconsistencies in Sir Joshua Reynolds's Discourses', in *Complete Works*, vol. 8, pp. 122–31, and essay 14, 'The same subject continued', *ibid.*, vol. 8, pp. 131–45.

25. Charles Robert Leslie, 'Professor Leslie's Lectures on Painting. Lecture II', *Athenaeum*, 1848, pp. 220–23, p. 221.

26. *Ibid.*, p. 220, likewise the following quotation.

27. Hazlitt, 'Farington's Life', in *Complete Works*, vol. 16, p. 206.

28. Leslie, 'Professor Leslie's Lectures on Painting. Lecture I', *Athenaeum*, 1848, pp. 191–4, p. 193.

29. Leslie, 'Professor Leslie's Lectures on Painting. Lecture III', *Athenaeum*, 1848, pp. 247–50, p. 248.

30. Leslie, 'Lecture II', p. 222.

31. *Ibid.*, p. 223.

32. Charles Robert Leslie, *Life and Times of Sir Joshua Reynolds: With Notices of Some of His Contemporaries*, continued and concluded by Tom Taylor, 2 vols, London: John Murray, 1865, vol. 1, p. 426, note 1. Taylor's additions are identified by square brackets.

33. *Ibid.*, vol. 1, pp. 371 and 421.

34. *Ibid.*, p. 426, note 1.

35. Leslie, 'Lecture III', p. 250.

36. Leslie, 'Lecture II', p. 223.

37. Shearer West, 'Tom Taylor, William Powell Frith, and the British School of Art', *Victorian Studies*, 33 (1990), pp. 307–26, p. 311. Tom Taylor edited C. R. Leslie's *Autobiographical Recollections* (1860) and was one of the most persuasive advocates of Hogarth's modern moral art.

38. Leslie, 'Lecture I', p. 193.

39. *Ibid.*, p. 194, likewise the following quotation.

40. See Francis Haskell, *Rediscoveries in Art: Some Aspects of Taste, Fashion and Collecting in England and France*, 2nd edn, London: Phaidon, 1980, pp. 85–106; Wolfgang Lottes, *Wie ein goldener Traum: die Rezeption des Mittelalters in der Kunst der Präraffaeliten*, Munich: Wilhelm Fink Verlag, 1984, pp. 20–38; Vaughan, *German Romanticism and English Art*, pp. 80–97; and R. W. Lightbown, 'The inspiration of Christian Art', in Sarah Macready and F. H. Thompson (eds), *Influences in Victorian Art and Architecture* (Occasional Papers (New Series), 7: The Society of Antiquaries of London), London: Thames & Hudson, 1985, pp. 3–40.

41. Adele M. Holcomb, 'Anna Jameson: the first professional English art historian', *Art History*, 6 (1983), pp. 171–87; Judith Johnston, 'Invading the house of Titian: the colonisation of Italian art: Anna Jameson, John Ruskin and the *Penny Magazine*', *Victorian Periodicals Review*, 27:2 (1994), pp. 127–43.

42. See Kingsley's review of Jameson's *Sacred and Legendary Art*, 'The poetry of *Sacred and Legendary Art*', in *The Works of Charles Kingsley*, 28 vols, London: Macmillan, 1880–85, vol. 20 (1880), pp. 188–226 (first published in *Fraser's Magazine*, 1849).

43. Thomas Phillips, *Lectures on the History and Principles of Painting*, London: Longman, Brown, Green & Longmans, 1833, p. xi.

44. Leslie, 'Lecture III', p. 249.

45. Franz Kugler, *Handbook of Painting: The Italian Schools*, ed. Lady Eastlake, 2 vols, 4th, rev. edn, London: John Murray, 1874, 'Preface by Sir Charles L. Eastlake to first English edition', pp. v–xi, p. v. For interesting comments on Eastlake's edition of Kugler see Vaughan, *German Romanticism and English Art*, pp. 88–9.

46. For this and the following quotations, see Leslie, 'Lecture II', pp. 221–2.

47. Leslie, 'Lecture I', p. 192.

48. This and the following quotations are *ibid.*, pp. 192–3.

49. 'The progress of British art', *Art-Union*, 1848, pp. 3–4, p. 3.

50. Macleod, *Art and the Victorian Middle Class*, p. 61.

51. For a more detailed analysis of the statistical material, see Michaela Giebelhausen, 'Representation, belief and the Pre-Raphaelite project 1840–1860', unpublished DPhil thesis, Oxford University, 1998. To my knowledge there exists no comparable analysis for other European countries. But Foucart's study contains several appendices listing the paintings that were commissioned by the French government for display in churches both in Paris and the provinces. These by far outnumber the annual RA average. See Foucart, *Le Renouveau*, pp. 358–416.

52. *The Times*, 6 May 1845, p. 6.

53. Hazlitt, 'Farington's Life', in *Complete Works*, vol. 16, p. 204.

54. For this useful notion of value, see Barbara Herrnstein Smith, *Contingencies of Value: Alternative Perspectives for Critical Theory*, Cambridge, Mass. and London: Harvard University Press, 1988, pp. 126–31.

55. For a useful analysis of the RA's image, see Colin Trodd, 'The authority of art: cultural criticism and the idea of the Royal Academy in mid-Victorian Britain', *Art History*, 20 (1997), pp. 3–22.

56. Elizabeth Prettejohn, 'Aesthetic value and the professionalization of Victorian art criticism 1837–78', *Journal of Victorian Culture*, 2 (1997), pp. 71–94, p. 72. For a good general overview of art reviewing, see Helene E. Roberts, 'Art reviewing in the early nineteenth-century art periodicals', *Victorian Periodicals Newsletter*, 19 (1973), pp. 9–20.

57. Julie Chandler L'Enfant, *William Michael Rossetti's Art Criticism: The Search for Truth in Victorian Art*, Lanham: University Press of America, 1999, p. 2.

58. *Ibid.*, p. 8.

59. 'Articles on art', *Punch*, 8 (1845), p. 247; likewise the following quotation.

60. Judith L. Fisher, 'The aesthetic of the mediocre: Thackeray and the visual arts', *Victorian Studies*, 26 (1982), pp. 65–82.

61. Thackeray, 'An exhibition gossip', *Ainsworth's Magazine*, June 1842, quoted from William Makepeace Thackeray, *The Paris Sketch Book and Art Criticisms*, ed. by George Saintsbury, London, New York and Toronto, n.d., p. 572.

62. 'The progress of British art', *Art-Union*, 1848, p. 3.

63. Thackeray, 'May gambols', *Fraser's Magazine*, June 1844, quoted from his *The Paris Sketch Book*, pp. 609–10; for a useful analysis of the Art Union, see Lyndel Saunders King, *The Industrialization of Taste: Victorian England and the Art Union of London*, Ann Arbor, Mich.: UMI Research Press, 1985. Although interesting in its attempts to promote private patronage and elevate taste, the Art Union had little influence on the production and consumption of religious painting.

64. 'Hints for the next exhibition', *Punch*, 8 (1845), p. 246.

65. 'Reflections arising out of the late "Exhibition"', *Art-Union*, 1840, pp. 126–7, p. 127.

66. Prettejohn, 'Aesthetic value', p. 81.

67. 'Historical painting in England', part I, *Art-Union*, 1840, pp. 65–6, p. 65.

68. For a useful discussion of private patronage at the RA, see Colin Trodd, 'Representing the Victorian Royal Academy: the properties of culture and the promotion of art', in Paul Barlow and Colin Trodd (eds), *Governing Cultures: Art Institutions in Victorian London*, Aldershot: Ashgate, 2000, pp. 56–68.

69. *Art-Union*, 1846, p. 171.

70. *The Times*, 3 May 1842, p. 5.

71. *Athenaeum*, 1843, p. 492.

72. *Ibid.*, 1843, p. 511.

73. For a full list of subjects, see William Sandby, *The History of the Royal Academy of Arts from Its Foundation in 1768 to the Present Time, With Biographical Notices of all the Members*, 2 vols [1862], reprinted London: Cornmarket Press, 1970, pp. 384–5.

74. See the still useful T. S. R. Boase, 'The decoration of the new Palace of Westminster', *Journal of the Warburg and Courtauld Institutes*, 17 (1954), pp. 319–58. For a contemporary description of the newly built Houses of Parliament see the anonymous compilation, *Illustrated London News: A Description of the New Palace of Westminster*, London: W. Warrington & Son, 1848. Useful recent literature includes Janet McLean, 'Prince Albert and the Fine Arts Commission', in Christine Riding and Jacqueline Riding (eds), *The Houses of Parliament: History, Art, Architecture*, London: Merrell Publishers Ltd, 2000, pp. 213–23, and William Vaughan, '"God help the minister who meddles in art": history painting in the new Palace of Westminster', *ibid.*, pp. 225–39.

75. See Frederick Knight Hunt, *The Book of Art: Cartoons, Frescoes, Sculpture, and Decorative Art, as Applied to the New Houses of Parliament and to Buildings in General: With an Historical Notice of the Exhibitions in Westminster Hall, and Directions for Painting in Fresco*, London: Jeremiah How, 1846, pp. 79, 114, 145–6; for a full catalogue of works submitted to the 1845 exhibition, see pp. 172–83.

76. Charles Lock Eastlake, 'The fine arts', in his *Contributions to the Literature of the Fine Arts*, London: John Murray, 1848, pp. 1–6, p. 3.

77. Eastlake, 'State and prospect of the English school' (from the First Report of the Commissioners on the Fine Arts 1842), in his *Contributions*, pp. 29–50, p. 33; the following quotation *ibid.*, p. 34.

78. *Art-Union*, 1847, p. 185; see also *Art-Union*, 1846, p. 171, and *The Times*, 29 April 1848, p. 3.

79. *Art-Union*, 1847, p. 185; likewise the following quotations.

80. *Athenaeum*, 1848, p. 463.

81. For a discussion of the impact of German art on the Westminster Cartoon Competitions and the RA see Vaughan, *German Romanticism and English Art*, pp. 177–225, and Quentin Bell, *Victorian Artists*, London: Routledge & Kegan Paul, 1967, pp. 14–27.

82. *The Times*, 29 April 1848, p. 3; see *Art-Union*, 1843, p. 163, for a comparatively early remark on the quality of the productions of younger artists; see also *Art-Union*, 1846, p. 171.

83. See *The Times*, 1 May 1847, p. 6. *The Times* frequently commented on the number of portraits shown at the RA exhibitions; see *The Times*, 3 May 1842, p. 5, on the high number of portraits, and also *The Times*, 6 May 1845, p. 6.

84. Clarke Olney, *Benjamin Robert Haydon: Historical Painter*, Athens, Georgia: University of Georgia Press, 1952, pp. 245–6. For Haydon's involvement in the Cartoon Competitions, see Eric George, *The Life and Death of Benjamin Robert Haydon 1786–1846*, London, New York and Toronto: Oxford University Press, 1948, pp. 263–78.

85. *Ibid.*, p. 280.

86. Benjamin Robert Haydon, *Description of Two Pictures, I. The Banishment of Aristeides, and II. The Burning of Rome by Nero, Parts of a Series of Six Designs, 1812, and Laid Before Every Minister from that Time to the Present*, London: Wilson and Ogilvy, n.d. [1846].

87. For Haydon's objections to the influence of German art, see Benjamin Robert Haydon, *Life of Benjamin Robert Haydon, Historical Painter, from His Autobiography and Journals*, ed. and compiled by Tom Taylor, 3 vols, 2nd edn, London: Longman, Brown, Green and Longmans, 1853, vol. 1, p. 350; also Frederic Wordsworth Haydon, *Benjamin Robert Haydon: Correspondence and Table-Talk, with a Memoir by his Son, F. W. Haydon*, 2 vols, London: Chatto and Windus, 1876, vol. 1, pp. 430–33.

88. David Robertson, *Sir Charles Eastlake and the Victorian Art World*, Princeton: Princeton University Press, 1978, p. 331.

89. For Haydon's involvement in the foundation of the Schools of Design see Quentin Bell, *The Schools of Design*, London: Routledge & Kegan Paul, 1963, especially chapters 3 and 4.

90. Haydon, *Life*, vol. 1, p. 55.

91. For an analysis of Haydon's theoretical writings see Ilse Wagner, *Das literarische Werk des Malers Benjamin Robert Haydon*, Göttingen, PhD thesis, 1934.

92. For comments on Haydon's copy of Bell's *Anatomy*, see A. N. L. Munby, 'The bibliophile: B. R. Haydon's anatomy book', *Apollo*, 26 (1937), pp. 345–7. Haydon's copy is now kept at the Yale Center for British Art in New Haven.

93. Haydon, *Life*, vol. 1, p. 95. His insights were based on two treatises in particular: John Bell, *The Anatomy of Bones, Muscles and Joints*, 2 vols, Edinburgh: Cadell & Davies, 1797, of whose work he said in the *Life* (vol. 1, p. 23): 'I took the book home, hugging it, and it has ever since been the text book of my school.' Haydon also attended Charles Bell's anatomy classes, which formed the basis for this Bell's *Essays on the Anatomy of Expression in Painting* (1806). See Haydon, *Life*, vol. 1, p. 43.

94. B. R. Haydon and W. Hazlitt, *Painting, and The Fine Arts: Being the Articles under Those Heads Contributed to the Seventh Edition of the Encyclopaedia Britannica*, Edinburgh: Adam & Charles Black, 1838, p. 177.

95. Benjamin Robert Haydon, *On Academies of Art, (More Particularly the Royal Academy); And Their Pernicious Effect on the Genius of Europe*, London: Henry Hooper, 1839, p. 1; likewise the following quotation.

96. John Barrell, *The Political Theory of Painting from Reynolds to Hazlitt*, New Haven: Yale University Press, 1986, pp. 311–14.

97. Haydon, *Academies*, pp. 5–6; likewise the following quotation.

98. For a useful analysis of Haydon's self-image as artist, see John Barrell, 'Benjamin Robert Haydon: the Curtius of the Khyber Pass', in Barrell (ed.), *Painting and the Politics of Culture: New Essays on British Art 1700–1850*, Oxford and New York: Oxford University Press, 1992, pp. 253–90.

99. For an account of *Dentatus*, see Haydon, *Life*, vol. 1, pp. 92–6; for the quarrel over the scene from *Macbeth* see *ibid.*, pp. 136–45.

100. *Ibid.*, p. 210; for an early incident of disagreement about the size of his paintings, see *ibid.*, p. 57.

101. *Ibid.*, p. 285. For Haydon's account of the public success of *The Judgement of Solomon*, see *ibid.*, pp. 236–9.

102. For a good account of art shows in London, see Richard D. Altick, *The Shows of London*, Cambridge, Mass. and London: The Belknap Press of Harvard University Press, 1978, pp. 404–19, also pp. 235–52.

103. Benjamin Robert Haydon, *Description of Christ's* Triumphant Entry into Jerusalem, *And Other Pictures; Now Exhibiting at Bullock's Great Room, Egyptian Hall Piccadilly*, London: C. H. Reynell, 1820, p. 8; likewise the following quotation.

104. *Ibid.*, pp. 9–10; also Haydon, *Life*, vol. 1, pp. 404 and 408.

105. *Blackwood's Magazine*, November 1821; quoted from Olney, *Benjamin Robert Haydon*, p. 112.

106. For a useful analysis of the painting see Richard and Samuel Redgrave, *A Century of British Painters* [1866], reprint, 2nd edn, Oxford: Phaidon, 1981, pp. 278–9.

107. Haydon, *Life*, vol. 1, p. 359.

108. Hazlitt, 'Haydon's "Christ's Agony In The Garden"', in *Complete Works*, vol. 18, pp. 140–45, p. 142. Haydon regarded the picture as a failure; see *Life*, vol. 1, pp. 418–19.

109. William Feaver, *The Art of John Martin*, Oxford: Clarendon Press, 1975, p. 55.

110. Thomas Balston, *John Martin 1789–1854: His Life and Works*, London: Gerald Duckworth, 1947, p. 66.

111. *Ibid.*, pp. 281–5.

112. Feaver, *The Art of John Martin*, pp. 72–84.

113. Ralph Hyde, *Panoramania! The Art and Entertainment of the 'All-Embracing' View*, London: Trefoil Publications in association with Barbican Art Gallery, 1988, pp. 109–24.

114. *Ibid.*, pp. 122–4. For a general discussion of the popularity and international practices of Holy Land dioramas and panoramas, see John Davis, *The Landscape of Belief: Encountering the Holy Land in Nineteenth-Century American Art and Culture*, Princeton: Princeton University Press, 1996, pp. 53–72.

115. For a useful analysis of the interdependencies, see Ann Bermingham, 'Landscape-O-Rama: the exhibition landscape at Somerset House and the rise of popular landscape entertainments', in David H. Solkin (ed.), *Art on the Line: Royal Academy Exhibitions at Somerset House 1780–1836*, New Haven and London: Yale University Press, 2001, pp. 127–43.

116. Balston, *John Martin*, p. 191.

117. Haydon, *Life*, vol. 1, p. 368.

118. Gordon Fyfe, *Art, Power and Modernity: English Art Institutions 1750–1950*, London: Leicester University Press, 2000, pp. 77–100. For a useful analysis of some of the issues raised in the debate, see Quentin Bell, 'Haydon versus Shee', *Journal of the Warburg and Courtauld Institutes*, 22 (1959), pp. 347–58.

119. *The Times*, 25 June 1846, p. 8.

120. George, *Benjamin Haydon*, p. 155.

121. *Art Journal*, 1853, pp. 187–8; likewise the following quotations.

122. 'British artists: their style and character. No 15. – Benjamin Robert Haydon', *Art Journal*, 1856, pp. 181–3; for a similar view of Haydon see also W. H. Hunt, *Pre-Raphaelitism*, vol. 1, pp. 46–7.

123. Samuel Smiles, *Self-Help: With Illustrations of Character and Conduct*, London: John Murray, 1859, p. 222.

124. *Ibid.*, p. 121.

125. *Ibid.*, p. 306.

126. Robertson, *Sir Charles Eastlake*, pp. 3–4.

127. For a recent account of Nazarene art see Mitchell Benjamin Frank, *German Romantic Painting Redefined: Nazarene Tradition and the Narratives of Romanticism*, Aldershot: Ashgate, 2001.

128. Thackeray, 'Strictures on pictures', *Fraser's Magazine*, June 1838; quoted from his *The Paris Sketch Book*, p. 382.

129. Thackeray, 'A pictorial rhapsody', *Fraser's Magazine*, June 1840; quoted from his *The Paris Sketch Book*, p. 503.

130. *Art-Union*, 1839, p. 68.

131. *Art-Union*, 1839, p. 20.

132. *Athenaeum*, 1841, pp. 367–8.

133. *Art-Union*, 1841, p. 76.

134. *Athenaeum*, 1841, p. 367; likewise the following quotations.

135. *The Times*, 4 May 1841, p. 5.

136. *Art-Union*, 1841, p. 76.

137. *The Times*, 4 May 1841, p. 5; *Art-Union*, 1841, p. 76; *Athenaeum*, 1841, p. 367.

138. For the different versions see Robertson, *Sir Charles Eastlake*, pp. 268–72. For a listing of the different engravings see Rosemary Treble (ed.), *Great Victorian Paintings: Their Paths to Fame*, London: Arts Council of Great Britain, 1978, p. 31.

139. *Art-Union*, 1847, pp. 368–9.

140. Letter from Eastlake to Harman, from Lady Eastlake's 'Memoir', in Sir Charles Lock Eastlake, *Contributions to the Literature of the Fine Arts*, second series, ed. with a memoir by Lady Eastlake, London: John Murray, 1870, p. 98.

141. *Athenaeum*, 1843, p. 492, and *Art-Union*, 1843, p. 164; likewise the following quotations.

142. *The Times*, 4 May 1850, p. 4.

143. *Art Journal*, 1850, p. 166.

144. *Athenaeum*, 1850, p. 508; likewise the following quotations. Further reviews included *Art Journal*, 1850, p. 166, and *The Times*, 4 May 1850, p. 4.

145. *Athenaeum*, 1840, p. 401.

146. Thackeray, 'A second lecture on the fine arts', *Fraser's Magazine*, June 1839, quoted from his *The Paris Sketch Book*, p. 397.

147. Quoted from Robertson, *Sir Charles Eastlake*, opposite p. 46.

148. *Athenaeum*, 1853, p. 566.

149. 'British artists: their style and character. No. 9. – Sir Charles Lock Eastlake, K.B., P.R.A.', *Art Journal*, 1855, pp. 277–80, p. 279.

150. For a good analysis of the influence of German art on Eastlake's work see Vaughan, *German Romanticism and English Art*, pp. 183–9.

151. Sandby, *History of the Royal Academy*, vol. 2, p. 188.

152. See Maria Pointon, *William Dyce 1806–1864: A Critical Biography*, Oxford: Clarendon Press, 1979, p. 120; for comments on the different versions see Frederick Cummings and Allen Staley, *Romantic Art in Britain: Paintings and Drawings 1760-1860*, exh. cat., The Detroit Institute of Arts and Philadelphia Museum of Art, 1968, pp. 272–3.

153. *The Times*, 4 May 1850, p. 5.

154. *Ibid.*, 9 May 1850, p. 5.

155. *Ibid.*, 4 May 1850, p. 5.

156. *Ibid.*, 9 May 1850, p. 5.

157. *Athenaeum*, 1850, p. 509; likewise the following quotation.

158. Pointon, *William Dyce*, pp. 119–21 and ills 74, 75 and 80.

159. James Dafforne, 'British painters: their style and character. No. 51, William Dyce R.A.', *Art Journal*, 1860, pp. 293–6, p. 296.

160. *Art Journal*, 1850, p. 167.

161. *Athenaeum*, 1850, p. 615.

162. *Athenaeum* 1850, p. 509; also *Art Journal* 1850, p. 166.

163. *Art-Union*, 1844, p. 158.

164. *Ibid.*; also *Athenaeum*, 1844, p. 459.

165. *The Times*, 8 May 1844, p. 7.

166. See Christopher Wright, *Poussin Paintings: A Catalogue Raisonné*, New York and London: Alpine Fine Arts Collection, 1984, p. 161. The work was widely known in an engraving of 1746; John Turpin, 'German influence on Daniel Maclise', *Apollo*, 97 (1973), pp. 169–75.

167. From a letter to John Foster that Maclise wrote from Paris in 1844; quoted from William Justin O'Driscoll, *A Memoir of Daniel Maclise, R.A.*, London: Longmans, Green and Co., 1871, p. 88.

168. Vaughan, *German Romanticism and English Art*, p. 217.

169. *Art-Union*, 1847, p. 190; likewise the following quotations.

170. *Athenaeum*, 1847, p. 496. Maclise was frequently criticized for the lack of colour; see for example *The Times*, 3 May 1842, p. 5; also *Athenaeum*, 1852, p. 582–3.

171. It was engraved by William Henry Simmons; see O'Driscoll, *A Memoir of Daniel Maclise*, p. 96.

172. *The Exhibition of the Royal Academy. MDCCCXLVII. The Seventy-Ninth*, London: W. Clowes and Sons, 1847, p. 9.

173. David Roberts, *The Holy Land, Syria, Idumea, Egypt, Nubia*, 3 vols, London: F. G. Moon, 1842–49.

174. *Art-Union*, 1847, p. 189.

175. *The Times*, 1 May 1847, p. 6.

176. *Athenaeum*, 1847, pp. 526–7; likewise the following quotations.

3 The fascination of paradox

1. William Michael Rossetti, 'Introduction', in Andrea Rose (ed.), *The Germ: The Literary Magazine of the Pre-Raphaelites*, Ashmolean Museum, Oxford and Birmingham Museums and Art Gallery, 1984, p. 6.

2. See Alastair Grieve, 'The Pre-Raphaelite Brotherhood and the Anglican High Church', *Burlington Magazine*, 111 (1969), pp. 294–5; Edward Morris, 'The subject of Millais's *Christ in the House of His Parents*', *Journal of the Warburg and Courtauld Institutes*, 33 (1970), pp. 343–5; and Howard Leathlean, 'Blood on his hands: the "inimitable pains" of a Pre-Raphaelite episode', *Journal of Pre-Raphaelite & Aesthetic Studies*, 1:2 (1988), pp. 41–53. The scholarly debate over the artistic intention of *Christ in the House of His Parents* has neglected a reading of the painting's realism and anti-conventionalism as fundamentally Protestant that was first put forward by F. G. Stephens in *The Grosvenor Gallery: Exhibition of the Works of Sir John Everett Millais, Bt., R.A. with Notes by F. G. Stephens*, London: Henry Good & Son, 1886, p. 13, and followed up by A. L. Baldry in *Sir John Everett Millais: His Art and Influence*, London: George Bell & Sons, 1899, pp. 99–100.

3. William E. Fredeman (ed.), *The P.R.B. Journal: William Michael Rossetti's Diary of the Pre-Raphaelite Brotherhood 1849–1853, Together with Other Pre-Raphaelite Documents*, Oxford: Clarendon Press, 1975, summary entry for January 1851, pp. 86–7, also p. 242; W. M. Rossetti (ed.), *Dante Gabriel Rossetti: His Family-Letters, with a Memoir by W. M. Rossetti*, 2 vols, London: Ellis & Elvey, 1895, vol. 1, pp. 134–5. For the phrase 'the fascination of paradox' see note 145, this chapter.

4. W. M. Rossetti (ed.), *Family-Letters*, vol. 1, p. 135.

5. Compare Anna Brownell Jameson, *Sacred and Legendary Art*, 2 vols, London: Longman, Brown, Green & Longmans, 1848; Lord Lindsay, *Sketches of the History of Christian Art*, 3 vols, London: John Murray, 1847; and John Ruskin, *Modern Painters*, vol. 2, London: Smith, Elder & Co., 1846. For an interesting discussion of Lindsay's book and Ruskin's review of it, see John Steegman, 'Lord Lindsay's *History of Christian Art*', *Journal of the Warburg and Courtauld Institutes*, 10 (1947), pp. 123–31. Charles Kingsley's review of Jameson's work made it quite clear that iconographical and historical investigations of early art could be conducted without giving offence to even the staunchest and most militant of Protestants. His verdict was unequivocal: 'we think Mrs. Jameson's book especially Protestant'; quoted from 'The poetry of *Sacred and Legendary Art*', in *The Works of Charles Kingsley*, vol. 20, p. 189.

6. Lindsay Errington, *Social and Religious Themes in English Painting 1840–1860*, New York and London: Garland Publishing, 1984, p. 255.

7. Jameson, *Sacred and Legendary Art*, vol. 1, p. xx; likewise the following quotation.

8. Lindsay, *Sketches of the History of Christian Art*, vol. 3, p. 419.

9. Carlo Lasinio, *Pitture a Fresco del Campo Santo di Pisa*, Florence: Presso Molini, Landi e Compagno, 1812.

10. W. H. Hunt, *Pre-Raphaelitism*, vol. 1, pp. 130–31.

11. Sussman, *Fact into Figure*, p. 42.

12. Letter from Ruskin to his father, 18 May 1845, in *Ruskin in Italy: Letters to his Parents, 1845*, ed. by Harold I. Shapiro, Oxford: Clarendon Press, 1972, pp. 67–8.

13. Frederic George Stephens, 'The purpose and tendency of early Italian art', in Rose (ed.), *The Germ*, pp. 58–64, p. 59; likewise the following quotation.

14. *Ibid.*, p. 61.

15. W. M. Rossetti, *Fine Art*, p. 185.

16. Bourdieu, 'Production of belief', in his *The Field of Cultural Production*, p. 102.

17. Herbert L. Sussman, *Victorian Masculinities: Manhood and Masculine Poetics in Early Victorian Literature and Art* (Cambridge Studies in Nineteenth-Century Literature and Culture, 3), Cambridge: Cambridge University Press, 1995, p. 115.

18. W. H. Hunt, *Pre-Raphaelitism*, vol. 1 , pp. 140–41; likewise the following quotation. See also vol. 1, pp. 132–3 for Hunt's description of revivalism. For an evaluation of the distinct positions of Rossetti and Hunt on the matter of early Christian art, see David Arthur Ludley, 'Sources for the "early Christian" style and content in the art of Dante Gabriel Rossetti', unpublished PhD thesis, Emory University, 1981, pp. 1–6.

19. Ruskin, *Modern Painters*, vol. 1 (1843), in *Works*, vol. 3, p. 137.

20. *Ibid.*, p. 198.

21. *Ibid.*, vol. 2 (1846), in *Works*, vol. 4, pp. 264–5.

22. Reynolds, *Discourses*, p. 146.

23. *Ibid.*, p. 238.

24. W. H. Hunt, *Pre-Raphaelitism*, vol. 1, pp. 73 and 90. In 1869 Hunt and Ruskin had a chance meeting in Venice and together visited the Scuola di San Rocco; see *ibid.*, vol. 2, pp. 258–70. For a useful analysis of their relationship see George P. Landow (ed.), '"Your good influence on me": the correspondence of John Ruskin and William Holman Hunt', *Bulletin of the John Rylands University Library of Manchester*, 59 (1976–77), pp. 95–126 and 367–96.

25. W. H. Hunt, *Pre-Raphaelitism*, vol. 1, p. 90.

26. Ruskin, *Modern Painters*, vol. 1 (1843), in *Works*, vol. 3, pp. 87–92.

27. For a useful introduction to typological thought see, George P. Landow, *Victorian Types, Victorian Shadows: Biblical Typology in Victorian Literature, Art and Thought*, Boston, Mass. and London: Routledge and Kegan Paul, 1980, ch. 1.

28. Chris Brooks, *Signs for the Times: Symbolic Realism in the Mid-Victorian World*, London: Allan & Unwin, 1984, p. 123.

29. Sussman, *Fact into Figure*, p. 44.

30. Brooks, *Signs for the Times*, p. 141.

31. For a useful analysis of Bell's work in relation to the PRB, see Julie F. Codell, 'Expression over beauty: facial expression, body language, and circumstantiality in the paintings of the Pre-Raphaelite Brotherhood', *Victorian Studies*, 29 (1986), pp. 255–90, pp. 268–72. For anecdotal evidence on the Pre-Raphaelites' engagement with phrenology, see W. H. Hunt, *Pre-Raphaelitism*, vol. 1, pp. 257–60.

32. Charles Bell, *The Anatomy and Philosophy of Expression as Connected with the Fine Arts* [1816], 3rd, enlarged edn, London: John Murray, 1844, p. 20.

33. Codell, 'Expression over beauty', p. 256.

34. W. H. Hunt, *Pre-Raphaelitism*, vol. 1, pp. 100–101.

35. *Ibid.*, p. 64.

36. The fact that Hunt sought to dispel this notion in his autobiography does not diminish its value; *ibid.*, vol. 1, pp. 120–27.

37. Ford Madox Brown, 'On the mechanism of a historical picture', in Rose (ed.), *The Germ*, pp. 70–73, p. 71; likewise the following quotations.

38. Brooks, *Signs for the Times*, p. 126.

39. William Blake, *The Note-book of William Blake, called the Rossetti Manuscript*, ed. by G. Keynes, London: The Nonesuch Press, 1935.

40. Quentin Bell, 'The Pre-Raphaelites and their critics', in Leslie Parris (ed.), *Pre-Raphaelite Papers*, London: The Tate Gallery, 1984, pp. 11–22, p. 11.

41. Rossetti, *Fine Art*, pp. 185 and 187.

42. Ford Madox Brown, *The Exhibition of Work, and Other Paintings* (1865), catalogue reprinted in Kenneth Paul Bendiner, *The Art of Ford Madox Brown*, University Park: The Pennsylvania State University Press, 1998, pp. 131–56, p. 143.

43. See the forthcoming article by William Vaughan, 'Written out? The case of Ford Madox Brown', in Tim Barringer and Michaela Giebelhausen (eds), *Writing the Pre-Raphaelites: The Textual Formation of a Victorian Avant-Garde*, Aldershot: Ashgate, forthcoming (2007).

44. Brown, *The Exhibition of* Work, in Bendiner, *The Art of Ford Madox Brown*, p. 133; likewise the following quotations.

45. See James Byam Shaw, *Paintings by Old Masters at Christ Church Oxford: Catalogue*, London: Phaidon Press, 1967, p. 53.

46. In Leslie Parris (ed.), *The Pre-Raphaelites*, exh. cat., London: The Tate Gallery, 1984, p. 241.

47. Compare the two preparatory sketches for *Jesus washing Peter's Feet*, Tate, London, T01035 and N04281. Entries in Brown's diary from the late summer of 1856 show his extensive repainting of the picture; see *The Diary of Ford Madox Brown*, ed. by Virginia Surtees, New Haven and London: Yale University Press for the Paul Mellon Centre for Studies in British Art, 1981.

48. Brown, *Exhibition of* Work, in Bendiner, *The Art of Ford Madox Brown*, p. 135; likewise the following quotations.

49. For full identification of the sitters see *The Diary of Ford Madox Brown*, p. 83, note 35.

50. Quoted in Parris (ed.), *The Pre-Raphaelites*, p. 101.

51. W. M. Rossetti, *Fine Art*, p. 187.

52. Errington, *Social and Religious Themes*, pp. 137–79.

53. Cunningham, *The Life of Sir David Wilkie*, vol. 3, pp. 112–13.

54. Errington, *Social and Religious Themes*, pp. 157–8.

55. Nicholas Tromans, 'David Wilkie: painter of everyday life', in Tromans (ed.), *David Wilkie: Painter of Everyday Life*, exh. cat., London: Dulwich Picture Gallery, 2002, pp. 8–29, pp. 27–9.

56. William Vaughan has argued that Catholic or High Church artists were not singled out by the reviewers for their particular religious convictions; see his 'Realism and tradition in religious art', in Zentralinstitut für Kunstgeschichte (ed.), *'Sind Briten hier?' Relations between British and Continental Art 1680–1880*, Munich: Wilhelm Fink Verlag, 1981, pp. 207–23, p. 217.

57. The critic in the *Athenaeum*, 1844, p. 483, reviewed both paintings favourably, celebrating them as 'truly English' and citing them as examples of an art produced under the *laissez-faire* conditions of private patronage.

58. Errington, *Social and Religious Themes*, pp. 163–6. This was clearly just the beginning of a long and militant appropriation of this image for the Protestant cause. See for example Augusta Cook and W. Stanley Martin, *The Story of the Light That Never Went Out: A History of English Protestantism for Young Readers*, London: Morgan & Scott, 1903, p. 489, which contains a full-page engraving of Herbert's painting.

59. See Fredeman (ed.), *P.R.B. Journal*, entry 30 May 1849, p. 8.

60. Quoted *ibid.*, entry 6 March 1850, p. 60. For an account of Collinson's career, see Ronald Parkinson, 'James Collinson', in Parris (ed.), *Pre-Raphaelite Papers*, pp. 61–75.

61. W. H. Hunt, *Pre-Raphaelitism*, vol. 1, p. 128.

62. Quoted in Fredeman (ed.), *P.R.B. Journal*, 21 July 1850 [summary entry for period 8 April to 21 July], p. 71; likewise the following quotation.

63. W. H. Hunt, *Pre-Raphaelitism*, vol. 1, pp. 158–60. See for example James Collinson's poem *The Child Jesus* and accompanying print, in Rose (ed.), *The Germ*, pp. 49–57.

64. See Wolfgang Lottes, 'The lure of Romish art: reflections of religious controversy in nineteenth-century English art criticism', *Journal of Pre-Raphaelite & Aesthetic Studies*, 1:1 (1988), pp. 45–61, pp. 52–3; Helene E. Roberts, 'Cardinal Wiseman, the Vatican and the Pre-Raphaelites', in Susan P. Casteras and Alicia Craig Faxon (eds), *Pre-Raphaelite Art in its European Context*, Madison, Teaneck: Farleigh Dickinson University Press and London: Associated University Presses, 1995, pp. 143–59, p. 148. Mary Lutyens, in 'Selling the missionary', *Apollo*, 86 (1967), pp. 380–87, shows Millais's astute business sense in his subtle courting of Thomas Combe, the early Pre-Raphaelite patron.

65. Bourdieu, 'Production of belief', in his *The Field of Cultural Production*, p. 84.

66. In his introduction to his edition of the *PRB Journal* (p. xxvi), Fredeman suggested that the omissions from W. M. Rossetti's earlier edition aimed to underline the artistic asceticism of the PRB.

67. See Bendiner, *The Art of Ford Madox Brown*, p. 19.

68. J. B. Bullen, *The Pre-Raphaelite Body: Fear and Desire in Painting, Poetry and Criticism*, Oxford: Clarendon Press, 1998, p. 11.

69. Ernst Kris, 'Psychology of caricature', in his *Psychoanalytic Explorations in Art*, New York: Schocken Books, 1967, pp. 173–88, p. 180.

70. 'The Pre-Raffaelites', *Art Journal*, 1 July 1851, pp. 185–6, p. 185.

71. *Art Journal*, 1851, p. 153.

72. T. Tindall Wildridge, *The Grotesque in Church Art*, London: William Andrews & Co., 1899, p. 5.

73. Frances K. Barasch, *The Grotesque: A Study in Meanings*, The Hague: Mouton & Co., 1971, p. 107.

74. Theodor Heuss, *Zur Ästhetik der Karikatur*, ed. by the Gesellschaft der Bibliophilen, 31 January 1954, no place of publication, p. 17.

75. M. H. Spielmann, *The History of 'Punch'*, London: Cassell and Company, 1895, p. 4; see also R. G. G. Price, *A History of* Punch, London: Collins, 1957, p. 31.

76. Ralph Waldo Emerson, 'The "Times"', in *Emerson's Complete Works*, 12 vols, Cambridge, Mass.: Riverside Press, 1883–93, vol. 5, pp. 247–58, p. 256.

77. See for example, 'Mr. Smith's reason for not sending his pictures to the exhibition', *Punch*, 8 (1845), p. 152; 'High art in Westminster Hall', *Punch*, 12 (1847), p. 267; 'A change for high art', *Punch*, 12 (1847), pp. 218–19; 'Fine art at every station', *Punch*, 12 (1847), p. 55; 'Punch's own picture', *Punch*, 13 (1847), p. 19. *Punch* was also critical of royal patronage; see for example: 'The Commission of Fine Arts', *Punch*, 8 (1845), p. 172; 'Princely patronage of art', *Punch*, 8 (1845), p. 189. For *Punch*'s more general criticism of 'Germanizing tendencies', see 'The classical German mania', *Punch*, 10 (1846), pp. 31–2.

78. In a short notice entitled 'Mr. Dyce's designs', *Punch* satirized Dyce's designs for Osborne House for their 'Germanism' and stiffness; *Punch*, 12 (1847), p. 42. See also *ibid.*, p. 56 for a caricature of Dyce's *Neptune resigning the Dominion of the Seas to Britannia*, also for Osborne House.

79. *Punch*, 9 (1845), p. 150. For a detailed analysis of this cartoon, see Roger Simpson, 'A triumph of common sense: the work of Sir John Tenniel 1820–1914', unpublished PhD thesis, University of Essex, 1987, pp. 140–41.

80. Reynolds, *Discourses*, p. 60.

81. Charles Kingsley, *Yeast*, Stroud: Alan Sutton Publishing Limited, 1994, p. 59 (first published in *Fraser's Magazine*, 1848).

82. Bullen, *The Pre-Raphaelite Body*, pp. 20–22.

83. 'Punch's dream of the House of Lords', *Punch*, 12 (1847), p. 193; likewise the following quotations.

84. Rodney Engen, *Richard Doyle*, Stroud: Catalpa, 1983, pp. 53–4; 'High art and the Royal Academy', *Punch*, 14 (1848), p. 197; likewise the following quotations. For a list of topics set in 1845, see F. N. Hunt, *Book of Art*, p. 145.

85. Although the revivalist idiom provided ample opportunities for *Punch*'s satirical attacks, academic conventions were also occasionally satirized; see 'Punch's own picture', *Punch*, 13 (1847), p. 19.

86. Richard Doyle, *God's Englishmen: The Forty Drawings by R. Doyle from 'Manners and Customs of ye Englyshe …'*, introduced by Michael Sadleir, London: Avalon Press & John Bradley, 1948, p. 4.

87. Engen, *Richard Doyle*, pp. 89–92; see also W. H. Hunt, *Pre-Raphaelitism*, vol. 1, p. 274. Volumes 19 (1850) and 20 (1851) of *Punch* are full of anti-Catholic comments and cartoons. For eight consecutive weeks *Punch* devoted the full-page cartoon, the so-called 'Big Cuts', to the 'Papal Aggression' and other anti-Catholic themes. This practice continued, if less regularly, in the following volume.

88. Kris, 'Psychology of caricature', in his *Psychoanalytic Explorations*, pp. 174–5.

89. On the Carracci as the inventors of caricature, see Donald Posner, *Annibale Carracci: A Study in the Reform of Italian Painting around 1590* (National Gallery of Art: Kress Foundation Studies in the History of European Art), 2 vols, London: Phaidon, 1971, vol. 1, pp. 65–70; see also Ernst Kris and Ernst Gombrich, 'The principles of caricature', in Kris, *Psychoanalytic Explorations*, pp. 189–203, p. 192.

90. *Ibid.*, p. 202.

91. W. H. Hunt, *Pre-Raphaelitism*, vol. 2, pp. 273–4; Engen, *Richard Doyle*, p. 58. Engen (pp. 183–7) reprints the complete article by Lewis Lask, 'The best of Richard Doyle', which appeared in the *Art Journal* in 1902. Lask, who had consulted Hunt for the article, claimed that the Pre-Raphaelites 'took pleasure in buying … the "Manners and Customs of Ye Englyshe" as they

appeared in *Punch*, and studied with real appreciation the artistic arrangement of the groups, and the character' (p. 184). Doyle became a friend of the Pre-Raphaelites and was one of the few admirers of Millais's *Christ in the House of His Parents* (see Engen, *Richard Doyle*, p. 116). There is also visual evidence, which dates to the autumn of 1850, that the Pre-Raphaelites engaged with the cartoons in *Punch*. The so-called 'Combe Scrap Book' (Ashmolean Museum, Oxford) contains an anonymous sketch based on the *Punch* cartoon 'The Pope "trying it on" Mr. John Bull', *Punch*, 19 (1850), p. 192. In the sketch the figure of John Bull is replaced by James Rogers, an Oxford graduate and High Churchman. Although the 'in-joke' remains obscure, the sketch further proves Pre-Raphaelite engagement with *Punch*.

92. Kris, 'Psychology of caricature', in his *Psychoanalytical Explorations*, p. 180.

93. *Punch*, 9 (1845), p. 103.

94. Fredeman (ed.), *P.R.B. Journal*, entry for 24 November 1849, p. 29.

95. *Athenaeum*, 7 April 1849, p. 362. For the identity of the reviewer, see Robyn Cooper, 'The relationship between the Pre-Raphaelite Brotherhood and painters before Raphael in English criticism of the late 1840s and 1850s', *Victorian Studies*, 24 (1981), pp. 405–38, p. 413, note 16. Similar concerns were voiced in the *Art Journal*, 1849, p. 147.

96. See, for example, *Art Journal*, 1850, p. 140; *Observer*, 15 April 1850, p. 5; *The Times*, 15 April 1850, p. 5. The obvious exceptions are W. M. Rossetti's review (*The Critic*, 1 July 1850, pp. 334–5) and Frank Stone's review (*Athenaeum*, 1850, p. 424). Lottes (*Goldener Traum*, p. 88) suggested that the severity of Stone's review might have been motivated by the fact that W. M. Rossetti had unfavourably reviewed one of Stone's paintings in the March issue of *The Critic*.

97. *The Times*, 15 April 1850, p. 5, likewise the following quotations.

98. My analysis of the review differs from that of Helene E. Roberts (put forward in Casteras and Faxon (eds), *Pre-Raphaelite Art in Its European Context*), who seeks to establish a literal reading of the religious terminology embedded in the reviews of early Pre-Raphaelite work. Robyn Cooper has warned against the tendency to 'overemphasize the importance of anti-Catholic sentiment' when accounting for the hostile reception of early Pre-Raphaelite work. She has rightly suggested that 'religious prejudice reinforced other prejudices against paintings that did not conform to accepted conventions' ('Relationship between PRB and painters before Raphael', pp. 415–16). This view is also shared by Lottes, in 'Lure of Romish art', p. 53: 'religious prejudice was only too welcome to support their ostracism'.

99. *Athenaeum*, 1849, p. 575; likewise the following quotations.

100. For reviews of *The Germ* see, for example, *Art Journal* (1850, p. 96) and *Ecclesiologist* (June 1850, p. 47). For evidence that the reception of Pre-Raphaelite work changed with this disclosure, see W. M. Rossetti (ed.), *Family-Letters*, vol. 1, p. 161; W. H. Hunt, *Pre-Raphaelitism*, vol. 1, p. 200; see also Cooper, 'Relationship between PRB and painters before Raphael', p. 413, and Herbert L. Sussman, 'The language of criticism and the language of art: the response of Victorian periodicals to the Pre-Raphaelite Brotherhood', *Victorian Periodicals Newsletter*, 6 (1973), pp. 21–9, p. 23.

101. Cooper's analysis has helped to clarify the conceptual muddle over the term 'Pre-Raphaelite', both in relation to early art and to the work of the Brotherhood; see her 'Relationship between PRB and painters before Raphael', p. 434, and also Robyn Cooper, 'British attitudes towards the Italian Primitives 1815–1865, with special reference to the mid-nineteenth century fashion', unpublished PhD thesis, University of Sussex, 1976.

102. *Illustrated London News*, 4 May 1850, 'Town talk and table talk', p. 306. The notice was signed A. B. R.; it was written by Munroe's friend Angus Reach; see Fredeman (ed.), *P.R.B. Journal*, 21 July 1850 [summary entry for period 8 April to 21 July], p. 70, and W. M. Rossetti (ed.), *Family-Letters*, vol. 1, p. 161.

103. I am here using Roland Barthes's concept of myth, which he developed in 'Myth today', in his *Mythologies*, selected and trans. by Annette Lavers, London: Vintage, 1993, pp. 109–58.

104. Smith, *Contingencies of Value*, pp. 36–41.

105. *Art Journal*, 1850, p. 176.

106. Bourdieu, 'Production of belief', in his *The Field of Cultural Production*, p. 83.

107. Bourdieu, 'Field of cultural production', *ibid.*, p. 60.

108. W. H. Hunt, *Pre-Raphaelitism*, vol. 1, p. 200.

109. Kris, 'Psychology of caricature', in his *Psychoanalytical Explorations*, p. 180; Bourdieu, 'Production of belief', in his *The Field of Cultural Production*, p. 83.

110. Fredeman (ed.), *P.R.B. Journal*, 21 July 1850 [summary entry for period 8 April to 21 July], p. 70.

111. *Ecclesiologist*, June 1850, p. 46. Similar reservations were voiced by Nicholas Wiseman; see his *Essays on Various Subjects*, 3 vols, London: Dolman, 1853, vol. 3, pp. 380–81. The footnote was added to Wiseman's article on 'Christian Art' which had first appeared in the *Dublin Review* in 1847. The High Church periodical *Guardian* showed the most persistent and sympathetic response, yet it did not claim the picture as a typical or desirable example of High Church art; see *Guardian*, 8 May 1850, p. 336.

112. For a detailed account of Millais's early career, see Malcolm Warner, 'The professional career of John Everett Millais to 1863', unpublished PhD thesis, University of London, Courtauld Institute of Art, 1985, pp. 24–45. Warner has demonstrated that Millais modelled his early style on established painters like William Etty and Henry Perronet Briggs.

113. However, the passage referred to a *false* prophet and has therefore traditionally been interpreted as a type of the Antichrist. The only biblical scholar to read it as a type of Christ was the medieval scholastic Rupert von Deutz. Although his interpretation has been refuted by later Bible commentators, it retained some currency in Catholic circles. The High Churchman E. B. Pusey supported such a reading in his *The Minor Prophets with a Commentary* (1860).

114. *Athenaeum*, 1850, pp. 590–91; likewise the following quotations. For an analysis of notions of taste and decorum in relation to the reception of Pre-Raphaelite work, see Susan P. Casteras, 'Pre-Raphaelite challenges to Victorian canons of beauty', in Malcolm Warner *et al.*, *Pre-Raphaelites in Context*, Henry E. Huntington Library and Art Gallery, San Marino, California, 1992, pp. 13–35.

115. Bourdieu, 'Production of belief', in his *The Field of Cultural Production*, p. 83.

116. *The Times*, 5 May 1850, p. 5.

117. On the prevalent strategies of anti-Catholic rhetoric, see Owen Chadwick, *The Victorian Church*, 2 vols, London: Adam & Charles Black, 1966, vol. 1, pp. 167–231 and 271–309; E. R. Norman, *Anti-Catholicism in Victorian England*, London: George Allen & Unwin, 1968, pp. 13–22, and *The English Catholic Church in the Nineteenth Century*, Oxford: Clarendon Press, 1984, pp. 201–43; and Walter Ralls, 'The Papal Aggression of 1850: a study in Victorian anti-Catholicism', in Gerald Parsons (ed.), *Religion in Britain*, vol. 4: *Interpretations*, Manchester and New York: Manchester University Press in association with the Open University, 1988, pp. 115–34.

118. *Art Journal*, 1850, p. 175.

119. *Athenaeum*, 1850, p. 590.

120. *The Times*, 4 May 1850, p. 5.

121. Charles Dickens, 'Old lamps for new ones', *Household Words*, 15 June 1850, pp. 265–7. For a useful analysis of Dickens's interest in Millais's painting, see J. B. Bullen, 'John Everett Millais and Charles Dickens: new light on old lamps', *English Literature in Transition 1880–1920*, Special Series no. 4, 1990, pp. 125–44.

122. Dickens, 'Old lamps', p. 267; likewise the following quotation.

123. *Athenaeum*, 1850, p. 590.

124. See for example *The Times*, 9 May 1850, p. 5.

125. *Art Journal*, 1850, p. 175.

126. Dickens, 'Old lamps', p. 266; similar rhetoric was also used by *Tait's Edinburgh Magazine* in an article entitled 'Fine arts. The Pre-Raphaelites' (August 1851, pp. 512–13): 'Mr Millais plunges headlong into this revolting absurdity when he represents the infant Christ under the semblance of an unhealthy, unwashed, whining brat, scratching itself against rusty nails in a carpenter's shop in the Seven Dials.' See also [Alexander Gilchrist's?], *A Glance at the Exhibition of the Royal Academy 1850*, London: Joseph Cundall, 1850, pp. 18–19.

127. Ralph N. Wornum, 'Modern moves in art', *Art Journal*, 1850, pp. 269–71, p. 271.

128. *Ibid*. p. 270; likewise the following quotation.

129. 'Pathological exhibition at the Royal Academy', *Punch*, 18 (1850), p. 198; likewise the following quotations.

130. Letter from Millais to Stephens, no date [probably June 1850], Bodleian Library, Oxford, Ms. Don e 57, fols 27v–28r.

131. Dickens, 'Old lamps', p. 265.

132. *Ibid*., pp. 265–6.

133. *Punch*, 12 (1847), p. 177.

134. For example, 'Punch among the pictures', *Punch*, 18 (1850), p. 214; 'Punch among the painters', *Punch*, 20 (1851), p. 219 (in this note *Punch* caricatured Pre-Raphaelite work and portraiture) and 'Punch upon portraits', *Punch*, 21 (1851), pp. 24–5.

135. *Punch*, 13 (1847), p. 90.

136. See also the short article on the Egyptian Hall, entitled 'The taste for the horrible', *Punch*, 13 (1847), p. 109, and the article on the strategies of the popular press, 'Penny-a-line atrocities', *Punch*, 17 (1849), p. 140. Similar allegations were made of the RA. In June 1851 *Tait's Edinburgh Magazine* complained about Landseer's *The Last Run of the Season*: 'Physical suffering, unless connected with some ennobling emotion of the mind, is an unfit subject either for painting or sculpture ... Such subjects only delight the morbid appetites which revel in Madame Tussaud's Chamber of Horrors' (p. 377). In his attack on the Pre-Raphaelites, Wornum also asserted that deformity and physical suffering had to be intrinsic to the subject matter; see Wornum, 'Modern moves', p. 271.

137. Dickens, 'Old lamps', p. 266. *Tait's Edinburgh Magazine* voiced similar objections to the Pre-Raphaelites: 'These gentlemen have forced themselves into temporary notice, as any one might do who chose to walk down Fleet-street in the dress of a pantaloon' (June 1851, p. 378). For similar juxtapositions of mercantile and spiritual values at work in the art exhibitions, see Helene E. Roberts, 'Exhibition and review: the periodical press and the Victorian art exhibition system', in Joanne Shattock and Michael Wolff (eds), *The Victorian Periodical Press: Samplings and Soundings*, Leicester: Leicester University Press, 1982, pp. 79–107, pp. 88–9.

138. Ruskin, *Pre-Raphaelitism*, 1851, in *Works*, vol. 12, p. 356.

139. *Punch*, 20 (1851), p. 219.

140. *Illustrated London News*, 11 May 1850, pp. 336–8; likewise the following quotations.

141. Wornum, 'Modern moves', p. 271.

142. *Guardian*, 1 June 1850, p. 396.

143. This was further emphasized by the canonized narrations of the hostile reception of early Pre-Raphaelite work, which failed to mention positive reviews and repeatedly rehearsed the litany of the most violent attacks; see John Guille Millais, *The Life and Letters of Sir John Everett Millais*, 2 vols, 2nd edn, London: Methuen & Co., 1900, vol. 1, pp. 75–6, and W. H. Hunt, *Pre-Raphaelitism*, vol. 1, pp. 203–206.

144. Stephens, *Exhibition of the Works of Sir John Everett Millais*, p. 12.

145. *Ibid.*, p. 15; likewise the following quotation. A similar evaluation of Millais's endeavours is to be found in an earlier article by F. G. Stephens, 'John Everett Millais', *The London Review*, 22 February 1862, pp. 183–4.

146. *Athenaeum*, 1850, p. 590, and *Illustrated London News*, 11 May 1850, p. 336.

147. Errington, *Social and Religious Themes*, p. 247.

148. W. H. Hunt, *Pre-Raphaelitism*, vol. 1, p. 91.

149. See Albert Boime, 'Sources for Sir John Everett Millais's "Christ in the House of His Parents"', *Gazette des Beaux Arts*, 86 (1975), pp. 71–84.

150. *Ibid.*, p. 74.

151. Shaw, *Paintings by Old Masters*, p. 47. For the better-known Pre-Raphaelite engagement with old master paintings, see Malcolm Warner, 'The Pre-Raphaelites and the National Gallery', in Warner et al., *Pre-Raphaelites in Context*, pp. 1–11.

152. Fredeman (ed.), *P.R.B. Journal*, entry 1 November 1849, p. 21.

153. Reynolds, *Discourses*, p. 146.

154. Jameson, *Sacred and Legendary Art*, vol. 1, p. xxvii; likewise the following quotation.

155. For a detailed analysis of the painting's iconography see Errington, *Social and Religious Themes*, pp. 260–63.

156. Landow, *Victorian Types*, p. 131.

157. Lindsay, *Sketches of the History of Christian Art*, vol. 1, p. xv.

158. W. H. Hunt, *Pre-Raphaelitism*, vol. 1, p. 203.

159. Errington, *Social and Religious Themes*, pp. 248–9.

160. Posner (*Annibale Carracci*, vol. 2, pp. 3-4) rejected the portrait theory upheld by John Rupert Martin, 'The Butcher's Shop of the Carracci', *Art Bulletin*, 95 (1963), pp. 263–6. See also Shaw, *Paintings by Old Masters*, pp. 100–101.

161. Gustav Friedrich Waagen, *Treasures of Art in Great Britain*, 3 vols, London: John Murray, 1854, vol. 3, p. 47. His fellow-German Johann David Passavant gave a similar account: 'Several excellent pictures by the *Carracci*, or their scholars, appear in this collection, one, in particular, of a butcher family by *Annibale*, supposed to be that of the painter himself'; J. D. Passavant, *Tour of a German Artist in England, with Notices of Private Galleries, and Remarks on the State of Art*, 2 vols, London: Saunders and Otley, 1836, vol. 1, p. 332.

162. Dickens, 'Old lamps', p. 266.

163. For comparable versions of the awkward boy, see *Design for a Picture of the Canterbury Pilgrims*, reproduced in J. G. Millais, *Life and Letters*, vol. 1, p. 59; see also Millais's drawing *A Lady in a Garden cutting a Flower from a Trellis* (1849–50), reproduced in J. A. Gere, *Pre-Raphaelite Drawings in the British Museum*, London: British Museum Press, 1994, cat. no. 38, p. 63. Versions of the woman folding a cloth are included in Millais's studies for *Mariana* and the unexecuted *Eve of the Deluge*, now held at Birmingham Museum and Art Gallery, inventory numbers 634'06, 635'06, 638'06; see City of Birmingham Museum and Art Gallery, *Catalogue of the Permanent Collection of Drawings*, Derby: Bemrose & Sons Ltd, 1939, pp. 266–7. No. 638'06 is reproduced in J. G. Millais, *Life and Letters*, vol. 1, p. 104.

164. Posner, *Annibale Carracci*, vol. 1, pp. 14–15.

165. J. G. Millais, *Life and Letters*, vol. 1, p. 76.

166. Tupper, 'The subject in art', in Rose (ed.), *The Germ*, pp. 11–18, p. 14.

167. Boime, 'Sources', p. 76.

168. Luigi Antonio Lanzi, *The History of Painting in Italy, from the Period of the Revival of the Fine Arts, to the End of the Eighteenth Century*, translated from the original Italian by Thomas Roscoe, 6 vols, London: W. Simpkin and R. Marshall, 1828, vol. 5, p. 96; W. H. Hunt, *Pre-Raphaelitism*, vol.1, p. 54.

169. Lanzi, *The History of Painting in Italy*, vol. 5, pp. 102–103.

170. *Ibid.*, vol. 5, p. 105.

171. Collinson, *The child Jesus*, in Rose (ed.), *The Germ*, p. 56.

172. Elizabeth Prettejohn, *The Art of the Pre-Raphaelites*, London: Tate Publishing, 2000, pp. 20–23.

173. Quoted in W. H. Hunt, *Pre-Raphaelitism*, vol. 1, p. 91.

174. Peter Funnell and Malcolm Warner, *Millais: Portraits*, exh. cat., London: National Portrait Gallery, 1999, p. 72. See also the useful essay by Leonée Ormond, 'Early and Pre-Raphaelite portraits', *ibid.*, pp. 39–65.

175. W. M. Rossetti, *Fine Art*, p. 209; the following quotation *ibid.*, pp. 209–10.

176. *Athenaeum*, 1854, p. 559. Similar remarks had been made as early as 1852; see *Athenaeum*, 1852, p. 581, and *The Times*, 14 May 1852, p. 6.

177. *Athenaeum*, 1854, p. 627.

178. *Athenaeum*, 1852, p. 581. In 1854 the *Athenaeum* made similar remarks, arguing that the 'fanaticism' of the Pre-Raphaelites had brought about 'the greater earnestness of the younger men' (p. 559). In 1858, the *Art Journal* (p. 161) commented on the tightened pictorial conventions which increasingly dominated the RA exhibits. According to the *Art Journal* (1859, p. 161) this tendency was even more pronounced in the following year. A similarly 'progressive' view of the Pre-Raphaelite project was expressed by Henry Noel Humphreys, in *Ten Centuries of Art: Its Progress in Europe from the IXth to the XIXth Century*, London: Grant and Griffith, 1852, pp. 61–3.

4 The making of William Holman Hunt as the painter of the Christ

1. Farrar and Meynell, *William Holman Hunt*, p. 1.

2. Wyke Bayliss, *Five Great Painters of the Victorian Era: Leighton, Millais, Burne-Jones, Watts, Holman Hunt*, London: Sampson Low, Marston & Co., 1902, p. v.

3. W. H. Hunt, *Pre-Raphaelitism*, vol. 2, p. 334.

4. See the coda-like final chapter, vol. 2, pp. 468–93, with its hyperbolic vindication of the Pre-Raphaelite principle.

5. Sussman, *Victorian Masculinities*, p. 128.

6. Julie F. Codell, 'The artist colonised: Holman Hunt's 'bio-history', masculinity, nationalism and the English school', in Ellen Harding (ed.), *Re-Framing the Pre-Raphaelites: Historical and Theoretical Essays*, Aldershot: Scolar Press, 1996, pp. 211–29, p. 216.

7. William Vaughan, 'Realism and tradition in religious art', in Zentralinstitut für Kunstgeschichte (ed.) *'Sind Briten hier?'*, p. 219; Marcia Pointon, 'The artist as ethnographer: Holman Hunt and the Holy Land', in Marcia Pointon (ed.), *Pre-Raphaelites Reviewed*, Manchester and New York: Manchester University Press, 1989, pp. 22–44, p. 40.

8. Robin Gilmour, *The Victorian Period: The Intellectual and Cultural Context of English Literature 1830–1890*, London and New York: Longman, 1993, p. 99.

9. David Friedrich Strauss, *The Life of Jesus, Critically Examined* [1835], ed. Peter C. Hodgson, London: SCM Press Ltd, 1973, p. li.

10. Quoted by Hodgson, 'Editor's introduction', in Strauss, *The Life of Jesus*, p. xlviii.

11. Hans Frei, 'David Friedrich Strauss', in N. Smart *et al.* (eds), *Nineteenth-Century Religious Thought in the West*, 3 vols, Cambridge: Cambridge University Press, 1985, vol. 1, pp. 215–60, p. 222.

12. For a useful discussion of the changes in the four major editions, see Peter C. Hodgson, 'Editor's introduction: Strauss's theological development from 1825 to 1840', in Strauss, *The Life of Jesus*, pp. xv–l. For a thorough analysis of the critical responses to Strauss's *The Life of Jesus*, see Edwina G. Lawler, *David Friedrich Strauss and his Critics: The Life of Jesus Debate in Early Nineteenth-Century German Journals*, New York, Berne, Frankfurt: Peter Lang, 1986.

13. David Friedrich Strauss, *Das Leben Jesu für das Deutsche Volk bearbeitet*, Leipzig: F. U. Brockhaus, 1864.

14. [John Robert Seeley], *Ecce Homo: A Survey of the Life and Work of Jesus Christ* [1865], London: Macmillan and Co., 1866.

15. For example George P. Fisher, *Essays on the Supernatural Origin of Christianity, with Special Reference to the Theories of Renan, Strauss, and the Tübingen School*, New York: Charles Scribner & Co., 1866.

16. William Ewart Gladstone, '*Ecce Homo*', London: Strahan and Co., 1868; quoted in George Warington, '*Ecce Homo' and Its Detractors: A Review*, London: William Skeffington, 1866, p. 14; see also the anonymous detailed, book-length riposte that aimed to reclaim the supernatural status of Jesus, *Ecce Deus: Essays on the Life and Doctrine of Jesus Christ with Controversial Notes on 'Ecce Homo'*, Edinburgh: T. & T. Clark, 1867.

17. Edward Ash, '*Ecce Homo': Its Character and Teaching*, London: W. Macintosh, F. B. Kitto, and Bristol: I. E. Chillcott, 1868, p. 34.

18. Henry Rogers, *Reason and Faith: Their Claims and Conflicts*, 2nd edn, London: Longman, Brown, Green and Longmans, 1850, p. 56. A typical example of conservative rearguard action which tries to eradicate historicism's relativism is the anonymously published *Essays on the Bible*, 2nd edn, London: Seeley, Jackson and Halliday, 1870.

19. Eduard Zeller, *Strauss and Renan: An Essay, Translated from the German*, London: Trübner & Co., 1866. See also his *David Friedrich Strauß in seinem Leben und seinen Schriften*, Bonn: Verlag von Emil Strauß, 1874. The slim volume immediately appeared in an English translation: *David Friedrich Strauss in His Life and Writings*, London: Smith, Elder & Co., 1874.

20. Zeller, *Strauss and Renan*, pp. 99–100.

21. Ernest Renan, *The Life of Jesus*, London: Trübner & Co., and Paris: M. Lévy Frères, 1864, p. vii.

22. Strauss, *The Life of Jesus*, p. lii (preface to the first volume of the first German edition, 1835).

23. Renan, *The Life of Jesus*, p. 34.

24. Joseph Hillis Miller, *The Disappearance of God: Five Nineteenth-Century Writers*, Cambridge, Mass. and London: The Belknap Press of Harvard University Press, 1975, p. 11.

25. *Ibid.*, p. 12.

26. Friedrich Nietzsche, *The Gay Science* [1887] trans., with commentary, by Walter Kaufmann, New York: Vintage Books, 1974, pp. 181–2.

27. Zeller, *Strauss and Renan*, p. 96.

28. Strauss, *The Life of Jesus*, p. 736.

29. Zeller, *Strauss and Renan*, p. 33.

30. Renan, *The Life of Jesus*, p. vii.

31. John Cairns, *False Christs and the True or the Gospel History Maintained in Answer to Strauss and Renan: A Sermon*, Edinburgh: Edmonston and Douglas, 1864, pp. 7–8.

32. Zeller, *Strauss and Renan*, p. 73.

33. David Friedrich Strauss, *A New Life of Jesus*, 2 vols, London and Edinburgh: Williams and Norgate, 1865, vol. 1, p. 1.

34. *Ibid.*, pp. 1–2.

35. *Ibid.*, pp. 3–4.

36. Gilmour, *The Victorian Period*, p. 55.

37. Warington, 'Ecce Homo', p. 4.

38. W. H. Hunt, *Pre-Raphaelitism*, vol. 1, pp. 355–6; likewise the following quotation.

39. For Carlyle's interest in the historical portrait, see Paul Barlow, 'The imagined hero as incarnate sign: Thomas Carlyle and the mythology of the "national portrait" in Victorian Britain', *Art History*, 17 (1994), pp. 517–45.

40. Reprinted in W. H. Hunt, *Pre-Raphaelitism*, vol. 1, p. 159.

41. *Ibid.*, p. 356.

42. *Ibid.*, p. 357.

43. *Ibid.*, p. 358.

44. Maurice Hewlett to Hunt, letter dated 13 December 1905 (Getty Research Institute, Los Angeles, Hunt Family Papers 860667-11).

45. W. H. Hunt, *Pre-Raphaelitism*, vol. 2, pp. 409–10.

46. *Ibid.*, vol. 1, p. viii.

47. Jeremy Maas, *Holman Hunt and The Light of the World*, 2nd edn, Aldershot: Wildwood House, 1987, p. 4. On the influence the images of *The Pictorial Bible* had on contemporary artists, see *ibid.*, pp. 2–6, 32–3 and 82–4.

48. For a full discussion see Giebelhausen, 'Representation, belief and the Pre-Raphaelite project', pp. 218–34 and 312–15.

49. *The Pictorial Bible*, 3 vols, London: Charles Knight, 1836–38.

50. For a useful analysis of Knight's enterprise and its educational motivations, see Patricia Anderson, *The Printed Image and the Transformation of Popular Culture 1790–1860*, 2nd edn, Oxford: Clarendon Press, 1994, pp. 50–83. Also see Rosemary Ann Mitchell, 'Approaches to history in text and image in England circa 1830–70', unpublished DPhil thesis, Oxford University, 1993, pp. 90–130.

51. 'Preface', n.p., *The Pictorial Bible*, 4 vols, 3rd edn, London: Charles Knight, 1847–48. The original edition had no preface.

52. Bann, *Romanticism and the Rise of History*, pp. 3–29.

53. For a useful account of the basic orientalist tropes deployed by travellers and artists, see James Thompson, 'Mapping the mind: the quest for Eastern metaphors and meaning', in Thompson (ed.), *The East Imagined, Experienced, Remembered: Orientalist Nineteenth Century Painting*, exh. cat., Dublin: National Gallery of Ireland and National Museums & Galleries on Merseyside, 1988, pp. 18–35. See also David Scott, 'The literary Orient', *ibid.*, pp. 3–17.

54. W. H. Hunt, *Pre-Raphaelitism*, vol. 2, pp. 380 and 386. See also Hunt's letter to Farrar, 11 February 1893 (Getty Research Institute, Los Angeles, Hunt Family Papers 860667-7).

55. Stephen Bann, in *The Clothing of Clio: A Study of the Representation of History in Nineteenth-Century Britain and France*, Cambridge: Cambridge University Press, 1984, pp. 42–5, charts a similar development in illustrated history books. Mitchell has rightly cautioned against a too-dogmatic application of this distinction, arguing that 'it is wise not to accept uncritically the claims of authenticity offered by the metanymic [sic] illustrations, which had all the apparent objectivity of photographs and just as much, or even more, subjective conditioning' ('Approaches to history', p. 16).

56. Ruskin, *Modern Painters*, vol. 3 (1856), in *Works*, vol. 5, p. 88; likewise the following quotation.

57. T. S. R. Boase, 'Biblical illustration in nineteenth-century English art', *Journal of the Warburg and Courtauld Institutes*, 29 (1966), pp. 349–67, pp. 356–7.

58. *The Pictorial Bible* ran into five editions: 1836–38 and 1838; the 1847–48 edition was greatly modified and reprinted in the 1850s; the 1874 edition again showed some modifications.

59. See for example the lavishly illustrated Roberts, *The Holy Land*. For Turner's engagement with biblical landscape, see Mordechai Omer, *J. M. W. Turner and the Romantic Vision of the Holy Land and the Bible*, exh. cat., Boston: McMullen Museum of Art, Boston College, 1996.

60. For useful discussions of the context, see Kenneth Paul Bendiner, 'The portrayal of the Middle East in British paintings 1835–1860', unpublished PhD thesis, Columbia University, 1979, pp. 3–14, and Malcolm Warner, 'The question of faith: Orientalism, Christianity and Islam', in M. A. Stevens (ed.), *The Orientalists: Delacroix to Matisse*, exh. cat., London: Royal Academy of Arts, 1984, pp. 32–9.

61. John Marius Wilson, *Landscapes of Interesting Localities Mentioned in the Holy Scriptures, Engraved … by W. and E. Finden; etc*, 2 vols, Edinburgh: W. and E. Finden, 1852, p. iii; likewise the following quotation.

62. John Kitto, *The Gallery of Scripture Engravings, Historical and Landscape … with Descriptions by J. Kitto*, 3 vols, London: Fisher, Son & Co., 1846–47, vol. 1, n.p.

63. The first Bible edition to introduce this mixture was *The Imperial Family Bible*, Glasgow: Blackie & Son, 1844.

64. See Vaughan, 'Realism and tradition in religious art', in Zentraliustitut für Kunstgeschichte (ed.), *'Sind Briten hier?'*, pp. 211–13 and 218–19.

65. W. H. Hunt, *Pre-Raphaelitism*, vol. 1, p. 149.

66. *Ibid.*, p. 150.

67. Preface, n.p., *The Pictorial Bible*, 3rd edn, 1847–48; likewise the following quotations.

68. *Cassell's Illustrated Family Bible*, 4 vols, London and New York: Cassell, Petter & Galpin, 1859–63. *Cassell's Illustrated Family Bible* was a commercial success: it sold '3000 copies a week in penny numbers', went through seven editions with only minor changes and remained in print until the 1880s; see E. M. Kauffmann (ed.), *The Bible in British Art*, exh. cat., London: Victoria & Albert Museum, 1977, p. 31.

69. W. H. Hunt, *Pre-Raphaelitism*, vol. 1, p. 150.

70. *Ibid.*, p. 85.

71. *Ibid.*, p. 48.

72. In Parris (ed.), *The Pre-Raphaelites*, p. 51.

73. For a useful account of the difficulties of relying on Hunt's autobiographical writings, see Laura Marcus, 'Brothers in their anecdotage: Holman Hunt's *Pre-Raphaelitism* and the Pre-Raphaelite Brotherhood', in Pointon (ed.), *Pre-Raphaelites Reviewed*, pp. 11–21. For a perceptive analysis of the ideologies embedded in Hunt's texts, see Codell, 'The artist colonized', in Harding (ed.), *Re-Framing the Pre-Raphaelites*, pp. 211–29.

74. W. H. Hunt, *Pre-Raphaelitism*, vol. 1, p. 81.

75. *Ibid.*, pp. 80 and 81.

76. *Ibid.*, pp. 84–5; likewise the following quotation.

77. *Ibid.*, p. 85.

78. *Ibid.*, p. 53; likewise the following quotations.

79. *Ibid.*, p. 79.

80. *Ibid.*, p. 82.

81. For a concise account of the painting's other biblical references see Parris (ed.), *The Pre-Raphaelites*, p. 117.

82. For the painting's connection with the genre of fairy painting, see Pointon, 'The artist as ethnographer', in Pointon (ed.), *Pre-Raphaelites Reviewed*, p. 34. Roskill has compared Christ to 'the fairy-tale prince, coming to the cottage with its clinging growth of years and its lack of any sign of life, to awaken the Sleeping Beauty'; see Mark Roskill and Herbert Sussman, 'Holman

Hunt's "The Scapegoat" a discussion', *Victorian Studies*, 12 (1969), pp. 465–70, p. 467.

83. W. H. Hunt, *Pre-Raphaelitism*, vol. 1, p. 292.

84. *Ibid.*, p. 347. Hunt stated that the two pictures were conceived in dialectical relationship to each other.

85. For a detailed analysis of the image, see Kate Flint, 'Reading *The Awakening Conscience* rightly', in Pointon (ed.), *Pre-Raphaelites Reviewed*, pp. 45–65.

86. William Bell Scott, *Autobiographical Notes of the Life of William Bell Scott … and Notices of His Artistic and Poetic Circle of Friends 1830 to 1882*, ed. W. Minto, 2 vols, London: Osgood, McIlvaine & Co., 1892, vol. 1, pp. 312–13.

87. *Ibid.*, p. 311.

88. W. H. Hunt, *Pre-Raphaelitism*, vol. 2, pp. 425–6.

89. H. W. Shrewsbury, *Brothers in Art: Studies in William Holman Hunt, O.M., D.C.L. and John Everett Millais, Bart., D.C.L., P.R.A. with Verse Interpretations*, London: The Epworth Press, J. Alfred Sharp, 1920, p. 118.

90. Mark Roskill, 'Holman Hunt's differing versions of the "Light of the World"', *Victorian Studies*, 6 (1963), pp. 229–44, p. 231, note 5. This is further corroborated by Bennett's detailed catalogue entry on *The Light of the World*; see Mary Bennett, *William Holman Hunt*, exh. cat., Liverpool: Walker Art Gallery, 1969, pp. 31–4.

91. W. H. Hunt, *Pre-Raphaelitism*, vol. 1, p. 289; likewise the following quotation.

92. *Ibid.*, p. 296, likewise the following quotations.

93. Sussman, *Victorian Masculinities*, p. 118.

94. Ruskin, *Modern Painters*, vol. 2 (1846), in *Works*, vol. 4, p. 327; likewise the following quotations.

95. *Ibid.*, pp. 315–16.

96. W. H. Hunt, *Pre-Raphaelitism*, vol. 1, p. 296.

97. *Athenaeum*, 1854, p. 561; likewise the following quotations.

98. *Art Journal*, 1854, p.169; likewise the following quotations.

99. *Athenaeum*, 1854, p. 884; likewise the following quotations.

100. Ruskin, 'Letter to *The Times*, 5 May 1854', in *Works*, vol. 12, p. 328.

101. *Ibid.*, p. 330.

102. 'In the picture-galleries. The Holman Hunt exhibition', in *The World*, 24 March 1886, quoted from Roskill, 'Differing versions of the "Light of the World"', p. 236.

103. Michael Wheeler, '*The Light of the World* as "true sacred art": Ruskin and William Holman Hunt', in Robert Hewison (ed.), *Ruskin's Artists: Studies in the Victorian Visual Economy*, Aldershot: Ashgate, 2000, pp. 111–29, p. 123.

104. W. H. Hunt, *Pre-Raphaelitism*, vol. 1, p. 356.

105. Thomas Carlyle, *On Heroes, Hero-Worship and the Heroic in History*, in Carlyle, *Works: The Ashburton Edition*, 17 vols, London: Chapman and Hall, 1888–89, vol. 3, p. 11. For a still-useful analysis of Victorian hero-worship, see Walter E. Houghton, *The Victorian Frame of Mind 1830–1870*, 15th reprinting, New Haven and London: Yale University Press, 1975, pp. 305–40.

106. Carlyle, *On Heroes*, in *Works*, vol. 3, p. 9.

107. *Ibid.*, p. 65.

108. Ruskin, 'Letter to *The Times*, 5 May 1854', in *Works*, vol. 12, p. 329.

109. W. H. Hunt, *Pre-Raphaelitism*, vol. 1, p. 419.

110. Stephens, *Hunt and His Works*, p. 30.

111. Richard Salmon, 'Thomas Carlyle and the idolatry of the man of letters', *Journal of Victorian Culture*, 7:1 (2002), pp. 1–22, p. 2.

112. Carlyle, *On Heroes*, in *Works*, vol. 3, p. 24.

113. *Ibid.*, pp. 134–5.

114. Ruskin, *Modern Painters*, vol. 3 (1856), in *Works*, vol. 5, p. 124; the following quotation *ibid.*, pp. 123–4.

115. Smiles, *Self-Help*, p. 103.

116. *Ibid.*, p. 101.

117. *Ibid.*, p. 108.

118. George P. Landow, 'William Holman Hunt's "The Shadow of Death"', *Bulletin of the John Rylands Library*, 55 (1972), pp. 197–239, p. 211.

119. William Holman Hunt, 'The Pre-Raphaelite Brotherhood: a fight for art', *Contemporary Review*, 1886, pp. 471–88; Part II, pp. 737–50; Part III, pp. 820–33. He continued his autobiographical reminiscences in 'Painting "The Scapegoat"', *Contemporary Review*, 1887, pp. 21–38 and 206–20.

120. W. H. Hunt, *Pre-Raphaelitism*, vol. 1, pp. 356–7.

121. *Ibid.*, p. 358.

122. *Ibid.*, p. 359.

123. Hunt's intentions were first mentioned in W. M. Rossetti's summary entry for October 1850; see Fredeman (ed.), *P.R.B. Journal*, p. 73, and again mentioned in his summary entry for January 1853, p. 98. His travel intentions are also mentioned in Hunt's correspondence with Thomas Combe, in a letter dated 14 March 1853, now in the Bodleian Library, Oxford, Ms. Eng. lett. C 296, fols 6–7.

124. Hayden White, *Metahistory: The Historical Imagination in Nineteenth-Century Europe*, Baltimore and London: The Johns Hopkins University Press, 1973, pp. 7–11. Hunt's autobiography falls into White's definition of the romance as 'a drama of self-identification' (p. 8).

125. Smiles, *Self-Help*, p. 120 (on Wilkie).

126. These sketches accompanied a letter Hunt wrote to Rosalie Orme. For excerpts, see Mary Bennett, 'Footnotes to the Holman Hunt exhibition', *Liverpool Bulletin*, 13 (1968–70), pp. 27–64, pp. 32–3. Hunt included a similar, imaginary sketch of himself working in the East in a letter to Combe dated 14 March 1853, now in the Bodleian Library, Oxford, Ms. Eng. lett. C 296, fol. 7r. It shows Hunt in Western dress sitting at an easel, palette in hand. Palm-trees and a Bedouin onlooker indicate the Eastern location.

127. Quoted in Diana Holman Hunt, *My Grandfather, His Wives and Loves* [1969], London: Columbus Books, 1987, pp.117–18.

128. Stephens, *Hunt and His Works*, p. 38.

129. W. H. Hunt, *Pre-Raphaelitism*, vol. 1, p. 348.

130. Sussman has discussed the performative aspects of Hunt's artistic identity; see *Victorian Masculinities*, pp. 158–66. For a detailed account of the notion of Christian manliness, see Norman Vance, *The Sinews of the Spirit: The Ideal of Christian Manliness in Victorian Literature and Religious Thought*, Cambridge: Cambridge University Press, 1985.

131. It has been estimated that about 5,000 books on the Holy Land appeared during the nineteenth century, and most of them were illustrated; see Eyal Onne (ed.), *Photographic Heritage of the Holy Land 1839–1914*, Manchester: Institute of Advanced Studies, Manchester Polytechnic, 1980, p. 12, and Edward Robinson, *Biblical Researches in Palestine, Mount Sinai and Arabia Petraea*, 3 vols, London: John Murray, 1841. For an account of Robinson's work, see Frederick Jones Bliss, *The Development of Palestine Exploration*, London: Hodder & Stoughton, 1906, pp. 184–223, and *Handbook for Travellers in the Holy Land*, London: John Murray, 1854, reprinted in 1857 and 1858. See also Patrick Brantlinger, *Rule of Darkness: British Literature and Imperialism 1830–1914*, Ithaca: Cornell University Press, 1988, pp. 135–46. A good general account is Peter A. Clayton, *The Rediscovery of Ancient Egypt: Artists and Travellers in the Nineteenth Century*, London: Thames & Hudson, 1982.

132. W. H. Hunt, *Pre-Raphaelitism*, vol. 1, p. 348.

133. Thompson, 'Mapping the mind', in Thompson (ed.), *The East*, p. 18.

134. See Judith Bronkhurst, '"An interesting series of adventures to look back upon": William Holman Hunt's visit to the Dead Sea in November 1854', in Parris (ed.), *Pre-Raphaelite Papers*, pp. 111–25, and also Pointon, 'The artist as ethnographer', in Pointon (ed.), *Pre-Raphaelites Reviewed*. Both authors have highlighted the discrepancies between Hunt's public bravura and the less-assured stance documented in his private writings.

135. See his diary entry for 2 November 1855 (John Rylands University Library of Manchester, Ms Eng. 1211, fol. 75v), and for 18 November 1855 (*ibid.*, fol. 82v).

136. Diary entry for 9 March 1855 (*ibid.*, fol. 6r).

137. Diary entry for 24 April 1855 (*ibid.*, fol. 69v).

138. W. H. Hunt, *Pre-Raphaelitism*, vol. 1, p. 370.

139. *Ibid.*, vol. 2, p. 83.

140. *Ibid.*, vol. 1, p. 375.

141. *Ibid.*, p. 359.

142. Letter dated 24 July 1854, quoted from James H. Coombs (ed.), *A Pre-Raphaelite Friendship: The Correspondence of William Holman Hunt and John Lucas Tupper*, Ann Arbor, Mich.: UMI Research Press, 1986, p. 45.

143. [Arthur Penrhyn Stanley], 'Sacred geography', *Quarterly Review*, vol. 94 (1854), pp. 353–84.

144. Arthur Penrhyn Stanley, *Sinai and Palestine in Connection with Their History*, London: John Murray, 1856, p. xxi.

145. *Ibid.*, p. xxii.

146. *Ibid.*, p. xix.

147. Hunt, diary of 1855, undated entry, John Rylands University Library of Manchester, Ms Eng. 1211, p. 69v.

148. Stephens, *Hunt and His Works*, pp. 37–8.

149. *Ibid.*, p. 62.

150. Quoted in Bronkhurst, '"An interesting series of adventures"', in Parris (ed.), *Pre-Raphaelite Papers*, p. 124.

151. In Parris (ed.), *The Pre-Raphaelites*, p. 153.

152. W. H. Hunt, *Pre-Raphaelitism*, vol. 2, pp. 108–10.

153. W. H. Hunt, 'Painting "The Scapegoat"', p. 218; for a longer version of this story see W. H. Hunt, *Pre-Raphaelitism*, vol. 2, pp. 106–108.

154. See Ruskin, *Academy Notes*, 1856, in *Works*, vol. 14, pp. 61–6, for this and the following quotations.

155. *Athenaeum*, 10 May 1856, p. 589.

156. For the lengthy transactions, see W. H. Hunt, *Pre-Raphaelitism*, vol. 2, pp. 184–94; see also Stephens, *Hunt and His Works*, p. 79, and Jeremy Maas, *Gambart: Prince of the Victorian Art World*, London: Barrie and Jenkins, 1975, pp. 114–22.

157. W. H. Hunt, *Pre-Raphaelitism*, vol. 2, pp. 197–8; Maas, *Gambart*, pp. 126–7 and 131–3.

158. W. H. Hunt, *Pre-Raphaelitism*, vol. 2, pp. 46–7.

159. Stephens, *Hunt and His Works* pp. 24–5.

160. George P. Landow, *William Holman Hunt and Typological Symbolism*, New Haven and London: Yale University Press for the Paul Mellon Centre for Studies in British Art, 1979, p. 95. A wide range of reviews is reprinted in the appendix to Stephens, *Hunt and His Works*, pp. 85–115.

161. For a useful account of the relationship between Hunt, Gambart and Stephens, see Maas, *Gambart*.

162. In Parris (ed.), *The Pre-Raphaelites*, p. 159. For a succinct analysis of the picture, the two versions and their commercial success, see Mary Bennett, *Artists of the Pre-Raphaelite Circle: The First Generation*, London: Lund Humphreys Publishers Ltd, 1988, pp. 77–83.

163. Stephens, *Hunt and His Works*, p. 63.

164. *Ibid.*, p. 62.

165. For a detailed account of Hunt's research and important deviation from historical truth for the sake of symbolic meaning, see Bendiner, 'Portrayal', pp. 253–4 and 265–6.

166. Edmund Gosse, *Father and Son* [1907], 3rd edn, Harmondsworth: Penguin Books, 1972, p. 164.

167. For a detailed reading of the painting's symbolism, see Landow, *Hunt and Typological Symbolism*, pp. 87–103. See also Bendiner, 'Portrayal', pp. 243–9, and the more recent and widely available Kenneth Bendiner, *An Introduction to Victorian Painting*, New Haven: Yale University Press, 1985, pp. 65–77.

168. Roland Barthes, 'The rhetoric of the image', in his *Image, Music, Text*, ed. and trans. by Stephen Heath, London: Flamingo, 1984, pp. 32–51, p. 39.

169. Stephens, *Hunt and His Works*, p. 71.

170. Carlyle, *On Heroes*, in *Works*, vol. 3, p. 174.

171. Linda Nochlin, 'The imaginary orient', *Art in America*, 71 (1983), pp. 119–31 and 186–91.

172. *Macmillan's Magazine*, May 1860, reprinted in Stephens, *Hunt and His Works*, p. 88.

173. *Athenaeum*, 21 April 1860, reprinted *ibid.*, p. 85; likewise the following quotation.

174. *Macmillan's Magazine*, May 1860, reprinted *ibid.*, p. 89; likewise the following quotation.

175. *Fraser's Magazine*, May 1860, reprinted *ibid.*, p. 99.

176. *Ibid.*, p. 100.

177. *Daily News*, 23 April 1860, reprinted *ibid.*, p. 110.

178. *Once a Week*, 14 July 1860, reprinted *ibid.*, p. 101.

179. However, there were other voices too. The *Art Journal* for example complained, 'Our conceptions of a sacred event have here been taken to Jerusalem but to be smothered in turbans, shawls, fringes, and phylacteries, and there buried in mere picturesqueness'; *Art Journal*, 1860, p. 182.

180. *Once a Week*, 14 July 1860, reprinted in Stephens, *Hunt and His Works*, p. 104; likewise the following quotation.

181. *Manchester Guardian*, 24 April 1860, reprinted *ibid.*, p. 115.

182. *The Critic*, 5 May 1860, reprinted *ibid.*, p. 104; likewise the following quotation.

183. *Edinburgh News*, 23 June 1860, reprinted *ibid.*, p. 107.

184. *Ibid.*, p. 108.

185. *Manchester Guardian*, 24 April 1860; reprinted *ibid.*, p. 115.

186. They were further explained by Hunt's key plate to the picture published by Gambart. For a reproduction and explanations, see Bennett, *The Pre-Raphaelite Circle*, pp. 81–3.

187. Stephens, *Hunt and His Works*, p. 83.

188. *The Dial*, 4 May 1860, reprinted *ibid.*, p. 114.

189. *Morning Chronicle*, 21 April 1860, reprinted *ibid.*, p. 109.

190. *The Critic*, 5 May 1860, reprinted *ibid.*, p. 105.

191. *Ibid.*, p. 60.

192. *Ibid.*, p. 61.

193. Letter from Hunt to Stephens, n.d. [probably 10 November 1866, according to postscript] (Bodleian Library, Oxford, Ms. Don e 67, fols 3–5, fol. 5r): 'All my relatives from the first appearance of the pamphlet which you wrote on my life and works have been in a state of feverish indignation at the references therein to my state of poverty during student and other days, they declare that it is all *untrue* that I was provided for most liberally, if not extravagantly, and that my allowing such statements to remain as those w[hic]h convey the idea that I was in some difficulty for want of proper patronage is an unpardonable wickedness …' [emphasis in the original]. In the course of the letter it becomes clear, however, that Hunt had no intention of changing the text should the catalogue ever be reprinted.

194. Stephens, *Hunt and His Works*, pp. 15–16.

195. Hunt to W. M. Rossetti, Jerusalem, 24 August 1855, quoted in Bendiner, 'Portrayal', p. 14.

196. Ruskin, *The Political Economy of Art*, 1857, in *Works*, vol. 16, pp. 29–30.

197. *Ibid.*, p. 42.

198. Stephens, *Hunt and His Works*, p. 79. The extended colonial tour of the third version of *The Light of the World* provided an even more drastic manifestation of artistic imperialism.

199. *Ibid.*, p. 13. Hunt also presented his Eastern trip as a logical continuation of the original Pre-Raphaelite agenda; see W. H. Hunt, *Pre-Raphaelitism*, vol. 2, p. 75.

200. W. H. Hunt, *Pre-Raphaelitism*, vol. 2, pp. 409–10.

201. Gilmour, *The Victorian Period*, p. 56.

202. Ieuan Ellis, *Seven against Christ: A Study of 'Essays and Reviews'*, Leiden: Brill, 1980, p. ix. For a useful introduction to the Broad Church tradition, see Gerald Parsons, 'On speaking plainly: "honest doubt" and the ethics of belief', in Parsons (ed.), *Religion in Victorian Britain*, vol. 2, pp. 191–219.

203. Joseph L. Altholz, *Anatomy of a Controversy: The Debate over* Essays and Reviews *1860–1864*, Aldershot: Scolar Press, 1994, pp. 15 and 34. In his review for the *Westminster Review*, Frederic Harrison called it 'a manifesto from a body of kindred or associated thinkers'; see [Frederic Harrison], 'Art. 1 — Neo-Christianity' *Essays and Reviews*. Second Edition. London: J. W. Parker and Son. 1860', *Westminster Review*, New Series, 17 (1860), pp. 293–332, p. 293. Charles Kingsley wrote to A. P. Stanley on 29 February 1861, 'The "Essays and Reviews" are one book in the mind of the world, and if they were not meant to be, they should not have been published in one volume'; quoted in Charles Kingsley, *His Letters and Memories of His Life, Edited by His Wife*, 2 vols, London: Henry S. King and Co., 1877, vol. 2, p. 129.

204. Frederick Temple, 'The education of the world', in *Essays and Reviews*, London: John W. Parker and Son, 1860, pp. 1–49, p. 44, likewise the following quotation.

205. *Ibid.*, pp. 24–5.

206. *Ibid.*, p. 25.

207. Benjamin Jowett, 'On the interpretation of Scripture', in *Essays and Reviews*, pp. 330–433, p. 372.

208. *Ibid.*, p. 338.

209. *Ibid.*, p. 367.

210. *Ibid.*, pp. 377–8.

211. James R. Moore, 'Geologists and interpreters of Genesis in the nineteenth century', in David C. Lindberg and Ronald L. Numbers (eds), *God and Nature: Historical Essays on the Encounter between Christianity and Science*, Berkeley: University of California Press, 1986, pp. 322–50, p. 334.

212. Jowett, 'On the interpretation of Scripture', in *Essays and Reviews*, p. 389.

213. Kingsley to A. P. Stanley 19 February, 1861; Kingsley, *Letters and Memories*, vol. 2., p. 130.

214. For a detailed account of the critical reception, see Altholz, *Anatomy of a Controversy*, pp. 39–49; see also Joseph L. Altholz, 'The mind of Victorian orthodoxy: Anglican responses to 'Essays and Reviews', 1860–1864', in Parsons (ed.), *Religion in Victorian Britain*, vol. 4, pp. 28–40.

215. [Harrison], 'Neo-Christianity', p. 312.

216. [Samuel Wilberforce], 'Art. VIII. — *Essays and Reviews*. London. 1860.', *Quarterly Review*, 109 (1861), 248–305, p. 269.

217. *Ibid.*, p. 304.

218. *Ibid.*, p. 286.

219. Ellis, *Seven against Christ*, p. 98.

220. Altholz, *Anatomy of a Controversy*, p. 32.

221. W. H. Hunt, *Pre-Raphaelitism*, vol. 2, p. 197.

222. My analysis of Dyce's religious images follows Marcia Pointon, in 'William Dyce as a painter of biblical subjects', *Art Bulletin*, 58 (1976), pp. 260–68. She rightly argues that pictures such as *The Man of Sorrows* must be regarded as religious-subject pictures and rejects Staley's categorization of them as landscapes; see Allen Staley, 'William Dyce and outdoor naturalism', *Burlington Magazine*, 105 (1963), pp. 470–76. She extended her analysis of religious implications to non-religious subjects; see Marcia Pointon, 'The representation of time in painting: a study of William Dyce's *Pegwell Bay: A Recollection of October 5th, 1858*', *Art History*, 1 (1978), pp. 99–103. See also my 'Holman Hunt, William Dyce and the image of Christ', in Nicola Bown *et al.* (eds), *The Victorian Supernatural*, Cambridge, Cambridge University Press, 2004, pp. 173–194.

223. Gertrud Schiller, *Iconography of Christian Art* [1966], trans. by Janet Seligman, 2 vols, London: Lund Humphreys, 1972, vol. 2, pp. 197–8.

224. *Athenaeum*, 1860, p. 653.

225. Pointon, *William Dyce*, pp. 163–4.

226. *Art Journal*, 1859, p. 164; likewise the following quotation.

227. *Athenaeum*, 1859, p. 651.

228. Hunt to John Graham, 3 August 1886 (Getty Research Institute, Los Angeles, Hunt Family Papers, 860667-3).

229. Letter to Stephens, 25 July 1868 (Bodleian Library, Oxford, Ms. Don e 67, fol. 22). Hunt regarded Seeley's *Ecce Homo*, first published anonymously in 1865, as a thought-provoking and sensitive historical analysis of Christ's life. He compared it favourably to Renan's *The Life of Jesus*; letter to Stephens, 31 August 1869 (Bodleian Library, Oxford, Ms. Don e 67, fols 43–5). Hunt stated that Renan's unimaginative account of Christ's life had led to a reaffirmation of his Evangelical belief (fol. 45v). He expressed similar views in a letter to William Bell Scott written in Jerusalem on 7 April 1870; see Scott, *Autobiographical Notes*, vol. 2, p. 89. See also a letter to Scott dated 19 August 1883 which contains the admission that *The Light of the World* was Hunt's conversion painting; *ibid.*, vol. 1, p. 314. On Renan see also W. H. Hunt, *Pre-Raphaelitism*, vol. 2, p. 409.

230. W. H. Hunt, *Pre-Raphaelitism*, vol. 1, p. 358.

231. Temple, 'The education of the world', in *Essays and Reviews*, pp. 24–5.

232. Farrar and Meynell, *William Holman Hunt*, p. 4.

233. W. H. Hunt, *Pre-Raphaelitism*, vol. 2, pp. 305–308.

234. Letter from Ruskin to his father, 18 May 1845, in *Ruskin in Italy*, ed. Shapiro, pp. 67–8.

235. W. H. Hunt, *Pre-Raphaelitism*, vol. 2, p. 310; likewise the following quotations.

236. *Ibid.*, vol. 1, p. 48.

237. F. W. Farrar, 'Part II. The principal pictures of William Holman Hunt', in Farrar and Meynell, *William Holman Hunt*, pp. 5–24.

238. Frederic W. Farrar, *The Life of Christ*, London: Cassell, Petter & Galpin, 2 vols, 2nd edn, 1874, vol.1, p. viii.

239. *Ibid.*, p. xiii.

240. Hunt to Farrar, 27 April 1870 (Getty Research Institute, Los Angeles, Hunt Family Papers, 860667-7).

241. Hunt to Farrar, 11 February 1893 (*ibid.*).

242. W. H. Hunt, *Pre-Raphaelitism*, vol. 2, p. 191.

243. *Ibid.*, p. 276.

244. Landow, '"The Shadow of Death"', p. 227.

245. W. H. Hunt, *Pre-Raphaelitism*, vol. 2, p. 197.

246. *Daily News*, 23 April 1860, reprinted in Stephens, *Hunt and His Works*, p. 110.

247. W. H. Hunt, *Pre-Raphaelitism*, vol. 1. pp. 358–9.

248. Hunt to Farrar, 3 March 1893 (Getty Research Institute, Los Angeles, Hunt Family Papers, 860667-7).

249. Farrar and Meynell, *William Holman Hunt*, p. 10.

250. *Ibid.*, p. 16.

251. Hunt to Farrar, 5 June 1893 (Getty Research Institute, Los Angeles, Hunt Family Papers, 860667-7); likewise the following quotation.

252. See for example a letter of 11 February 1893 (*ibid.*).

5 Epilogue

1. W. M. Rossetti, 'The externals of sacred art' in his, *Fine Art*, p. 47.

2. Armstrong, *Sir J. E. Millais*, p. 25.

3. *Ibid.*, pp. 25–6. Armstrong anglicized the name of the German artist to Frederick Uhde.

4. First published in France in 1865 and serialized by Cassell from 1866 onward, this was *The Holy Bible*, with illustrations by Gustave Doré, 2 vols, London: Cassell & Co., 1866–70. For a perceptive account of Doré's bourgeois commercialism and success, see Konrad Farner, *Gustave Doré der industrialisierte Romantiker*, Munich: Rogner und Bernhard GmbH & Co., 1975, pp. 177–87.

5. See *The Parables of Our Lord and Saviour Jesus Christ*, with pictures by John Everett Millais engraved by the brothers Dalziel, London: Routledge, Warne and Routledge, 1864.

6. *Athenaeum*, 1864, p. 881; likewise the following quotation.

7. *Ibid.*, p. 882; likewise the following quotations.

8. Ruskin, *The Art of England* (1883), in *Works*, vol. 33, p. 271.

9. *The Correspondence of Dante Gabriel Rossetti*, ed. by William E. Fredeman, vol. 2: *The Formative Years 1835–1862* Cambridge: D. S. Brewer, 2002, p. 114, letter 56.23.

10. Ruskin, *Academy Notes*, 1858, in *Works*, vol. 14, p. 163.

11. William Bell Scott, *William Blake: Etchings from His Works*, London: Chatto and Windus, 1878, p. 6.

12. *Dalziels' Bible Gallery: Illustrations from the Old Testament*, London: Dalziel Brothers, 1880; for a brief account of the aborted Bible edition, see G. E. Dalziel, *The Brothers Dalziel: A Record of Fifty Years Work 1840–1890* [1901], reprinted London: B. T. Batsford Ltd, 1978, pp. 258–62.

13. *The Illustrated Family Bible*, London: A. Fullarton and Co., n.d. [1876], 'Publisher's notice', p. 2.

14. Scott, *William Blake*, p. 5.

Bibliography

Archival sources

LONDON, TATE ARCHIVE
Dyce Papers [microfiches], typescript of Alexander Dyce's unpublished biography of his father, William Dyce.

LOS ANGELES, GETTY RESEARCH INSTITUTE
William Holman Hunt, Personal and Family Papers, c.1833–1930, 860667.

MANCHESTER, JOHN RYLANDS UNIVERSITY LIBRARY OF MANCHESTER
Account of William Holman Hunt's trip to the Dead Sea, 1854, Ms. Eng. 1210.
William Holman Hunt's diary of his first journey to Palestine (1855), Ms. Eng. 1211.
William Holman Hunt's diary of second journey to Palestine (1872), Ms. Eng. 1212.
William Holman Hunt's letters to Thomas Combe, 1853–76, Ms. Eng. 1213.

OXFORD, ASHMOLEAN MUSEUM
The Combe Scrapbook.

OXFORD, BODLEIAN LIBRARY
F. G. Stephens Correspondence:
 Letters of William Holman Hunt to FGS, 1849–80:
 MS. Don. e. 66 (168 leaves) = 1849–66
 MS. Don. e. 67 (295 leaves) = 1866–78
 MS. Don. e. 68 (101 leaves) = 1878–80
 Letters of (Sir) John Everett Millais to FGS, 1850–85:
 MS. Don. e. 57, fols. 25–43, with (fols 45–65) letters (of JEM) concerning the biography of JEM, 1897–99.
 Letters of W. H. Hunt to Thomas Combe, 1852–72:
 MS. Eng. lett. c. 296, fols 1–137

Printed Sources

Altholz, Joseph L., *Anatomy of a Controversy: The Debate over* Essays and Reviews *1860–1864*, Aldershot: Scolar Press, 1994.
Altick, Richard D., *The Shows of London*, Cambridge, Mass. and London: The Belknap Press of Harvard University Press, 1978.

Anderson, Patricia, *The Printed Image and the Transformation of Popular Culture 1790–1860*, 2nd edn, Oxford: Clarendon Press, 1994.

Armstrong, Walter, *Sir J. E. Millais, Bart., RA: His Life and Work, Art Journal*: Art Annual series, London: J. S. Virtue & Co., 1885.

Ash, Edward, *'Ecce Homo': Its Character and Teaching*, London: W. Macintosh, F. B. Kitto, and Bristol: I. E. Chillcott, 1868.

Baldry, A. L., *Sir John Everett Millais: His Art and Influence*, London: George Bell & Sons, 1899.

Balston, Thomas, *John Martin 1789–1854: His Life and Works*, London: Gerald Duckworth, 1947.

Bann, Stephen, *Romanticism and the Rise of History*, New York: Twayne Publishers, 1995.

____ *The Clothing of Clio: A Study of the Representation of History in Nineteenth-Century Britain and France*, Cambridge: Cambridge University Press, 1984.

Barasch, Frances K., *The Grotesque: A Study in Meanings*, The Hague: Mouton & Co., 1971.

Barlow, Paul, 'The imagined hero as incarnate sign: Thomas Carlyle and the mythology of the "national portrait" in Victorian Britain', *Art History*, 17 (1994), pp. 517–45.

____ and Colin Trodd (eds), *Governing Cultures: Art Institutions in Victorian London*, Aldershot: Ashgate, 2000.

Barrell, John, *The Political Theory of Painting from Reynolds to Hazlitt*, New Haven: Yale University Press, 1986.

____ (ed.), *Painting and the Politics of Culture: New Essays on British Art 1700–1850*, Oxford and New York: Oxford University Press, 1992.

Barringer, Tim, and Michaela Giebelhausen (eds), *Writing the Pre-Raphaelites: The Textual Formation of a Victorian Avant-Garde*, Aldershot: Ashgate (forthcoming, 2007).

Barthes, Roland, *Image, Music, Text*, essays selected and trans. by Stephen Heath, London: Flamingo, 1984.

____ *Mythologies* [1957], selected and trans. by Annette Lavers, London: Vintage, 1993.

Bayliss, Sir Wyke, *Five Great Painters of the Victorian Era: Leighton, Millais, Burne-Jones, Watts, Holman Hunt*, London: Sampson Low, Marston & Co., 1902.

Bell, Charles, *Essays on the Anatomy of Expression in Painting*, London: Longmans & Co., 1806.

Bell, Charles, *The Anatomy and Philosophy of Expression as Connected with the Fine Arts* [1816], 3rd, enlarged edn, London: John Murray, 1844.

Bell, John, *The Anatomy of Bones, Muscles and Joints*, 2 vols, Edinburgh: Cadell & Davies, 1797.

Bell, Quentin, 'Haydon versus Shee', *Journal of the Warburg and Courtauld Institutes*, 22 (1959), pp. 347–58.

____ *The Schools of Design*, London: Routledge & Kegan Paul, 1963.

____ *Victorian Artists*, London: Routledge & Kegan Paul, 1967.

Bendiner, Kenneth Paul, 'The portrayal of the Middle East in British paintings 1835–1860', unpublished PhD thesis, Columbia University, 1979.

____ *An Introduction to Victorian Painting*, New Haven: Yale University Press, 1985.

____ *The Art of Ford Madox Brown*, University Park: The Pennsylvania State University Press, 1998.

Bennett, Mary, *William Holman Hunt*, exh. cat., Liverpool: Walker Art Gallery, 1969.

____ 'Footnotes to the Holman Hunt exhibition', *Liverpool Bulletin*, 13 (1968–70), pp. 27–64.

____ *Artists of the Pre-Raphaelite Circle: The First Generation*, London: Lund Humphreys Publishers Ltd, 1988.

Die Bibel mit Bildern, Stuttgart: Cotta, 1844.

Blake, William, *The Note-book of William Blake, called the Rossetti Manuscript*, ed. by G. Keynes, London: Nonesuch Press, 1935.

Bliss, Frederick Jones, *The Development of Palestine Exploration*, London: Hodder & Stoughton, 1906.

Boase, T. S. R., 'The decoration of the new Palace of Westminster', *Journal of the Warburg and Courtauld Institutes*, 17 (1954), pp. 319–58.

____ 'Biblical illustration in nineteenth-century English art', *Journal of the Warburg and Courtauld Institutes*, 29 (1966), pp. 349–67.

Boime, Albert, 'Sources for Sir John Everett Millais's "Christ in the House of His Parents"', *Gazette des Beaux Arts*, 86 (1975), pp. 71–84.

Bourdieu, Pierre, *The Field of Cultural Production: Essays on Art and Literature*, ed. and introduced by Randal Johnson, Cambridge: Polity Press, 1993.

____ *The Rules of Art: Genesis and Structure of the Literary Field* [1992], trans. by Susan Emanuel, Cambridge: Polity Press, 1996.

Brantlinger, Patrick, *Rule of Darkness: British Literature and Imperialism 1830–1914*, Ithaca: Cornell University Press, 1988.

Brooks, Chris, *Signs for the Times: Symbolic Realism in the Mid-Victorian World*, London: Allan & Unwin, 1984.

Brown, Ford Madox, *The Exhibition of Work and other Paintings*, London: M'Corquodale & Co., 1865.

____ *The Diary of Ford Madox Brown*, ed. by Virginia Surtees, New Haven and London: Yale University Press for the Paul Mellon Centre for Studies in British Art, 1981.

Bullen, J. B., 'John Everett Millais and Charles Dickens: new light on old lamps', *English Literature in Transition 1880–1920*, Special Series no. 4, 1990, pp. 125–44.

____ *The Pre-Raphaelite Body: Fear and Desire in Painting, Poetry and Criticism*, Oxford: Clarendon Press, 1998.

Cairns, John, *False Christs and the True or the Gospel History Maintained in Answer to Strauss and Renan: A Sermon*, Edinburgh: Edmonston and Douglas, 1864.

Carlyle, Thomas, *Works: The Ashburton Edition*, 17 vols, London: Chapman and Hall, 1888–89.

Cassell's Illustrated Family Bible, 4 vols, London and New York: Cassell, Petter & Galpin, 1859–63.

Casteras, Susan P., and Alicia Craig Faxon (eds), *Pre-Raphaelite Art in its European Context*, Madison, Teaneck: Farleigh Dickinson University Press and London: Associated University Presses, 1995.

Chadwick, Owen, *The Victorian Church*, 2 vols, London: Adam & Charles Black, 1966.

City of Birmingham Museum and Art Gallery, *Catalogue of the Permanent Collection of Drawings*, Derby: Bemrose & Sons Ltd, 1939.

Clayton, Peter A., *The Rediscovery of Ancient Egypt: Artists and Travellers in the Nineteenth Century*, London: Thames & Hudson, 1982.

Codell, Julie F., 'Expression over beauty: facial expression, body language, and circumstantiality in the paintings of the Pre-Raphaelite Brotherhood', *Victorian Studies*, 29 (1986), pp. 255–90.

Cook, Augusta, and W. Stanley Martin, *The Story of The Light That Never Went Out: A History of English Protestantism for Young Readers*, London: Morgan & Scott, 1903.

Coombs, James H. (ed.), *A Pre-Raphaelite Friendship: The Correspondence of William Holman Hunt and John Lucas Tupper*, Ann Arbor, Mich.: UMI Research Press, 1986.

Cooper, Robyn, 'British attitudes towards the Italian Primitives 1815–1865, with special reference to the mid-nineteenth century fashion', unpublished PhD thesis, University of Sussex, 1976.

____ 'The relationship between the Pre-Raphaelite Brotherhood and painters before Raphael in English criticism of the late 1840s and 1850s', *Victorian Studies*, 24 (1981), pp. 405–38.

Cummings, Frederick, and Allen Staley, *Romantic Art in Britain: Paintings and Drawings 1760–1860*, exh. cat., The Detroit Institute of Arts and Philadelphia Museum of Art, 1968.

Cunningham, Allan, *The Life of Sir David Wilkie: With His Journals, Tours, and Critical Remarks on Works of Art, and a Selection from His Correspondence*, 3 vols, London: John Murray, 1843.

Dafforne, James, 'British painters: their style and character. No. 51, William Dyce R.A.', *Art Journal*, 1860, pp. 293–6.

Dalziel, G. E., *The Brothers Dalziel: A Record of Fifty Years Work 1840–1890* [1901], reprinted London: B. T. Batsford Ltd, 1978.

Dalziels' Bible Gallery: Illustrations from the Old Testament, London: Dalziel Brothers, 1880.

Davis, John, *The Landscape of Belief: Encountering the Holy Land in Nineteenth-Century American Art and Culture*, Princeton: Princeton University Press, 1996.

Dickens, Charles, 'Old lamps for new ones', *Household Words*, 15 June 1850, pp. 265–7.

Doyle, Richard, *God's Englishmen: The Forty Drawings by R. Doyle from 'Manners and Customs of ye Englyshe …'*, introduced by Michael Sadleir, London: Avalon Press & John Bradley, 1948.

Driskel, Michael Paul, *Representing Belief: Religion, Art and Society in Nineteenth-Century France*, University Park: Pennsylvania State University Press, 1992.

Eastlake, Charles Lock, *Contributions to the Literature of the Fine Arts*, London: John Murray, 1848.

____ *Contributions to the Literature of the Fine Arts*, second series, ed. with a memoir by Lady Eastlake, London: John Murray, 1870.

Ecce Deus: Essays on the Life and Doctrine of Jesus Christ with Controversial Notes on 'Ecce Homo', Edinburgh: T. & T. Clark, 1867.

Ellis, Ieuan, *Seven against Christ: A Study of 'Essays and Reviews'*, Leiden: Brill, 1980.

Emerson, Ralph Waldo, *Emerson's Complete Works*, 12 vols, Cambridge, Mass.: Riverside Press, 1883–93.

Engen, Rodney, *Richard Doyle*, Stroud: Catalpa, 1983.

Erffa, Helmut von, and Allen Staley, *The Paintings of Benjamin West*, New Haven and London: Yale University Press, 1986.

Errington, Lindsay, *Social and Religious Themes in English Painting 1840–1860*, New York and London: Garland Publishing, 1984.

Essays and Reviews, London: John W. Parker and Son, 1860.

Essays on the Bible, 2nd edn, London: Seeley, Jackson and Halliday, 1870.

The Exhibition of the Royal Academy. MDCCCXLVII. The Seventy-Ninth, London: W. Clowes and Sons, 1847.

Farner, Konrad, *Gustave Doré der industrialisierte Romantiker*, Munich: Rogner und Bernhard GmbH & Co., 1975.

Farrar, Frederic W., *The Life of Christ*, London: Cassell, Petter & Galpin, 2 vols, 2nd edn, 1874.

____ and Mrs Meynell, *William Holman Hunt: His Life and Work*, London: Art Journal Office, 1893.

Feaver, William, *The Art of John Martin*, Oxford: Clarendon Press, 1975.

Fisher, George P., *Essays on the Supernatural Origin of Christianity, with Special Reference to the Theories of Renan, Strauss, and the Tübingen School*, New York: Charles Scribner & Co., 1866.

Fisher, Judith L., 'The aesthetic of the mediocre: Thackeray and the visual arts', *Victorian Studies*, 26 (1982), pp. 65–82.

Flaxman, John, *Lectures on Sculpture, As Delivered Before the President and Members of the Royal Academy*, 2nd edn, London: Henry G. Bohn, 1838.

Foucart, Bruno, *Le Renouveau de la peinture religieuse en France 1800–1860*, Paris: Arthena, 1987.

Frank, Mitchell Benjamin, *German Romantic Painting Redefined: Nazarene Tradition and the Narratives of Romanticism*, Aldershot: Ashgate, 2001.

Fredeman, William E. (ed.), *The P.R.B. Journal: William Michael Rossetti's Diary of the Pre-Raphaelite Brotherhood 1849–1853, Together with Other Pre-Raphaelite Documents*, Oxford: Clarendon Press, 1975.

Funnell, Peter, and Malcolm Warner, *Millais: Portraits*, exh. cat., London: National Portrait Gallery, 1999.

Fuseli, Henry, *Lectures on Painting*, 2 vols, London: J. Johnson, 1801 and London: T. Cadell and W. Davies, 1820.

Fyfe, Gordon, *Art, Power and Modernity: English Art Institutions 1750–1950*, London: Leicester University Press, 2000.

George, Eric, *The Life and Death of Benjamin Robert Haydon 1786–1846*, London, New York and Toronto: Oxford University Press, 1948.

Gere, J. A., *Pre-Raphaelite Drawings in the British Museum*, London: British Museum Press, 1994.

Giebelhausen, Michaela, 'Representation, belief and the Pre-Raphaelite project 1840–1860', unpublished DPhil thesis, Oxford University, 1998.

____ 'Holman Hunt, William Dyce and the image of Christ', in Nicola Bown *et al.* (eds), *The Victorian Supernatural*, Cambridge, Cambridge University Press, 2004, pp. 173–194.

[Gilchrist, Alexander?], *A Glance at the Exhibition of the Royal Academy 1850*, London: Joseph Cundall, 1850.

Gilmour, Robin, *The Victorian Period: The Intellectual and Cultural Context of English Literature 1830–1890*, London and New York: Longman, 1993.

Gladstone, William Ewart, '*Ecce Homo*', London: Strahan and Co., 1868.

Gosse, Edmund, *Father and Son* [1907], 3rd edn, Harmondsworth: Penguin Books, 1972.

Grieve, Alastair, 'The Pre-Raphaelite Brotherhood and the Anglican High Church', *Burlington Magazine*, 111 (1969), pp. 294–5.

Handbook for Travellers in the Holy Land, London: John Murray, 1854.

Harding, Ellen (ed.), *Re-Framing the Pre-Raphaelites: Historical and Theoretical Essays*, Aldershot: Scolar Press, 1996.

Harris, Horton, *David Friedrich Strauss and his Theology*, Cambridge: Cambridge University Press, 1973.

[Harrison, Frederic], 'Art. 1 — Neo-Christianity, *Essays and Reviews*, Second Edn, London: J. W. Parker and Son. 1860', *Westminster Review*, New Series, 17 (1860), pp. 293–332.

Haskell, Francis, *Rediscoveries in Art: Some Aspects of Taste, Fashion and Collecting in England and France*, 2nd edn, London: Phaidon, 1980.

Haydon, Benjamin Robert, *Description of* Christ's Triumphant Entry into Jerusalem, *And Other Pictures; Now Exhibiting at Bullock's Great Room, Egyptian Hall Piccadilly*, London: C. H. Reynell, 1820.

____ *On Academies of Art, (More Particularly the Royal Academy); And Their Pernicious Effect on The Genius of Europe*, London: Henry Hooper, 1839.

____ *Description of Two Pictures, I.* The Banishment of Aristeides, *and II.* The Burning of Rome by Nero, *Parts of a Series of Six Designs, 1812, and Laid Before Every Minister from that Time to the Present*, London: Wilson and Ogilvy, n.d. [1846].

____ *Life of Benjamin Robert Haydon, Historical Painter, from His Autobiography and Journals*, ed. and compiled by Tom Taylor, 3 vols, 2nd edn, London: Longman, Brown, Green and Longmans, 1853.

____ and W. Hazlitt, *Painting, and The Fine Arts: Being the Articles under Those Heads Contributed to the Seventh Edition of the Encyclopaedia Britannica*, Edinburgh: Adam & Charles Black, 1838.

Haydon, Frederic Wordsworth, *Benjamin Robert Haydon: Correspondence and Table-Talk, with a Memoir by his Son, F. W. Haydon*, 2 vols, London: Chatto and Windus, 1876.

Hazlitt, William, *The Complete Works of William Hazlitt*, ed. by P. P. Howe, 21 vols, London and Toronto: J. M. Dent and Sons, 1930–34.

Heuss, Theodor, *Zur Ästhetik der Karikatur*, ed. by the Gesellschaft der Bibliophilen, 31 January 1954, no place of publication.

Hewison, Robert (ed.), *Ruskin's Artists: Studies in the Victorian Visual Economy*, Aldershot: Ashgate, 2000.

Holcomb, Adele M., 'Anna Jameson: the first professional English art historian', *Art History*, 6 (1983), pp. 171–87.

The Holy Bible, with illustrations by Gustave Doré, 2 vols, London: Cassell & Co., 1866–70.

Houghton, Walter E., *The Victorian Frame of Mind 1830–1870*, 15th reprinting, New Haven and London: Yale University Press, 1975.

Howard, Henry, *A Course of Lectures on Painting, Delivered at the Royal Academy of Fine Arts*, ed. with a memoir of the author by Frank Howard, London: Henry G. Bohn, 1848.

Humphreys, Henry Noel, *Ten Centuries of Art: Its Progress in Europe from the IXth to the XIXth Century*, London: Grant and Griffith, 1852.

Hunt, Diana Holman, *My Grandfather, His Wives and Loves* [1969], London: Columbus Books, 1987.

Hunt, Frederick Knight, *The Book of Art: Cartoons, Frescoes, Sculpture, and Decorative Art, as Applied to the New Houses of Parliament and to Buildings in General: With an Historical Notice of the Exhibitions in Westminster Hall, and Directions for Painting in Fresco*, London: Jeremiah How, 1846.

Hunt, William Holman, 'The Pre-Raphaelite Brotherhood: a fight for art', *Contemporary Review*, 1886, pp. 471–88; Part II, pp. 737–50; Part III, pp. 820–33.

____ 'Painting "The Scapegoat"', *Contemporary Review*, 1887, pp. 21–38 and 206–20.

____ *Pre-Raphaelitism and the Pre-Raphaelite Brotherhood*, 2 vols, London: Macmillan & Co., 1905.

Hyde, Ralph, *Panoramania! The Art and Entertainment of the 'All-Embracing' View*, London: Trefoil Publications in association with Barbican Art Gallery, 1988.

The Illustrated Family Bible, London: A. Fullarton and Co., n.d. [1876].

Illustrated London News: A Description of the New Palace of Westminster, London: W. Warrington & Son, 1848.

The Imperial Family Bible, Glasgow: Blackie & Son, 1844.

Jameson, Anna Brownell, *Sacred and Legendary Art*, 2 vols, London: Longman, Brown, Green & Longmans, 1848.

Johnston, Judith, 'Invading the house of Titian: the colonisation of Italian art: Anna Jameson, John Ruskin and the *Penny Magazine*', *Victorian Periodicals Review*, 27:2 (1994), pp. 127–43.

Kauffmann, E. M. (ed.), *The Bible in British Art*, exh. cat., London: Victoria & Albert Museum, 1977.

Keuss, Jeffrey F., *A Poetics of Jesus: The Search for Christ through Writing in the Nineteenth Century*, Aldershot: Ashgate, 2002.

King, Lyndel Saunders, *The Industrialization of Taste: Victorian England and the Art Union of London*, Ann Arbor, Mich.: UMI Research Press, 1985.

Kingsley, Charles, *The Works of Charles Kingsley*, 28 vols, London: Macmillan, 1880–85.

____ *His Letters and Memories of His Life, Edited by His Wife*, 2 vols, London: Henry S. King and Co., 1877.

____ *Yeast* [serialised 1848; published in book form 1849], Stroud: Alan Sutton Publishing Limited, 1994.

Kitto, John, *The Gallery of Scripture Engravings, Historical and Landscape ... with Descriptions by J. Kitto*, 3 vols, London: Fisher, Son & Co., 1846–47.

Kris, Ernst, *Psychoanalytic Explorations in Art*, New York: Schocken Books, 1967.

Kugler, Franz, *Handbook of Painting: The Italian Schools* [first published under a slightly different title in 1842], ed. Lady Eastlake, 2 vols, 4th, rev. edn, London: John Murray, 1874.

L'Enfant, Julie Chandler, *William Michael Rossetti's Art Criticism: The Search for Truth in Victorian Art*, Lanham: University Press of America, 1999.

Landow, George P., 'William Holman Hunt's "The Shadow of Death"', *Bulletin of the John Rylands Library*, 55 (1972), pp. 197–239.

____ (ed.), '"Your good influence on me": the correspondence of John Ruskin and William Holman Hunt', *Bulletin of the John Rylands University Library of Manchester*, 59 (1976–77), pp. 95–126 and 367–96.

____ *William Holman Hunt and Typological Symbolism*, New Haven and London: Yale University Press for the Paul Mellon Centre for Studies in British Art, 1979.

____ *Victorian Types, Victorian Shadows: Biblical Typology in Victorian Literature, Art and Thought*, Boston, Mass. and London: Routledge and Kegan Paul, 1980.

Lanzi, Luigi Antonio, *The History of Painting in Italy, from the Period of the Revival of the Fine Arts, to the End of the Eighteenth Century*, translated from the original Italian by Thomas Roscoe, 6 vols, London: W. Simpkin and R. Marshall, 1828.

Lasinio, Carlo, *Pitture a Fresco del Campo Santo di Pisa*, Florence: Presso Molini, Landi e Compagno, 1812.

Lawler, Edwina G., *David Friedrich Strauss and his Critics: The Life of Jesus Debate in Early Nineteenth-Century German Journals*, New York, Berne, Frankfurt: Peter Lang, 1986.

Leathlean, Howard, 'Blood on his hands: the "inimitable pains" of a Pre-Raphaelite episode', *Journal of Pre-Raphaelite & Aesthetic Studies*, 1:2 (1988), pp. 41–53.

Leslie, Charles Robert, 'Professor Leslie's Lectures on Painting. Lecture I', *Athenaeum*, 1848, pp. 191–4.

____ 'Professor Leslie's Lectures on Painting. Lecture II', *Athenaeum*, 1848, pp. 220–23.

____ 'Professor Leslie's Lectures on Painting. Lecture III', *Athenaeum*, 1848, pp. 247–50.

____ *Life and Times of Sir Joshua Reynolds: With Notices of Some of His Contemporaries*, continued and concluded by Tom Taylor, 2 vols, London: John Murray, 1865.

Lindberg, David C., and Ronald L. Numbers (eds), *God and Nature: Historical Essays on the Encounter between Christianity and Science*, Berkeley: University of California Press, 1986.

Lindsay, Lord, *Sketches of the History of Christian Art*, 3 vols, London: John Murray, 1847.

Lottes, Wolfgang, *Wie ein goldener Traum: die Rezeption des Mittelalters in der Kunst der Präraffaeliten*, Munich: Wilhelm Fink Verlag, 1984.

____ 'The lure of Romish art: reflections of religious controversy in nineteenth-century English art criticism', *Journal of Pre-Raphaelite & Aesthetic Studies*, 1:1 (1988), pp. 45–61.

Ludley, David Arthur, 'Sources for the "early Christian" style and content in the art of Dante Gabriel Rossetti', unpublished PhD thesis, Emory University, 1981.

Lutyens, Mary, 'Selling the missionary', *Apollo*, 86 (1967), pp. 380–87.

Maas, Jeremy, *Gambart: Prince of the Victorian Art World*, London: Barrie and Jenkins, 1975.

____ *Holman Hunt and* The Light of the World, 2nd edn, Aldershot: Wildwood House, 1987.

Macleod, Dianne Sachko, *Art and the Victorian Middle Class: Money and the Making of Cultural Identity*, Cambridge: Cambridge University Press, 1996.

Macready, Sarah, and F. H. Thompson (eds), *Influences in Victorian Art and Architecture* (Occasional Papers (New Series), 7: The Society of Antiquaries of London), London: Thames & Hudson, 1985.

Martin, John Rupert, 'The Butcher's Shop of the Carracci', *Art Bulletin*, 95 (1963), pp. 263–6.

Millais, John Guille, *The Life and Letters of Sir John Everett Millais*, 2 vols, 2nd edn, London: Methuen & Co., 1900.

Miller, Joseph Hillis, *The Disappearance of God: Five Nineteenth-Century Writers*, Cambridge, Mass. and London: The Belknap Press of Harvard University Press, 1975.

Mitchell, Rosemary Ann, 'Approaches to history in text and image in England circa 1830–70', unpublished DPhil thesis, Oxford University, 1993.

Morris, Edward, 'The subject of Millais's *Christ in the House of His Parents*', *Journal of the Warburg and Courtauld Institutes*, 33 (1970), pp. 343–5.

Munby, A. N. L., 'The bibliophile: B. R. Haydon's anatomy book', *Apollo*, 26 (1937), pp. 345–7.

Nietzsche, Friedrich, *The Gay Science* [1887], trans., with commentary, by Walter Kaufmann, New York: Vintage Books, 1974.

Nochlin, Linda, 'The imaginary orient', *Art in America*, 71 (1983), pp. 119–31 and 186–91.

Norman, Edward Robert, *Anti-Catholicism in Victorian England*, London: George Allen & Unwin, 1968.

_____ *The English Catholic Church in the Nineteenth Century*, Oxford: Clarendon Press, 1984.

O'Driscoll, William Justin, *A Memoir of Daniel Maclise, R.A.*, London: Longmans, Green and Co., 1871.

Olney, Clarke, *Benjamin Robert Haydon: Historical Painter*, Athens, Georgia: University of Georgia Press, 1952.

Omer, Mordechai, *J. M. W. Turner and the Romantic Vision of the Holy Land and the Bible*, exh. cat., Boston: McMullen Museum of Art, Boston College, 1996.

Onne, Eyal (ed.), *Photographic Heritage of the Holy Land 1839–1914*, Manchester: Institute of Advanced Studies, Manchester Polytechnic, 1980.

The Parables of Our Lord and Saviour Jesus Christ, with pictures by John Everett Millais engraved by the brothers Dalziel, London: Routledge, Warne and Routledge, 1864.

Parris, Leslie (ed.), *The Pre-Raphaelites*, exh. cat., London: The Tate Gallery, 1984.

_____ (ed.), *Pre-Raphaelite Papers*, London: The Tate Gallery, 1984.

Parsons, Gerald (ed.), *Religion in Victorian Britain*, 4 vols, Manchester and New York: Manchester University Press in association with the Open University, 1988.

Passavant, Johann David, *Tour of a German Artist in England, with Notices of Private Galleries, and Remarks on the State of Art*, 2 vols, London: Saunders and Otley, 1836.

Phillips, Thomas, *Lectures on the History and Principles of Painting*, London: Longman, Brown, Green & Longmans, 1833.

The Pictorial Bible, 3 vols, London: Charles Knight, 1836–38.

The Pictorial Bible, 4 vols, 3rd edn, London: Charles Knight, 1847–48.

Pointon, Marcia, 'William Dyce as a painter of biblical subjects', *Art Bulletin*, 58 (1976), pp. 260–68.

_____ 'The representation of time in painting: a study of William Dyce's *Pegwell Bay: A Recollection of October 5th, 1858*', *Art History*, 1 (1978), pp. 99–103.

_____ *William Dyce 1806–1864: A Critical Biography*, Oxford: Clarendon Press, 1979.

_____ (ed.), *Pre-Raphaelites Reviewed*, Manchester and New York: Manchester University Press, 1989.

Posner, Donald, *Annibale Carracci: A Study in the Reform of Italian Painting around 1590* (National Gallery of Art: Kress Foundation Studies in the History of European Art), 2 vols, London: Phaidon, 1971.

Prettejohn, Elizabeth, 'Aesthetic value and the professionalization of Victorian art criticism 1837–78', *Journal of Victorian Culture*, 2 (1997), pp. 71–94.

_____ *The Art of the Pre-Raphaelites*, London: Tate Publishing, 2000.

Price, R. G. G., *A History of* Punch, London: Collins, 1957.

Redgrave, Richard, and Samuel Redgrave, *A Century of British Painters* [1866], reprint, 2nd edn, Oxford: Phaidon, 1981.

Renan, Ernest, *The Life of Jesus*, London: Trübner & Co., and Paris: M. Lévy Frères, 1864.

Reynolds, Sir Joshua, *Discourses on Art*, ed. by Robert R. Wark, New Haven and London: Yale University Press, 1975.

Riding, Christine, and Jacqueline Riding (eds), *The Houses of Parliament: History, Art, Architecture*, London: Merrell Publishers Ltd, 2000.

Roberts, David, *The Holy Land, Syria, Idumea, Egypt, Nubia*, 3 vols, London: F. G. Moon, 1842–49.

Roberts, Helene E., 'Art reviewing in the early nineteenth-century art periodicals', *Victorian Periodicals Newsletter*, 19 (1973), pp. 9–20.

Robertson, David, *Sir Charles Eastlake and the Victorian Art World*, Princeton: Princeton University Press, 1978.

Robinson, Edward, *Biblical Researches in Palestine, Mount Sinai and Arabia Petraea*, 3 vols, London: John Murray, 1841.

Rogers, Henry, *Reason and Faith: Their Claims and Conflicts*, 2nd edn, London: Longman, Brown, Green and Longmans, 1850.

Rose, Andrea (ed.), *The Germ: The Literary Magazine of the Pre-Raphaelites*, Ashmolean Museum, Oxford and Birmingham Museums & Art Gallery, 1984.

Roskill, Mark, 'Holman Hunt's differing versions of the "Light of the World"', *Victorian Studies*, 6 (1963), pp. 229–44.

____ and Herbert Sussman, 'Holman Hunt's "The Scapegoat": a discussion', *Victorian Studies*, 12 (1969), pp. 465–70.

Rossetti, Dante Gabriel, *The Correspondence of Dante Gabriel Rossetti*, ed. by William E. Fredeman, 4 vols. [to date], Cambridge: D. S. Brewer, 2002–04.

Rossetti, William Michael, *Fine Art, Chiefly Contemporary: Notices Re-Printed, with Revisions*, London: Macmillan, 1867.

____ (ed.), *Dante Gabriel Rossetti: His Family-Letters, with a Memoir by W. M. Rossetti*, 2 vols, London: Ellis & Elvey, 1895.

Ruskin, John, *The Works of John Ruskin*, ed. by E. T. Cook and Alexander Wedderburn, 39 vols, London: George Allen, 1903–12.

Ruskin in Italy: Letters to his Parents, 1845 ed. by Harold I. Shapiro, Oxford: Clarendon Press, 1972.

Salmon, Richard, 'Thomas Carlyle and the idolatry of the man of letters', *Journal of Victorian Culture*, 7:1 (2002), pp. 1–22.

Sandby, William, *The History of the Royal Academy of Arts from Its Foundation in 1768 to the Present Time, With Biographical Notices of all the Members*, 2 vols [1862], reprinted London: Cornmarket Press, 1970.

Schiller, Gertrud, *Iconography of Christian Art* [1966], trans. by Janet Seligman, 2 vols, London: Lund Humphreys, 1972.

Scott, William Bell, *William Blake: Etchings from his Works*, London: Chatto and Windus, 1878.

____ *Autobiographical Notes of the Life of William Bell Scott ... and Notices of His Artistic and Poetic Circle of Friends 1830 to 1882*, ed. W. Minto, 2 vols, London: Osgood, McIlvaine & Co., 1892.

[Seeley, John Robert], *Ecce Homo: A Survey of the Life and Work of Jesus Christ* [1865], London: Macmillan and Co., 1866.

Shattock, Joanne, and Michael Wolff (eds), *The Victorian Periodical Press: Samplings and Soundings*, Leicester: Leicester University Press, 1982.

Shaw, James Byam, *Paintings by Old Masters at Christ Church Oxford: Catalogue*, London: Phaidon Press, 1967.

Shrewsbury, H. W., *Brothers in Art: Studies in William Holman Hunt, O.M., D.C.L. and John Everett Millais, Bart., D.C.L., P.R.A. with Verse Interpretations*, London: The Epworth Press, J. Alfred Sharp, 1920.

Simpson, Roger, 'A triumph of common sense: the work of Sir John Tenniel 1820–1914', unpublished PhD thesis, University of Essex, 1987.

Smart, N. *et al.* (eds), *Nineteenth-Century Religious Thought in the West*, 3 vols, Cambridge: Cambridge University Press, 1985.

Smiles, Samuel, *Self-Help: With Illustrations of Character and Conduct*, London: John Murray, 1859.

Smith, Barbara Herrnstein, *Contingencies of Value: Alternative Perspectives for Critical Theory*, Cambridge, Mass. and London: Harvard University Press, 1988.

Solkin, David H. (ed.), *Art on the Line: Royal Academy Exhibitions at Somerset House 1780–1836*, New Haven and London: Yale University Press, 2001.

Spielmann, M. H., *The History of 'Punch'*, London: Cassell and Company, 1895.

Staley, Allen, 'William Dyce and outdoor naturalism', *Burlington Magazine*, 105 (1963), pp. 470–76.

[Stanley, Arthur Penrhyn], 'Sacred geography', *Quarterly Review*, vol. 94 (1854), pp. 353–84.

____ *Sinai and Palestine in Connection with Their History*, London: John Murray, 1856.

Steegman, John, 'Lord Lindsay's *History of Christian Art'*, *Journal of the Warburg and Courtauld Institutes*, 10 (1947), pp. 123–31.

Stephens, Frederic George, *William Holman Hunt and His Works: A Memoir of the Artist's Life, with Descriptions of His Pictures*, London: James Nisbet & Co., 1860.

____ 'John Everett Millais', *The London Review*, 22 February 1862, pp. 183–4.

____ *The Grosvenor Gallery: Exhibition of the Works of Sir John Everett Millais, Bt., R.A. with Notes by F. G. Stephens*, London: Henry Good & Son, 1886.

Stevens, M. A. (ed.), *The Orientalists: Delacroix to Matisse*, exh. cat., London: Royal Academy of Arts, 1984.

Strauss, David Friedrich, *The Life of Jesus Critically Examined* [1835], ed. Peter C. Hodgson, London: SCM Press Ltd, 1973.

____ *Das Leben Jesu für das Deutsche Volk bearbeitet*, Leipzig: F. U. Brockhaus, 1864.

____ *A New Life of Jesus*, 2 vols, London and Edinburgh: Williams and Norgate, 1865.

Strong, Roy, *And When Did You Last See Your Father? The Victorian Painter and British History*, London: Thames & Hudson, 1978.

Sussman, Herbert L., 'The language of criticism and the language of art: the response of Victorian periodicals to the Pre-Raphaelite Brotherhood', *Victorian Periodicals Newsletter*, 6 (1973), pp. 21–9.

____ *Fact into Figure: Typology in Carlyle, Ruskin, and the Pre-Raphaelite Brotherhood*, Columbus: Ohio State University Press, 1979.

____ *Victorian Masculinities: Manhood and Masculine Poetics in Early Victorian Literature and Art* (Cambridge Studies in Nineteenth-Century Literature and Culture, 3), Cambridge: Cambridge University Press, 1995.

Templeton, Douglas A., *The New Testament as True Fiction: Literature, Literary Criticism, Aesthetics*, Sheffield: Sheffield Academic Press, 1999.

Thackeray, William Makepeace, *The Paris Sketch Book and Art Criticisms*, ed. by George Saintsbury, London, New York and Toronto, n.d.

Thompson, James (ed.), *The East Imagined, Experienced, Remembered: Orientalist Nineteenth Century Painting*, exh. cat., Dublin: National Gallery of Ireland and National Museums & Galleries on Merseyside, 1988.

Treble, Rosemary (ed.), *Great Victorian Paintings: Their Paths to Fame*, London: Arts Council of Great Britain, 1978.

Trodd, Colin, 'The authority of art: cultural criticism and the idea of the Royal Academy in mid-Victorian Britain', *Art History*, 20 (1997), pp. 3–22.

Tromans, Nicholas (ed.), *David Wilkie: Painter of Everyday Life*, exh. cat., London: Dulwich Picture Gallery, 2002.

Turpin, John, 'German influence on Daniel Maclise', *Apollo*, 97 (1973), pp. 169-75.

Vance, Norman, *The Sinews of the Spirit: The Ideal of Christian Manliness in Victorian Literature and Religious Thought*, Cambridge: Cambridge University Press, 1985.

Vasari, Giorgio, *The Lives of the Artists* [1550], trans. by Julia Conaway Bondanella and Peter Bondanella, Oxford: Oxford University Press, 1991.

Vaughan, William, *German Romanticism and English Art*, New Haven and London: Yale University Press for the Paul Mellon Centre for Studies in British Art, 1979.

Waagen, Gustav Friedrich, *Treasures of Art in Great Britain*, 3 vols, London: John Murray, 1854.

Wagner, Ilse, *Das literarische Werk des Malers Benjamin Robert Haydon*, Göttingen, PhD thesis, 1934.

Warington, George, *'Ecce Homo' and Its Detractors: A Review*, London: William Skeffington, 1866.

Warner, Malcolm, 'The professional career of John Everett Millais to 1863', unpublished PhD thesis, University of London, Courtauld Institute of Art, 1985.

____ *et al.*, *Pre-Raphaelites in Context*, Henry E. Huntington Library and Art Gallery, San Marino, California, 1992.

West, Shearer, 'Tom Taylor, William Powell Frith, and the British School of Art', *Victorian Studies*, 33 (1990), pp. 307–326.

White, Hayden, *Metahistory: The Historical Imagination in Nineteenth-Century Europe*, Baltimore and London: The Johns Hopkins University Press, 1973.

[Wilberforce, Samuel], 'Art. VIII. — *Essays and Reviews*. London. 1860.', *Quarterly Review*, 109 (1861), 248–305.

Wildridge, T. Tindall, *The Grotesque in Church Art*, London: William Andrews & Co., 1899.

Wilson, John Marius, *Landscapes of Interesting Localities Mentioned in the Holy Scriptures, Engraved ... by W. and E. Finden; etc*, 2 vols, Edinburgh: W. and E. Finden, 1852.

Wiseman, Nicholas, 'Art. X.—1. *Sketches of the History of Christian Art*. By Lord Lindsay. 3 vols. Murray, 1847.', *The Dublin Review*, 22 (1847), pp. 486–515.

____ *Essays on Various Subjects*, 3 vols, London: Dolman, 1853.

Wornum, Ralph N. (ed.), *Lectures on Painting by the Royal Academicians: Barry, Opie, and Fuseli*, London: Henry G. Bohn, 1848.

____ 'Modern moves in art', *Art Journal*, 1850, pp. 269–71.

____ 'Romanism and Protestantism in their relation to painting', *Art Journal*, 1850, pp. 133–6.

Wright, Christopher, *Poussin Paintings: A Catalogue Raisonné*, New York and London: Alpine Fine Arts Collection, 1984.

Zeller, Eduard, *Strauss and Renan: An Essay, Translated from the German*, London: Trübner & Co., 1866.

____ *David Friedrich Strauß in seinem Leben und seinen Schriften*, Bonn: Verlag von Emil Strauß, 1874.

____ *David Friedrich Strauss in His Life and Writings*, London: Smith, Elder & Co., 1874.

Zentralinstitut für Kunstgeschichte (ed.), *'Sind Briten hier?' Relations between British and Continental Art 1680–1880*, Munich: Wilhelm Fink Verlag, 1981.

Index

Note: page references in *italics* indicate illustrations.

Abstract Representation of Justice, An
 (Brown) 108, *110*
Aesthetic Movement 95–7, 194
Agnew, Thomas 181
 All Saints Church, Margaret Street,
 London 55
Altholz, Josef 175
Angelico, Fra 13
Apollinarisberg church frescoes 6
Armstrong, Walter 189
art criticism 35–40
art history 27–8
Art Journal 47, 57, 84, 88, 99, 177
 on Eastlake 52, 54
 on Hunt, W. H. 127, 152, 153, 163, 182,
 186
 on Millais 101, 102, *104*
 on RA 34, 35
Art-Union 30, 35, 36–7, 39, 63, 65, 85
 on Dyce 57–8
 on Eastlake 49–50, 51
Athenaeum 37–8, 57, 63, 65, 97, 103, 125
 on Dyce 57, 176, 177
 on Eastlake 50–51, 52–4
 on Hunt, W. H. 152, 153, 167
 on Millais 101–2, 103, 190–91
 on RA 34, 35, 39
Autobiography (Haydon) 46, 47
Awakening Conscience, The (W. H. Hunt)
 147, 185

Banishment of Aristides, The (Haydon)
 40–41, 46
Bann, Stephen 135
Barasch, Frances 88
Barrell, John 42
Barry, James 22

Barthes, Roland 166
Bayliss, Wyke 127
Bell, Charles 74
Belshazzar's Feast (Martin) 46
Bendiner, Kenneth 78, 87
Bennett, Mary 80
Biago di Antonio da Firenze 78–80, *81*
Bibel mit Bildern 60, 62
Bibles, illustrated 134–41, 190, *191*
 Bibel mit Bildern 60, 62
 Cassell's Illustrated Family Bible 141,
 142, 143, 144
 Dalziels' Bible Gallery 194–6
 Illustrated Family Bible 196–7, *198, 199*
 Imperial Family Bible 139, *140*
 Pictorial Bible 134–6, *137–8, 139–40*
 topographical engravings in 136–9
Blackwood's Magazine 44, 54
Blake, William 75, 193, *195*
Boase, T. S. R. 136
Bourdieu, Pierre 12, 14, 18–19, 72, 87, 99,
 102
Boxall, William 122
British Diorama 45–6
British Institution 43
Broad Church movement 173, 174
Bronkhurst, Judith 142–3, 165
Brooks, Chris 75
Brown, Ford Madox 72, 75, 78, 84
 Abstract Representation of Justice, An
 108, *110*
 Jesus washing Peter's Feet Pl.5, 78, 83–4
 Our Lady of Good Children 78–80, *79,*
 81–2
 Wycliffe reading his Translation of the
 New Testament to John of Gaunt
 2–4, *3, 5,* 14

Bullen, J. B. 87
Burne-Jones, Edward 195, *196*
Butcher's Shop, The (A. Carracci) *Pl.9*,
 116–17, 120, 122, 124

Cairns, John 132
Campo Santo frescoes, Pisa 28, 69–70, *71*,
 94
Carlyle, Thomas 133–4, 155–7
Carracci, Annibale
 Butcher's Shop, The Pl.9, 116–17, 120,
 122, 124
 Holy Family in the Carpenter's Shop, The
 112, *113*
Carracci, Ludovico 121
Cassell, John 141
Cassell's Illustrated Family Bible 141, *142*,
 143, *144*
Child Jesus, The (Collinson) 115, *116*,
 121–2
Christ and the Two Marys (W. H. Hunt)
 141–2, 144–6, *145*, 147, 184, 197
Christ blessing Little Children (Doré) 190,
 191
Christ blessing Little Children (Eastlake)
 49, *50*
Christ in the House of His Parents (Millais)
 Pl.7, 2, 101, 107, 108–25, *110*, 126,
 184
 comparison with Carracci 117–20, 121,
 122, 124
 controversy over 31, 33, 68, 100, 103–4
 sketches for *118–19*
Christ lamenting over Jerusalem (Eastlake)
 Pl. 2, 50–52, *53*
Christ's Agony in the Garden (Haydon) 44
Christ's Charge to Peter (Raphael) 8–9, *9*
Christ's Entry into Jerusalem (Haydon)
 Pl.1, 43–4
Codell, Julie 74, 128
Collins, Charles Allston 107, *109*
Collinson, James 86, 115, *116*, 121–2
Contemporary Review 160, 161, 186
Convent Thoughts (Collins) 107, *109*
Cook, Thomas 159
Cope, Charles West 41
Correggio, Antonio 112
Critic, The 169

Dafforne, James 57
Dalziel brothers 194–5
Dalziels' Bible Gallery 195–6
Death of Dentatus, The (Haydon) 42–3
Deformito-Mania, The 107, *108*

Delaroche, Paul 61
Departure of Hagar from the House of
 Abraham (Gozzoli) 70, *71*
Dickens, Charles 103, 104, 105, 107, 117
Discourses on Art (Reynolds) 22, 26–7
Doré, Gustave 141, 190, *191*, 197
Doyle, Richard 89, 91, *92*
Dyce, William 41, 89, 176
 Good Shepherd, The 177, *178*
 Jacob and Rachel 55–7, *56*
 Joash shooting the Arrow of Deliverance
 Pl.3, 57–8, 66
 Madonna and Child 80–81, *82*
 Man of Sorrows, The Pl.11, 176–7

Eastlake, Charles Lock 21–2, 28, 38–9,
 48–55
 Christ blessing Little Children 49, *50*
 Christ lamenting over Jerusalem Pl.2,
 50–52, *53*
 Good Samaritan, The 52–3, *54*, 57
 Hagar and Ishmael (1830) 48, *49*
 Hagar and Ishmael (1843) 52, *53*
 Pilgrims in Sight of Rome 48, *49*
Ecce Ancilla Domini (D. G. Rossetti) 93,
 95–7, *96*, 193
Ecclesiologist 100
Egyptian Hall, Piccadilly 40, 43, 44, *45*,
 46
Eliot, George 129
Ellis, Ieuan 175
Embalming of Joseph, The 141, *142*
Emerson, Ralph Waldo 88
Ensuing Exhibition of the Royal Academy
 and Smithfield Market Prize Show, The
 105–6, *106*
Errington, Lindsay 84, 111–12
Essays and Reviews 172–5, 181
Esther (O'Neil) 57, *59*
Etty, William 57

Farrar, Frederic William 17, 130, 182–3,
 183, 186
Finding of the Saviour in the Temple, The
 (W. H. Hunt) *Pl.10*, 16, 31–3, 164–72,
 175, 176, 186
 reviews of 167–70, 185
Fine Arts Commission 25, 38, 41
Fine Arts Society 154, 179
Foolish Virgins, The (Millais) 190, *192*
Fra Angelico Painting (D. G. Rossetti) 14,
 15
Fraser's Magazine 48, 168
Free Exhibition 93, 97

Frei, Hans 129
fresco paintings 6, 52, 69–70, *71*, 94, 146
Fuseli, Henry 22, 24

Gambart, Ernest 162–3, *164*
George, Eric 47
Géricault, Theodore 45
Germ, The (magazine) 67, 69, 98, 115, 120
 Brown in 75, 83
 Stephens in 70–72
German Gallery, London 11, 164
Girlhood of Mary Virgin, The (D. G.
 Rossetti) *Pl.6*, 78, 93–5, 97, 112, 121,
 193
Gladstone, William 129
Good Samaritan, The (Eastlake) 52–3, *54*,
 57
Good Shepherd, The (Dyce) 177, *178*
Gosse, Edmund 166
Gozzoli, Benozzo 28, 70, 71
Guardian (High Church magazine) 111

Hagar and Ishmael (Eastlake, 1830) 48, *49*
Hagar and Ishmael (Eastlake, 1843) 52, *53*
Hall, C. S. 36
Handbook for Travellers in the Holy Land
 159
Hand-book of the History of Paintings, A
 (Kugler) 28
Harrison, Frederic 174–5
Hart, Solomon 97, 98
Haydon, Benjamin Robert 21, 40–48, 51
 Autobiography 46, 47
 Banishment of Aristides, The 40–41, 46
 Christ's Agony in the Garden 44
 Christ's Entry into Jerusalem Pl.1, 43, 44
 Death of Dentatus, The 42–3
 exhibition at Egyptian Hall 43, 44, 46
 Judgement of Solomon, The 43
 Nero at the Burning of Rome 40–41, 46
 Raising of Lazarus, The 44, *45*
 suicide 40, 46–7
Hazlitt, William 16–17, 22, 34, 44–5
Herbert, John Rogers 41, 55, 85; see also
 Our Saviour subject to His Parents at
 Nazareth
Hewlett, Maurice 134
High Art and the Royal Academy 89–90, *91*
Higher Criticism 172–3
Hogarth, William 24, 26, 27
Holy Family in the Carpenter's Shop, The
 (A. Carracci) 112, *113*
Houses of Parliament 25, 38–9, 40–41, 46,
 55

Howard, Henry 22, 23, 24–5, 29–30, 31,
 66, 169
Hughes, Arthur *Pl.13*, 193
Hunt, F. K. 108, *110*
Hunt, William Holman 4, 17, 83–4, 86,
 112, 143–4, 186–7
 Art Journal on 127, 182, 186
 Awakening Conscience, The 147, 185
 on Campo Santo frescoes 69, 70
 and Carlyle 133–4, 155–7
 Christ and the Two Marys 141–2, 144–6,
 145, 147, 184, 197
 Eastern travels 14–16, *18*, 19–20,
 157–63, *159*
 on historical veracity 139
 and historicization of Christ 177–9
 Interior of a Carpenter's Shop 182–4, *183*
 on Millais 116
 Painting in England. Hastings 1852
 14–16, *17*
 Painting in the East, Grand Cairo 185—
 158, *159*
 and pre-Raphaelitism 72, 74–5, 99–100,
 146–7
 on Raphael 74–5, 123
 and Ruskin 73, 192
 Scapegoat, The 160, 161–3, *162*, 186
 Self-portrait in Egyptian Landscape 16,
 18
 Shadow of Death, The Pl.12, 128, 146,
 179–82, *183*–4, 185
 see also *Finding of the Saviour in the*
 Temple, The; Light of the World, The

Illustrated Family Bible, The 196–7, *198*,
 199
Illustrated London News 98–9, 107, *110*,
 113
Imperial Family Bible, The 139, *140*
Interior of a Carpenter's Shop (W. H. Hunt)
 182–4, *183*
Israelites leaving Egypt, The (Roberts) 45–6

Jacob and Rachel (Dyce) 55–7, *56*
Jäger, Gustav 60, *62*
James Wyatt and his Granddaughter Mary
 Wyatt (Millais) 122, *123*
Jameson, Anna 69, 27–8, 69, 114–15
Jerusalem with the Mount of Olives 136,
 138
Jesus washing Peter's Feet (Brown) *Pl.5*,
 78, 83–4
Joash shooting the Arrow of Deliverance
 (Dyce) *Pl.3*, 57, 66

Johnson, Randal 12
Jowett, Benjamin 131, 172–4
Judas Iscariot bargaining with the Chief Priests 141, *143*
Judgement of Solomon, The (Haydon) 43
Justice 89, *90*

Keble, John 176
Kingsley, Charles 28, 89, 174, *175*
Kitto, John 139
Knight, Charles 38–9, 134–6
Kris, Ernst 87, 92
Kugler, Franz 27, 28

Landow, George 115, 165
Lanzi, Luigi 120–21
Lasinio, Carlo 69, *71*
Leslie, Charles Robert 22, 25–6, 31, 53, 66, 120
 Hand-book for Young Painters 26, 27
 lectures 28–30
 on Raphael 28–9
Light of the World, The (W. H. Hunt) 16, 128, 147–54, *148*, 184–5, *186*, 197
 Athenaeum on 152, 153
 Carlyle on 133–4
 sketches for 149, *150*
Lindsay, Lord 13, 69, 116
Lost Sheep, The (Webb) 179, *180*

Macleod, Dianne Sachko 31
Maclise, Daniel 41, 55, 60–64, *61*, *63*, 89
Macmillan's Magazine 167
Madonna and Child (Dyce) 80–81, *82*
Man of Sorrows, The (Dyce) *Pl.11*, 176–7
Manchester Guardian 169
Mariana (Millais) 107, *109*
Martin, John 45, 46
Mary in the House of St John (D. G. Rossetti) 193, *194*
Meeting of Jacob and Rachel, The (Strähuber) 57, *58*
Memoirs of Early Italian Painters (Jameson) 27–8
Meynell, Mrs 16, 127, 163, 181
Michelangelo Buonarroti 28
Millais, John Everett 98, 100–102, 117, 127, 143, 189–91
 Foolish Virgins, The 190, *192*
 James Wyatt and his Granddaughter Mary Wyatt 122, *123*
 Mariana 107, *109*
 Mrs James Wyatt Jnr and her Daughter Sarah 122–3, *124*

Parables of Our Lord, The 190, 192, 194
 on realism 189, 190
 Sketch of Madonna and Child 123, 125
 see also *Christ in the House of His Parents*
Miller, Joseph Hillis 131
Modern Painters (Ruskin) 27, 72–3, 151–2
Moses bringing down the Tables of the Law (Scott) 197, *198*
Mr Holman Hunt in his Costume when painting 'The Scapegoat' 164
Mrs James Wyatt Jnr and her Daughter Sarah (Millais) 122–3, *124*

National Gallery 46
National Portrait Gallery 133
Nativity, The (Hughes) *Pl.13*, 193
Nativity, The (Scott) 193–4, *195*
Natural Theology 72
Nazarene artists 6, 48, 52, 57, 64, 140
Nero at the Burning of Rome (Haydon) 40–41, 46
Nietzsche, Friedrich 131
Noah's Sacrifice (Jäger) 60, *62*
Noah's Sacrifice (Maclise) 60–64, *61*, *63*
Noah's Sacrifice (Poussin) 60–61, *62*

Once a Week 168–9
O'Neil, Henry Nelson 57, *59*
Opie, John 22
Ottley, William Young 27
Our Lady of Good Children (Brown) 78–80, *79*, 81–2
Our Saviour subject to His Parents at Nazareth (*The Youth of our Lord*, Herbert) *Pl.4*, 6–7, 66, 97
 symbolism in 64, 85, 112, 121, 184
 topography in 64–5, 139, 184

Painting in England. Hastings 1852 (W. H. Hunt) 14–16, *17*
Painting in the East, Grand Cairo 185— (W. H. Hunt) 158, *159*
Palestine Exploration Fund 159
Parable of the Boiling Pot, The (Burne-Jones) 195, *196*
Penny Magazine 27–8, 135
Phillips, Thomas 28
Pickersgill, F. R. 57, *60*
Pictorial Bible (Knight) 134–6, *137–8*, 139–40
Pilgrims in Sight of Rome (Eastlake) 48, *49*
Pitture a Fresco del Campo Santo di Pisa (Lasinio) 69, *71*

Pointon, Marcia 128, 177
Poussin, Nicolas 60–61, 62
Powell, Baden 172–3
PRB Journal 85–6, 95, 113–14
Pre-Raphaelite Brotherhood (PRB) 31–3,
 103
 aesthetic 5, 12, 14, 25–6, 75–8, 84, 88,
 98–9, 171
 foundation and aims 2, 68–9, 72
 Germ, The 67, 69, 70–72, 75, 83, 98, 115,
 120
 PRB Journal 85–6, 95, 113–14
Prettejohn, Elizabeth 122–3
Punch magazine 35, 36, 88, 105–8, 109
 cartoons 89–93, *91*, *92*, *94*, *95*
 on Millais 104
 on RA 105–7
*Punch presenting Ye Tenth Volume to Ye
 Queene* (Doyle) *91*, *92*

RA, *see* Royal Academy
Raising of Lazarus, The (Haydon) 44, *45*
Raphael (Raffaello Santi) 5, 10, 28–9,
 74–5
 Cartoons 8, 22–3, 24
 Christ's Charge to Peter 8–9, *9*
Reach, Angus 98–9
Rebekah and Abraham's Servant (Vernet)
 139, *140*
Renan, Ernest 129, 130–3, 179
Resurrection, The (Scott) 197, *199*
Reynolds, Joshua 22–3, 26–7, 73, 104
Rio, Alexis François 27
Roberts, David 45–6, 65, 159
Robinson, Edward 159
Roskill, Mark 149
Rossetti, Dante Gabriel 72, 75, 122, 127
 caricatures 75, *76*, *77*
 Ecce Ancilla Domini 93, 95–7, *96*, 193
 Fra Angelico Painting 14, *15*
 Girlhood of Mary Virgin, The Pl.6, 78,
 93–5, 97, 112, 121, 193
 on historical veracity 139
 Mary in the House of St John 193, *194*
 Ruskin on 192–3
 Sir John Everett Millais (caricature) 75,
 77
 William Holman Hunt (caricature) 75, *76*
Rossetti, William Michael 1, 95–7, 115
 on Hunt 123–4, 169
 on Millais 100, 123–4
 on naturalism 10–11
 on pre-Raphaelitism 67, 68–9, 72, 84,
 85–6

 on religious art 3, 10–11, 12, 13, 16, 17,
 38
Royal Academy (RA) 22, 24–5, 46
 annual exhibitions 13, 31, 34, 36, 39,
 55, 85
 in *Punch* 105–7
 religious subjects shown (1825–70) 31,
 32–3
Rumohr, Carl Friedrich von 27
Ruskin, John 13, 69, 70, 74, 107, 136, 156
 on W. H. Hunt 153–5, 163, 168, 192
 Modern Painters 27, 72–3, 151–2, 153–4,
 168
 Political Economy of Art, The 171
 on religious art 4, 7–10, 12, 20
 on Rossetti, D. G. 192–3

Sacred and Legendary Art (Jameson) 28,
 69, 114–15
Salmon, Richard 155
Samson Betrayed (Pickersgill) 57, *60*
Sandby, William 55
Sano di Pietro Pl.8, 113, 120, 124
Scapegoat, The (W. H. Hunt) 160, *161*–3,
 162, 186
Scene from Gothic Life, A 93, *95*
Scott, William Bell 149, 193–4, *195*, 197,
 198, *199*
Scottish Academy 45
Seeley, John 129–30, 179
Self-Help (Smiles) 47, 156
Self-portrait in Egyptian Landscape (W. H.
 Hunt) 16, *18*
Shadow of Death, The (Hunt) Pl.12, 128,
 146, 179–82, *183*–4, *185*
Shaw, George Bernard 154
Sicilian Women grinding in a Mill 136, *138*
Sick laid in the Streets to be healed, The 141,
 144
Sir John Everett Millais (caricature) (D. G.
 Rossetti) 75, *77*
Sketch of Madonna and Child (Millais) 123,
 125
Smiles, Samuel 47–8, 156, 157–8, 170
Society for the Diffusion of Useful
 Knowledge 135
Stanley, Arthur Penrhyn 161, 174
Stephens, Frederic George 16, 17, 70–72,
 155, 176, 190
 on W. H. Hunt 158, 161, 164–6, 167–8,
 169–70
 on Millais 111
 on Pre-Raphaelitism 171
Strähuber, A. 57, *58*

Strauss, David Friedrich 128–32, 179
Sussman, Herbert 1, 72, 74, 128, 151

Taylor, Tom 26–7
Temple, Frederick 172–3, 181
Tennyson, Alfred 128
Thackeray, William Makepeace 35–6, 48, 54
Thompson, James 159
Times, The 37, 39, 88, 186
 and Pre-Raphaelitism 103
 on Dyce 56, 58
 on Eastlake 52
 on Haydon's suicide 46–7
 on Herbert 65
 on hierarchy of genres 33–4, 35
 on Millais 101, 102
 on RA exhibitions, predominance of
 portraits at 33–4
 on Rossetti, D. G. 97
 Ruskin in 153, 155
Tintoretto, Jacopo 72–3
Tupper, John 120, 121

Uhde, Fritz von 189

Vasari, Giorgio 13
Vaughan, William 61, 128
Vernet, Horace 11, 139, *140*
Virgin and Child with Six Saints (Sano di
 Pietro) *Pl.8*, 113, 120, 124
*Virgin and Child with the Young Saint John
 and an Angel holding the Three Holy*

Nails (Biago di Antonio da Firenze)
 78–80, *81*

Waagen, Gustav Friedrich 116–17, 121, 153
Warner, Malcolm 123
Watercolour Society 43
Webb, William J. 179, *180*
West, Benjamin 23–4
Westminster Cartoon Competitions 2,
 38–9, 40, 41, 55, 88–9, 108
Westminster Review 174
Wheeler, Michael 154
Wilberforce, Samuel 175
Wildridge, Tindall 88
Wilkie, David 19, 20, 84, 85, 146, 157–8, 159
William Holman Hunt (caricature) (D. G.
 Rossetti) 75, *76*
Wilson, John Marius 136–9
Wiseman, Nicholas 5–7, 12, 13, 16
Wornum, Ralph N. 4–5, 12, 22, 104, 108
Wycliffe, John 2
*Wycliffe reading his Translation of the New
 Testament to John of Gaunt* (Brown)
 2–4, *3*, *5*, 14

Young Man about Town, A (Gothic) 93, *94*
Youth of our Lord, The, see *Our Saviour
 subject to His Parents at Nazareth*
 (Herbert)

Zeller, Eduard 130, 131, 132

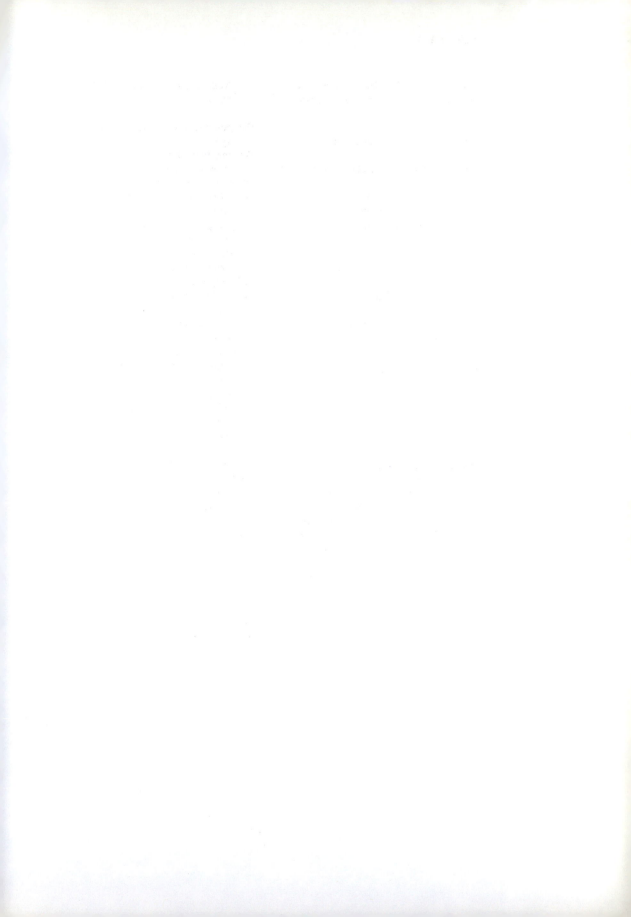